PANORAMANIA!

An exhibition at Barbican Art Gallery
from 3rd November 1988 to 15th January 1989

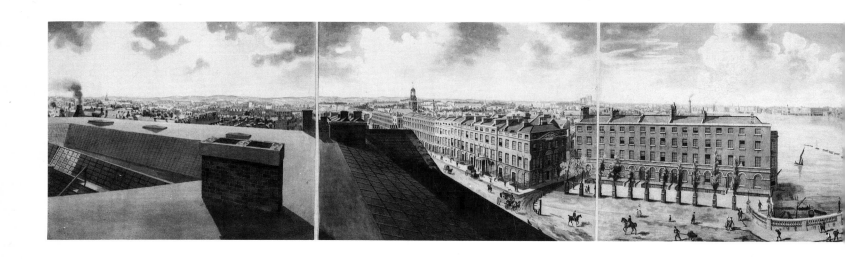

PANORAMANIA!

THE ART AND ENTERTAINMENT OF THE 'ALL-EMBRACING' VIEW

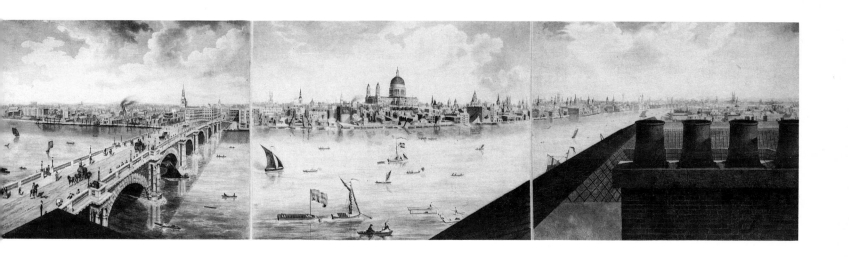

BY RALPH HYDE

INTRODUCTION BY SCOTT B. WILCOX

TREFOIL PUBLICATIONS, LONDON,
IN ASSOCIATION WITH BARBICAN ART GALLERY

Published on behalf of Barbican Art Gallery by
Trefoil Publications Ltd
7 Royal Parade, Dawes Road, London SW6

First Published 1988

© Barbican Art Gallery, Corporation of the City of London, 1988

ISBN 0 86294 125 3

Designed by Elizabeth van Amerongen
Edited by Diana Dethloff, assisted by Charles Benn
Typeset by Wandsworth Typesetting Limited
Origination by Database Resources, Singapore
Printed and bound in Italy by Graphicom s.r.l.

In the catalogue sizes are given in centimetres, height before width.
In some cases only part of a very long work is illustrated.

British Library Cataloguing in Publication Data

Hyde, Ralph
 Panoramania!
 1. Landscape paintings — Catalogues
 I. Title
 758′ .1′0714

(page 6)
63 View of the Observatory over St. Paul's

(previous page)
28 London from the Roof of the Albion Mills
After Robert and Henry Aston Barker

CONTENTS

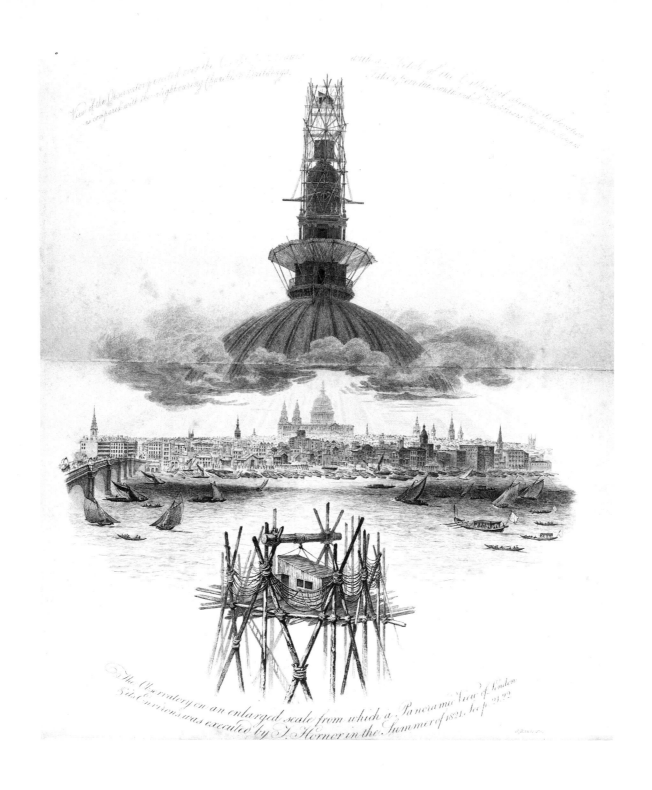

View of the Observatory erected over the [illegible] with a Sketch of the [illegible] as compared with the neighbouring Churches & buildings. taken from [illegible]

The Observatory on an enlarged scale from which a Panoramic View of London & its Environs was executed by T. Horner in the Summer of 1821. See p. 21,22

FOREWORD

My first experience of an enormous 360° painting was during a visit to Atlanta in 1953 when I saw the 'Battle of Atlanta' panorama. Painted by a German panorama artist in 1885-86, it commemorates one of the most dramatic Confederate defeats during the closing stages of the American Civil War, and, like many panoramas, underwent an extensive tour before eventually finding a permanent home. Anyone who visits Atlanta today will now see this extraordinary painting restored to its original brilliance and vigour. Its visual impact is remarkable enough but it also struck me on that first visit that such a vivid re-creation of an historic event could not fail to arouse conflicting responses in an American audience.

In the course of my association with the planning of this exhibition I have become acquainted with the astonishing variety of forms which panoramic works can take. There are, for example, those which blend the spectacular illusions of the static panorama with the light and movement of the diorama, which itself derives effects from both fine art and the theatre; there are moving panoramas, photographic panoramas, as well as the cosmorama, a sophisticated variant of the fairground peepshow; each seeks to entertain and inform while giving the spectator a powerful sense of all-encompassing realism. Finally, there is the cinema which has inherited so much from the tradition established by the panorama and diorama. The decision of the National Film Theatre to mount a season of widescreen films in conjunction with *Panoramania!* allows us to bring the story up to date and to make connections between a major contemporary art form and its immediate precursors.

However, I must be careful not to give the impression that panorama painting has been entirely superceded. In an era when much contemporary art speaks a language which is often incomprehensible to the mass of people it is significant that we seem to be experiencing an international revival of this form of popular art. Great nineteenth-century panoramas like the 'Battle of Atlanta' and the Raclawice panorama, which celebrates the victory of the Poles over the Russians in 1794, have recently been restored, while at Bad Frankenhausen in East Germany a gigantic panorama of the sixteenth-century Peasants' War is due to open in 1989. Elsewhere similarly ambitious works have been commissioned or recently completed, often seeking, in similar fashion, to portray an historic place or event which has a particular resonance for local audiences.

From the beginning the panoramists' desire to escape the physical limitations of conventional painting led them to exploit a range of topical and dramatic subjects on such an ambitious scale that special buildings were required to house them. Naturally, this presents a considerable challenge when it comes to mounting an exhibition devoted to the many aspects of the panorama phenomenon. Whole buildings and their contents cannot be transported to London, and much has sadly been destroyed, but by blending a wealth of original small scale exhibits with models and larger scale reconstructions it is possible to recreate some of the impact of the real thing. By these means the exhibition attempts to reassess an art form which until recently was relegated to a mere footnote in the history of art, and barely represented in our museums and galleries. I trust therefore that one consequence of this exhibition and its accompanying catalogue will be a far greater understanding of a neglected aspect of our artistic heritage. All those concerned with the planning and mounting of this very special exhibition deserve our congratulations and thanks.

LORD MONTAGU OF BEAULIEU,
CHAIRMAN, EXHIBITION ADVISORY COMMITTEE

9

ACKNOWLEDGEMENTS

When John Hoole, the Barbican Art Gallery's Curator, invited me to research an exhibition devoted to panoramas — panoramas of all types and in all places, from the invention of the first to the painting of the most recent – I tried my best to disguise considerable trepidation. I already knew something of such matters as the Regent's Park Colosseum and Mr Wyld's Monster Globe and considered myself an expert on engraved prospects and panoramas of British towns. But these were narrow specialisations, small fragments of the total subject. There were whole classes of panoramas of which I knew next to nothing, and about panoramas abroad I knew nothing whatsoever. Clearly if the exhibition and its catalogue were to work I would need to research large, previously totally unexplored areas — panoramic entertainments in the U.K. provinces, for example. And I would also need the help of those who were expert in such areas as dioramas, theatre panoramas, and panoramic photography. Their cooperation would be crucial.

I need not have worried. Panoramas, I soon found, attract scholarly enthusiasts and enthusiastic scholars who enjoy hugely opportunities to share their knowledge and discoveries with the like-minded. Curators and private collectors went out of their way to help me, continuing to pass on information and to bring in potential exhibits for me to inspect long after I made my initial enquiries.

My first thanks must go to John Hoole who had the courage to take this very large-scale and uniquely problematical exhibition on board. To Francis Pugh, the Exhibition Coordinator, I owe a similar debt of gratitude. Ever professional he kept a stern yet kindly eye on all developments, disposing of my maddest proposals with the utmost tact whilst methodically seeing some of the saner ones through to fruition. Tomoko Sato as Exhibition Organiser for the last year, took care of the day to day development of the exhibition with splendid efficiency and good humour. Brigette Lardinois' assistance as translator of foreign texts and interpreter was indispensible.

The works of three scholars must receive special mention here: Professor Richard Altick's *Shows of London,* Dr Scott Wilcox's 'Panoramas and Related Exhibitions in London', and Dr François Robichon's 'Les Panoramas en France'. In compiling the list of exhibits and in preparing the text of the catalogue I turned repeatedly to each of them. References to 'Wilcox' in my text refer to the above thesis; specific dates for the display of panoramas at the Panorama, Leicester Square and the Panorama in the Strand have, with Dr Wilcox's permission, been taken from an appendix in it. Kevin Avery at the Metropolitan Museum, New York; Lionel Lambourne at the Victoria & Albert Museum; Dr Pieter van der Merwe at the National Maritime Museum;

David Taylor, Local History Librarian at Manchester City Libraries; Brian Polden, Chairman of the International Panorama & Diorama Society; David Robinson, Bill Douglas, Peter Jewell, John and William Barnes, and Jonathan Gestetner all bombarded me with ideas and information, drawing my attention to panoramas I would have missed and instructing me in areas where my knowledge was severely limited. All errors in the text are my own.

The following individuals also provided me with information or assisted substantially with loans: Peter Barber, Dr Kathleen Barker, Dr Dominik Bartmann, Christopher Baugh, Gustav and Mira Berger, Mao-Wen Biao, the Hon. Christopher Lennox-Boyd, Jilliana Ranicar-Breese, Jane Carmichael, John and Barbara Cavenagh, David Cheshire, Mimi Colligan, Mary Cosh, James Cuming, Robert Douwma, Paul Draper, Vicomte Michèl du Bosc de Beaumont, Lawrence Duttson, John Earl, John R. Earnst, Simon Edsor, Lady Elton, Ann Escott, P.K. Escreet, William Feaver, Berekhardt and Christoph Fischer, Celina Fox, David Francis, Joan Fuglesang, Mireille Galinou, Svoboda Giurova, Helen Guiterman, John Hammond, Peter Harrington, Robert Headland, R.M. Healey, Francis Herbert, Ronald A. Hetrick, John Hillelson, Dr Hans-Eberhard Hilpert, Stanley K. Hunter, Janet Johnstone, Elspeth King, Gérard Lévy, Cyril and Violet Luckham, Linda McAllister, Michael Mallinson, Harry Margary, Ian Maxted, Y.Y. Mazepov, Dr David Mayer, Roger Morgan, Susan Morris, Bernard Nurse, Dr Stephan Oetermann, Paul Osborne, Jim Poole, Gaby Porter, Bob Pullen, Sidney Ray, Caroline L. Reitz, Dr. André Mayer, Howard Ricketts, Dr Gottfried Riemann, Pamela Roberts, Bruce Robertson, Andrew Robson, Dr Nikolaus Schaffer, Janet Smith, Jenny Spencer-Smith, Roger Taylor, Mike Simkin, the Earl and Countess of Stair, Rowland Stephenson, Miss S. Stoddard, Mgr Beata Stragierowicz, Prof. Dr Helmut Börsch-Supan, Heather Thorn, Robert Thorne, P.J. van Dijk, John Ward, John Watts, David Webb, Margaret Wilkes, Michael Willis, the late Aileen Wyllie, and Dr Paul Zoetmulder.

Finally I must express thanks my Director, Melvyn Barnes, and to my colleagues at Guildhall Library, especially John Fisher, Jeremy Smith, and Andrew Spencer who bore the strain over long periods when panoramas had to be my prior concern; to the staff of Barbican Art Gallery, especially Carol Brown, and Anna Parker who were ever cheerful and supportive; and to my wife and children whose toleration of my succeeding obsessions never ceases to fill me with admiration.

RALPH HYDE

PREFACE

In July 1983 an international Panorama and Diorama Seminar was held at the Victoria and Albert Museum to celebrate the restoration, and re-installation in the Museum's Henry Cole Wing, of Lodovico Carocciola's 'Panorama of Rome'. The event proved extremely successful and led directly to proposals that an exhibition devoted to all aspects of the panorama and diorama should be mounted in London, a particularly appropriate location since the first purpose-built panorama rotunda was erected in this city by Robert Barker in 1793. In 1984 the Barbican Art Gallery committed itself to organise the exhibition and Ralph Hyde, Keeper of Prints and Maps, Guildhall Library was appointed researcher and selector. He has been aided by a Working Party and an Advisory Committee of enthusiasts and experts, ably chaired by Lord Montagu. Both groups have given invaluable scholarly and practical advice and encouraged an extraordinary process of rediscovery.

Central to the exhibition is an exploration of the connections between high art and mass entertainment, largely ignored in the histories of art, where popular culture and self-education blend to produce the phenomenon, referred to in the *Illustrated London News* in 1850 as 'panoramania' — a phenomenon which, in many respects can be considered the progenitor of our present day electronic mass-media.

The exhibition also illustrates the diversity of the panorama phenonomen by including the various forms in which the wide-view was represented. Besides remains of large scale panoramas, the exhibition contains moving panoramas, dioramas, panoramic photography, working drawings and the commemmorative prints that, like theatre programmes, are often the only remaining evidence of some of the major schemes. Further to this, *Panoramania!* has brought together work by both well-known and unknown artists who participated in the production of panoramas or were influenced by its contemporary popularity.

The final intention of the exhibition is to draw attention to the continuing vitality of the panorama painting tradition, which, in an age of instant, global telecommunication, still continues to manifest itself in many countries today. The sight of Werner Tubke's massive painting of the Peasants' War, soon to be opened in Bad Frankenhausen, is enough to convince any one that panoramic painting is still a vital force.

By their very nature panoramic works of art present a special challenge both to the selector and to the exhibition organisers. Quite apart from their unusual dimensions many have been in store, or seldom displayed, and so require extensive repair and conservation. To do justice

to some it is important to attempt an approximation of the way in which they were originally displayed. With others wholesale re-creation is essential if the impact of the original experience is to be fully appreciated. Clearly an exhibition which explores an art that set about 'unlimiting the bounds of painting' has to some extent to attempt the impossible.

In doing this we have been greatly assisted by our sponsors Arthur Ackerman and Son Ltd, and the Mercers' Company; by conservators Brian Cardy, Kate Colleran, Sheila Fairbrass, Jane McAusland and Hilary Ordman; by scene painters Kimpton Walker; by the set designer Christopher Baugh; and by the installation designer John Ronayne without whose commitment and support 'Panoramania!' would not have been possible. We are indebted to Her Majesty Queen Elizabeth II, and many private and institutional lenders. Finally we thank Ralph Hyde whose indefatigable research, writing and editing has enabled us to assemble a comprehensive display and to produce this catalogue. Tomoko Sato, as Exhibition Organiser, has proved indispensible in bringing order to so vast a project.

JOHN HOOLE,
CURATOR, BARBICAN ART GALLERY

FRANCIS PUGH,
EXHIBITION CO-ORDINATOR

UNLIMITING THE BOUNDS OF PAINTING
BY SCOTT B. WILCOX

I

On 14 March 1789, 'MR BARKER'S INTERESTING and NOVEL VIEW of the CITY and CASTLE of EDINBURGH, and the whole adjacent and surrounding country'[1] opened in London. The novelty of the view was that it comprised a full 360°. Standing at the centre of a huge cylinder, the spectator was completely surrounded by the view painted on the inside of the cylinder. Robert Barker, an Irish-born artist working in Edinburgh, had devised this form of painting several years earlier. The picture of the Scottish capital, his first large-scale attempt to put the idea into practice, had already achieved success in Edinburgh and Glasgow.

The view of Edinburgh was the first of a prodigious series of such paintings, for which Barker two years later coined the name 'panorama.' In 1793 he opened a permanent establishment for the exhibition of his panoramas in London – an establishment that continued in operation for seventy years[2]. Other pictorial entertainments, either based on Barker's principle, or on other related schemes, proliferated, early in the nineteenth century to become a considerable attraction in the English capital[3]. The popularity of the panoramas was restricted neither to London nor to Britain, but was a truly international phenomenon[4]. As early as 1795 there was a panorama on exhibition in New York, and by 1800 they had been seen in Paris and several German cities. Throughout the nineteenth century the various forms of the circular panorama, the diorama, and the moving panorama drifted in and out of fashion. In the later years of the century, when the original circular form enjoyed a dramatic revival, not only Europe and America but Australia, Brazil, Korea and Japan boasted panorama rotundas

The impact of the panorama and related exhibitions on the general public's perceptions of art and the world, although hard to quantify, must have been considerable. Although they were frequently discounted as less than art, such exhibitions' influence on the 'legitimate' arts was also substantial – a subject which art-historical scholarship is just beginning to address.

What has hindered the appreciation of the panorama's role in the visual culture of the nineteenth century is the scarcity of actual examples – the outcome of an ephemeral art which has left us scanty visual remains. With only a few notable exceptions, such as John Vanderlyn's 1819 panorama of Versailles (Metropolitan Museum of Art, New York), panoramas from the first half of the nineteenth century have not survived. The economics of

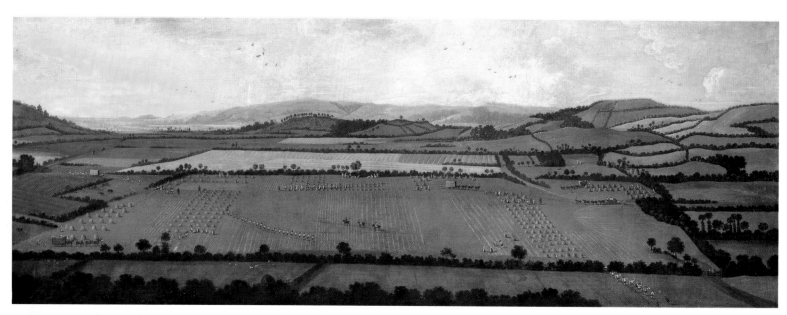

6 The countryside around Dixon Manor c.1725-35
ANON

24 Painted Room, Drakelowe Hall 1793
PAUL SANDBY

panorama-exhibiting demanded that these vast canvases either be toured until they wore out or be repainted if their subject could no longer attract audiences.

Recent years have seen renewed interest in the handful of later nineteenth and early twentieth-century survivals, such as Hendrik Mesdag's panorama of Scheveningen and Paul Philippoteaux's Battle of Gettysburg, as well as restoration programmes for a number of these panoramas, including William Wehner's Battle of Atlanta and Edouard Castres' Bour-baki Panorama. Yet the percentage of present-day art-lovers who have actually experienced one of these exhibitions is inevitably small.

The history of the panorama and the diorama has as its subject an art form the experience of which is largely denied us. It must be reconstructed on the basis of sketches, engravings, scaled-down replicas, and contemporary descriptions and criticism. This exhibition brings together the varied documentary record of this phenomenon.

It must be admitted that the assembled evidence has its limitations. The keyed outline prints that accompanied the panoramas provide an invaluable record of the compositions but tell us nothing of quality or technique. The sets of engravings issued after a few of the pan-oramas give us a clearer picture of the paintings they record, but scarcely suggest the experi-ence of the full-scale originals and leave us wondering about the colour, the handling of paint, and the treatment of distances through aerial perspective. Sketches, whether Henry Aston Barker's careful, precise rendering of Paris (cat. No. 44) or Thomas Girtin's more vital and visually exciting watercolours of London (cat. No. 34), provide important evidence, but can convey little sense of the huge paintings which grew out of them.

For further elucidation of quality and technique in the panoramas and dioramas, we must rely on contemporary descriptions. With many published accounts the hyperbole of prom-otion must be recognised and discounted. Even in those instances that seem free of commer-cial taint, the differences between nineteenth and twentieth-century perceptions make the evaluation of their testimony less than straightforward. Reliance on criticism in the absence of its object is always perilous, particularly so in the case of the panorama. Considered as a popular entertainment, it was often not judged on the same level as 'high art', nor evaluated in the same terms, consequently depriving us of the possibility of interpreting panorama criticism through a comparison with the contemporary criticism of works of art that have survived.

Nevertheless, the extant materials can tell us much about the panorama as an art form and even more about the panorama as a social phenomenon. The variety of artists involved, of exhibition forms created, and of media employed precludes any easy generalizations about the subject. Yet through the long and varied history of such exhibitions, some general char-acteristics can be discerned. They form the subject of this necessarily somewhat im-pressionistic essay, which, after sketching in the emergence of the panoramic form in Edi-nburgh and London, will consider the panorama as art, as illusion, as education and as a cultural presence. Like the exhibition it accompanies, the scope of the essay is international,

but the emphasis will be on the early years in Britain when the forms of panoramic and dioramic entertainments were developing and were being greeted by fresh and enthusiastic eyes.

II

While Robert Barker's idea of a 360 ° painting had a certain novelty value, it was his conception of the painting as a large-scale exhibition mimicking nature that was his most original and influential contribution. He took out a patent on 19 June 1787, which gave him exclusive rights to the invention for a period of fourteen years. He called his proposed exhibition '*la nature à coup d'oeil*' or '*nature at a glance.*'[5]

The specification of the patent was concerned with the display of circular views, rather than the problems of making them. Nothing was said of the painting itself except that 'the painter or drawer must fix his station, and delineate correctly and connectedly every object which presents itself to his view as he turns around, concluding his drawings by a connection with where he began', and that 'he must observe the lights and shadows, how they fall, and perfect his piece to the best of his abilities.' There was no mention of the movable framing device used to make the sketches and nothing of the problems of presenting the perspective of a 360 degree view. There was, furthermore, no acknowledgement of the difficulties of presenting straight lines on a curved canvas.

When he came to the exhibition of the paintings, Barker became much more specific – right down to the method of ventilation. The patent mentions the circular framing for the canvas, the top-lighting, the central viewing-platform or 'inclosure' to prevent viewers from approaching too close to the painting, 'interceptions' to block the view of the top and bottom edges of the painting – everything to the end that observers, in the words of the patent, 'feel as if really on the very spot.'

Here in this patent, before any such exhibit had actually been set up, Barker outlined the panorama exhibition in its ultimate form. The 'inclosure' or viewing-platform would undergo further elaboration, as would the 'interception' between the viewing-platform and the painting itself. In any event Barker had left this matter to the artist's discretion. Methods of lighting would be perfected. Buildings would be constructed containing several circular views in apartments stacked one above the other. Technology would provide new means of mounting to the viewing-platforms (including in the 1820s the first hydraulic lift in London). Nevertheless, the basic arrangement, as Barker set it out in the patent, would remain unaltered.

The view of Edinburgh that Barker exhibited first there in 1788 and then in London the following year could scarcely have represented the sort of exhibition envisaged in the patent. Most importantly it lacked the requisite size. The circle was so small that it could only be viewed by parties of six at a time. The distance between the viewers and the painting – an element crucial to the illusion – could not have much exceeded ten feet. As he was exhibiting within an ordinary hall, Barker had to light the painting with lamps rather than the glazed

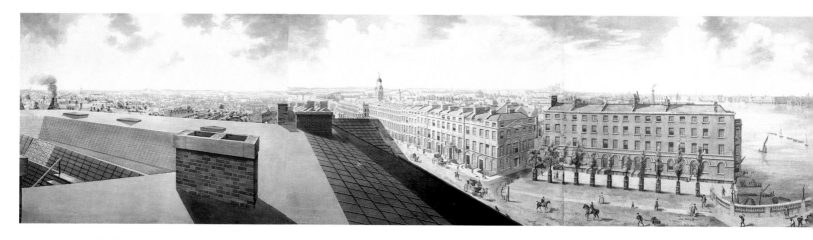

28 London from the Roof of the Albion Mills 1792
FREDERICK BIRNIE AFTER ROBERT (AND HENRY ASTON) BARKER

34 Drawings for the Eidometropolis 1797-98
THOMAS GIRTIN

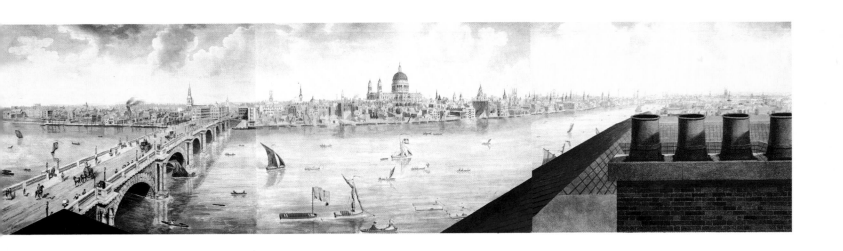

dome he had suggested in the patent.

The exhibition roused a certain degree of interest; however, it was the potentiality rather than the actuality of this first view that attracted attention. Realising that to be successful the painting had to be bigger, Barker produced a larger, but only semicircular, view of London. This covered, as he was to emphasise in his advertisements, a full 1,479 square feet. Not only did this new view have the benefit of greater size, it also had a new name. 'La nature à coup d'oeil' had neither caught the imagination nor characterised very well the nature of the exhibition. Friends of the proprietor provided him with a new title which was sufficiently striking to gain a permanent place in the English language, even when the exhibition it originally designated had been generally forgotten. 'Panorama', derived from the Greek words meaning 'all' and 'view' had its first use in 1791 in the advertisements for the picture of London.

Although it represented only a part of the full 360° view, the painting of London achieved for Barker his first real success, remaining open for a period of almost three years until early 1794, even after he had opened a much more elaborate place of exhibition in Leicester Square. It was within this permanent panorama rotunda that Barker was finally able to present a painting which completely fulfilled the specifications of his patent and did justice to his original conception. This panorama, the 'Grand Fleet at Spithead in 1791', painted on about 10,000 square feet of canvas, was the first to fulfil all the requirements for a successful illusion of reality. Standing on the platform, the spectator had the scene around him on all sides. The platform prevented him from approaching close enough to the painting to be aware of paint and canvas. All terms of comparison by which the eye could judge the difference between painting and reality were excluded. The viewer, having become accustomed to the dimness of light in the purposely obscure corridor by which he entered, would emerge into the light of the viewing area to find that, by contrast, it appeared as bright as the remembered daylight outside. The canopy above the platform both kept viewers from directly seeing actual daylight through the skylights above and prevented their figures from casting shadows across the painting. Barker followed the 'The Fleet at Spithead' by a succession of views of British cities and recent British naval victories.

In the years immediately following the expiration of Barker's exclusive license in 1801, a host of rival panoramas appeared in London. They were, as John Constable put it, 'all the rage'.[6]

With Robert Barker's death in 1806, the Leicester Square Panorama passed into the hands of his son Henry Aston Barker. As he had been largely, if not entirely, responsible for the panorama long before his father's death, the change of hands could have made little difference to the actual running of the business. Henry Aston Barker was succeeded by John Burford, who was, in turn, succeeded by his son, Robert, under whose direction the rotunda in Leicester Square remained open into the 1860s. After Robert Burford's death in 1861, operations slowly ground to a halt.

Of the variety of alternative formats which arose to compete with the circular panorama

in the first decades of the nineteenth century, the hardiest and most influential were the moving panorama and diorama. While neither matched the all-encompassing illusion of the circular panorama, they did enjoy an advantage other than mere novelty over the original 360° form. They had movement and development in time.

Although the initial flurry of panoramic activity had largely died out by the 1820s, the circular panorama continued to occupy a modest niche among the art exhibitions and popular entertainments of London until the middle of the century. The opening of the Regent's Park Colosseum at the beginning of 1829 rekindled interest in the form, but also marked the last permanent establishment for the display of circular panoramas until the 1880s. When the Leicester Square Panorama finally closed its doors in 1863, it must have seemed a relic to the general public.

A similar pattern could be traced in the cities outside Britain where the panorama took hold. The temporary eclipse of popularity for the circular form of the panorama was so profound that an article on such panoramas, or 'cycloramas' as they were then more frequently styled, in *Scientific American* in 1886 speculated that the form did not date back over fifty years.[7] During the panorama renaissance of the 1870s and 1880s, when circular panoramas became big international business, the centres of production were not in Britain, but in France, Germany, Belgium, and the United States.

III

When Robert Barker opened his first 360° painting in Edinburgh, he portrayed himself in the advertisements for his exhibition not just as the inventor of an ingenious amusement, but as a radical artistic innovator who had swept aside the conventions of landscape painting. He desired the public to see him as the emancipator of landscape art and his picture as an 'IMPROVEMENT ON PAINTING, Which relieves that sublime Art from a Restraint it has ever laboured under.'[8]

While it is difficult to separate intentions and achievement from advertisement and promotion, it is clear that Barker asked that his experiment be taken seriously. It was necessary to this view of his invention that he should be well received by his fellow artists. The failure of Sir Joshua Reynolds to find any merit in Barker's initial sketch did not prevent Barker from proclaiming that he had gained the approbation of Sir Joshua as well as Benjamin West 'and several of the most eminent artists.'[9]

When, in the spring of the following year, Barker opened his view of Edinburgh in London, his advertisements sought to distinguish his exhibition from other less novel and less artistic attractions on display in the English capital. He complained that his exhibition was generally understood to be a model or transparent painting:

There is no deception of glasses, or any other whatever; the view being only a fair sketch, displaying at once a circle of a very extraordinary extent, the same as if on the spot; forming perhaps, one of the most picturesque views in Europe. The idea is entirely new, and the effect produced by fair

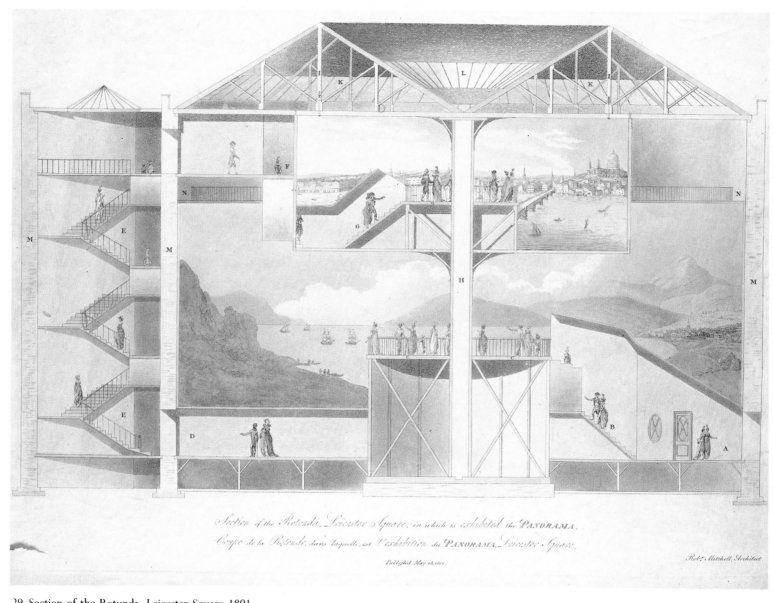

Section of the Rotunda, Leicester Square, in which is exhibited the PANORAMA.

Coupe de la Rotonde, dans laquelle est l'exhibition du PANORAMA, Leicester Square.

Publish'd May 15,1801.

Rob.t Mitchell, Architect.

29 Section of the Rotunda, Leicester Square 1801
ROBERT MITCHELL

22

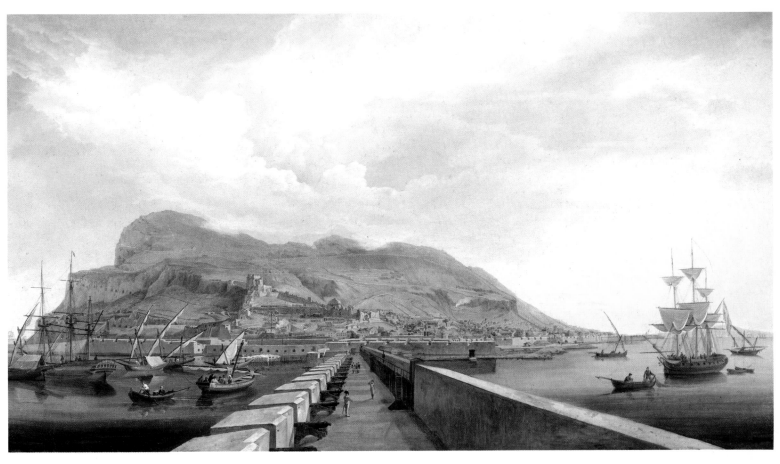

45 Rock of Gibraltar, Devil's Tongue Battery 1804

HENRY ASTON BAKER

perspective, a proper point of view, and unlimiting the bounds of the Art of Painting.[10]

Appealing now to a more sophisticated audience, Barker made even more of his claim to artistic merit:

Mr Barker Begs to mention, that as his improvement is genuine and pointed, it may not be understood as an Exhibition merely for emolument, but being the result of a minute investigation of the principles of art, it is intended chiefly for the criticism of artists, and admirers of painting in general.[11]

Barker's second attempt at a panorama, his semicircular view of London, did win the approval of important figures in the artistic community. His son, Henry Aston Barker recalled:

This view was very successful. Even Sir Joshua Reynolds' came to see it and gratified my father much, when, taking him by the hand, he said, 'I find I was in error in supposing your invention could never succeed, for the present exhibition proves it is capable of producing effects, and representing nature in a manner far superior to the limited scale of pictures in general.'[12]

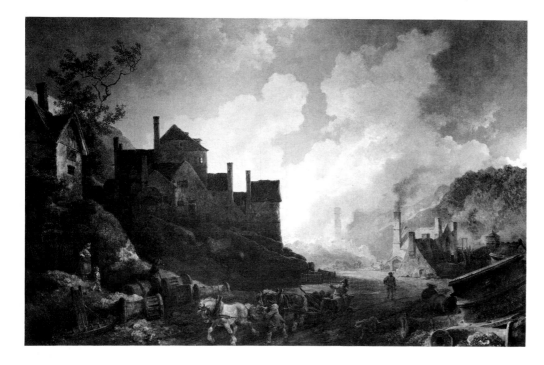

79 Coalbrookdale by Night 1801
PHILIPPE JACQUES DE LOUTHERBOURG

In later accounts of the panorama it was often stated that it was greeted rather coolly by the artistic community,but here we have Sir Joshua Reynolds' response, and if we are inclined to doubt Henry Aston's word, there is the following passage from James Northcote's biography of Reynolds:

He [Reynolds] was a prodigious admirer of the invention and striking effect of the Panorama in Leicester-fields, and went repeatedly to see it. He was the first person who mentioned it to me, and earnestly recommended me to go also, saying it would surprise me more than anything of the kind I had ever seen in my life; and I confess I found it to be as he had said.[13]

Benjamin West, Reynolds' successor as Royal Academy President, allowed himself to be quoted to the effect that this was the greatest improvement in the history of painting, which was extravagant praise indeed.

The acclaim in France after the panorama's introduction there in 1799 by the American Robert Fulton, later renowned for the invention of the first commercially viable steamboat, was, if anything, greater. Less than a year after the opening of the first panorama in Paris, the Institut de France had established its commission on the panorama. The report presented by Leon Dufourny on 15 September 1800 concluded that 'cette ingenieuse application de principes plus ingenieux' merited the interest and approbation of the Institut.[14]

The panorama was hailed as a triumph of perspective and optics which seemed to herald further achievements in both fields. The methods employed in the creation of the panorama's illusion were seen as applicable to more conventional painting; it appeared momentarily to those overcome by the panorama's effects that a new age of verisimilitude in painting was being ushered in. Dufourny's report suggested that the lesson provided by the panorama's removal of terms of comparison should be heeded by all exhibiting artists and that the lighting techniques of the panorama could be profitably adopted by all museums and galleries.

Such official interest in the panorama did not exist in Britain, although it was seen as a phenomenon of intellectual and artistic interest and merited inclusion in the 1801 supplement to the Encyclopaedia Britannica. While this article simply reproduced the specification of Barker's patent, the next supplement, which came out in 1824, had a completely revised entry. There were no claims about the panorama's epoch-making significance or encomiums on its uncanny reproduction of the natural world. Instead the article placed the panorama in the context of the tradition of illusionistic perspective painting, mentioning Giulio Romano's Room of the Giants at the Palazzo del Te as a precursor and providing a complex explanation of the perspective basis of the circular painting. If the article betrayed a certain lack of enthusiasm for the form, it at least made clear that the panorama was still to be considered seriously as art.

With the passing of the first wave of enthusiasm, the view that the panorama was a great artistic achievement or even that it was serious art at all generally declined. Sir George

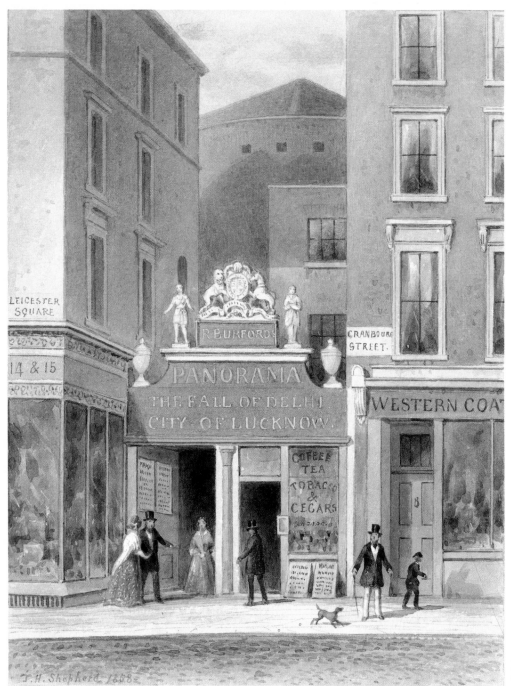

30 Cranborne Street entrance to Burford's Panorama 1858
THOMAS HOSMER SHEPHERD

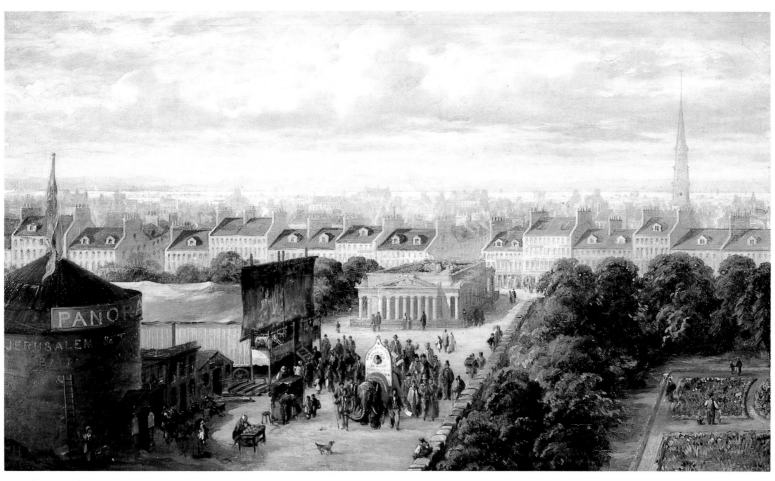

41 The rotunda on the Mound, Edinburgh 1843
CHARLES HALKERSTON

Beaumont, who had shown interest in the panoramic format before it had been adopted for public exhibition, was of the opinion that the effect of panorama painting had been injurious to the taste of both artists and the public[15]. Constable enjoyed both the panorama and diorama but said of the one that 'great principles are neither expected nor looked for in this mode of describing nature', and of the other that 'it is without the pale of Art because its object is deception – Claude's never was – or any other great landscape painter's'.[16] On the other hand, Constable's friend and biographer, Charles Robert Leslie, expressed in a letter to his brother in Philadelphia in 1812 the same sense of wonder that characterised the early responses to the panorama:

I have been to see Mr Barker's panoramas, the Siege of Flushing, and Bay of Messina. They are so well painted as to be quite deception, particularly the latter one, as they extend in a circular form all round the rooms and the spectators are placed in the centre the effect is very astonishing. I actually put on my hat imagining myself to be in the open air. These pictures exhibit both branches of perspective in perfection, for I was so far deceived that I could form no idea how far the canvas was from my eye, in one spot it appears thirty miles off and in another not so many feet, such is the astonishing effect that can be produced by a strict adherence to Nature.[17]

Later in a lecture at the Royal Academy in 1849, Leslie echoed Constable's objection, finding 'something unsatisfactory – to speak from my own feelings I should say unpleasant – in all Art of every kind of which deception is an object'.[18]

Reviewers in periodicals and daily papers continued to extol the virtues of panoramas and their high standard of illusionism, but they were also forced to justify the exhibitions as art. A *Repository of Arts* review of one of Burford's panoramas in 1827 noted that:

its execution belongs to a department of art which is not thought very highly of by artists generally, from the mechanical dexterity and sort of knack which is considered to form so large a share of its merit. Many of the best and most studied rules of art are, however, necessary for its perfection...[19]

The ambivalence of critical response to so questionable an artistic form is reflected by John Ruskin. Long after the Leicester Square Panorama had closed, Ruskin recalled the importance that the establishment had had for him. In writing of his first visit to Milan, he noted:

I had been partly prepared for this view by the admirable presentment of it in London, a year or two before, in an exhibition, of which the vanishing has been in later life a greatly felt loss to me. – Burford's panorama in Leicester Square, which was an educational institution of the highest and purest value, and ought to have been supported by the government as one of the most beneficial school instruments in London.[20]

It was for its educational rather than its artistic value that Ruskin mourned the passing of the panorama, but the aims of art and education were for Ruskin intrinsically intertwined. His critical appreciation of the landscapes of John Brett and Thomas Seddon indicates that he

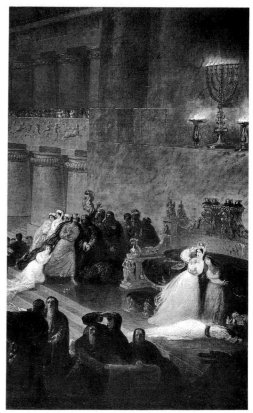

109 Belshazzar's Feast (Detail)
JOHN MARTIN

Heart of the Andes
FREDERIC EDWIN CHURCH
as exhibited in New York, 1864
(By courtesy of Kevin Avery)

judged their work in much the same terms as panoramas were commonly evaluated. When he said of Seddon's landscapes that their 'primal object is to place the spectator, as far as art can do, in the scene represented, and to give him the perfect sensation of its reality, wholly unmodified by the artist's execution',[21] he was echoing any number of panorama reviews and advertisements.

However much Ruskin may have valued the experience and knowledge provided by the panorama, he seems, like Constable, to have considered it beyond the pale of art. In attacking two artists, who were not panoramists, Ruskin referred to them as 'merely vulgar and stupid panorama painters'. Although he went on to add that 'the real old Burford's work was worth a million of them',[22] the use of 'panorama painter' as a term of abuse confirms a prevailing low opinion of the form.

While it is true that few of the major artists of the nineteenth century would appear in the lists of panorama and diorama painters, one can point to Thomas Girtin, David Roberts and Clarkson Stanfield in Britain, John Vanderlyn in America, and Karl Friedrich Schinkel in Germany. Paul Philippoteaux and Hendrik Mesdag may not be familiar to many art-lovers today, but their academic credentials, as well as those of most of the artists responsible for the vast panoramas of the late nineteenth-century revival, were impeccable.

More important than the roster of significant artists who turned their hands to panoramas and dioramas is the extent to which the experience of these forms permeated the more traditional and traditionally more highly respected forms of art. The evidence is largely suggestive rather than definitive.

Certain paintings by J.M.W. Turner show affinities to panoramic forms, although the alleged association of Turner with such an exhibition is simply a case of mistaken identity.[23] The connections between John Martin's vast apocalyptic canvases and the grandiose scenic entertainments of the day have been noted[24]; as has the relationship between the panorama and paintings of the American Hudson River School.[25]

The panorama experience affected both the scale and subject matter of conventional paintings and the ways in which they were brought before the public. Philippe Jacques de Loutherbourg's 'Battle of the Nile', exhibited in London in 1799, was shown by firelight to increase the illusion of its representation of a ship exploding at night.[26] As a recent article devoted to the early exhibitions of Frederic Edwin Church's 'Heart of the Andes' has demonstrated persuasively, panoramic and dioramic modes provided important models for presentation of mid-nineteenth century American landscape paintings.[27]

To receptive artists, the unselective nature of a 360° painted view may have encouraged greater compositional freedom. The diorama's emphasis on changing effects of light mirrored that concern with capturing the evanescent effects of light and atmosphere which was at the heart of so much of the century's art. Whether these exhibitions promoted or merely reflected these trends, they had a role in that struggle for freshness of vision which was a dominant theme of nineteenth-century art.

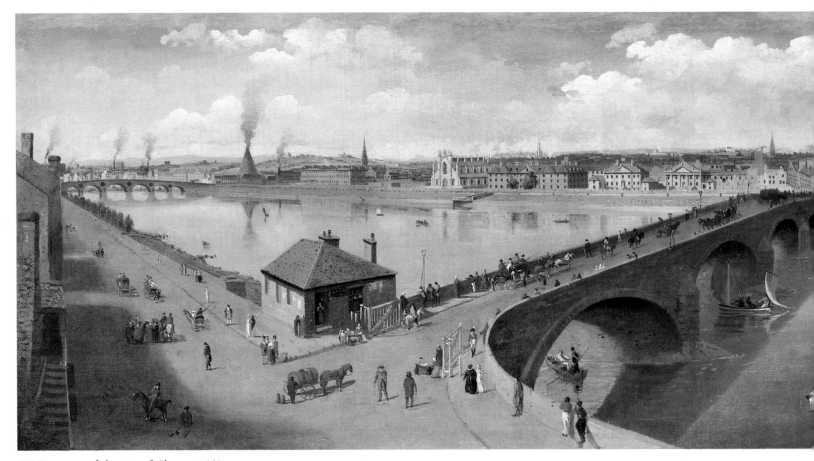

39 Panorama of the city of Glasgow 1809
JOHN KNOX

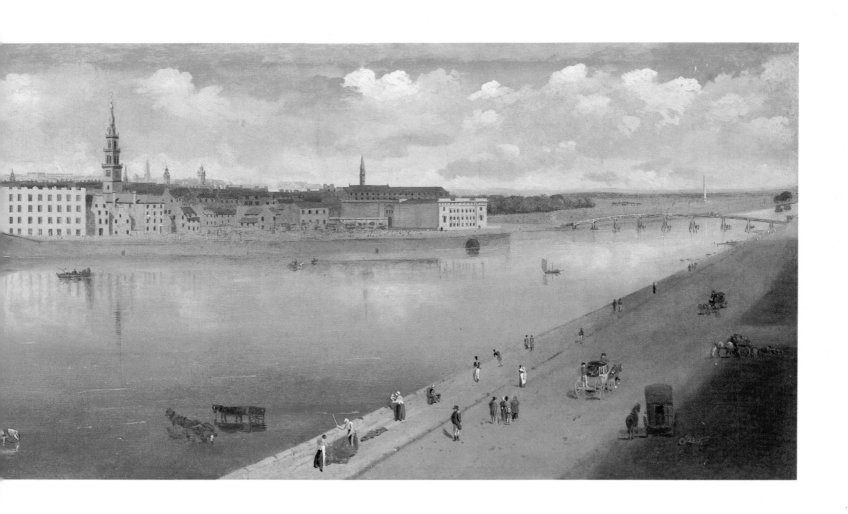

IV

Constable dismissed the diorama as art 'because its object is deception'. From ancient times there has been a fascination with the idea that man can be deceived by art into mistaking it for reality. However, the artist's aim, even if his avowed intention has been to reproduce nature with strict fidelity, has seldom been to trick his audience into believing that they are looking upon nature itself. Rather it has been to elicit a response to the truth of the artist's vision or the skilfulness of his hand. Even in *trompe l'oeil* painting, the deception is only momentary – a joke on the spectator perpetrated to draw attention to the artist's skill.

In the panorama the deception was supposed to be complete and sustained. One could, of course, reflect on the skill of the artist, but only afterwards. For the illusion to be successful, it was necessary that during the experience of viewing the panorama, the presence of the artist should not be felt at all.

The viewing of a painting isolated within a frame, even if painted in a meticulously realistic style and faithful to some conception of visual reality, was a qualitatively different experience from submitting to the illusion of a panorama. If the panorama provided sufficient evidence that it was not just a representation of reality but reality itself, the mind would accept this and supply certain deficiencies in the representation. However, as one stripped away the conventions and removed the indications that the object was a painting and not reality, the remaining impediments to total verisimilitude, such as the absence of sound or movement, became more pronounced. In the imaginative act of looking at a conventional painting such considerations are irrelevant; in the more passive experience of the panorama, they could be disturbing and illusion-destroying.

Unfortunately many of the devices employed by the panoramists for the purpose of increasing the interest and information in their works aggravated the problem of the absence of motion. As soon as one introduced figures or animals, one created an expectation of movement, and as foreground groups grew in prominence, the arrested motion of these groups could only become more obvious. French observers seemed to have been bothered by this from the beginning. The report of the commission on panoramas set up by the Institut de France in 1800 recommended that the inclusion of figures in motion in such works be managed with care so as not to call attention to the painting.[28] A.L. Millin, in his *Dictionnaire des Beaux Arts* of 1806, recommended that the panoramist should avoid such figures completely, suggesting that a vast landscape was preferable to a city or battle as a panoramic subject for that very reason.[29]

While these reactions to the unnatural stillness of the panorama largely centred on the most obvious examples of arrested movement, a similar response to the static atmospheric conditions represented in a panorama must have led to the French invention of the diorama. Illusionism was, more exclusively than in the panorama, the *raison d'être* of this form of exhibition. Topography was much less important than the creation of atmosphere. The completeness of the panorama's presentation of a subject was exchanged for a more limited but,

within those limits, more convincing illusion of the reality of that subject. The diorama remained more an aesthetic than an educational experience.

In an attempt to bridge the remaining gap between their art and complete illusion, artists incorporated lighting, music, sound effects, mechanical devices, and actual three-dimensional objects in their exhibitions. The introduction of special effects, particularly mechanical devices, was often unsatisfactory. When, in addition to the changing atmospheric effects, several instances of motion were introduced in the diorama, critics deplored the innovation. The *Morning Chronicle* judged it 'rather a pantomime trick to astonish and be pointed at by children, than to deceive or give pleasure to an artist'[30]. The *Repository of Arts* stated that:

This mixture of principles is in bad taste. The diorama ought to stand upon its own ground – to afford a more irresistible deception to the eye, and through the eye to the understanding, than any other arrangement in the art of painting, but beyond this it should not attempt to go.[31]

Whether the attempts to add sound and motion resulted in heightened illusion or in the distraction of unconvincing gimmickry, the success of these exhibitions did remain primarily dependent on the quality of the painting. For most of the panorama's history, this question of what the paintings were actually like must remain a matter for speculation. From the points of criticism and praise reiterated in the reviews of various panoramas and dioramas, we can, however, discover those qualities which were expected of these exhibitions.

One of these qualities was evenness of tone; another was brilliance of colour. It was probably rare that a panorama excelled in both simultaneously. A balance also had to be sought between an effective use of aerial perspective and the demand for clarity and detail.

Were the panoramas as a rule broadly painted or minutely finished? By analogy with their closest counterpart, theatrical scene-painting, we would assume that the treatment was fairly broad. It seems unlikely that an inordinate amount of care should have been taken with these vast canvases that were destined to be painted out or worn out after a round of exhibiting. This view is supported by certain statements about pictures being 'boldly painted and well adapted for this kind of entertainment'[32] or comments that 'works of this kind, painted for effect, exclude minute examination; fidelity rather than finish of execution, is the artist's aim'.[33]

On the other hand, an article *Chambers's Journal* discussing Robert Burford's panoramas, presented them as models of careful finishing, executed with the finest materials.[34] The account is probably excessive in its claims, yet we should remember that at the Colosseum opera glasses were provided for the closer inspection of the panorama there. Constable wrote of one panoramist that he "views nature minutely and cunningly, but with no greatness or breadth."[35]

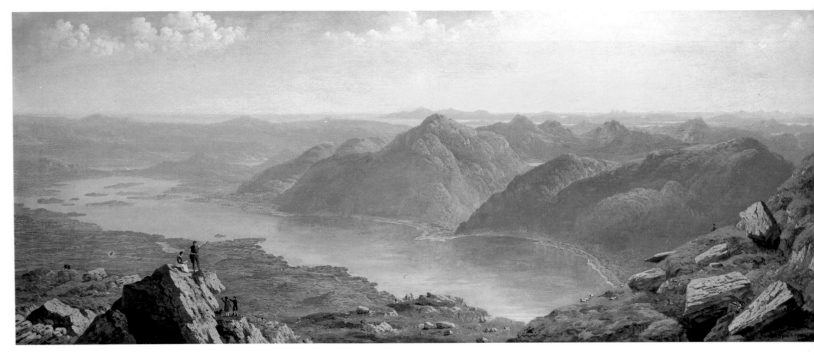

40 South-western view from Loch Lomond and
South-western view from Ben Lomond 1810
JOHN KNOX

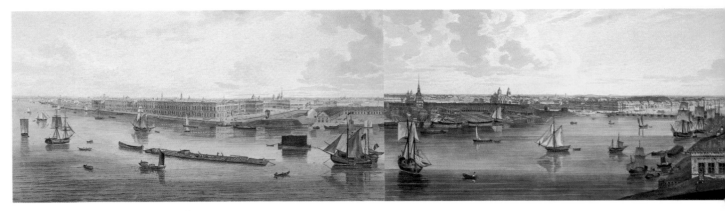

43 Panoramic view of St. Petersburg c.1807
JOSHUA AUGUSTUS ATKINSON

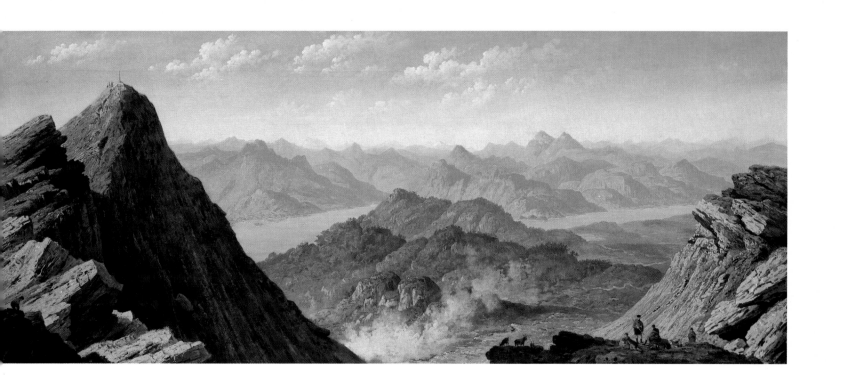

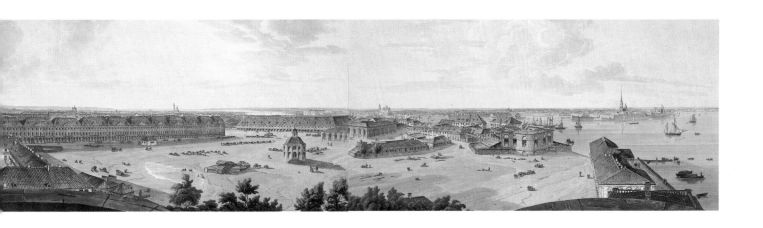

V

Almost from its inception the panorama was valued as an instrument of instruction. Grouped on the one hand with the more frivolous forms of popular entertainment, it took its place, on the other, in the venerable tradition of art as edification. Certainly the panorama's educational objectives were more pedestrian than the objectives of spiritual and moral uplift which had long been associated with 'high art', yet in conveying information about the material facts of the world, the panorama served a purpose which Ruskinian thought was to sanctify. It was a role which the Barkers adopted very early.

When their monopoly ended in 1801, the Barkers realised that they had to take further steps to ensure that their patrons were not enticed away by newer exhibitions. Robert Barker announced that he was 'determined to spare no expense or trouble to bring forward scenes of useful information, as well as gratifying amusement; and the public may expect to have the most interesting Views and the most noticed cities in Europe, in due time, laid before them'.[36] In fact, views not only from Europe but from all parts of the globe appeared at the Leicester Square rotunda. The first foreign city to be presented was Constantinople (see cat. No. 46), which was displayed in two different panoramas in 1801.

With these views of Constantinople, the Barkers instituted the selling of descriptive booklets. For the earlier panoramas a crude outline print of the painting had been given gratis to each visitor. Objects of interest were numbered and identified in a key. The booklets, which sold for sixpence, contained not only fuller descriptions of the numbered objects (the keyed prints were included), but also a general historical background, facts on native manners and costumes, and a wealth of interesting anecdotes. The introduction of these booklets, which became a permanent feature, together with the idea of showing complementary views of the same subject, was indicative of a growing concern for completeness and educational value. This was the Barker's response to competition. Throughout the seventy years of its existence the Leicester Square Panorama never resorted to the flashy novelties and gimmicks or the extra-pictorial diversions by which so many similar exhibitions sought to attract the public.

The value of the panorama as an educational experience was dependent on its success in conveying visual information about the real world, and to this end the panorama had to be able to claim accuracy. With Robert Barker's very first 360° view, the concern with total accuracy was already evident. Barker informed the London public that his view of Edinburgh had been exhibited in the Scottish capital prior to its exhibition in London 'to gain it an indisputable character for correctness'.[37] On learning of criticisms that he had deviated from nature to produce a more attractive view, Barker applied to Thomas Elder, the Lord Provost of Edinburgh, who supplied Barker with a statement that 'it is a most correct and just representation of the city and its environs to the fullest extent of the horizon in every direction'.[38] It was the first of a long line of testimonials to the fidelity of panorama views by persons intimately acquainted with the locations represented.

The information that a panorama was painted from sketches taken on the spot also be-

came a necessary feature of panorama advertisements. That the painter himself had visited the depicted spot and made the preliminary drawings himself was of course to be preferred and Henry Aston Barker and Robert Burford both travelled widely, taking views for their panoramas. For views of battles and of the most inaccessible and exotic locales, the painters often had to rely on the sketches of others. The traveller or military or naval officer with a pencil and some proficiency in drawing could, on his return to England, make money or gain public recognition by selling or loaning his sketches to a panorama painter. If he had greater reserves of talent and enterprise he could produce a panorama himself.

Topographical accuracy was often gained through the use of the camera obscura and similar optical devices. It is not clear whether the Barkers and Burfords made use of such devices. In the production of those early panoramas for which we have more complete accounts of the process of view-taking, it is evident that no such device was employed. Several French accounts of panoramas in the early years of the nineteenth century, however, describe the use of a pivoting camera obscura as the standard procedure. With the advent of photography, an even greater degree of topographical certainty could be achieved by the substitution of photographs for preliminary sketches.[39] Although panoramic photographs had some popularity on their own, full-scale panoramas of projected photographs were not attempted until almost the end of the century and then enjoyed little success.

While evidence of artistic taste was expected, artistic license was not to be tolerated. Even the title 'artist' could at times seem suspect; S.C. Brees stated that his panorama of New Zealand, shown in London in 1849, was 'not the work of a mere artist, but of a surveyor, whose business it was to explore and set down with topographical accuracy the natural features of the Colony'.[40] Education demanded accuracy, but accuracy was independent of and at times opposed to the demands of art. The comment of the reviewer of Girtin's Eidometropolis that 'a license is allowed to painters as well as poets; and where a picturesque effect can be produced, a trifling deviation would, in a picture of this description, be overlooked or forgiven'[41] was rarely echoed in panorama criticism. If a view was artistically unsatisfactory, the critic generally suggested that a better viewpoint or indeed a better subject might have been chosen.

The panorama struck a responsive chord in the nineteenth century. It satisfied, or at least helped to satisfy, an increasing appetite for visual information. A revolution in travel had made the world seem smaller. The growth of a literate middle class and the burgeoning newspaper industry meant that many more people were aware of a greater number of happenings over a larger area of the globe. It is not surprising that people should desire visual images of a world of which they were becoming increasingly aware through the printed word.

The panorama supplied a substitute for travel and a supplement to the newspaper. As a writer in the *Repository of Arts* expressed it: 'What between steam-boats and panoramic exhi-

bitions, we are every day not only informed of, but actually brought into contact with remote objects.'[42]

When in 1842 a news publication married printed word to visual image in the form of the *Illustrated London News*, the panorama had already been providing a pictorial documentation of current events and places of interest for over half a century. The *Illustrated London News* introduced itself with a bow to the panorama. In an address to readers in the first number it stated that its goal was 'to keep continually before the eye of the world a living and moving panorama of all its actions and influences'.[43] As a present to its subscribers, it published a panoramic engraving of London which it entitled the 'Colosseum Print' (cat. No. 201). In subsequent years subscribers were presented with other panoramic prints.

From 1789 when *Woodfall's Register* suggested the benefits of the Royal Family gaining knowledge of foreign lands through the panorama',[44] such exhibitions had been celebrated as substitutes for travel. The panorama provided not some pale reflection of a distant scene but an almost palpable sense of its reality. Indeed not a few writers attempted to convince their readers that the illusion was preferable to the reality. According to a *Times* critic:

There are aspects of soil and climate which . . . in great panoramas such as those of Mr Burford, are conveyed to the mind with a completeness and truthfulness not always to be gained from a visit to the scene itself.[45]

The panorama of Naples that opened at the Burford establishment in 1861, was stated to be 'even more pleasant to look upon in Leicester Square, than is the reality with all its abominations of tyranny, licentiousness, poverty and dirt'.[46]

The circumvention of the hardships of travel through the means of the panorama became a common theme. An article in *Blackwood's Magazine* in 1824 developed this idea at length:

Panoramas are among the happiest contrivances for saving time and expense in this age of contrivances. What cost a couple of hundred pounds and a half year a century ago, now costs a shilling and a quarter of an hour...The affair is settled in a summary manner. The mountain or the sea, the classic vale of the ancient city, is transported to us on the wings of the wind...If we have not the waters of the Lake of Geneva, and the bricks and mortar of the little Greek town, tangible by our hands, we have them tangible by the eye – the fullest impression that could be purchased, by our being parched, passported, plundered, starved, and stenched, for 1,200 miles east and by south, could not be fuller than the work of Messrs Parker's [sic] and Burford's brushes. The scene is absolutely alive, vivid, and true; we feel all but the breeze, and hear all but the dashing of the wave.[47]

In 1850 Charles Dickens's journal, *Household Words,* carried an article entitled 'Some Account of an Extraordinary Traveller.' It chronicled the adventures of a Mr Booley, a retired bank clerk who, at the age of sixty-five, had set out on a remarkable series of journeys that carried him to all parts of the globe. At the conclusion of the article, Booley revealed that his travelling had been by 'the gigantic-moving-panorama or diorama mode of conveyance,

which I have principally adopted (all my modes of conveyance have been pictorial)'.[48]

The educational value of the panorama, recognised from the outset, had become, by the time of Booley's travels at mid-century, its fundamental merit. The nouns 'panorama' and 'diorama' were commonly joined with the adjective 'instructive'. Middle class audiences were aware that never before had people in their position been as knowledgeable about the outside world. As Mr Booley expressed it:

It is a delightful characteristic of these times, that new and cheap means are continually being devised, for conveying the results of actual experience, to those who are unable to obtain such experiences for them-selves; and to bring them within the reach of the people – emphatically of the people; for it is they at large who are addressed in these endeavours, and not exclusive audiences. Hence, even if I see a run on idea, like the panorama one,it awakens no ill-humour within me, but gives me pleasant thoughts. Some of the best results of actual travel are suggested by such means to those whose lot it is to stay at home. New worlds open out to them, beyond their little worlds, and widen their range of reflection, information, sympathy and interest. The more man knows of man, the better for the common brotherhood among us all.[49]

As a consequence of this attitude towards the panorama, the panoramist came to be regarded as a public benefactor. In 1830 the *Morning Chronicle* attributed to Robert Burford 'the merit of having contributed as much to the instruction and amusement of his countrymen as, with few exceptions, any man of his day'.[50] The American panoramist, John Rowson Smith, commented on his own high calling:

The love of travel is inherent in mankind, but the occupations of life preclude its gratification. He, therefore, who by means of panoramic exhibitions makes travellers of those who would otherwise tarry at home, is no ordinary benefactor to his fellow creatures.[51]

Of course, the panoramists did all they could to enhance this image by emphasising the great expense, difficulties, and personal danger which they had undergone in bringing their views before the public. The hazards of panorama-taking were undoubtedly exaggerated, but the panoramists did go out of their way to obtain unusual and topical views. And they were at times at personal risk, as when Thomas Hornor was nearly blown from his perch at the top of St Paul's in the process of taking drawings for his panorama of London.

VI

In considering the relationship of the panorama and the public, we must first establish just what constituted its public. Exactly who went to the panorama is difficult to determine but it would seem that panorama-going was an essentially middle class phenomenon and the panorama's public became broader as the nineteenth century progressed. It was not initially a middle class entertainment; but like the earlier Eidophusikon, seems to have been aimed at a select body of connoisseurs. Robert Barker's earliest advertisements, as well as his initial

admission charge of three shillings, indicate that he sought an audience from the upper classes.

While it is impossible to trace in detail the change in the panorama's patronage, a few signposts do exist. Quite early the Barker advertisements ceased to be addressed to 'the nobility and gentry', that formula being replaced by 'the public'. Barker, having lowered his admission price to two shillings while still exhibiting in Edinburgh in 1788, further reduced his price to one shilling shortly after his arrival in London and the one shilling admission remained the standard for all exhibitions throughout the nineteenth century. When discriminatory price ranges (three shillings in the boxes; two in the amphitheatre) were introduced in the Regent's Park Diorama, there was protest. By mid-century, references were being made to the exhibitions' effects on 'the middle and humbler classes', and it was assumed that these were the classes at which such exhibitions were aimed.

Of course the nature of those exhibitions like the Leicester Square Panorama and the Regent's Park Diorama, in which daylight was utilised, limited the opportunities for members of the working public to attend. The audience at the Kineorama, a hybrid of the diorama and moving panorama, on the afternoon in 1841 when it burned down consisted only of ladies.[52] The special attention which newspapers gave to such exhibitions during holidays must indicate something of the pattern of attendance which developed.

In opposition to the image of serious-minded middle class panorama-goers, intent on self-improvement, there was the body of visitors known in the press as 'fashionable loungers', who frequented the exhibitions in the proper season. Like the Royal Academy exhibitions, the panorama and diorama remained to some extent fashionable entertainments. As nobility and royalty set the fashions, their patronage placed an important stamp of approval on an exhibition.

In describing the appeal of the panoramas and similar exhibitions, critics upheld the distinction between the art-loving few and the vulgar masses. A reviewer of the Stereorama in 1860 wrote of two levels of appreciation: the mechanical effects charming the 'uninitiated' while 'the pictorial treatment of the plain surfaces' would attract the attention of the 'art-loving public'.[53]

How deeply did the panorama leave its mark on the sensibilities of the nineteenth century? To those who would never see the real locations, panorama images were a surrogate reality, against which other representations, either verbal or pictorial, could be weighed. To those who would later visit the sites represented, the panorama image provided a framework for the actual experience of reality. Even though his memory of the panorama image was somewhat faulty, Ruskin made it quite clear that his view of Milan was affected by his prior experience of the panorama. To those who had already visited the sites or experienced the events, a panorama, if we can believe the anecdotes, brought back the reality. We hear of the Duke of Wellington growing more and more excited as he viewed Barker's panorama of Sobraon and straining against the barriers of the viewing platform.[54]

The modern tendency to equate the significance of an event with the amount of news coverage given to it must also have operated with the panorama. We have a hint of this in the tribute paid to Robert Burford in his obituary in *The Times*:

Year after year he remained the pictorial illustrator of his times, and an event of public interest seemed scarcely to have received its due acknowledgement until the spot where it had occurred had formed the subject of one of his beautiful panoramas.[55]

The very form of the panorama image suggested a new mode of viewing one's environment. As Claudian composition influenced the eighteenth century connoisseurs' response to nature, so the panorama influenced a far greater proportion of the population. From the almost innumerable instances in which writers of the period called upon the panorama to express their meaning, a few examples must suffice. Robert Southey, visiting the entrance to the Caledonian Canal in 1819, wrote of the scene in terms of what a panorama painted from that point would include.[56] Walter Scott described the view from the Calton Hill in Edinburgh – which had provided the subject for the very first panorama – as 'an unrivalled panorama'.[57]

The difficulty in assessing the adoption of panoramic modes of vision is that the panorama was originally an attempt to bring painting closer to the actual nature of seeing than it had ever been before. To what extent statements like those of Southey and Scott reflect a real change in viewing habits, and to what extent the panorama simply provided a convenient label for a visual experience people had always had, we can never fully know.

The word 'panorama' did enjoy a vogue perhaps greater than that of the exhibition which it designated. Certainly the word gained a permanence which the exhibition did not. To what extent was this vogue related to the popularity of the exhibition? The word captured the public imagination, and it is only reasonable to assume that this reflects the response to the exhibition. As early as 1792 the panorama – here referring literally to the form of painted exhibition – was employed as a framework for political satire. By 1801 the name, if not actually the principle of the exhibition, had made its way into the theatre. Figurative usage of the word was not long in following. Again in 1801 a publication appeared bearing the title *The Political Panorama*. Mrs Mary Sterndale's *The Panorama of Youth* was published in 1806, and in 1812 J. Smith's *The Panorama of Science and Art* appeared. By 1806 the periodical *Literary Panorama* was being published.

Two main streams of figurative usage developed from the two forms of panorama exhibitions. From the original 360° exhibition derived the sense of an unbroken view of a surrounding region, as in Scott's appreciation of the view from Calton Hill. The meaning was transferred to an overview or comprehensive survey of any subject – the sense in which it appears in the titles above. From the moving panorama came the sense of a continuous passing scene. In Maria Edgeworth's novel, *Patronage*, of 1814 (just four years after Marshall's moving panorama first appeared in London), a character showed his knowledge by 'his rapid

panorama of foreign countries'.[58]

Once the word had been established in a figurative sense, did subsequent usage refer to the exhibition or simply to the figurative sense? The latter has certainly been the case in the twentieth century, when the word is so frequently used, while the exhibition which gave birth to the name is largely forgotten. In the nineteenth century some writers made a distinction between real and painted panoramas, which suggests that the word was beginning to be associated more with a general form of visual experience rather than a particular type of exhibition. Nevertheless, for much of the century, the use of the term must have been dependent on the author's familiarity with the exhibitions and the assumption that readers would share this familiarity.[59]

In spite of fluctuations of taste through the nineteenth century, there can be little doubt that the panoramas and dioramas enjoyed tremendous popularity and that few other varieties of art could have been known to a wider public. The real success story of the panorama lay not in the creation of great lasting works of art, but in the creation of a new public for art and a new conception of what a work of art could be. The only lasting reminder of its impact is the frequency with which we employ its name today.

1. *Morning Chronicle, and London Advertiser*, 14 March 1789.

2. The major sources of information about Robert Barker and his son and successor, Henry Aston Barker, are Theophilus Quin, *The Biographical Exemplar: Comprising Memoirs of Persons Who Have Risen to Eminence by Industry and Perseverance in the Beneficial Occupations of Life* (London: Sharpe and Hailes, 1814), pp.18-19, and G.R. Corner, *The Panorama: With Memoirs of its Inventor, Robert Barker, and His Son, the Late Henry Aston Barker* (London: J. & W. Robins, 1857), A shorter version of Corner's text originally appeared as an obituary for H.A. Barker in the *Gentleman's Magazine*, N.S. 1 (1856), pp.515-18. It was reprinted in the *Art Journal* (1857), pp.46-47 in an expanded form with extensive quotations from the memoranda of H.A. Barker. The Corner pamphlet reproduced the text of this article with only one minor alteration. The most complete modern account of the Barkers is to be found in Scott Wilcox, The Panorama and Related Exhibitions in London' (University of Edinburgh, M Litt. thesis, 1976).

3. The whole panoply of popular entertainments, including panoramas and dioramas, in London from the sixteenth to the mid-nineteenth century is admirably and comprehensively treated by Richard Altick, *The Shows of London* (Cambridge, Mass. Belknap Press, 1978).

4. *The Panorama Phenomenon*, the catalogue of an exhibition organised to commemorate the centennial of the Mesdag Panorama (Hague, 1981), provides a useful introduction to the panorama worldwide. A much fuller treatment of the international scope of panorama painting and exhibiting is provided by Stephan Oettermann, *Das Panorama: Die Geschichte eines Massenmediums* (Frankfurt: Syndikat, 1980).

5. *Repertory of Arts and Manufactures: 4 (1796), pp.165-67.*

6. *Letter from John Constable to John Dunthorne, Senior, 23 May 1803, John Constable's Correspondence,* ed. R B Beckett, vol.2 (Ipswich: Suffolk Records Society, 1964), p.34.

7. 'The Cyclorama', *Scientific American*, 55 (1886), p.296.

8. *Edinburgh Evening Courant*, 29 Dec. 1787.

9. *Ibid*, 2 February 1788.

10. *The Diary: or Woodfall's Register*, 9 April 1789.

11. *Morning Chronicle, and London Advertiser*, 14 March 1789.

12. Corner, p.6.

13. James Northcote, *The Life of Sir Joshua Reynolds*, vol.2 (London: Henry Colburn, 1818), p.42.

14. Leon Dufourny, Report of the Institut de France Commission on the Panorama, *Memoires de la classe des beaux-arts de l'institut*, 1800, reprinted in Heinz Buddemeier, *Panorama, Diorama, Photographie: Enstehung und Wirkung Neuer Medien im 19. Jahrhundert* (Munich: W. Fink, 1970), pp.168-70.

15. Charles Robert Leslie, *Memoires of the Life of John Constable, R.A.* (London: The Medici Society, 1937), pp.24n. Robert Southey reported that in 1777 the watercolourist Thomas Hearne had made a 360° sketch of Derwentwater for George Beaumont, who intended to have the artist paint the view on the walls of a circular banqueting room (*The Discovery of the Lake District*, exhibition catalogue, (London: Victoria & Albert Museum, 1984), pp.22).

16. Constable, *Correspondence*, vol. 2, p.34, and vol. 6, p.134.

17. C.R. Leslie to Thomas J. Leslie (2 February 1812), Yale Center for British Art.

18. 'Royal Academy. Professor Leslie's Lectures on Painting. Lecture I', *Athenaeum*, 17 February 1849, p.173; reprinted in C.R. Leslie, *A Handbook for Young Painters* (London, 1855), p.4.

19. *Repository of Arts*, third series, 9 (1827), p.305.

20. John Ruskin, 'Praeterita', in *The Works of John Ruskin*, ed. E.T. Cook and Alexander Wedderburn, vol.24 (London: George Allen, 1908), p.117.

21. Ruskin, *Works*, vol. 14, p.465n.

22. Ruskin, *Works*, vol. 26, p.567.

23. It was suggested by John Gage, 'Turner and the Picturesque - I', *Burlington Magazine*, 107 (1965), pp.24-25, that an exhibition of 1799 titled the Naumachia may have been J.M.W. Turner's work; however, advertisements for the Naumachia reveal that the Mr Turner responsible for the exhibition was a coachmaker from Shoreditch.

24. The relationship between Martin's art and the Eidophusikon and theatrical painting is most interestingly discussed by Martin Meisel, *Realisations: Narrative, Pictorial, and Theatrical Arts in Nineteenth Century England* (Princeton, N.J.: Princeton University Press, 1983), pp.166-88. William Feaver, *The Art of John Martin* (Oxford: Clarendon Press, 1975) considered the panorama as part of the context for Martin's work (pp.67-70). He did not note, as Altick did (pp.181-82), that in 1829 the Leicester Square Panorama presented a clearly Martinesque 'Pandemonium'.

25. Claims have been made that the panorama was a particularly American form of art, reflecting a mode of vision which was the natural response to the American landscape. (See Wolfgang Born, 'The Panoramic Landscape as an American Art Form', *Art in America*, 36 (1948), pp.3-4. Barbara Novak assessed the mid-nineteenth century America in *Nature and Culture: American Landscape and Painting, 1825-1875* (New York: Oxford University Press, 1980), pp.18-33.

26. *Morning Chronicle*, 20 May 1799.

27. Kevin J. Avery, '*The Heart of the Andes* Exhibited: Frederic E. Church's Window on the Equatorial World', *The American Art Journal*, 18 (1986), pp.52-72.

28. Dufourny, p.168.

29. A.L. Millin, 'Panorama', *Dictionnaire des Beaux-Arts* (Paris: Chez Desray, 1806), p.168.

30. *Morning Chronicle*, 31 August 1824.

31. *Repository of Arts*, third series, 4 (1824), p.41.

32. *Art Journal*, N.S., 6 (1860), p.245.

33. *Repository of Arts*, third series, 5 (1825), p.298.

34. 'Panoramas', *Chambers's Journal*, 13 (1860), p.34.

35. Constable, *Correspondence*, vol. 2, p.34

36. *Morning Chronicle*, 21 April 1801.

37. *Ibid.*, 14 March 1789.

38. *The Diary: or Woodfall's Register*, 10 June 1789.

39. The 1886 article on Philippoteaux's Cyclorama of the Battle of Gettysburg in *Scientific American*, p.296, described the process of taking three 360 degree sets of photographs of the battlefield: one set for the foreground, one for the middle distance, and one for the background.

40. *The Times*, 26 December 1849.

41. *Monthly Magazine*, 14 (1802), pp.254-55.

42. *Repository of Arts*, third series, 28 (1826), p.297.

43. *Illustrated London News*, 14 May 1842.

44. *The Diary: or Woodfall's Register*, 22 April 1789.

45. *The Times*, 27 December 1861.

46. *Art Journal*, N.S.7 (1861), p.319.

47. *Blackwood's Edinburgh Magazine,* 15 (1824), pp.472-73. This article was reprinted in *Somerset House Gazette*, 2 (1824), pp.151-53.

48. 'Some Account of an Extraordinary Traveller', *Household Words,* 1 (1850), p.77.

49. *Ibid.*

50. *Morning Chronicle*, 23 December 1830.

51. *Professor Risley and Mr J. R. Smith's Original Gigantic Moving Panorama of the Mississippi River* (London: John K. Chapman and Co, 1849), p.ix.

52. *Art-Union*, 3 (1841), p.139.

53. *Art Journal*, N.S. 6 (1860), p.350.

54. 'Panoramas', *Chambers's Journal*, 13 (1860), pp.34-35.

55. *The Times*, 2 March 1863.

56. Francis D. Klingender, *Art and the Industrial Revolution*, ed. and rev. by Arthur Elton (Chatham: Evelyn, Adams & Mackay, 1968), p.105.

57. *Oxford English Dictionary*, sv 'panorama'. Of course, the panorama experience could have broader formal and structural implications for writers. Martin Meisel has argued that 'panoramic and dioramic models affect the style, the form, and the scope of Dickens' fiction' (*Realisations*, pp.61-64.)

58. These examples of the use of the word are from the *OED*, which provides other illustrations of nineteenth-century usage of the word.

59. A very partial list of major nineteenth-century British authors who visited and commented on the panoramas would include Wordsworth, Thackeray, Keats, Southey, Scott, Dickens, and George Eliot.

I PRECURSORS

The panorama as a great optical entertainment was not patented until 1787, but most of the elements that made it work had been understood for generations. In fact it could be said that Robert Barker did not invent the panoramic experience at all – he simply captured, reproduced, and marketed it.

The compulsion, especially when away from home, to reach the top of the highest feature on the landscape – be it a cathedral lantern, skyscraper, or mountain-top – and view the world from that giddy height, is something almost everyone experiences. It is not just vertigo that provides the thrill: it is the chance it gives one to distance oneself from the detail and appreciate the whole. The consciousness is extended in every direction – from the topography immediately below to the distant horizon. In the countryside there will be ranges of mountains, ridges, valleys with field-patterns, a river, and eventually the sea; in the city a confusion of allies, lanes, streets, churches, prisons, parks, docks, and then the suburbs. For a while the spectator has a God's-eye view of creation as modified by man. It is an exhilarating, intoxicating experience. It cannot have been coincidental that Barker invented the panorama within three years of the invention of ballooning. The experience of the privileged aeronauts had to be replicated for the masses without delay.

The wish to see an entire city from above must therefore be as old as the city itself. In 1493 Hartmann Schedel's *Nuremberg Chronicle* was published, an incunabulum that included amongst its woodcut views of cities throughout the world. Frequently the same block was used to represent several quite different cities, but in just a few cases – Jerusalem, Venice, and Nuremberg itself, for instance – a not too strenuous attempt was made at representing the town as it was. In 1500 the first significant multi-sheet city prospect appeared in all its glory – a woodcut bird's-eye view of Venice, nowadays attributed with confidence to Jacopo de' Barbari (cat. No. 1). This print conveys the immensity, wealth, and beauty of a Renaissance city in one all-embracing view. It has no obvious focal-point, and not much in the way of composition. The eye is at liberty to wander where it will.

Barbari's prospect of Venice, Jan Christaensz Micker's painted Amsterdam, Jan Kip's twelve-sheet London and Westminster, Louis Bretez's Paris, and like images were essentially mani-festations of civic pride. They were commonly financed by the city fathers of the towns depicted. Normally the publishers were mapmakers, wishing to compliment existing town plans with bird's-eye views. Their titles, coats of arms, dedications, and panegyrics are presented in a highly

cartographic manner. Just as the surveyor making a town plan would use scientific instruments, so the artist drawing a prospect would use a perspective glass or a camera obscura.

Battles and sieges also lent themselves to the prospect format. Here the objective was not to represent an entire site in bird's-eye perspective, but an event, indicating perhaps why one side – your own side naturally – won. Durer's 'Siege of a Fortress', Stefano Della Bella's 'Siege of Arras', Emil Hildebrand's 'Battle of Lutzen', and J. Callot's 'Siege of Breda' all come in this category. The prospect format was also suitable for certain working documents. Accurate pictorial records were periodically needed of coastlines, demonstrating where potential enemies might land their armies and where extra fortifications were required. At the Woolwich Royal Military Academy cadets received instruction from such able artists as Paul Sandby, Thales Fielding, and John Callow. As a result of such training, a number of panoramic prints of the nineteenth century were engraved after drawings that had been supplied by officers. Robert Burford would also use drawings supplied by army officers stationed in distant corners of the Empire for the painted panoramas of Benares, Delhi, and Hong Kong exhibited at the Panorama, Leicester Square.

The conventional rectangular proportions of a picture were not always suited for town prospects. In the eighteenth century prospects of river towns grew in length. In 1749 for instance Samuel and Nathaniel Buck published a five-sheet prospect of London and Westminster which was 125 inches long. In the next century rivers would supply the proprietors of moving panoramas with a subject perfect for the medium. Precisely the same can be said with regard to processions. The 'Triumph of Maximillian' by Dürer and others is 89¾ inches long, John Ogilby's 'Coronation Procession of King Charles II', engraved by Hollar, measures 306 inches, and Thomas Lant's Funeral of Sir Philip Sidney 435 inches. A coronation procession – that of George IV – would become the most successful of Messrs Marshall's peristrephic panoramas. The long format was also appropriate when the image had to tell a story. Centuries before the invention of the moving panorama it had been used, of course, for the Bayeux Tapestry (see cat. No 11). Once the moving panorama arrived it served for panoramas of overland trips to India, polar explorations, and various colonial uprisings. In the United States many moving panoramas were painted that told the story of Civil War battles. Narrative toy panoramas abounded. Interestingly, when John Hassall wished to produce a paper panorama telling the story of the First World War, it was to the Bayeux Tapestry that he turned for inspiration (cat. No. 183).

Not just realism but ultra-realism was needed for panorama painting. The spectator had to be fooled into imagining that what he was looking at was not mere paint applied to canvas but reality itself. This was something for which showmen had long been striving. At fairgrounds there were peepshows. One peered, as if through a round window, at a magical world beyond with changing scenes of wars, cities, and scenes of exotic places and battles In the home one could look at *vues d'optiques* with the aid of a zograscope. With this machine and optical prints one could set out on an imaginary Grand Tour. Excellent for painlessly teaching geography to children, they provided, as panoramas would later, both a stimulous to, and a substitute for, foreign travel.

To create an image that was ultra-realistic one needed not only a good understanding of per-

spective but also, paradoxically, an understanding of distortion since panoramas would have to be drawn on curved, hyperboloid surfaces. The most distorted views are the anamorphic pictures produced from the sixteenth century onwards. These fall into three main categories: the slant views, sometimes painted down corridors but occasionally, as with the skull in Hans Holbein's 'Ambassadors', included as a detail in a painting; the cylindrical anamorphosis where the image is reconstituted with the aid of a cylindrical mirror or anamorphoscope; and the conical anamorphosis where a conical mirror was called for.

But above all it was the all-embracing painting that lead to Barker's invention. Decorative painting of an illusionistic nature was popular in ancient Rome, and then again in the Baroque period. In Baroque churches it was most often the ceilings that were decorated, the splendour of the liturgy combining with the Assumption of the Virgin or the Adoration of the Holy Name of Jesus to produce what we might call, perhaps rather crudely, total experience. Decorative painting was applied in palaces and houses of the especially wealthy. It might cover a ceiling as at the Palazzo Pitti in Florence where, through what appears to be a ceiling opening, we view *trompe l'oeil* marble columns, ballustrades, decorated cornices, and finally Alexander's flying chariot, painted by Mengozzi Colonna and Agostino Mitelli. It might also cover an entire wall as in the ballroom of the Villa Lechi at Brescia where an elegant couple with a small dog walk towards us down a splendid *trompe l'oeil* staircase, painted by Giacomo Lecchi and Carlo Carloni. Or it might cover all the walls and the ceiling too. In Britain the best example of this is the 'Heaven Room' at Burghley House in Northants., painted by Antonio Verrio (see No.23). Though surrounded by the *trompe l'oeil* scene the preposterousness of the subject makes it difficult for a visitor to imagine that he is anywhere but at Burghley House. For the illusion to be successful one needed a more natural subject and a circular room. Sir George Beaumont in 1777 commissioned Thomas Hearne to paint such a work in a circular room at his seat near Keswick. The subject was to be Derwentwater from Crow Park. Hearne prepared the drawing but never executed the painting. Paul Sandby in 1793, however, completed a totally decorated (albeit rectangular) room at Drakelowe Hall in Derbyshire (cat. No.24).

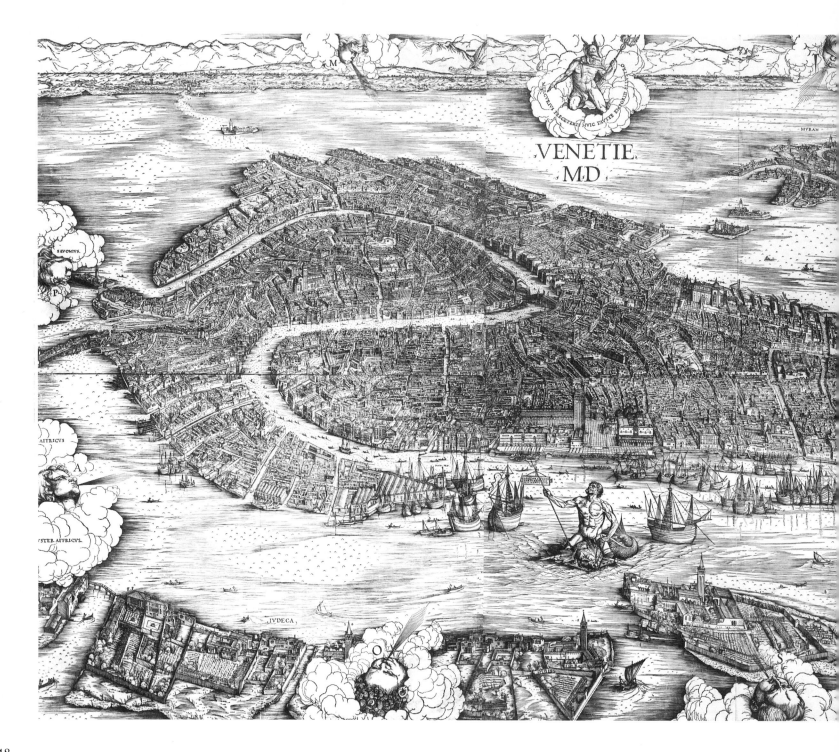

VENETIE
MD

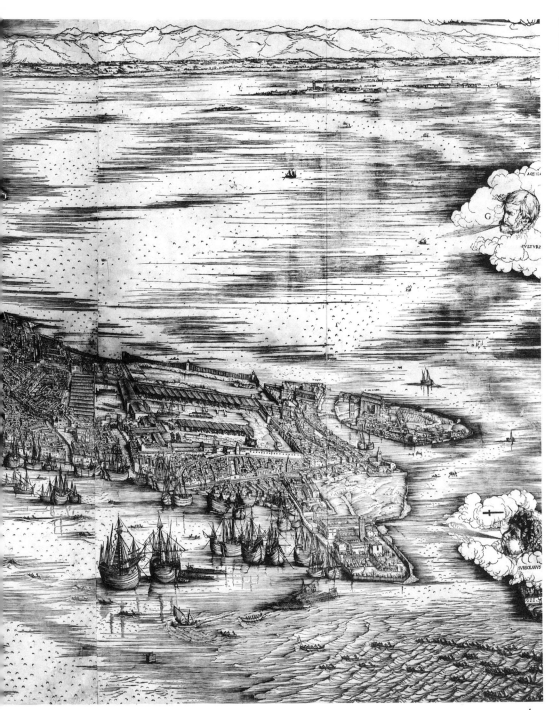

1 (detail)

1. **Bird's-eye view of Venice,** 1500

Woodcut
134.5 x 281.8 cm (6 sheets)
Trustees of the British Museum, Department of Prints &
Drawings

This print, almost certainly intended for wall decora-
tion, shows Venice from the S.W. in bird's-eye per-
spective. Though prints of towns had been published in
the previous century, no town prospect on this scale or
of this accuracy had ever been attempted. It was a work
of art rather than a functional map-view. It can be con-
sidered a visual counterpart to Marcantonio Sabellico's
De Ventiae Urbis Situ (1490). The print shows the entire
city, presenting the detail indiscriminately. When
Barker in the 1780s invented the 360-degree panorama
he took these ideas to their ultimate conclusion.

1

2. Bird's-eye view of the coast and hinterland from Land's End to Exmouth

Manuscript

66 x 287 cm (4 sheets)

British Library Board, Manuscripts Department

In February 1539, when an invasion by the French fleet was considered imminent a survey of the nation's coast-line was ordered. This map-view of the S. Coast, covering the Land's End to Exmouth portion, is thought to have been drawn in London being based on pilot surveys, local knowledge, and perhaps existing town plans. The map-view has no fixed scale. It shows potentially useful features such as beacons and church towers. Bays and other places where the enemy might choose to land are given prominence, cliffs where they could not land are ignored. The map-view carries notes inscribed in 1540 which indicate the progress made in the construction of fortifications.

3. Amsterdam

CLAES JANSZ VISSCHER

Line engraving (4 sheets)

41.2 x 215 cm

Guildhall Library, City of London

C. J. Visscher (1587-1652) was the founder of a dynasty of prolific Amsterdam map and print-makers. In addition to this rare long prosepct of Amsterdam Visscher published two long views of London.

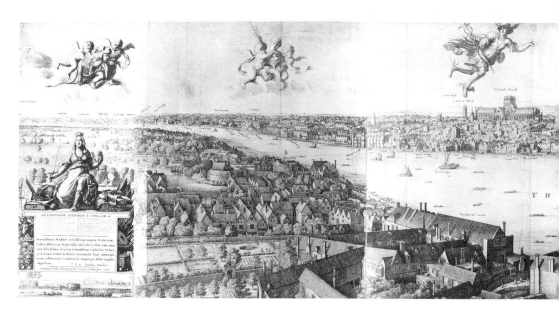

4. London

WENCESLAUS HOLLAR

Published by Cornelis Dankers, 1647

Etching

46 x 233.7 cm (6 sheets, one consisting of left and right endpieces)

Guildhall Library, City of London

The viewpoint for Hollar's long prospect of London is the tower of St Mary Overy (today's Southwark Cathedral). John Orell in the *Quest for Shakespeare's Globe*, 1983, convincingly argues that Hollar would have used a perspective glass when making his drawings. On the N. side of the river the relationships between the buildings are very accurately calculated; on the S. side, the composition of necessity has been the overriding factor.

Hollar made his drawings at some point between 1636 and 1644 when as a royalist he went into exile. He etched the plates for publication in Antwerp.

5. Tangier from the Land it beeing [sic] the South-West Side, 1669

WENCESLAUS HOLLAR

Pen & ink & watercolour

32 x 89 cm

Trustees of the British Museum, Department of Prints & Drawings

Tangier became a British territory in 1662 as part of Catherine of Braganza's dowry. Hollar visited the place in 1669 and made a series of at least twenty-three drawings. These are now scattered in several collections though the majority are in the British Museum. This view was taken from a point below Catherine Fort. The road leads to the fortified town; Gibraltar and the Spanish coast are to be seen in the distance. Hollar would later etch the image, modifying the foreground.

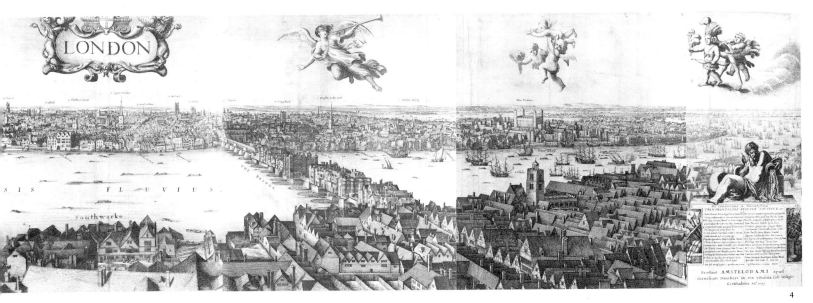

4

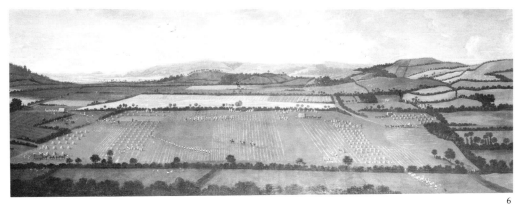

6

6. The countryside around Dixton Manor
c.1725-35

ANON.

Oil on canvas
113 x 287 cm
Cheltenham Museum & Art Gallery

This harvesting scene is one of a pair that depict Dixton Manor, the Gloucestershire home of James Higford and his family. In it we look eastwards towards the Cotswold Hills, Alderton Hill appearing on the left and Langley Hill on the right. In his *Artist and the Country House* (1979), John Harris calls it 'one of the great social

documents in the history of farming life, and by a village genius who seems to have flowered and disappeared'. Each stage in the process of making hay is represented – mowing, raking, stooking, and carting. In the centre the squire with his wife and daughter ride to the scene to see how the work is progressing. Morris men are dancing at bottom right.

7. Taymouth Castle from the south, 1733-39

JAMES NORRIE AND JAN GRIFFIER II

Oil on canvas
66 x 133 cm
Scottish National Portrait Gallery

Norrie and Griffier's bird's-eye view is very much in the late seventeenth-century and early early eighteenth-century Dutch manner, made familiar to the British nobility and gentry by the town prospects and engravings of country seats produced by Leonard Knyff and Jan Kip. The bottom half of the canvas was repainted in 1739 to show the alterations that Lord Glenarchy had made to his garden.

8. Prospetto del All'alma Citta di Roma dal Monte Gianicolo, 1765

GIUSEPPE AGOSTINO VASI

Line engraving
102 x 262 cm (12 sheets)
Society of Antiquaries

Vasi's prospect of Rome was planned as an appropriate climax to his *Magnificeze di Roma,* ten volumes of plates of important buildings published between 1747 and 1761. First announced in 1747 the prospect did not appear until 1761. Its view-point was a casino belonging to the Palazzo Corsini, high up on the Gianicolo. (Vasi had dedicated volume 9 of the *Magnificenze* to Cardinal Nero Corsini). The print, a popular purchase for British gentry making the Grand Tour, was accompanied by an *Indici istorico de Gran Prospetto.* It has been convincingly argued that Vasi employed Giambattista Piranesi (earlier his pupil) to draw the work.

9

9. **The Camp on Cox Heath,** 1778

THOMAS AND PAUL SANDBY

Watercolour
49.1 x 147.3 cm
Her Majesty Queen Elizabeth

A camp of 10,000 Hanoverians was reviewed by the Duke of Cumberland on 24 September 1754. Despite the inscription it is thought that the camp may have been that one. The format allowed the artists to show not only the post-mill with its round house, but the view over the fields to the extensive camp and the houses of the village on the right.

10

10. **Trajan's Column, Rome**

Copy photograph
Original in Conway Library, Courtauld Institute

Trajan's column may be considered an antique fore-runner of the moving panorama of the nineteeth century. Constructed in 112 – 113 AD it commemorates the victories over the Dacians in 101 and 105 – 106 AD. The band of low-relief carving on it, about three feet wide, winds twenty-three times up the shaft presenting a series of episodes in chronological sequence. Like the panoramas of Messrs Marshall, Monsieur Gompertz, the Hamiltons, and the Pooles, this Roman 'panorama' deals with war and victory; it is patriotic and propagandistic. As on many Victorian panoramas, too, the story unfolds in one continuous image.

Roman friezes were Hellenic in inspiration. The Telphus frieze from the great altar at Pergamon, panorama-like, also presents successive events against an uninterrupted setting.

52

11. Facsimile of the Bayeux Tapestry

J. BASIRE AFTER C.A. STOTHARD

Published by the Society of Antiquaries, 1 June 1819 – 1 July 1823
Coloured line engraving
19 x 2,025 cm, on roller in cabinet
Guildhall Library, City of London

Like Trajan's Column the Bayeux Tapestry may be considered a forerunner of the moving panorama: it chronicles a story, which includes a battle, in a continuous image of very great length. It was made to decorate the nave of Bayeux Cathedral on certain feast days. During two periods of its existence – at the beginning of the nineteenth century and again during the Nazi Occupation, the tapestry, in the manner of the *Illustrated London News* panoramas of the 1840s, was attached to wooden rollers, and rolled out along a table for the curious. Today it is displayed in Bayeux at the Centre Guillanme le Conquerant.

Stothard was appointed to copy the Tapestry by the Society in 1816. The facsimile appeared in 1821-23 and was later reissued in 1885 in Vol. 6 of *Vetusta Monumenta*. Stothard's drawings are still in the Society's collection.

12. Zograscope

Maker unidentified
58 cm high
Guildhall Library, City of London

The zograscope consists of a large double convex lens attached to a retractable pillar. Behind the lens, at an angle that can be adjusted, is a mirror. The print is placed on a flat surface immediately behind the base of the instrument with the top of the print against the base. When the spectator peers through the lens he sees the image from the print reversed in the mirror. It has an appearance of great depth.

13

13. L'Optique

J.F. CASANAVE AFTER LOUIS LEOPOLD BOILLY

Coloured aquatint
57 x 47 cm
Bill Douglas & Peter Jewell Collection

Vues d'optiques could be used to teach children geography. The boy in this print is thought to have been Antoine Danton; the lady is Louise-Sebastienne Gely who later married the boy's father.

14

14. **Première Partie de la Ville et du Port de Bordeaux, Prise du Côte des Salinères [and] Seconde Partie de la Ville et du Port de Bordeaux . . .**

BALTHASAR FRIEDERIC LEIZELT AFTER J. VERNET

David Robinson

This pair of *vues d'optique,* forming a single prospect is derived from an engraving in J. Vernet's series of prospects of French ports. The image, of course, has been reversed.

Double *vues d'optique* were unusual: the vast majority consisted of one sheet measuring approximately twelve by eighteen inches. Most were based on existing topographical prints. Obviously those with an especially strong perspective element – views looking down streets with the lines converging on one vanishing point, for instance – were the ones selected. The image and the title in the top margin would be reversed. The principal centres for *vues d'optique* production were London, Paris, Augsburg, and Basano. Such prints were popular from the mid eighteenth century through to the early nineteenth century.

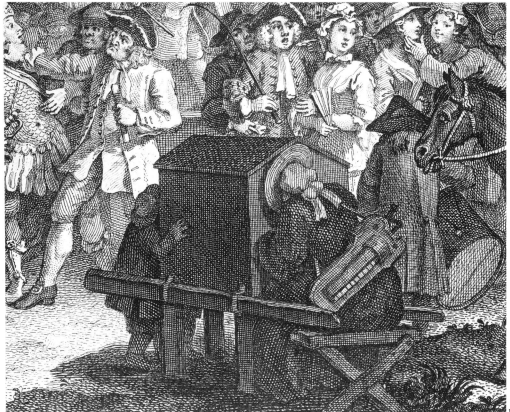

16 (deta

15. **Bartholomew Fair,** 1721

Published by J.F. Setchel, 1824
Coloured aquatint
28 x 56 cm
Guildhall Library, City of London

This design for a fan, though published in the early nineteenth century, is based on a drawing of c.1730 (not 1721 as in the title) which is now in the collection of the British Museum, Department of Prints & Drawings. The shows include theatrical booths, a very primitive big wheel, and, at bottom left, a peepshow of the 'Siege of Gibraltar', 1727.

16. **Southwark Fair**

WILLIAM HOGARTH

Line engraving
34 x 35 cm
Guildhall Library, City of London

At bottom right two spectators are able simultaneously to view scenes in a double peepshow.

17. **Sergeant Bell's peepshow**

Bill Douglas & Peter Jewell Collection

This travelling peepshow was made for the film, 'Comrades' directed by Bill Douglas in 1987. It was modelled on that shown in the frontispiece of *Sergeant Bell and His Raree-Show*, illustrated by George Cruikshank and published by Thomas Tegg in 1839.

18. **King Charles ye first head Drawn in Optics**

Published by Richard Holmes Laurie, 1 January 1821
9.1 x 55 x 176 cm

David Robinson

Example of a slant anamorphosis. The proportions are rectified when the print is held at a slant with the letter 'A' next to the eye. The plate was first published in the mid-seventeenth century.

19. **Anamorphoscope and an anamorphic portrait of Admiral Nelson**

F. WATERMAN

David Robinson

An early nineteenth-century example of a cylindrical anamorphosis. When the anamorphoscope is placed in the centre of the print the distorted image is reconstituted in the cylindrical mirror.

20. **L'Optique**

DOSSIER AND ALLOU

Published by Basan, Paris
24.5 x 30 cm
Barnes Museum of Cinematography

The engraving shows a lady drawing an anamorphic image. The anamorphoscope (cylindrical mirror), which will be used to rensconstitute the image, can be seen on the table.

21. **Camera obscura**

Photograph
20.3 x 25.5 cm

Large camera obscuras such as this can be seen at Dumfries, Edinburgh, Aberystwyth, and Bristol.

22. **Ballroom of the Villa Lechi, Brescia**

Photograph
25.5 x 20.3 cm

The architecture in *trompe l'oeil* painting of a staircase in the ballroom at the Villa Lecchi was painted by Giacomo Lechi, the figures by Carlo Carloni.

20

55

23. The Heaven Room, Burghley House, Northants.

Photograph
20.3 x 25.5 cm

Edward Croft-Murray in his *Decorative Painting in England* (1962) describes the Heaven Room, Burghley House, as the most spirited production of Antonio Verrio's full-blooded humour. The theme of the decoration is the capture of Mars and Venus in Vulcan's net. Olympus laughs down from the ceiling at the unsuspecting lovers on one wall. On the adjacent wall Mercury flies out of the colonnade to deliver Mars from his predicament. Neptune strides out of the sea and into the room.

24. Painted Room, Drakelowe Hall, Derbyshire

Photograph
20.3 x 25.5 cm
Trustees of the Victoria & Albert Museum

Sir Nigel Gresley commissioned Paul Sandby to decorate a room at Drakelowe Hall in 1793, within a few months of Barker opening the Panorama, Leicester Square. It is well described in a letter to a friend by Miss Anna Seward:

Sir Nigel hath adorned one of his rooms with singular happiness. It is large, one side painted with forest scenery whose majestic trees arch over the coved ceiling. Through them we see the glades, tufted banks, and ascending stairs in perspective. The opposite side of the room exhibits a Peak valley: the front shows a prospect of more distant country, vieing with the beauties of the real one, admitted opposite through a crystal wall of window the whole breadth of the appartment. Its chimney-piece, formed of spars, ores, and shells represents a grotto. Real pales [palings], painted green and breast-high, are placed a few inches from the walls and increase the power of deception. In these are little wicket gates, that, half open, invite us to ascend the seeming forest banks. The perspective is so well preserved as to produce a landscape deception little inferior to the watery illusion of the celebrated Panorama.

Drakelowe Hall was demolished in 1934. One wall from the Painted Room and the wicket gates were saved. The wall is preserved in the Costume Room at the Victoria & Albert Museum.

25. Four doors from the Painted Room, Drakelowe Hall

PAUL SANDBY

241.3 x 63.5 cm each
Trustees of the Victoria & Albert Museum

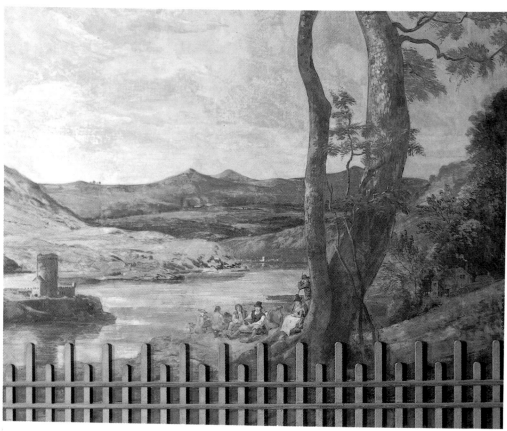

24 (detail)

II THE EARLY YEARS

In the mid-1780s Robert Barker, a portrait painter, took a walk with his daughter on the Calton Hill, Edinburgh. In G.E. Corner's account, based on Barker journals, we learn that the artist was uncharacteristically quiet. When his daughter asked what was on his mind he replied that he was calculating how one might reproduce the *total* view of Edinburgh. One could fix a square frame at one spot, draw the scene presented in the frame, turn the frame to the area adjacent, and then continue to turn the frame and draw the scene until the complete 360 degree prospect was recorded. Once the drawing was finished and coloured, in theory at any rate, one ought to be able to stand in the centre of the painting and experience the sensation of actually being there on Calton Hill.

A little while later Barker returned to Calton Hill with his younger son, Henry Aston Barker, then about twelve years old. The lad was installed at the top of the Observatory and set to work recording the city in outline. His lines were then redrawn on large sheets of paper which were pasted onto linen. When the two ends of the long scene were joined, the Barkers could view their work from the centre. At first they were disappointed: only horizontal lines at eye-level appeared straight. To achieve the illusion of reality they were seeking, large numbers of straight lines would have to be curved, and many curved lines straightened.

Once the trick had been mastered and the image corrected Robert Barker took his painting to London. Sir Joshua Reynolds, President of the Royal Academy, graciously agreed to inspect it. He was not over-impressed, and recommended that Barker abandon the idea. Barker was not dissuaded, however, and took out a patent on the invention.

Barker had realised that success in creating the looked-for illusion in large measure depended upon the design of the structure in which the paintings were to be displayed. It had to be circular, the painting being suspended around the inner circumference. It would have to be lit from above, 'either by a glazed dome or otherwise, as the artist may think proper'. There had to be an 'inclosure' to prevent the spectator going too near the painting, in the form of a room or a platform. (A circular form for it was particularly recommended.) Supported from the bottom or suspended from the top there would have to be a shade. This would project sufficiently to prevent the observer seeing the top of the painting when looking up. Beyond the inclosure at the bottom there should be a wall, paling, or other interception preventing the spectator seeing the bottom of the painting. The entrance to the inclosure had to be from below, for a door puncturing the painting would obviously injure the illusion. Ventilators were to be fixed below the painting. The artist was

to ensure that the inclosure was built to the right level 'to make observers...feel as if really on the very spot'.

Having registered his patent Robert Barker exhibited an improved version of his Edinburgh picture firstly in Archers' Hall; then in the Assembly Rooms, George Street; then in Glasgow; and finally, from 14 March 1789, at 28 Haymarket in London. Londoners welcomed it and the art world revised its opinion. Benjamin West praised it highly. Reynolds, taking Barker by the hand, would later apologise for judging the invention too hastily.

In the meantime Robert Barker despatched Henry Aston to the roof of the Albion Mills to draw the view of London, and engaged Robert Mitchell to design the world's first panorama rotunda. This was erected in Cranbourne Street on the north side of Leicester Square, in the grounds of the recently demolished Leicester House. It was designed to accommodate two panoramas simultaneously, a canvas of 2,700 square feet in the Upper Circle, and canvases of 10,000 square feet in the Large Circle. Between 1793 when the Panorama opened its doors and 1863 when it finally closed them a total of 126 different panoramas would be exhibited here.

Although covered at first by a patent the panorama idea rapidly spread. The marine artist, Robert Dodd, recorded the 'Fleet at Spithead in 1795', and his panorama of it was exhibited in the Great Room at Spring Gardens in 1796. Spring Gardens became the venue for a series of other panoramas which included Thomas Girtin's London panorama, the 'Eidometropolis' (see cat. No. 34); John Thomas Serres's 'Boulogne' depicting the French flotilla preparing for the invasion of Britain; and John Knox's 'Glasgow' (see cat. No. 39), which had previously been exhibited in Glasgow and Edinburgh. At the Lyceum in the Strand, Robert Ker Porter displayed several panoramas beginning with 'The Storming of Seringapatam', painted, so he claimed, in eight weeks. Porter's 'Defeat of the French and the Passage of Mont Gothard by General Surwarrow' and Girtin's 'Eidometropolis' were both taken to Russia. The other Porter panoramas, 'The Battle of Alexandria' and 'The Battle of Lodi', appeared in New York in 1804, and Philadelphia in 1806.

At the Panorama, Leicester Square, Robert Barker had been assisted by his two sons, Thomas Edward and Henry Aston. In 1803 Thomas Edward left to establish, with Ramsay Richard Reinagle, a rival Panorama in the Strand. Several panoramas from both establishments were exhibited in rotundas erected in Aberdeen, Glasgow, Edinburgh, Dublin, Liverpool, Manchester, and Birmingham. Most of these were temporary wooden buildings though Barker's Panorama in New Street, Birmingham must have been a more permanent structure.

Panorama buildings sprang up in major towns overseas, also. A copy of H.A. Barker's 'London from the Roof of the Albion Mills' was exhibited in 1795 in Greenwich Street, New York, and what may have been a second version of it toured Leipzig, Hamburg, Vienna, Paris, and Amsterdam. The panorama of Spithead toured also.

In Paris in 1799 Robert Fulton and James Barlow secured a *brevet d'importation* giving them exclusive rights to exploit panoramas in France for ten years. A rotunda was erected in the Jardin des Capucines, where a panorama of Paris was exhibited, painted by Constant Bourgeois and Denis Fontaine and an artist who was to become in some ways the French equivalent of H.A.

Small handbill advertising Barker's panorama, Leicester Square

Barker, Pierre Prevost. Towards the end of the year Fulton sold the *brevet* to an American compatriot, James Thayer, who erected a second rotunda close to the first, then three in Montmartre, and then a larger building, to replace the first two, in the Boulevard des Capucines. He also erected rotundas in Lyon and Amsterdam. Prevost's panoramas circulated these establishments. Napoleon visited the Boulevard des Capucines rotunda in 1810. Inspired by the experience he ordered his architect, Jacques Celerier, to design eight rotundas for the Champs-Elysées. In these he planned to show panoramas of the great battles of the Revolution and Empire which would also circulate the chief cities of Europe. The events of 1812 put a halt to this dream.

Prevost travelled to distant places for his sources. In 1816 he travelled to the Middle East and recorded Jerusalem, Athens, and Constantinople. He finished the panoramas of Jerusalem and Athens but was still working on Constantinople when he died. Jean Prevost, Pierre's brother, continued the business, but by 1831 all the original panoramas had closed down and were demolished.

At this point panorama entertainment would have vanished from the Paris scene had it not been for the enthusiasm and enterprise of a half-pay officer with an artistic flair, Major (later Colonel) Jean Charles Langlois. In 1830-31 he erected in the Rue des Marais the largest rotunda in France so far. Both building and panorama incorporated important innovations. The skylights were of ground glass: this solved the problem of shadows falling on the canvas. And between the viewing-platform and the canvas he introduced a *faux terrain* – three dimensional scenery which blended with the picture on the canvas. When organised skillfully it would be impossible for spectators to tell where three-dimensional elements ended and two-dimensional canvas commenced. For Langlois' first panorama, 'The Battle of Navarino', he purchased a ship that had distinguished itself in the engagement – the *Scorpio* – and incorporated a section of it into the rotunda. To reach the platform spectators had to pass through an officer's cabin, then up a stairway to the Captain's dining room, then up more stairs to the poop which served as the viewing-platform. The 'Battle of Navarino' was superseded by 'The Taking of Algiers' and 'The Battle of Moscow.'

In 1839 Langlois moved into a new rotunda designed for him by Jacques Ignace Hittorff, situated in the Champs-Elysées. Before designing his building Hittorff had visited the Colosseum in London and had reported critically on it. His own rotunda had no central column to cast a shadow on the canvas, the roof being self-supporting. The dimensions of the building provided for canvases 15 metres in height and 38 metres in diameter. (These measurements would become almost standard during the Panorama Revival facilitating world-wide circulation and exchange of panoramas.) When Hittorff's building was pulled down in 1857, the Paris municipality replaced it in 1860 with a rotunda designed by Gabriel Jean Antoine Davioud. This was also in the Champs-Elysées, at the angle with the Avenue d'Antin. It was here that Langlois' panorama of the Siege of Sebastopol was exhibited, based on drawings Langlois had taken on the spot during the event, and on photographs taken by the photographer who accompanied him.

Another significant centre in the early years of the panorama was Berlin. There the pioneer was

Johan Adam Breysig, a theatre decorator who specialised in illusionistic paintings for gardens. In 1800, with the landscape artist, Carl Ludwig Kaaz, he painted a panorama of Rome, and exhibited it in a rotunda which he himself designed. Rome was followed by panoramas of Berlin, St Petersburg, and Moscow, all painted by Johan Friedrich Tiekler. A watercolour cross-section of Breysig's rotunda in the Allen Art Museum, Oberlin College, Ohio, shows visitors viewing the panorama of Berlin.

A second temporary rotunda was erected in Berlin in 1808 to accommodate a panorama of Palermo by a man who was soon to become Berlin's most celebrated architect, Karl Friedrich Schinkel. This panorama, based on drawings he had made in Italy in 1804, was painted in the hall of the Royal Opera House in the space of four months.

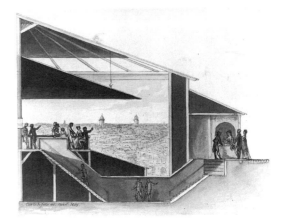

Cross Section of Breysig's Rotunda, Berlin, 1801
HALLER VON HALLERSTEIN
(By courtesy of Allen Art Museum, Ohio)

All that remains of Schinkel's panorama is the circular key. Where Eduard Gaertner's panorama of Berlin in 1834 is concerned, however, there is the complete original in the Schloss Charlottenburg in West Berlin, and an incomplete replica made in Leningrad. The Berlin Museum has a study for the whole work and a detailed alternative for one section. Gaertner's panorama takes the form of a double triptych. The view is taken from the roof of the Friedrich-Werdersche Kirche. On the roof the artist includes himself with his portfolio and drawing implements; his wife and mischievous children; Alexander von Humboldt with a telescope; Schinkel and his friend Peter Christian Beuth; and a workman rebuilding a pinnacle who is mixing cement in a wooden bucket.

London remained the world's principal centre of panorama production until the early 1860s. Panoramas for each of the two Circles at the Panorama, Leicester Square and for the Panorama in the Strand were changed at approximately twelve-monthly intervals. In all between the 1780s and 1860s over 150 panoramas were painted and exhibited by Robert Barker, H.A. Barker, and T.E. Barker, and their successors John Burford and Robert Burford. Of these at least thirteen went to North America, being imported by John Vanderlyn and Frederick Catherwood, both of whom were panoramists in their own right. Britain remained the United States' only supplier during this period.

The Barkers and Burfords painted their panoramas at great speed, undertaking the work themselves with very few staff. On three occasions artists of some standing were engaged – Edward Dayes ('Windsor'), David Roberts ('Cairo'), and John Burnet ('Waterloo'). Source drawings for remote places were supplied by people on the spot, by the archaeologist Frederick Catherwood ('Jerusalem', 'Thebes', and 'Baalbec'); by the roving artist, Augustus Earle ('Sydney', and 'The Bay of Islands, New Zealand'); by explorers, Capt John Ross ('Boothia') and Lt Browne, (Polar Regions'); and by such serving naval and military officers as Lt W. Smyth RN ('Lima'), Cpt Robert Smith RE ('Benares' and 'Delhi'), Lt F.J. White RE ('Hong Kong'), and Cpt Verschoyle ('Sebastopol'). John Trumbull offered paintings of the Niagara Falls which were not used. Robert Burford between 1829 and 1861 employed Henry Courtney Selous to help him with the painting of thirty-five of his panoramas. In the 1850s photographs were used as an aid in painting 'Sebastopol', 'Canton', and 'The Forum in Rome.'

The Strand Panorama closed in 1831, but the Panorama, Leicester Square flourished for many years, sustained by the professionalism and enthusiasm of its proprietor, Robert Burford. Like Pathé News later, Burford's panoramas in the 1850s concentrated on recent world events – particularly military incidents on the fringes of Britain's expanding Empire. Within weeks of a celebrated event, reported in detail day by day in the London newspapers – the Indian Mutiny, the Second Opium War, and the battles and sieges of the war in the Crimea, for example – Burford could offer visitors his simulated *experience*.

In 1861 Robert Burford died. His successors bravely re-exhibited topographical panoramas that had been popular – 'Athens', 'Rome', and 'Pompeii'. There were few appropriate news events, and, in any case, there was no-one in the family up to directing the production of new panoramas recording them. In the field of educational entertainment, moreover, the Panorama now had to compete with the Crystal Palace (accessible from 1858 on the West End & Crystal Palace Railway), and new museums in South Kensington – all of these establishments providing a richer, more varied, and more sophisticated fare.

The Panorama, Leicester Square, finally closed in December 1863. It was auctioned on 12 November 1864. Soon afterwards it was made into a Catholic church for London's French community.

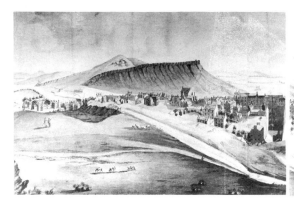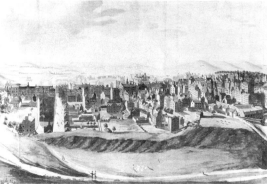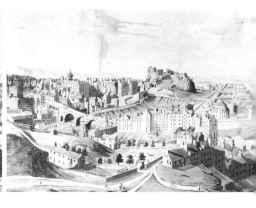

26. Mr. Barker, Inventor and Painter of the Panorama

J. FLIGHT AFTER CHARLES ALLINGHAM

Mezzotint

32.2 x 26.5

Barnes Museum of Cinematography

Robert Barker, inventor of the panorama, was born in 1739 in Kells, Co. Meath in Ireland. He married a Miss Aston, daughter of an eminent physician in Dublin. The family moved to Scotland, and Edinburgh was the subject of the first panorama. In London the Barkers lived first at 8 Castle Street, close to Leicester Square, then from 1799 at 14 West Square in Southwark. It was here that Robert Barker died on 8 April 1806, aged sixty-seven.

There is a second engraved portrait of Robert Barker, by J. Singleton after G. Ralph, 1802. The Victoria & Albert Museum has a small anonymous oil painting of him.

27. Panorama of Edinburgh from the Calton Hill, 1792

ROBERT BARKER

Watercolour

41 x 326 cm

University of Edinburgh Library

This drawing presents us with a representation of the first 360° entertainment panorama to be painted. The full-scale version measured 25 feet in diameter. In London it was exhibited at 28 Haymarket, then repain-

ted in oil for the Upper Circle of the Panorama, Leicester Square, where it was exhibited from 8 January 1804 to 5 June 1807. Another Edinburgh panorama, exhibited in the Panorama's Large Circle from April 1825 to September 1826, would show the city virtually from the same spot.

An aquatint of the original Edinburgh panorama, in six sheets engraved by John Wells, was published between 12 October 1789 and 25 March 1790. The drawing exhibited in the present exhibition is dated 1792; unless dated erroneously later it could not have been the drawing Wells used when making his engraving.

28. London from the Roof of the Albion Mills

FREDERICK BIRNIE AFTER ROBERT [AND HENRY ASTON] BARKER

Published 18 Aug. 1792 [sh.1]; 23 Oct. 1792 [sh.2]; 17 Dec. 1792 [sh.3]; 27 Mar. [sh.4]; [...] 1792 [sh.5 & 6] (imprints for shs. 5 and 6 cropped on most complete copy examined).

Coloured aquatint (6 sheets)

43.2 x 330 cm

Guardian Royal Exchange

This series of prints gives a clear idea of the appearance of Barker's 360 degree panorama, 'London from the Roof of the Albion Mills.' The drawings for that image were made during the winter of 1790/91. They were enlarged and painted in distemper to produce a show panorama measuring 1,479 square feet. This was exhibited from June 1791 in a crude building behind

Barker's residence at 28 Castle Street (part of today's Charing Cross Road). It seems the building was too small to accommodate the entire image so visitors saw less than the complete circle.

At this date only by purchasing the aquatints could one see the total view. The giant distemper original remained on show in Castle Street even after the Panorama, Leicester Square had been opened. (For a short period its opening hours were extended by the use of lamps.) The panorama ceased to be advertised early in 1794. On 28 March 1795 a second version of 'London from the Roof of the Albion Mills' was opened, this time in the Panorama, Leicester Square. It was the first panorama to be exhibited in the Upper Circle. This time it was bigger (2,700 square feet), it was painted in oil on canvas, and it displayed the complete 360° image. It remained on show until 13 Febuary 1796.

A large proportion of the engraved area of the aquatints is taken up by the leads and chimneys of the Albion Mills. This renders them unsatisfactory as topographical prints. Only when the images are enlarged and made to form a circle does the purpose of the intrusive foreground become fully apparent. Contemporary German sources state that the viewing-platform in the Large Circle for 'Spithead' represented the deck of a frigate. Though a roof and modelled chimneys are not indicated in Mitchell's cross-section (cat. No.29) they may well have featured as the viewing-platform for 'London' in the Upper Circle. (Modelled viewing-platforms were not used again by the Barkers or their successors.)

Though broadly painted the panorama contains a

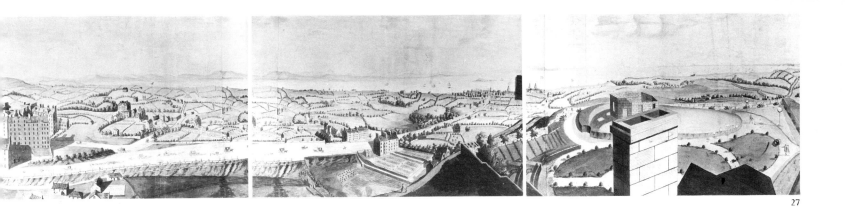

27

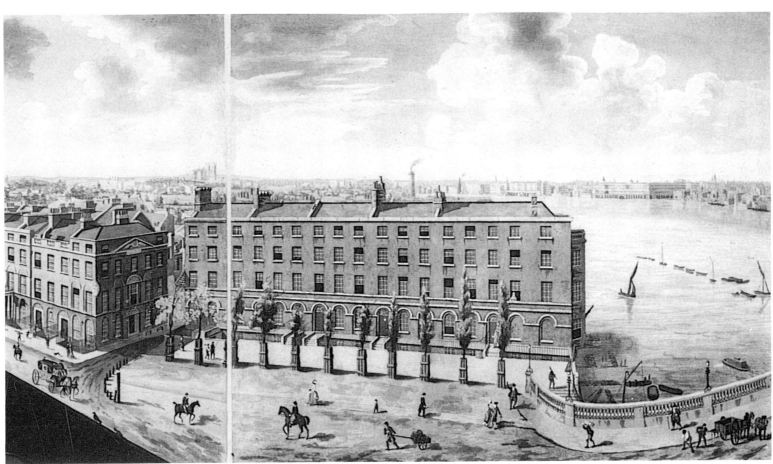

28 (detail)

63

number of nice details. At the S. end of Blackfriars Bridge workmen repair the road, a waterman descends the stairs to his vessel, a man raps on a door of Albion Place, and a woman calls out of a window. River craft close by includes a barge of the Royal Exchange Fire Office, an allusion to the fire, fought by insurance fire boats, which gutted the Albion Mills between the completion of Barker's drawings and the publication of the prints. A correspondent in *Notes & Queries*, 4 (1851),p.118 recalled seeing the Lord Mayor's Day river procession on the original panorama in Castle Street.

Guildhall Library has two keys to the painting. One with French references was most likely issued during the panorama's visit to Paris. The other lacks the list of references that is called for; rather than chimney pots the foreground is dominated by the upper portion of a ship's mast and the two furnaces of the Falcon Coal Wharf. The British Museum has a key with Dutch references.

29. **Section of the Rotunda, Leicester Square, in which is Exhibited the Panorama,** 1801

ROBERT MITCHELL ARCHT.

Coloured aquatint

28.5 x 44.5 cm

National Film Archive

A cross-section of the world's first panorama rotunda, constructed basically in accordance with Barker's patent. Unlike most rotundas built subsequently it provided for two panoramas to be simultaneously exhibited. Payments to Mitchell, the architect, are recorded in the Barker accounts at Coutts Bank.

The cross-section forms a plate in Mitchell's *Plans and Views in Perspective, with Descriptions of Buildings Erected in England and Scotland* (1801). A French edition of the work was published, conceivably to cater for Parisian interest aroused by the opening of Robert Fulton's rotunda in the Jardin du Couvent des Capucines, September 1799.

In the Upper Circle of the Panorama may be seen Henry Aston Barker's 'London from the Roof of the Albion Mills' (cat. No.28). The painting on view in the Large Circle has sometimes been mistaken for 'The Grand Fleet Lying at Spithead.'

Key to the cross-section:

A Entrance Gallery
B Staircase to Large Circle viewing-platform
C Large Circle viewing-platform
D Passage to staircase
E,F,G Staircase to Upper Circle
H Central supporting column
I Roof
K Skylight to illuminate Upper Circle panorama
L Skylight to illuminate Large Circle panorama
M Rotunda walls

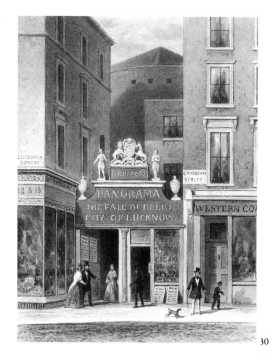

30

30. **Cranbourne Street entrance to Burford's Panorama,** 1858

THOMAS HOSMER SHEPHERD

Watercolour

22.4 x 17.1 cm

The Trustees of the British Museum, Department of Prints & Drawings

The entrance to Barker's (later Burford's) Leicester Square Panorama was in Cranbourne Street, on the

North side of the Square. On the left a long straight passage led to stairs ascending to the panoramas. The plan of the building which appeared later in the sale particulars indicates a cafe and a reading room on the right.

In Shepherd's watercolour the panorama advertised is 'The City of Delhi, with the Action Between Her Majesty's Troops and the Revolted Sepoys'. This panorama, based on drawings supplied by Cpt Robert Smith RE, was exhibited in the Large Circle, 23 January 1858 – 25 January 1859. The 'View of Lucknow', also advertised, was based on drawings made before the Mutiny by an East India Company employee, Mr B.H. Galland. It was exhibited from 27 March 1858 – 14 May 1859.

A related pencil drawing is held by the Bodleian Library in its John Johnson Collection. In that collection there is also a watercolour by C.J. Richardson, taken from the same spot in July 1871. By that date the rotunda had been converted into a church for the Marist fathers; the building then sports a cross over the central ventilator, and a rose window in its outer wall.

31. **Barker's 'Painting Room', West Square, Southwark,** 1827

JOHN BUCKLER

Pen and wash

15 x 23 cm

Guildhall Library, City of London

For over twenty years the Barkers and Burfords painted their panoramas in a wooden rotunda that had been erected at the back of Robert Barker's house, 14 West Square, St George's Fields. (Its position is indicated on Horwood's survey of London, 1799.) Once painted the massive canvases had to be rolled onto giant spools, and transported through often narrow and winding streets to Leicester Square.

The West Square 'Painting Room' in due course was replaced by a 'Painting Room' in Rochester Place, Kentish Town. A diary kept by an artist employed by Burford in the 1830s (V. & A. Ms. 86.55.67) records how work was conducted there. A plan of the Kentish Town 'Painting Room' appears in Robins' sale particulars, 12 November 1864. (The Kentish Town 'Painting Room' was acquired by Henry Willis, organ builder. For many years known as the Rotunda Organ Works it was eventually destroyed in a fire).

31

32. **The Storming of Seringapatam,** 1800

Stipple engraving (3 sheets)
59.8 x 270 cm
National Army Museum

Vendramini's engraving reveals the appearance of Robert Ker Porter's first and most popular panorama, exhibited at the Lyceum from 17 April 1800 – 10 January 1801.

The assault on the Mysorean capital by British and allied troops in 1800 triggered off general patriotic rejoicing and Porter's subject was welcomed. Novelty ensured the success of his panorama, too. Though its dimensions approached those of the panoramas painted for Barker's Upper Circle (2,550 compared with 2,700 square feet) it had been painted in only eight weeks.)

The hire of space at the Lyceum cost Porter £220 per annum. Nevertheless he was able to record in his Diary a clear profit of £1,202.14s. 7½d. 'Seringapatam' was despatched to Edinburgh and then toured, visiting Dublin, Liverpool, Plymouth (and also, the Diary implies) Bury St Edmunds, Glasgow, Belfast, Chester, and Tavistock. By 1805 it had reached Philadelphia. Nevertheless in 1825 it – or a copy of it – was being exhibited in Bristol, and two years later Nottingham. According to the *Dictionary of National Biography* it was eventually destroyed in a fire.

Seringapatam's success as a panorama indicated a market for a print. Vendramini had already demonstrated his virtuosity as a stipple engraver by his contributions to Wheatley's set of London *Cries*. Work was put in hand in 1801, and Porter presented George III with a proof of the central sheet on 16 Febuary 1802.

A reduced version of the image – 2ft 11in by 9ft – was acquired by the 10th Earl of Stair and remains in the family's collection. The compiler of the *Catalogue of Pictures ... at Lochinch Castle* (Privately Printed, 1912) suggests it was painted to provide Vendramini with an image of manageable proportions. Like the print this painting is divided into three sections.

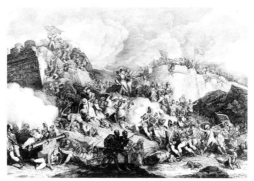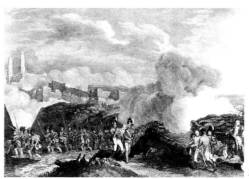

32

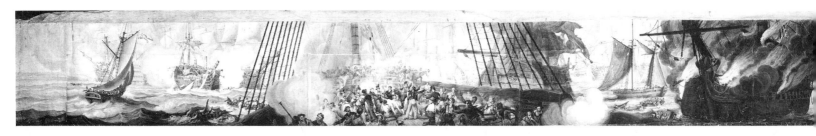

33. The Battle of Trafalgar

SIGNED 'WH' AND ATTRIBUTED TO WILLIAM HEATH

Watercolour on paper, laid on calico
62.2 x 1001.5 cm
National Maritime Museum, Greenwich

This is a miniature panorama of the Barker type, the two ends joining to form a circle approximately l0ft 6in (3.2m) in diameter. As originally mounted it may have been lit by diffused daylight from above or perhaps by footlights concealed in a masking circular base. In either case, spectators must have stepped up, head and shoulders, into the circle from below and only a few could have been accommodated at one time. Loose ends of thread along the top of the cloth backing are remains of the original suspension ties. The lower edge of the painting has been extended on a thin strip of paper running the whole length. The cloth below that is darkened to aid the lower masking which these measures suggest may originally have caused some problem. The top of the picture would have been hidden from view above a masking central hood or ceiling in the usual manner for a circular panorama.

Trafalgar was a popular panorama subject. Robert Barker, who had personally been thanked by Nelson for his Battle of the Nile panorama in l799, exhibited his 'Trafalgar' at Leicester Square in l806. Many other 'Trafalgar', panoramas, stationary and moving, followed into the present century. This one is the only surviving example, excepting the so-called Trafalgar panorama of W.L. Wyllie at Portsmouth. It demonstrates how successfully a circular panorama can show a sequence of events rather than just a single moment of time.

The incidents should be read from right to left. They are:
- Cadiz, with the Combined Franco-Spanish fleet emerging; the Spanish battery in the foreground is imaginary.
- A stern view of Nelson's famous double column order of battle advancing to intercept the distant enemy line at right angles. *Victory* appears to be the vessel with three stern galleries in the centre, leading the left or weather line.
- A French two-decker, the *Achille*, 74 guns, on fire. The blaze began about 4.30pm; the ship blew up at 5.45pm.
- Nelson shot on the quarter deck of the *Victory* by a marksman in the French *Redoubtable*, here seen stern-to on the right. This fatal incident occurred at the height of the action about l.25pm.

The individuals in the last scene are intended as portraits. The composition basically derives from a painting by Benjamin West for which a key was issued. The image was engraved in l8ll by James Heath (related to William Heath?) The figure in uniform to the right of Nelson, in this section, is Captain Hardy, apparently with Surgeon Dr Beatty in civilian dress between them. Behind Nelson and supporting him is a Royal Marine, intended as Sergeant Secker. To the left is the Chaplain, Dr Scott, while further left two seamen carry the body of Captain Adair of the Marines. None of the likenesses are particularly good and the panorama may itself have had an engraved key to identify people and incidents, not least the unusual and good representation of the frigates and small vessels of the British fleet. It is notable that both the West painting and the panorama falsify Nelson's shooting for neither Scott, nor Beatty, nor others shown, were on the deck at the time.

The exact purpose of the panorama is as yet a mystery. William Heath was a painter, watercolourist and illustrator noted for military subjects, 'penny-plain-tuppence coloured' theatrical prints and similar material. The panorama may itself have been linked to engravings and was perhaps intended for setting up as an attraction or for promotion in one of London's popular print shops.

(Pieter van der Merwe)

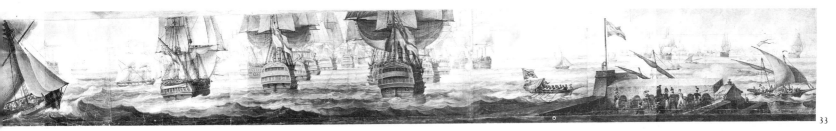

33

(detail)

33 (detail)

33 (detail)

34. **Drawings for the Eidometropolis,** 1797-98

THOMAS GIRTIN

Watercolours (5 sheets)
Sheet [1] 29.1 x 52.4; sheet [2] 24 x 53.9; sheet [3] 20.6 x 44.4; sheet [4] 21.1 x 48.4; sheet [5] 32.7 x 53.9 cm
Trustees of the British Museum, Department of Prints & Drawings

Girtin's 'Great Picture of London', as it is first referred to in advertisements, went on exhibition at Wigley's Great Room, Spring Gardens on 2 August 1802, replacing Samuel James Arnold's 'Battle of Alexandria.' It measured 18 feet by 108 feet, and was thus smaller than panoramas painted for the Upper Circle of Barker's Panorama, Leicester Square. Girtin's viewpoint was stated to be the top of the British Plate Glass Manufactory on the W. side of Albion Place, at the S. end of Blackfriars Bridge. It was therefore only a few yards from H.A. Barker's view-point (cat. No. 28). The exhibition continued until Girtin's early death on 9 November 1802. After his funeral it was reopened under the management of his brother John, as a benefit for Thomas's widow. It closed towards the end of March 1803. George Sanders 'Panorama of Edinburgh' followed it.

Girtin's 'Eidometropolis' was described by a *Monthly Magazine* contributor (October 1802) as a 'connoisseur's panorama'. The artist, he said, had 'placed particular attention to representing objects of the hues which they appear in nature.' The view towards the East appeared through a sort of mist rising from forges and manufactories. This lessened gradually as one turned towards the West. The Thames he described as 'pellucid'; near its shore one could see the earth

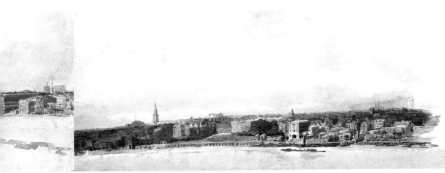

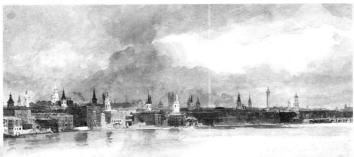

34

67

beneath the water. Though the panorama may have
been painted in only three months it was detailed. The
Morning Herald (12 November 1802) noticed that 'every
house was attended to', and the *Monthly Magazine* drew
attention to the figures in Blackfriars Road, 'where
there is a ring surrounding two pugilists...The horses,
asses, etc. have a very great spirit'.

A key to the 'Eidometropolis' was published by
Girtin's friend, Louis Francia, on 29 January 1803, el-
even weeks after Thomas's death and eight weeks be-
fore the exhibition closed. The image on it suggests that
the 'Eidometropolis' was semi-circular. Closer ex-
amination, however, reveals that it compresses the
view on the South of the river and some segments are
left out. It is now generally agreed that the panorama
was a full 360°.

Girtin had plans for a panorama of Paris, to be exhi-
bited it would seem in a building that could be erected
on a vacant site near Temple Bar. He also had plans to
exhibit his London panorama in Paris. Following the
closure of the Spring Gardens show the 'Eidometro-
polis' was rolled up and stored over a carpenter's or
architect's shop in St Martin's Lane. In c.1825, accord-
ing to another tradition, the panorama was sold by Ed-
ward Cohen, the second husband of Girtin's widow, to
a Russian nobleman, who exported it to his country
where it was exhibited in St Petersburg.

The watercolours show the appearance of the
Eidometropolis from Lambeth to London Bridge, with
a gap for the Blackfriars Bridge to St Paul's section.
They can be assumed to be part of the colour model
used when the full-scale oil was being painted.

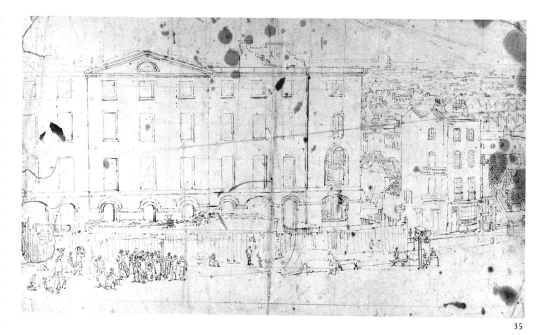

35

35

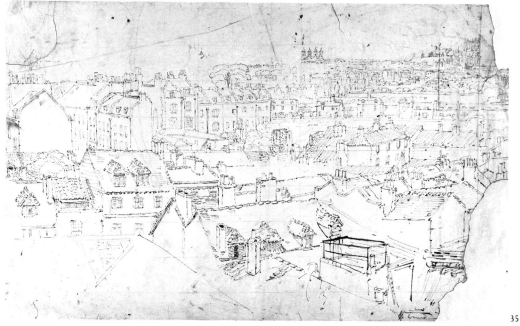

35

35. Sketches for the Eidometropolis, 1797-98

THOMAS GIRTIN

Pen and ink (sheet [1] pen and wash)
Sheet [1] The Trustees of the British Museum,
Department of Prints & Drawings; sheets [4] and [5]
Thomas Girtin; sheet [2] Guildhall Library, City of
London; sheet [3] Yale Center for British Art.

These squared drawings would have been used by the
artist to transfer the outlines of his London panorama
onto the canvas.

36. Proposed double London Bridge

WILLIAM DANIELL

Oil on canvas
92.3 x 181.6 cm
Guildhall Art Gallery, City of London

In the 1820s and 30s panoramas became a regular
feature at pantomimes. At first they were exhibited be-
fore or at the conclusion of performances but soon they
were integrated into the plot. The panoramas were
often linked to a subject of current interest – a royal
visit, a military campaign, or even a proposed town
improvement.

An early example of a theatre panorama was R.C.
Andrews' panorama of George Dance's proposal for a
double London Bridge. This was exhibited at Sadler's
Wells before performances of *Harlequin Benedict* on 12
July 1801 and for several weeks after. As at Barker's
Panorama, and also at the Lyceum and Spring Gardens,
a key was available. This was presented gratis to each
theatre-goer. (In 1806 Sadler's Wells exhibited two
panoramas of 'The Battle of Trafalgar.' These were also
painted by Andrews.)

A number of proposals for replacing old London
Bridge were put forward in the *Third Report from the
Select Committee upon the Improvement of the Port of London*
(1800). The most radical were those of George Dance,
the City architect, who suggested not one but two
bridges, each equipped with a drawbridge. By lifting
one drawbridge at a time ships would be able to pass
through without interrupting cross-river traffic.

Dance's scheme excited much curiosity. William
Daniell, Dance's friend, painted a large perspective of it
(that exhibited here) and issued two related aquatints.

It was this image that Andrews used as his source for
the Sadler's Wells pantomime.

In due course William Daniell would himself be-
come a panoramist. In 1830 he painted a 'Panorama of
Madras' with E.T. Parris after drawings supplied by
Augustus Earle. This was exhibited in a temporary
wooden rotunda in Coromandel Place, Euston. Five
years later he exhibited a panorama of 'The Capture
and Taming of Wild Elephants' and in 1836 a 'Pan-
orama of Lucknow'; both of these were exhibited at
121 Pall Mall.

**37. Panoramic View of the City of Norwich and
Surrounding Country, with a Perspective
View of the Castle and County Gaol**

WILLIAMS AFTER HENRY ASTON BARKER

Published by Stephenson, Matchett, & Stephenson,
1 September 1809
Aquatint
53 x 40.5 cm
The Hon. Christopher Lennox-Boyd

No show panorama of Norwich was ever painted by
Barker for the Panorama, Leicester Square; when this
print was issued Barker was exhibiting a panorama of
Dublin in the Upper Circle (replaced by 'The Siege of
Flushing'), and the 'View of the Rock and Bay of Gib-
raltar' in the Large Circle (replaced by a 'View of Grand
Cairo'). Nevertheless, the existence of this Norwich
print suggests that Barker may have envisaged a Nor-
wich panorama and made drawings for it. These
drawings most probably were used by Stephenson,
Matchett, & Stephenson in producing this plate.

The print, far more elaborate and finished than the
keys sold in panorama rotundas, was advertised in the
Norfolk Chronicle, 13 October 1809, at 10s 6d for colou-
red proofs, 7s 6d for common impressions: 'Those who
wish to secure good impressions are requested to
favour the printers of this paper with their orders as
soon as possible.'

38. Valley of the Stour, c.1809

JOHN CONSTABLE

Watercolour (4 sheets)
34.6 x 210.3 cm. (overall)
Victoria and Albert Museum (sheets [1], [3], and [4]);
Whitworth Art Gallery (sheet [2])

Constable's panorama stretches from Langham
Church to the estuary, sheet [1] showing Langham
Church in the distance, sheet [2] showing Stratford St
Mary in the distance, sheet [3] looking towards E. Ber-
gholt, and sheet [4] showing the estuary at Harwick
with Dedham Church. [1], [2], and [4] are all taken
from the same viewpoint – the hill south of Stratford St
Mary bridge; [3] is taken from a point slightly to the
East and further down the hill.

These four elaborate drawings were made by Const-
able as a wedding present for his friend Lucy Hurlock
when she married Thomas Blackburne at Dedham
Church on 22 November 1800, with the aim of provid-
ing her with a clear record of the landscape familiar to
her since childhood.

In 1799 and 1800 Constable formed a close friend-
ship with the artist Ramsay Richard Reinagle, sharing
rooms with him in Portland Place. Reinagle painted
panoramas at the Strand Panorama for T.E. Barker, and
this relationship may have led Constable to try his hand
at a partial panorama in these four elaborate water-
colours, which chart for the first time the landscape
with which his art was to become so closely identified.
But Constable was not enamoured of the panoramic
medium, as his trenchant description of Reinagle's
panorama of Rome written in 1803 reveals: 'Panorama
painting seems all the rage, great principles are neither
expected nor looked for in this mode of describing
nature.' Twenty years later Constable was also to criti-
cise the diorama for relying on what he described as the
art of deception. 'True art', he said, denying the
diorama's claim to such distinction, 'pleases by remind-
ing not by deceiving.'
(Lionel Lambourne)

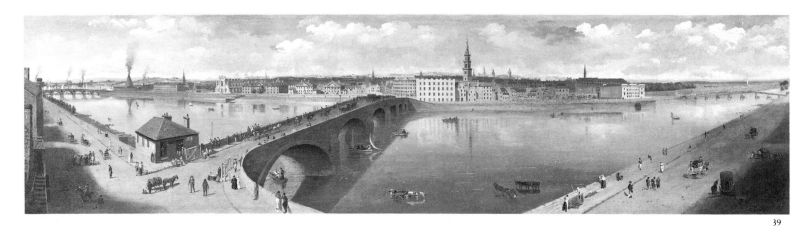

39

39. **Panorama of the City of Glasgow,** 1809

JOHN KNOX

Oil on canvas
31 x 120 cm
People's Palace, Glasgow

John Knox, topographical artist and portrait painter, produced panoramas of Glasgow, Dublin, Gibraltar, the Burning of Moscow, and Ben and Loch Lomond (cat. No.40).

This painting provides us with the image of Knox's 'Glasgow' (though updated to show St Andrews R.C. Cathedral). To rectify the distortion and see it as the spectators did one must curve the image, bringing the ends forward towards the eye. The full-scale version was displayed in Glasgow in a wooden rotunda that was erected S. of the New Theatre in Queen Street. The exhibition was advertised in the *Glasgow Herald*, 8 Febuary 1809, thus:

The view of this celebrated and beautiful City is taken from an elevated situation at the south end of the Old Bridge, and embraces the whole range of the City, with three Bridges. The middle distance is occupied with rising grounds about the City, Port-Dundas, The Green, and the furthest distance with the Campsie and Kilpatrick mountains forming altogether a *tout ensemble* seldom to be met with, and a very happy subject for the pencil, and submitted to the public, as a correct view, painted on a seal of magnitude occupying about 3,000 square feet of canvas.
Open every lawful day, from nine o'clock till dusk. Admission one shilling. Free Admission Ticket [i.e. season ticket] price five shillings to be had at the Panorama, Glasgow 7th February 1809.

In July Knox moved the panorama to Edinburgh, exhibiting it in a wooden rotunda at the North end of the Mound. (The Royal Scottish Academy now stands on the spot.) It arrived in London in 1810 to be exhibited at Spring Gardens.

40. **South-western view from Loch Lomond, and South-western view from Ben Lomond,** 1810

JOHN KNOX

Oil on canvas
62.2 x 157.5 cm each
Glasgow Museum & Art Gallery

These two Knox paintings when placed together form a continuous panoramic image. It is highly probable that they were painted as studies for the 'Grand Painting of the View from Ben Lomond', exhibited in a rotunda on the Mound, Edinburgh in 1811.

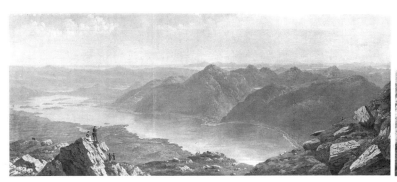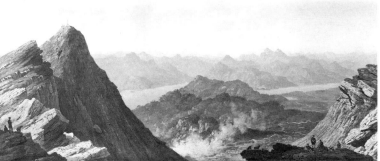

40

41. **The rotunda on the Mound, Edinburgh,** 1843

CHARLES HALKERSTON

Oil on canvas
27.5 x 47 cm
Edinburgh City Art Centre

Marshall's panorama rotunda is to be seen on the left, surmounted by a large flag. Note the building's conspicuous skylights. Advertised on the walls are the panoramas of 'Jerusalem & T[hebes].' Also advertised on the wall is the 'Battle of Waterloo' (Marshall's). Next to the rotunda is a travelling menagerie. An elephant is being hired out to advertise: 'Botanical Gardens a grand fête tonight fireworks'. Beyond can be seen the Royal Institution and Prince's Street.

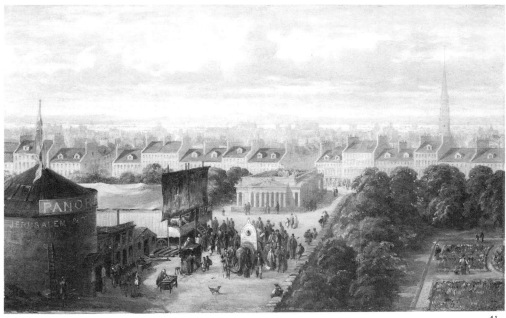

41

42. **Rotunda Gymnasium, Bold Street, Liverpool**

Lithograph
Liverpool City Libraries

Liverpool's first panorama rotunda, 'a neat brick building', was erected in 1805. Barker's Upper Circle 'Panorama of Ramsgate' was the first work to be exhibited there, from ten till dusk, admittance one shilling. The *Picture of Liverpool* (1805) promised it would 'be followed at proper intervals by various others.' Evidently there was insufficient demand to keep the business going; in the *Stranger in Liverpool* (1829) the rotunda is described as 'elegantly fitted as a billiard-room, for the accommodation of a select number of proprietors.' This print demonstrates that it was also used as a ladies' gymnasium.

A second panorama rotunda was opened in Great Charlotte Street in June 1825, showing H.A. Barker's 'Naples', followed in 1826 by H.A. Barker and John Burford's 'Venice'. Both panoramas came from the Panorama in the Strand, via the Panorama in Lower Abbey Street, Dublin.

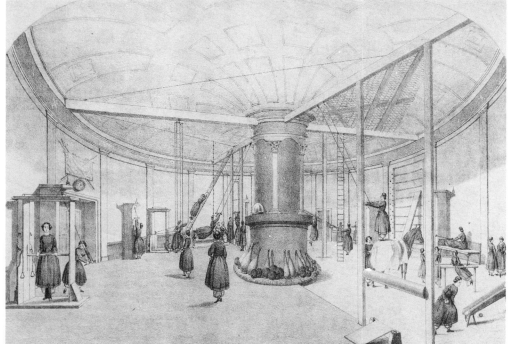

42

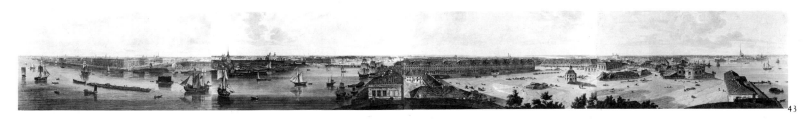

43

43. **Panoramic View of St Petersburg,** c.1807

Coloured aquatint (4 sheets, plus title sheet)
38 x 304.8 cm
British Library Board, Map Library

Atkinson was born in London but spent his youth in Russia. There he was patronised by the Empress Catherine and the Emperor Paul. On Paul's assasination he returned to England. Six years later, on 5 June 1807, he opened his panorama of St Petersburg at Mr Wigley's Great Room, Spring Gardens where visitors could also inspect John Thomas Serres's 'Panorama of Boulogne', a beautiful albiness, the experiment of the invisible girl, and a goose tree, all for one shilling.

The aquatints of Atkinson's 'St Petersburg' are dedicated to the recently crowned Czar, Alexander I. They celebrate the centenary of the city, founded by Peter the Great in 1703.

44. **Panorama of Paris,** 1802

HENRY ASTON BARKER

Pencil drawings (8 sheets)
36.5 x 426.4 cm
Trustees of the Victoria & Albert Museum

During the Peace of Amiens H.A. Barker sailed to France in order to make drawings for two panoramas of Paris. Whilst there he was introduced to Napoleon who addressed him as 'Citoyen Barker'. A 'View of Paris from the Seine', exhibited in the Large Circle from 2 May 1803 to April 1805; and a 'View of Paris Taken Between the Pont Neuf and the Louvre', exhibited in the Upper Circle from 15 August 1803 to 30 May 1804, resulted from this excursion. The drawings exhibited in the present exhibition relate to the first of these panoramas.

A rival Paris panorama was planned by Thomas Girtin but did not materialise. Evidently drawings were made for it; they have not been found.

45. **Rock of Gibraltar, Devil's Tongue Battery,** 1804

HENRY ASTON BARKER

Oil on canvas
74 x 136 cm
Kyburg Ltd.

This painting relates directly to a segment of Barker's 'Panorama of Gibraltar', exhibited in the Large Circle at the Leicester Square Panorama from 13 May 1805 – 3 May 1806.

To take his drawings Barker sailed to Gibraltar in September 1804 on *H.M.S. Hydra.* Readers of *The Times* were kept informed of progress; the artist had just returned with his drawings (16 January 1805); Gibraltar was now painting, and would be ready in the spring (12 March); 'Paris' would close on Sunday, to be replaced a few days later by a correct and interesting view of Gibraltar (29 April).

Fears of a French attack on Gibraltar dictated Barker's choice of subject and ensured the panorama's popularity. 'This late attempt of the Spanish Gun and Mortar Boats...by firing red-hot shot', wrote Barker, recalling the defeat of the floating batteries in 1792, 'renders the view...most interesting to all who read the accounts, as the whole scene of the attack lately made, and of any attack which may in future be made, is in this Painting faithfully represented'. (*Times,* 9 Sep-

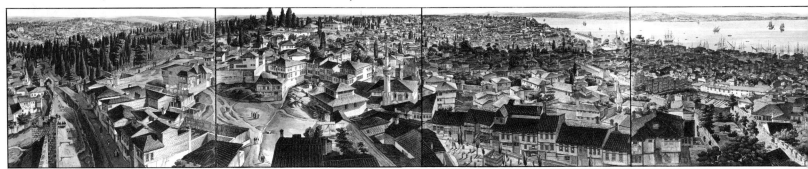

tember 1805.)

The portion of the panorama represented by this painting, was engraved by J.B. Harraden, and published as a pair of prints by H.A. Barker and T. Palser in 1808.

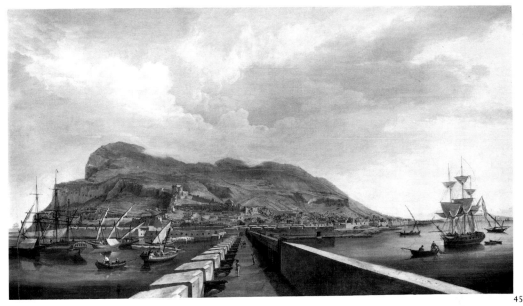

45

46. Panorama of Constantinople and Environs

C. TOMKINS AND F. C. & G. LEWIS AFTER HENRY ASTON BARKER.

Published by Thomas Palser and Henry Aston Barker, 1 January 1813

Coloured aquatint (8 sheets)

57.8 x 570 cm

David Robinson

In order that his panoramas should be authentic H.A. Barker travelled widely. His first excursion was to Turkey in 1799 where he prepared the drawings for the 'View of Constantinople from the Town of Gal-

atea', exhibited in the Large Circle from 27 April 1801 to 15 May 1802; and the 'View of Constantinople from the Tower of Leander', shown in the Upper Circle from 23 November 1801 to 14 May 1803. (The latter panorama was later exhibited in Edinburgh and Birmingham. Repainted by Robert Burford it reappeared at the Strand Panorama from 22 August 1829 to May 1830.)

The aquatints published by T. Palser and H.A. Barker relate to Barker's 'View of Constantinople, from the Town of Galatea'.

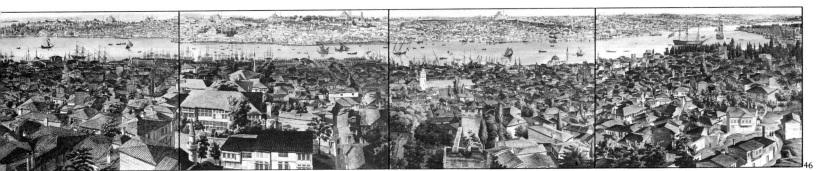

46

73

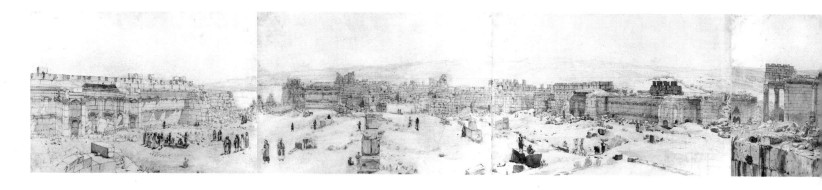

47. 'Description of the View of Venice; taken, and painted by Messrs. Barker and Burford, from the Piazza di S. Marco, with a Representation of the Carnival, now exhibiting in their Panorama, Strand', 1819

Descriptive booklet.
21 x 13.3 cm
Guildhall Library, City of London

Thomas Edward Barker's Panorama in the Strand, a rival to his father's (later his brother's) Panorama in Leicester Square, stood on the site of the Aldwych Underground Station. No illustration or plan of it is known. In 1817 Henry Aston Barker and John Burford took over the business, continuing the tradition of exhibiting panoramas of towns there. Occasionally panoramas were interchanged with Leicester Square Upper Circle panoramas. 'Venice' was exhibited in the Strand from 17 May 1819 till Nov. 1820, and then in Glasgow in 1821, Dublin in 1823, Liverpool in 1826, and Edinburgh in 1829.

48. 'An Explanation of the View of Rome, Taken from the Tower of the Capitol now Exhibiting at H.A. Barker and J. Burford's Panorama, near the New Church in the Strand', 1818

Descriptive booklet
Printed text
20 x 11.5 cm
Guildhall Library, City of London

'Rome' was exhibited in the Strand Panorama from August 1817 until early in 1818. Later in 1818 it was shown in Edinburgh.

49. Pandemonium, 1825

JOHN MARTIN

Mezzotint
54.9 x 75.2 cm
Trustees of the Victoria & Albert Museum

The Pandemonium scene in de Loutherbourg's Eidophusikon (see cat. No.89) was much remarked upon and apparently appreciated. In it Belzebub and Moloch rose from the horrid lake, and Pandemonium appeared, eerily illuminated. When illustrating Milton's *Paradise Lost* John Martin was given the opportunity of presenting his own interpretation. The plates included 'The Fall of the Rebel Angels', 'Satan Presiding at the Infernal Council', and 'Pandemonium' itself. In the 'Pandemonium' plate Satan stands in the foreground surveying the Great Hall across a chasm filled with unquenchable fire. In 1841 Martin returned to the theme with a large oil: its composition was the same as the mezzotint's but on this occasion the architecture had an unmistakable affinity with contemporary Thames Embankment proposals.

Burford exhibited a 360 degree panorama of Pandemonium in the Large Circle of the Panorama, Leicester Square from about 20 December 1829 to 17 Febuary 1830. In painting it he was assisted by Henry Courtney Selous (originally Slous), who is said to have been a pupil of Martin. This was the only occasion on which the Panorama attempted a literary subject.

50. Panorama of the Ruins of the Temple of Baalbec, 1833

FREDERICK CATHERWOOD

Watercolours (7 sheets)
27.6 x 262.5 cm
Private collector

Following his trip to the Near East in 1833 Frederick Catherwood, architect, archaeologist, engineer, explorer, and artist provided Robert Burford at the Panorama, Leicester Square with drawings for panoramas of Jerusalem, Thebes, and Baalbec. Catherwood also made a panoramic drawing of Damascus (later one of old Guatemala, also) which Burford did not use. Burford's 'View of the City of Jerusalem and the Surrounding Country' was exhibited in Leicester Square from April 1835 to Febuary 1836, the 'View of the Great Temple of Karnak and the Surrounding City of Thebes' from 15 June 1835 to June 1836, and the 'View of the Ruins of the Temple of Baalbec' from 29 June to 4 December 1844.

51. 'Description of a View of the City of Jerusalem and the Surrounding Country, now Exhibiting at the Panorama, Corner of Ninth and George Streets, Philadelphia'

Descriptive booklet
22 x 13 cm
David Robinson

'Jerusalem', painted by Robert Burford after drawings supplied by Frederick Catherwood, was exhibited at the Panorama, Leicester Square, 1835-36. It was then purchased by Catherwood and exhibited in New York,

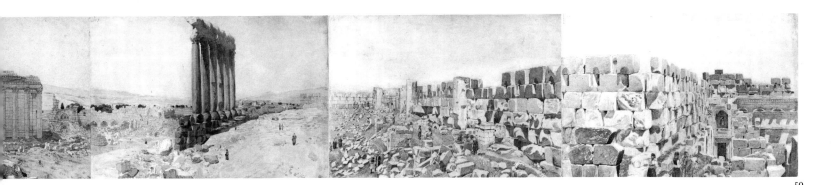

1838, and then (according to Van Hogen) in New Bedford, Providence, and Boston. It reached Philadelphia in 1840. The rotunda specially erected for it subsequently served as a horse bazaar, known as the Colosseum. The Jerusalem panorama was destroyed in the fire at Catherwood's New York rotunda in 1842.

Catherwood emigrated to the U.S. in 1836 and established his own panorama rotunda in New York City on Broadway, at the corner of Mercer and Prince Street. He imported 'Jerusalem', 'Thebes', and several other Burford panoramas to exhibit there. The enterprise was a success but the rotunda was burnt down in a fire on 31 July 1842.

52. Hindoo Excavations in the Mountain of Ellora, 1803

THOMAS DANIELL AFTER JAMES WALES

Coloured aquatint (3 sheets)
British Library Board, India Office

Between 1785 and 1794 Thomas Daniell and his nephew William undertook a series of sketching tours of the Indian subcontinent. On their return they published a long sequence of magnificent aquatints with the general title, *Oriental Scenery*. The sixth series of *Oriental Scenery* consisted of 24 views of 'Hindoo excavations' – Buddhist, Jain, and Brahmanical rock-cut temples in the Mountain of Ellora in Western India, which were engraved after drawings made in 1792 and 1793 by an amateur artist, James Wales. Plates I to III when put together form the panoramic view of the whole site and constitute a key to the rest of the work.

In 1824 widespread interest in the 'Hindoo excavations' was aroused by the publication of John B.

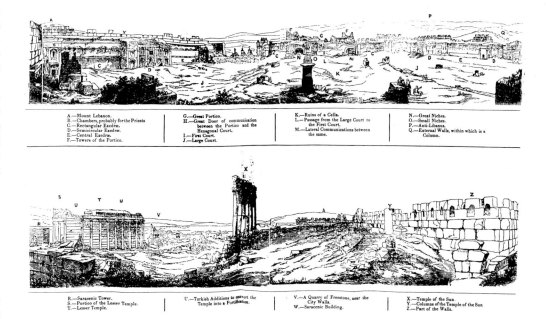

Seely's *Wonders of Elora*. Responding to that interest the Cosmorama in Regent Street exhibited that year a series of cosmoramas of these 'Subterranean Temples of Hindoostan'.

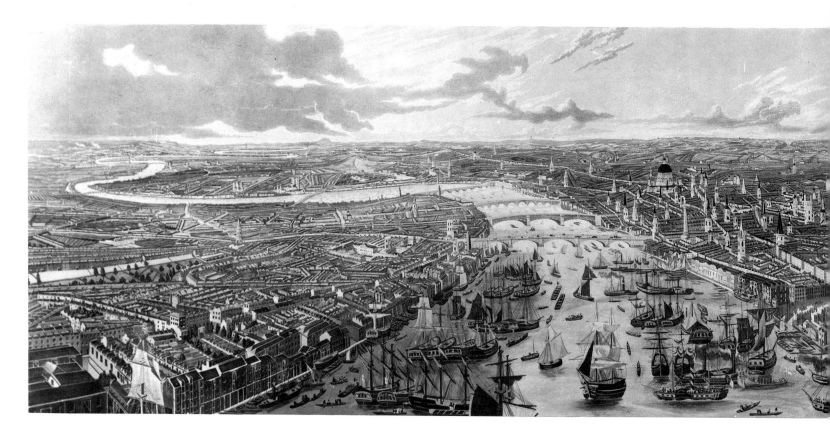

53. The 'Rhinebeck' panorama of London, c.1810

ANON.

Watercolour (4 sheets)
71.1 x 261.6 cm
Private collector

The viewpoint for this panorama is mid-way between Bermondsey on the left and the St Katherine's district on the right, looking West towards Windsor Castle which can be identified on the horizon.

These drawings were discovered stored in a barrel with pistols in a loft in a house in Rhinebeck, New York on the Hudson River. From topographical evidence it can be established that the drawings were prepared c.1810: the chapel of the Philanthropic Society, opened in November 1806, is shown in St George's Road; Waterloo Bridge, commenced in 1811 is not shown though its position is indicated by faint lines; Highgate Archway, commenced in 1813 is shown but seems to

have been added later. Three artists may have been involved in producing the drawing, one providing the marine detail, the second the topography, the third the more distant landmarks. The drawings served as the model for Robert Havell Jnr.'s 'Aeronautical View of London' (cat. No.54.) Havell would seem to have taken them to the United States when, on completing the engraving of J.J. Audubon's *Bird's of America,* he emigrated from England. The Havell family settled in Sing Sing (today Ossining) and in Tarrytown, both towns down-river from Rhinebeck where the drawings eventually were rediscovered.

54. An Aeronautical View of London

ROBERT HAVELL JNR.

Published by Robert Havell Jnr. 1831
Coloured aquatint
27.4 x 99 cm
Yale Center for British Art

This balloon view is based on the 'Rhinebeck' panorama (cat. No.53) of approximately twenty years earlier. Havell evidently acquired the drawing and redrew it on a reduced scale. Thus Laing's new Custom House is shown, and also St Katherine's Dock, opened in 1828. Some new vessels have been introduced: they include the Margate steampackets *Dart* and *Columbine.* New London Bridge, due to be opened on 1 August 1831, is shown completed. Old London Bridge, which was not demolished until the following year, has already gone. St Michael Crooked Lane, demolished in building the northern approach road to the Bridge, is

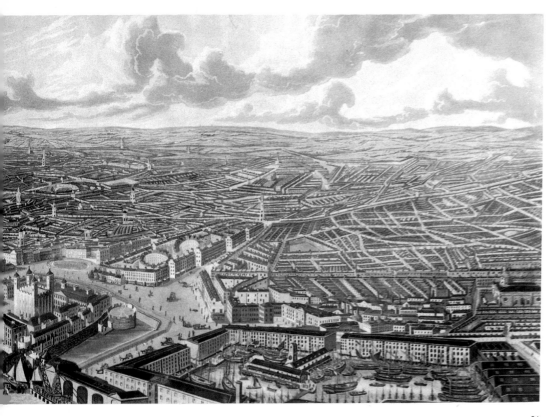

54

chaser of the drawing: the New Zig-zag (41) made in 1829 from the base of Hotwells House up to Clifton Down: the caves (100) West had opened up linking his Observatory to an opening a third of the way down the Gorge: and, on the other side of the Gorge, Leigh Woods (54,56), much frequented by Bristol-based artists.

In addition to this finished version of the image the City of Bristol Museum & Art Gallery holds another, freer version with minor differences in staffage. Accompanying it is a letter from Rowbotham demonstrating how the panorama should be viewed. One wonders whether Rowbotham in making the drawings entertained the hope of interesting Burford in converting it into a larger, show version. A facsimile of the view was printed c.1870-80 by a local firm called Mardon.

56. Vue du Théâtre des Variétés sur le Boulevard Montmartre, 1825

EUGENE AUBERT AFTER COURVOISIER

Line engraving
25.5 x 41.8
Trustees of the Victoria & Albert Museum

Courvoisier's view shows the twin panorama rotundas in the Boulevard Montmartre, Paris, which stood on either side of the Passage des Panoramas. It was in the rotunda adjacent to the *Théâtre* that Robert Barker's 'Panorama of London from the Roof of the Albion Mills' was exhibited in 1802. Most of the other panoramas exhibited in the twin rotudas were the work of Pierre Prevost. The rotunda on the E. was closed in 1826, that on the W. in 1831. The Passage des Panoramas, still named such, can be seen there today.

57. Rotunda for Sattler's 'Panorama of Salzburg' in the Kurpark, Salzburg

Photograph.
17 x 22 cm
Salzburger Museum Carolina Augusteum

Bird's-eye view of the rotunda erected by the Salzburg municipality to house J.M. Sattler's 'Panorama of Salzburg' and Hubert Sattler's cosmoramas (see Section V). The building was formally opened in 1875. By the 1930s it was considered unsafe; it was demolished in 1937.

still shown. Between the border lines on left and right are devices enabling the user to calculate distances within the print. Compasses between the border-lines indicate the extent to which the print should be curved when being viewed.

The publication of the print was announced in the *Literary Gazette* on 14 May 1831. The advertisement states that it was disposed 'in the form of a rotunda' and was to be viewed 'through the medium of Magnifying Glasses, providing the Appearance of Nature hitherto unobtainable other than in large Panoramic Views'.

55. Panoramic View from the Clifton Observatory, c.1830

THOMAS LEESON SCARSE ROWBOTHAM

Pen, ink, and grey wash
28.9 x 350 cm (10 sheets)
City of Bristol Museum and Art Gallery

Rowbotham drew four long prospects of Bristol which are in the Bristol Museum and Art Gallery. One is of the Floating Harbour, and the others are taken from Kingsdown, Totterdown and the Observatory on Clifton Down. All of these prospects are very much in the Samuel and Nathaniel Buck tradition.

The view from the Clifton Observatory is the longest and most lively of the Rowbotham views. Originally an old mill, the building was converted into an observatory by the artist William West in 1829. West installed an astronomical telescope and several smaller ones for viewing the surrounding scenery. Later he added the camera obscura which is still there. Rowbotham's drawing was made with the aid of the telescope; it has been suggested that he also used a camera obscura, rather smaller than the present one.

Topographical features keyed include: (5) the home in Brislington of George Weare Braikenridge, the pur-

58. Panorama of Ratisbon, 1846

GEORGE SCHARF SNR.

Gouache
61 x 345.5 cm
British Library Board, Manuscripts Department

As far as we know, no full-scale show panorama of this drawing was ever painted though, quite conceivably, it was produced with that intention. Although Burford never exhibited a panorama of Ratisbon (did Scharf offer it to him one wonders?) the town was included in Charles Marshalls' 'Grand Tour of Europe.'

George Scharf, a Bavarian who settled in England in 1816, produced several hundred drawings of London buildings and London life. His drawings of street characters included peripatetic advertisers of the Regent's Park Diorama, the British Diorama, and a moving panorama of the Emperor Napoleon's Funeral. In 1845, learning of his brother's serious illness, he returned to Germany. He remained there for two years. His most notable works during that stay were a panorama of his home town of Mainburg, and a series of fine drawings of Ratisbon (today Regensburg). These included a panoramic view of the town from the far side of the Danube (July 1846), and the panorama here exhibited showing it from the top of the tower of the Golden Cross Inn where Scharf was lodged. (The British Library also holds an exquisite study for the 'Golden Cross' panorama, and preparatory drawings for buildings that he incorporated into the image.)

Scharf's 360° view includes much charming detail, very much in the manner of Marquand Wocher's 'Panorama of Thun' (cat. No.257), and Eduard Gaertner's 'Panorama of Berlin' (which hangs in the Schinkel Pavilion, Schloss Charlottenburg, West Berlin). Tilers are to be seen pursuing their trade, women air pillows and hang out washing, two men clear a gutter, street traders sell their wares, and a religious procession makes its way across the town square.

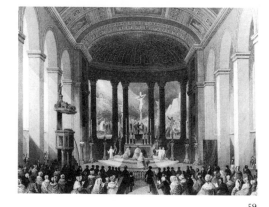

59

59. Roman Catholic Chapel, Moorfields, Celebration of High Mass on Christmas Day, 1842

H. MELVILLE AFTER THOMAS HOSMER SHEPHERD

Steel engraving
13 x 17.8 cm
Guildhall Library, City of London

St Mary Moorfields, built in Finsbury Circus, 1817-19, was designed to house a Crucifixion panorama and incorporated various features of panorama rotundas. Lighting was directed onto the paintings from a skylight concealed in the roof of the apse, and the panorama was viewed between fluted columns. The sanctuary – less so the nave – in effect became the viewing-platform.

The artist commissioned to paint the panorama was Agostino Aglio, an Italian scene-painter who had worked for several London theatres. The painting measured 33 feet by 55 feet. The foreground was occupied by 50 principal figures, larger than life, and Christ dying on the cross.

With his son, Aglio repainted the panorama in 1837. By the 1890s it was in a delapidated condition, and a 'clever young artist', Henry Jacobs, was hired to overpaint it in oil (handbill in Guildhall Library.) In 1900 church and panorama were demolished, the money raised by selling the site being used to build Westminster Cathedral and a smaller St Mary Moorfields in Eldon Street. The new church accommodated the original altar and the fluted pillars, and also a reduced

facsimile of Aglio's panorama, painted this time on canvas. This version remained in place until the mid-1960s when it was taken down, rolled up, and transferred to St Patrick's Soho. Its present whereabouts is unknown.

The steel engraving represents plate 15 in *London Interiors* (London: George Virtue 1841-4.)

60. Interior of the church of Notre Dame de France, Leicester Place, formerly the Panorama, 1988

Photograph
20 x 25 cm
Guildhall Library, City of London

In December 1863 the Panorama, Leicester Square finally went out of business. Two years later the lease was acquired by a French Marist priest, Père Charles Faure, who almost immediately set up a school, an orphanage and a temporary chapel. In due course Louis-Auguste Boileau designed a cruciform church within the circular shell. It was destroyed by enemy action in November 1940.

After the war the church was rebuilt to the designs of Hector O. Corfiato. The new building, still incorporating some elements of the Panorama structure, was opened on 16 October 1955. An attractive feature is the Jean Cocteau mural in the Blessed Sacrament Chapel.

60

III THE REGENT'S PARK COLOSSEUM

The Colosseum was easily Britain's most ambitious panorama entertainment. Modelled on the Pantheon in Rome, though named the Colosseum on account of its colossal proportions, the building was sited a few yards north of the Diorama at the south-east corner of Regent's Park. For fifty years it loomed over the North London skyline, a familiar landmark. Since its demolition it has been largely forgotten.

At other rotundas panoramas were changed regularly, new subjects attracting the public again and again; at the Colosseum for most of its life there was only one panorama, the very exceptional 'London from the Summit of St Paul's Cathedral'. Because of this, subsidiary, changing attractions were essential: at times these were more effective in bringing in visitors than the panorama itself.

The Colosseum was the brainchild of a Quaker land-surveyor named Thomas Hornor (1785-1844). Son of a Hull grocer, Hornor received tuition in engineering and surveying from his Quaker brother-in-law, William Johnson. He arrived in London in 1807 and was promptly contracted to survey the parish of Clerkenwell. The very detailed manuscript plan, 81 inches by 72 inches, is now in the Islington Public Library. What set him apart from other surveyors was his invention of a new way of presenting surveyed information which he called 'panoramic chorometry'. Using this method, propounded in his *Description of an Improved Method of Delineating Estates...to Which is Added Opinions on Landscape Gardening and Rural Entertainment*, he was able to transform his own maps, and other surveyors', into bird's-eye views. To demonstrate its effectiveness and bring in orders he published several aquatinted maps; one of them was a reduced version of his Parish of Clerkenwell survey (cat. No.61).

Several orders for 'pictural' maps were placed by estate owners in the Vale of Neath. In consequence Hornor set off in 1814 for South Wales. There he produced huge and magnificent maps which displayed not only his survey data, gloriously picturalised, but also long panoramic views of the local mountain scenery. When not surveying Hornor made watercolours of local beauty spots and industrial sites, which he drew with the aid of a graphic telescope. The drawings were bound up into sumptuous albums (see cat. No.62). By and large each album is the same. The most dramatic watercolour is always a long panorama of mountain scenery which folds out at the back.

In London in 1820 Hornor embarked on a very much larger panorama. This was to show the entire metropolis and its environs as from St Paul's. During the summer months he installed himself in the Bull's Eye Chamber in the lantern of the Cathedral and from this point made a large

number of drawings. Before he had finished the project the architect, C.R. Cockerell, erected wooden scaffolding above him in order to replace the Ball and Cross. Hornor applied to the Dean and Chapter for permission to build a platform over this scaffolding which would incorporate a trap door. Upon this platform he erected a cabin to serve as his studio, and into it moved a table, a chair, his graphic telescopes, and means for cooking.

From this new and far more effective view-point Hornor started work on a second series of drawings. At three o'clock each morning, before fires were lit and whilst the atmosphere was relatively clear, he climbed the 616 stairs and four external ladders to his studio and began sketching. The drawings – there were eventually about 280 of them – were arranged on a rotary frame enabling Hornor to recover any sheet he required almost instantly. The cabin was on casters and Hornor rotated it with wedges and fastenings to sketch whichever section of the townscape at any moment was visible through the swirling clouds.

Hornor's needs were attended to by a faithful Irishman called Sullivan. Several times a day Sullivan took food up for him; on occasions he could be picked out climbing the ladders, a cask of water on his back. For a bribe Sullivan would take up visitors. These included James Elmes, the architect, and a party of four men, their coats flapping in the wind, who had asked if they could watch the sun rise from the platform.

A lively account of a visit to Hornor's platform appeared in the *Morning Post* on 19 March 1823. It was signed, 'A Stranger'. The Stranger mounted the perpendicular ladders with his eyes closed striking his head on the trap door. Hornor gave him a friendly welcome, led him into the cabin, and invited him to view the scene through his apparatus. A storm was brewing over the Surrey hills and Hornor recommended that he should soon descend. As a stirrup cup he produced a bottle of port and poured its contents into two large glasses. 'It will not effect you', Hornor explained. 'Spirits at this level lose more than half their strength.' Nerves fortified by port the Stranger lowered himself through the trap door and scurried down the ladders. The storm was now raging and the circular framework of planks, erected by Cockerell to catch falling tools, disintegrated. Hornor's cabin broke loose from its fastenings and finished up poised on the edge of the platform. A multitude of drawings flew up into the air; an unperturbed Hornor descended the ladders. Following this incident Hornor sensibly secured the cabin to a cross-beam and erected a rope fence around the platform.

Hornor's original intention had been to produce a 360° print of London, supplemented by one hundred select views. The *European Magazine* thought the risks involved were entirely out of proportion to likely rewards. Hornor evidently came round to the same opinion, and with encouragement and financial help from a Lombard Street banker, Rowland Stephenson, planned a giant 360° show panorama.

To accommodate the panorama a rotunda was called for. Decimus Burton was selected as architect, and construction of the Colosseum commenced in 1824. The building contractor was Henry Peto. Even before the rotunda was completed in 1826 the canvas – 24,000 square feet of it – was suspended inside, being attached to a hoop three feet from the wall at the top, and to a

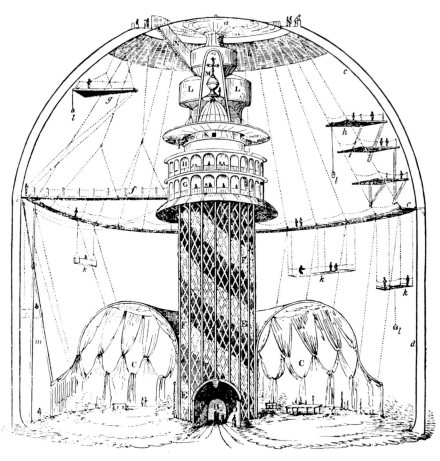

A	Column for supporting Ascending Room, etc.	a, b	Sky-lights
B	Entrance to Ascending Room	c	Plaster dome on which sky was painted
C	Saloon of Arts	d	Canvas on which the townscape was painted
D	Passage leading to Saloon, Ascending Room and stairs	e	Gallery suspended by ropes used for painting the distance and uniting the plaster and canvas
E, F	Two separate flights of stairs	f	Catwalk
G, H, I	Viewing galleries	g	One of 15 triangular platforms used for painting the sky
K	Refreshment Room	h	Platforms used for finishing and clouding the sky
L	Rooms for music or balls	k	Different methods for getting at the lower parts of the canvas
M	The old Ball from St. Paul's	l	Baskets for conveying colours, etc. to the artists
N	Stairs leading to outside of building	m	Shears from which cradle was suspended for completing the picture after the removal of the scaffolding and ropes

Cross section of Colosseum
(From the Literary Gazette 31 January 1829)

second hoop, held taunt by weights, at the bottom. As with all 360° panoramas the canvas contracted in the middle to adopt a modern cooling tower shape.

To paint the dome and canvas a very clever system of scaffolding was going to be needed. Edmund Thomas Parris, who had recently designed scaffolding for restoring Thornhill's frescoes in the dome of St Paul's, was engaged. Parris rigged up a gallery round the base of the dome, linked by strong ropes to the skylight. Cradles for the artists were suspended from this gallery. A

connected the gallery to the central core of the building. Oblong and triangular platforms, attached to the skylights by ropes, would be used for plastering the dome and painting the sky on it. Brushes, paints, and perhaps refreshments too could be sent up to the artists by ropes tied to buckets.

Once all the scaffolding was in place Hornor asked Parris to take charge of the painting. As aids Parris had the sketches Hornor had made in his cabin over St Paul's, a collection of drawings of individual London buildings carried out by Hornor's young assistants, and a drawing of the entire image squared for enlargement. Parris began drawing the outline in chalk on 12 December and finished it in April 1826. He engaged artists, professional ones at first who proved to be proud and temperamental, and then house painters and young artists untroubled by heights. Among the artists was a son of John Soane's visionary perspectivist, J.M. Gandy, and the future marine artist, George Chambers, who had lately been to sea and was practised at climbing rigging. It was Chambers who painted the Thames part of the panorama.

The painting was supposed to be completed in 1827 but was not. There were rumours of financial instability, hotly denied by Hornor. On 27 December 1828 Rowland Stephenson vanished, and his banking house stopped payments. Stephenson, the papers reported, had been a gambler, and the extent of his defalcations at the bank exceeded £200,000. He had also taken £20,000 in customers' Exchequer bills. A warrant was issued for his arrest, but he succeeded in reaching the United States. He set up house in Farley, near Bristol in Pennsylvania.

Stephenson had promised supplies for the Colosseum which never materialised. On 10 January a private view was held, and then, to bring in cash necessary to complete the painting, the establishment was opened to the public. On 9 March 1829 the *Morning Chronicle* announced that the Colosseum was in the hands of a Committee of Management; Hornor, it seemed, had also vanished. A report in *The Times* on 15 June 1830 claimed he had joined Stephenson at Farley and was living in luxury. In fact, although he was indeed in the United States, he was eking out a living only with difficulty. J.W. Parkins, an eccentric ex-Sheriff of the City of London, was accosted by Hornor in a New York court room. Hornor's face was 'as red as scarlet', he reported. 'His hand shook like an aspen leaf, his eye blinked, his voice faltered, and his breath smelt strong of the fumes of the life-destroying alcohol which he had recently swallowed in potent doses' (pamphlet entitled *An Abridged Correspondence between J.W. Parkins Esq. and His Late Bankers, Messrs. Lemington, Stephenson & Co.* — copy in Harvard Business School Library). In a letter to a new patron, the obstetrician Dr John Wakefield Francis, Hornor complained in 1836 of his 'crippled situation'. He offered large paintings of American scenery to the Colosseum management but received no reply. When John Braham, opera singer and owner, by now, of the Colosseum, visited New York City in 1840, Hornor attended a recital. On the following day he delivered to Braham a pathetic letter begging to be allowed to speak to him (Strachie MSS, Somerset Record Office). Hornor died in 1844, at the side of a road according to one account, mad according to another. He was buried in the Quaker Burial Ground in East Houston Street, New York.

At first the Regent's Park Colosseum proved very popular, particularly with high society. Visitors

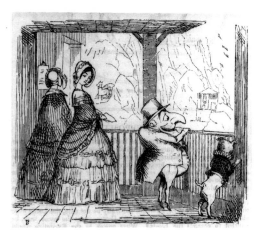

Mr Punch at Swiss Cottage in Colosseum

were transported up to the viewing-platform in the 'Ascending Room' – London's first hydraulic lift. From the viewing-platform they could examine the London panorama (still being painted) through binoculars provided. Below them the dome of St Paul's was represented by an apron-like structure; the exterior of the dark corridor, looked down upon from above, appeared to be the nave. Having enjoyed the painted panorama, and the living panorama from the top of the building, visitors descended to ground level where they could walk through the six conservatories, along a tunnel lined with coral, and relax on the balcony of a Swiss Cottage, viewing a deceptively small lake and soaring Alpine scenery. A little later an African Glen was added to the Colosseum's extra entertainments by Mr A. Steedman, lately returned from Southern Africa.

In 1835 the Committee of Management sold the Colosseum to John Braham and to the comedian Frederick Henry Yates for a bargain price of £30,000. Braham added a marine grotto, a hall of mirrors with crystal pillars, a gallery for the pictures of a Mr Cumberland, and a theatre-cum-concert hall in Albany Street. Entertainers included a certain Abdullah and his Bedouin Arabs. (Abdullah, Yates tells us, got married to a widow of ample proportions who kept a gin palace in the Old Kent Road.) Mr Steedman complained to Braham about the rudeness of the Colosseum staff; the Albany Street residents complained about the behaviour of the Colosseum's evening visitors. (The *Times* referred to the Colosseum as a 'sink of vice.') Besides the Colosseum Braham owned the St James's Theatre. Neither place flourished. To clear his debts Braham disposed of his house and many of his possessions and returned to singing. On coming back from America in 1843 he put the Colosseum up for auction.

The new owner of the Colosseum, a cement merchant, David Montague, closed the place for two years so that radical improvements could be made. 'London from the Summit of St Paul's Cathedral', shortly after rechristened 'London by Day', was cleaned and the distant scenery on it improved by E.T. Parris assisted by his son. William Bradwell redesigned the Conservatories, and George Danson built new Alpine scenery for the Swiss Cottage. A new Exterior Promenade was laid out through replicas of the Temple of Vesta, the Temple of Theseus, and the Arch of Titus. A new panorama – 'London by Night' – was painted by George Danson and William Telbin. This was raised in front of 'London by Day' each evening. 'Why Mary, there's that Tom shutting up the shop, and it isn't eight o'clock yet!', one visitor was overheard exclaiming on finding her house in Fleet Street (*Builder*, 13 May 1848). The revived Colosseum was visited by Queen Victoria and Prince Albert on 3 May 1845, and opened to the public a few days later.

For a few years the Colosseum was quite well attended, and more attractions were added to it. Danson was sent to Paris to make drawings for a 'Paris by Night' panorama. The artist and comic vocalist, Harry Howell, assisted with the painting of it during the day, singing at the Eagle Tavern in the evenings. It was completed in 1848. The Royal Cyclorama, consisting of a sequence of pictures with dramatic atmospheric and sound effects, was housed in a new building in Albany Street. At the Cyclorama visitors enjoyed 'The City of Lisbon Before and After the Great Earthquake of 1755', with raging seas, tidal waves, collapsing buildings, and a terrifying fire-storm. 'Never was better fright given for money', wrote Yates. Plans were announced for sending

'London by Night' to Liverpool where it would be exhibited before being sent on to New York (*Builder*, 4 January 1851).

By 1855 the Colosseum was again in difficulties. To repay the mortgage Montague put the establishment on the market. This time it was acquired by the Colosseum Arts Co. Ltd. with Dr George Henry Bachhoffner, a scientific showman, as its Managing Director. The Hornor-Parris panorama now found itself reduced to competing with sideshows such as oxy-hydrogen microscopes, dissolving views, fire-eating conjurers, and 'a little drummer boy of singular proficiency.' The entrance fee was reduced to one shilling. Unfortunately the low entrance fee and popular science formula still failed to bring in the visitors. Like Burford's Panorama the Colosseum could not compete with sophisticated educational entertainment now on offer elsewhere. It closed in March 1863, reopening in May with John Burns Bryson as its licence holder. It closed for ever early in 1864.

When the Colosseum's contents were auctioned the bidding for Hornor and Parris's 'London by Day' reached a paltry £23, and 'Paris by Night' £22. Both were bought in. The Royal Cyclorama's 'Lisbon Earthquake' fetched £33 (*Rendle*, pp.139-40). By 1873, however, the panoramas had been shipped across the Atlantic to New York. The Regent's Park Colosseum rotunda fell into a state of advanced decay. It was demolished in May 1875. Cambridge Gate was erected on the Park side of the site, and Colosseum Terrace in Albany Street.

On Broadway at 35th Street a new Colosseum had been erected. It was owned by R.L. Kennard of London, and its Director was the greatest of all showmen, P.T. Barnum. Unlike the brick and stucco affair in London the New York Colosseum was built of iron, – iron framework, iron walls, and even an ornate iron facade. Its handbook claimed it to be 'The Largest Iron Structure in the World'. In other respects it corresponded with the Regent's Park model. Its central core, for example, incorporated a lift (built by Otis and driven by steam) which could carry thirty people at a time. The viewing-platform was intended once again to represent the Golden Gallery of St Paul's though it could accommodate 500 visitors. When visitors looked down they could see the apron representing the dome of the Cathedral. And from the top of the building visitors, one hundred at a time, could view the real townscape, this time of Manhattan. During the day Hornor and Parris's 'London by Day' was shown; in the evening Danson & Sons' 'Paris by Night'. An extra attraction was the Grand Promenade with its 'high toned intellectual and moral entertainments'. These included an artificial head that 'in a most startling and inexplicable way' could open its eyes, smile, and talk in a 'perfectly normal manner'. This department, and also the Lectorium, came under Professor Tobin, 'late of the London Polytechnic'. The master machinist, whose job it was to erect 'Paris by Night', was O.T. Brown, who for twenty years had been employed at the Regent's Park Colosseum.

In 1874 'Paris by Night' moved on to Chicago. In the following year it reached Philadelphia where it was included in the Centennial celebrations. Here too it was shown in R.L. Kennard's iron rotunda, transferred from New York and re-erected at the south-east corner of Broad and Locust Streets. Now it had a taller tower which enabled visitors to enjoy a magnificent bird's-eye

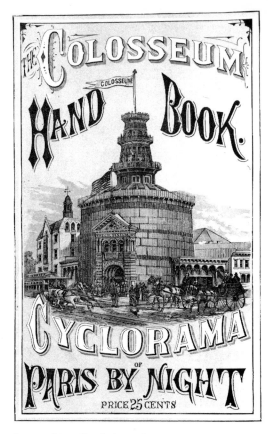

Cover of Handbook for Colosseum in Philadelphia (By courtesy of the New York Historical Society)

view of the city. 'Paris by Night' was provided with some new effects: storm clouds gathered and the rotunda was filled with the noise of sweeping rain and heavy gusts of wind. 'This transformation never fails to excite the liveliest surprise among spectators', the new handbook proudly boasted. Paintings, flowers, statuary, and singing and mechanical birds rendered the Colosseum 'the most refined and delightful resort in Philadelphia, one at which ladies can enjoy themselves without escort'. 'London by Day' and 'London by Night' were held in reserve.

In 1880 the Colosseum in Philadelphia was turned into a market. It is recorded that one of the London panoramas still lined the walls. (J. Jackson, *Cyclopedia of Philadelphia*, pp.960-64). Was it Hornor and Parris's 'London by Day', one wonders? In the hurly-burly of the market it would surely have received the roughest treatment, an ignominious end for the most famous of all panoramas. The Philadelphia Colosseum was taken down in 1883 and removed to Boston to be used for further panorama displays.

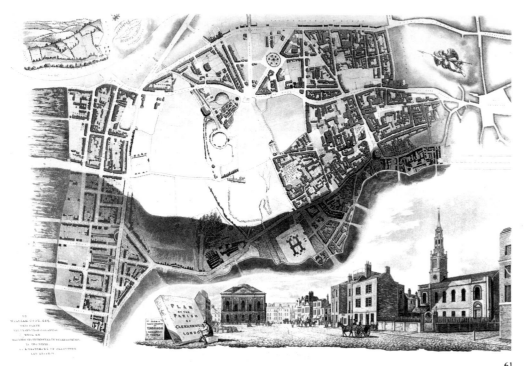

61

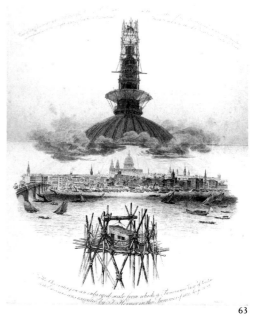

63. View of the Observatory erected over the Cross of St. Paul's, 1823

SAMUEL RAWLE AFTER THOMAS HORNOR

Lithograph
28.5 x 25 cm
Guildhall Library, City of London

In order to draw his panorama of London Hornor constructed a cabin over the Ball and Cross of St Paul's Cathedral, using this as his studio. As well as a prospectus for the intended prints (cat. No.64) Hornor produced several diagrams that demonstrated the perils involved in producing the drawings.

63

61. Plan of the Parish of Clerkenwell, London, 1813

J.C. STADLER AFTER THOMAS HORNOR

Coloured aquatint
58 x 89 cm
Guildhall Library, City of London

This map was published by Thomas Hornor to demonstrate his method of 'pictural' surveying. His source was the conventional survey of the parish that he had made five years earlier for the parish officers. In this reduced version of the survey one sees the shadow of a cloud passing overhead. The compass direction consists of an avenging angel with a spear. In the area of the parish bathed in sunlight the individual buildings cast shadows. Though decorative and intended for display the map is also fuctional: it carries street numbering, for instance, and names of public houses.

62. Panorama of the Vale of Neath, c.1815

THOMAS HORNOR

Watercolour in album
The Trustees of the British Museum, Department of Prints and Drawings

Hornor carried out 'pictural' surveys of several estates in the valleys of Taff and Neath in South Wales. He also produced an album of watercolours in at least nine versions. The British Museum's copy is probably the finest. In it Hornor used the landscape gardener's device of hinged cut-outs. The Reola estate is introduced by the figure of 'Night'. By lifting 'Night' 'Daybreak' is revealed. Contrasting scenes of tranquil landscapes and local heavy industry follow. The climax to the collection is the long fold-out panorama of the Vale of Neath.

64. View of London, and the Surrounding Country, taken with Mathematical Accuracy from an Observatory Purposely Erected over the Cross of St Paul's Cathedral...

Prospectus by T. Hornor, London, 1823
25.8 x 16.5 cm
Guildhall Library, City of London

Initially it was Hornor's intention to produce a long engraved panorama, not a giant, painted show panorama. This would consist of E. and W. sheets measuring 25 by 40 inches, and N. and S. sheets measuring 25 and 30 inches. The prints would be accompanied by four key sheets and supplemented by a hundred or so select views of London. Two sets of plates were to be issued, one executed in a bold manner 'by two eminent engravers', the other by an engraving method that had been invented by Hornor (a variation, one assumes on the lithographic process.) The latter impressions would be coloured to give the effect of highly finished drawings. The cost of the prints to subscribers would be five guineas for the line-engraved set and ten guineas for the coloured impressions. Publication was at first promised for 'early in 1823', then '1823', and finally '1824'. In the event the prints were never published.

65. Design for His [i.e. Thomas Hornor's] Proposed New Panorama of London., c.1823

THOMAS HORNOR AFTER JAMES ELMES

Watercolour
47 x 66 cm
Bodleian Library

In 1823 Thomas Hornor was persuaded by a Lombard Street banker, Rowland Stephenson, to use the drawings he had made for a show panorama, the largest painting in the world. To accompany it a rotunda had to be designed and built. Hornor's hope was for a site in Green Park, its entrance in Piccadilly, not too distant from the capital's entertainment district. George IV's support was sought but was not forthcoming. Thus the rotunda was erected at the S. E. corner of the new royal park, Regent's Park, which was still being laid out.

This rejected design for the rotunda was produced by an architect friend of Hornor's, James Elmes. Whilst Hornor was making his drawings over St Paul's, Elmes made several trips up the ladders, and watched the artist at work 'with powerful telescopes and curious machinery.'

Elmes' proposed rotunda has a large portico with four great columns. A huge seated figure of Britannia crowns its dome.

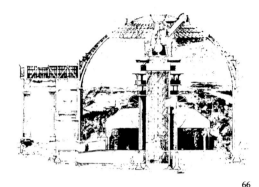

66

66. Cross-section of the adopted design for the Colosseum

DECIMUS BURTON [AND THOMAS HORNOR] c.1823

Watercolour
42.5 x 41.9 cm
Victoria & Albert Museum

This architectural drawing shows the Colosseum very nearly as built. When appointed Burton was only 24 years old. He had already designed Cornwall Terrace, Clarence Terrace, and the Holme for Regent's Park. The dome of the Regent's Park Colosseum was larger than that on St Paul's Cathedral, a point frequently made by successive proprietors in their publicity.

67. Grand Entrance to the Colosseum, Regent's Park

ANON.

Published by Ackermann & Co, 1829
Aquatint
27.3 x 33.5 cm
Guildhall Library, City of London

Visitors entered the grounds of the Colosseum through the entrance at the North Lodge. This plate, the first in a series of five aquatints published by R. Ackermann & Co. on 1 June 1829, shows the view visitors had when walking up the drive towards the massive portico. Five American aloes were arranged before the columns; one of these is visible. The railings separating the Colosseum from the Outer Circle were painted in imitation of bronze; the building itself had been tinted grey, yellow, and brown in order to make it look like a temple 2,000 years old.

67

68. South Side of the Grounds Surrounding the Colosseum, Regent's Park

ANON.

Published by R. Ackermann & Co, 1829
Aquatint
21.8 x 32 cm
Guildhall Library, City of London

This, the second plate in the Ackermann Colosseum series, shows the grounds by the South Lodge, with the rotunda's portico on the right. It was here that one entered the conservatories. The Reptonesque treillage pavilion in the foreground was most probably a structure intended by Thomas Hornor. It does not seem to have been erected.

69. The Fountain Surrounding a Marble Statue at the Colosseum, Regent's Park

ANON.

Published by R. Ackermann & Co, 1829
Aquatint
27 x 33 cm
Guildhall Library, City of London

The sixth conservatory, which accommodated an ingenious fountain, is well represented in Plate III of the Ackermann Colosseum series. It consisted of a circle of jets d'eaux throwing a veil of water high into the air. This fell onto the centre on a mass of shells, corals, and mosses. A dial of shells near the top of the fountain revolved continously. Beautiful prismatic effects were produced when the sun shone on it. The sleeping undine in front of the fountain had been carved by Robert William Siever.

70

69

70. The Geometrical Ascent to the Galleries, in the Colosseum, Regent's Park

ANON.

Published by R. Ackermann & Co, 1829
Aquatint
28 x 22 cm
Guildhall Library, City of London

The short flight of stairs from the vestibule led down to a corridor which extended across the Saloon of Arts to the central tower. Looked down upon from above this corridor doubled up as the roof of the nave of St Paul's. The Saloon was fitted up with a roof of fluted linen making it look like a colossal tent. In this, Plate IV, of Ackermann's Colosseum series, the workmen are still erecting it whilst carpenters lay the floor-boards. Settees have been placed in the recesses; tables would be added later. When completed the saloon would be used chiefly for exhibiting sculptures.

At the centre of the rotunda was the tower containing the two staircases and the Ascending Room –

London's first passenger lift. Lifts and stairs brought one to the Lower Gallery from which the best views of the panorama were obtained. It was balustraded to make it seem like the Golden Gallery of St Paul's. Small traversing telescopes were attached to pillars and through these one could examine the paintings more closely. Visitors can be seen inspecting the panorama from the Lower and Middle Galleries, and mounting the stairs past the Ball and Cross and Hornor's cabin to reach the exterior gallery. From here they would be able to view the living panorama of N. and W. London. Artists may be seen still at work, painting the sky on the dome, and applying the finishing touches to the painted canvas. A gentleman appears to be taking his wife for a perilous stroll along the catwalk.

The etcher Samuel Rawle, in his MS diary (at St Bride's Printing Library), on 3 October and 22 October 1828 refers to two aquatints of the interior of the Colosseum which he was preparing for Thomas Hornor. [Frederick] Mackenzie is stated to be the artist responsible for one of them, and [George] Hunt the aquatinter of both.

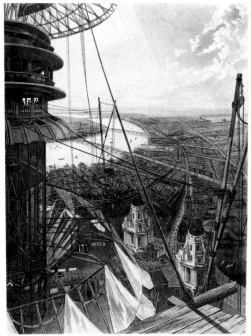

71. Bird's-Eye View from the Staircase and Upper Part of the Pavilion in the Colosseum, Regent's Park

ANON.

Published by R. Ackermann & Co, 1829
Aquatint
29.5 x 22 cm
Guildhall Library, City of London

The title of this print, Plate V of the Ackermann Colosseum series, is misleading for the view is taken in fact from one of the platforms used for clouding the sky. By this date much of the scaffolding had been removed. The artists were no longer using 'shears' consisting of two poles crossed from which they suspended their cradles. Visitors are to be seen viewing the panorama from the Lower Gallery. Immediately below them is a projecting frame; from where they stand the frame would appear to be the dome of the cathedral. The campanile towers were particularly realistic: though painted on the canvas many visitors imagined them to be three-dimensional. In the distance on the panorama canvas one can identify Regent's Park and the Colosseum.

72. The Regent's Park Colosseum

RALPH HYDE

Published by Ackermann, London, 1982
Guildhall Library, City of London

This volume reproduces in collotype the five aquatints which make up R. Ackermann & Co's Coloseeum series. Each plate carries the imprint date of June 1829: the prints were advertised at the end of October as 'Just Published...in a neat cover...6s.' The original title page that was supplied with the prints states that they were from drawings by 'Gandy, Mackenzie, and other eminent artists'. The Gandy referred to most probably was the son of J.M. Gandy who assisted Parris in painting Hornor's panorama. Mackenzie is likely to have been Frederick Mackenzie who had contributed numerous plates for Ackermann's *Westminster Abbey; University of Oxford*; and *University of Cambridge*. It is possible that the 'other eminent artists' were in fact just one artist – Thomas Hornor, not named since he was in disfavour at this date.

According to the title page the prints were published by 'R. Ackermann and Co., Strand; and at the Colosseum, Regent's Park'. That the Colosseum features in the imprint in this manner suggests that Rudolph Ackermann was a member of the Committee of Management. We know that tickets for the Colosseum were made available at Ackermann's print shop.

This Ackermann colour plate book was published in 1982 in celebration of the bicentenary of Rudolph Ackermann's arrival in Britain, and the establishment of the firm. Limited to 200 copies the text was printed from metal type and the volume hand-bound. The plates are hand-coloured.

73. Panoramic View Round the Regent's Park

RICHARD MORRIS

Published by R. Ackermann, 1831
Coloured aquatint
10.2 x 569 cm
Guildhall Library City of London

Morris's panorama represents the entire circuit of Regent's Park. It shows the newly completed terraces by John Nash and Decimus Burton and also St Katherine's Hospital, and the Colosseum. The panorama was issued folded in a portfolio, and also on a roller in a lacquered canister. The title label, used on both the portfolio and the canister, consists of an aquatinted view up Portland Place towards the Park.

No other print is known that shows the Colosseum's original aviary, situated immediately to the North of the rotunda.

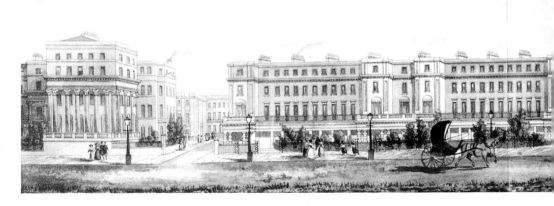

74. A view near the Colosseum in Regent's Park, c.1829

ANON.

Published by Benjamin Read
Coloured aquatint
38.5 x 53.5 cm
Westminster City Libraries (Marylebone Collection)

The Colosseum opened on 10 January 1829 and in the first few months proved to be London's most talked-about entertainment. Visits by the Duke of Wellington (then Prime Minister); the future Queen Adelaide with her brother-in-law, the Duke of Saxe Weimar; and a host of princes, princesses, dukes, duchesses, lords, ladies and foreign ambassadors were described in the newspapers.

The enthusiasm of London's high society is conveyed in this fashion plate, published by the Bloomsbury tailor, Benjamin Read. Read issued two aquatints each year showing fashions for the coming season. To set the right tone in them smart West End scenes served as topographical backgrounds. On five occasions Read used the Colosseum for this purpose.

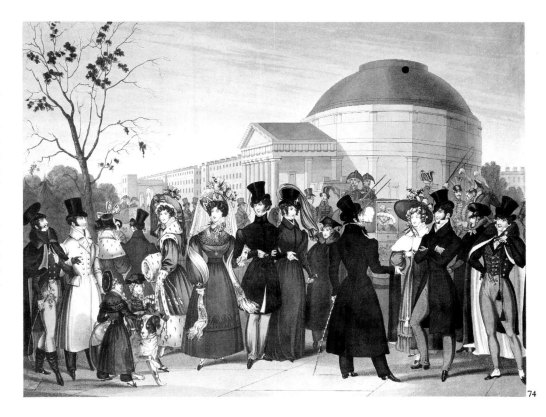

74

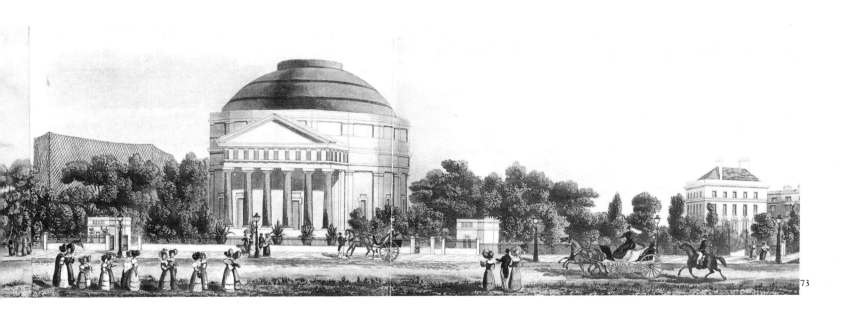

73

75. **View in the Colosseum, Regent's Park,** 1836

ANON.

Published by Benjamin Read
Coloured aquatint
38.5 x 53.5 cm
Westminster City Libraries (Marylebone Collection)

Benjamin Read's fashions for summer 1836 are shown
off in the Vestibule at the Colosseum. Here some walls
were painted in imitation of white marble, others dec-
orated with *trompe l'oeil* paintings; the pilasters were
painted in imitation of sienna marble. Leading from the
Vestibule were two flights of stairs with corridors;
visitors wishing to climb to the Middle Gallery took
one, visitors wishing to ascend to the Lower and Upper
Galleries took the other.

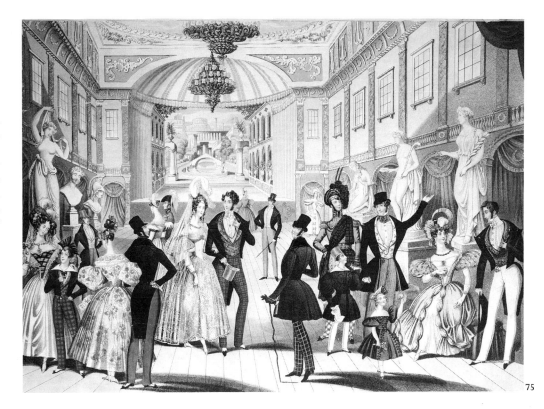

75

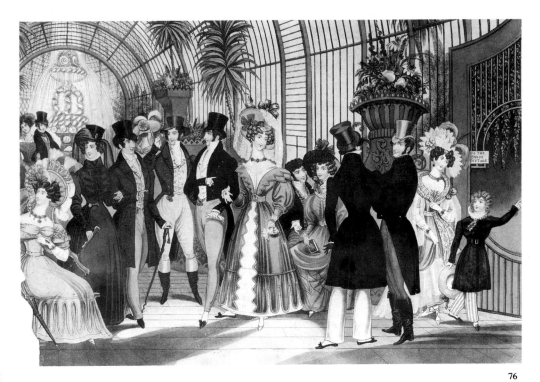

76

76. **Colosseum, Regents Park,** 1836

ANON.

Published by Benjamin Read
Coloured aquatint
38.5 x 53.5 cm
Westminster City Libraries (Marylebone Collection)

Here Benjamin Read displays summer fashions using the fifth of the Colosseum's sequence of six conservatories as a backdrop. The boy on the right points the way to the Swiss Cottage.

77. **The Swiss Cottage at the Colosseum,** c.1833

ANON.

Watercolour
18.3 x 29 cm
Museum of London

From the sixth Conservatory a passage led beneath the ground. (It appears to the right of centre in the foreground of No.69). When the visitor re-emerged he found himself in the Swiss Cottage, built by the cottage ornee specialist, Peter Frederick Robinson. The designs for this structure are supplied in Robinson's *Village Architecture* (1837). The cottage had four rooms, wainscoted with coloured wood, the largest of which (shown in this watercolour) had a fireplace wide enough for a family to sit in. From the veranda one could admire a lake, real crags, a painted canvas of dramatic

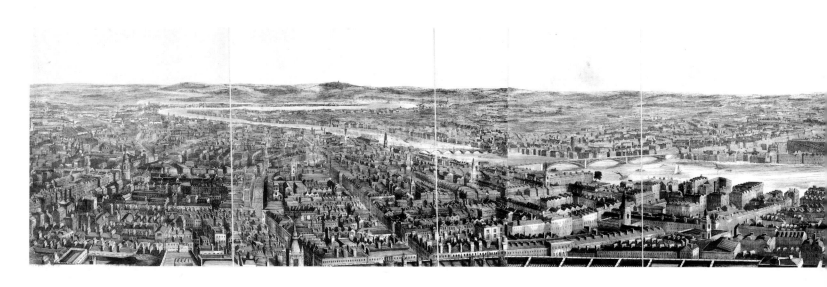

mountain scenery, and a sixty foot waterfall cascading ninety tons of water per hour. The illusion was easily spoilt when sparrows chose to perch on the Alpine peaks.

78. **Panorama of London,** c.1838

EDWARD BARWICK

Coloured wood engraving, highlighted with gum arabic
25 x 239.2 cm
Private collector

The engraved panorama of London which Thomas Hornor had initially intended to publish never materialised, but keys to the painted panorama were engraved for Hornor from his own original drawings by Samuel Rawle. These appeared in John Britton's *Brief Account of the Colosseum in the Regent's Park* (1829). Though sketchy the keys were used as the basic outline for several engraved panoramas of which Barwick's is the largest. The image has been slightly updated. Rennie's New London Bridge, opened 1831, is shown; Old London Bridge, removed in 1832 is not. The London & Greenwich Railway, completed in 1838, has been added. On the other hand the London & Southampton Railway, extended to Nine Elms in 1838, is not. By this date the Colosseum was in the hands of John Braham.

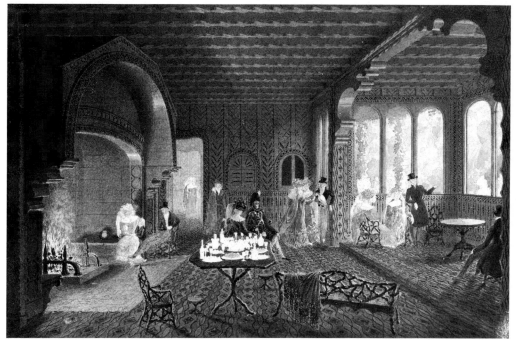

77

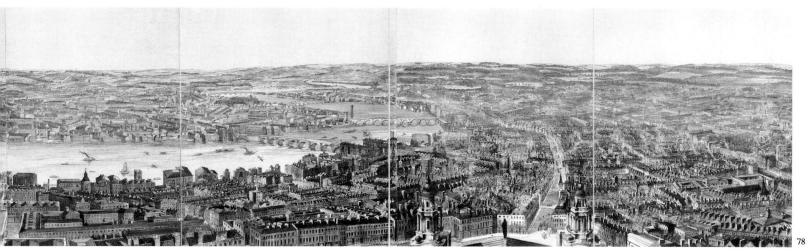

78

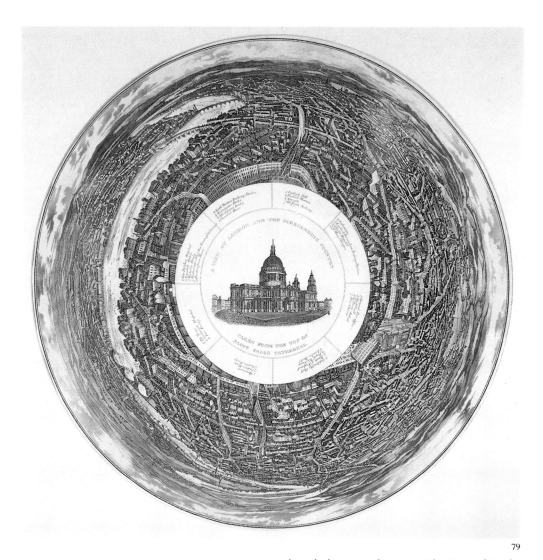

a vertical line on the keys. Then the trapezoid cells would have been lettered and numbered. At this point the topographical detail could be transferred from the squares to the trapezoids. The fish-eye view is the outcome.

Conceivably the fish-eye view was intended to be viewed in a viewing cabinet, recreating the vertigo feeling which visitors experienced at the Colosseum.

Although derived from the Hornor-Parris panorama, the 'View of London and the Surrounding Country...' was updated. The new Houses of Parliament, started in 1840, are referenced in the centre of the print though only the foundations are shown in the image. The third Royal Exchange, opened by Queen Victoria in 1844, is shown. One can also see the London & South Western Railway (until 1839 called the London & Southampton Railway), and the London & Birmingham Railway (which would change its name in 1846 to the North Western Railway.) From this evidence it would seem that this print was produced between 1844 and 1846. The possibility is that it was published at the time of the re-opening of the Colosseum by David Montague in 1845.

80A. Conservatory,Collosseum [sic], c.1845

G.F. SARGENT

Pen and ink and watercolour

16.7 x 11 cm

Guildhall Library, City of London

After David Montague acquired the Colosseum in 1843 the Colosseum and its subsidiary entertainments were radically improved. The Conservatories were redesigned by William Bradwell to appear like an Arabian Nights dream: gilt carvings, exotic plants and flowers were reflected in a myriad of mirrors.

G.F. Sargent, the artist responsible for this drawing and 80B and 80C, drew the '*Pictorial Times*' panorama of the Thames, 1845, from the Palace of Westminster to St Katherine's.

80B. Ball and Cross of St Paul's Cath[edral]...Colloseum [sic], c.1845

G.F. SARGENT

Pencil drawing

13.9 x 8.8 cm

Guildhall Library, City of London

79. A View of London and the Surrounding Country Taken from the Top of Saint Paul's Cathedral, c.1845

ANON.

Tinted aquatint

Circular, 75.5 cm diameter

Private collector

Barwick's engraved version of the Colosseum panorama (cat. No.78) does not give a 360° picture unless one joins the left and right ends and pokes one's head through the gap in the centre. The 'View of London and the Surrounding Country...', on the other hand, solves the problem by presenting the Hornor-Parris panorama as a fish-eye view. To create the image the keys to John Britton's *Brief Account of the Colosseum in Regent's Park* (1829) must have been squared, and these squares lettered and numbered. A drawing in the first place consisting of concentric circles would have been made, each circle corresponding with one of the horizontal lines superimposed on Britton's keys. Spokes would then have been added, each corresponding with

On ascending above the Hornor-Parris panorama of London to the Exterior Gallery one passed the Ball and Cross of St Paul's. The Ball was the actual Ball removed by Cockerell when carrying out repairs in the early 1820s. The Cross was a facsimile, though in publicity it was usually stated to be the original.

80

80C. Arch of Titus [and] Parthenon, Collosseum [sic] c.1845

G.F. SARGENT

Pen and ink
18 x 14 cm
Guildhall Library, City of London

A new feature of the Colosseum in 1845 was its Exterior Promenade where visitors could walk between marble columns and past mouldering frescoes of ancient Greece and Rome. Here William Bradwell had erected ruins intended to remind one of the Temple of Vesta, the Temple of Theseus, and the Arch of Titus in Rome. On the right in the background of this drawing may be seen the wall of the Colosseum rotunda.

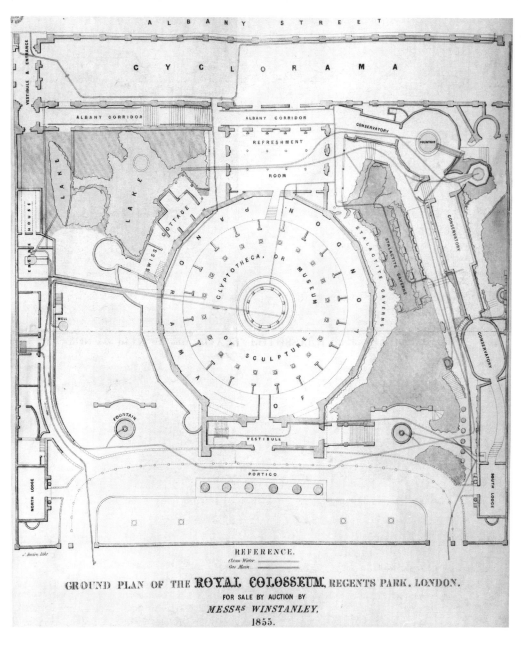

GROUND PLAN OF THE ROYAL COLOSSEUM, REGENT'S PARK, LONDON.
FOR SALE BY AUCTION BY
MESSRS WINSTANLEY,
1855.

81

81. **Auction catalogue for the sale of the Royal Colosseum by Messrs. Winstanley,** 14 March 1855

Westminster City Libraries (Marylebone Collection)

The Colosseum flourished during the year of the Great Exhibition but went into a decline afterwards. In 1855 the Colosseum was put up for sale by order of the Court of Chancery. The auctioneers published this large sheet catalogue which today is particularly valuable to us for its detailed ground-plan of the whole establishment. The text states that successive owners had spent over £200,000 on the place. Despite that the highest bid was only £20,000. It was bought in, and then acquired by the Colosseum and Arts Company Ltd. It continued until 1864.

82. The Colosseum immediately prior to its demoliton, 1875

ANON.

Photograph
20.5 x 24 cm
Guildhall Library, City of London

From 1864 the Colosseum stood deserted and fell into decay. There were proposals for making it into a Roman Catholic Church, a bachelors' club, and a School of Dramatic Art, and for replacing it with a Regent's Park Palace of Arts and Manufactures. It was demolished in March 1875. Cambridge Gate, the terrace shortly to be built on the site, is announced on the sign board in this photograph.

In the Bodleian Library's John Johnson Collection there are three water colours by G. Maund, 1875, showing the demolition of the building.

83. Colosseum, S.E. Corner Broad and Locust Sts. [Philadelphia] The Colossal Cycloramic Illusion of Paris by Night

Handbill with wood engraving
20.5 x 11.8 cm
Bill Douglas & Peter Jewell Collection

R.L. Kennard's iron rotunda, which had stood in Broadway, New York at 35th Street, was re-erected in Philadelphia for the hundredth anniversary of the Declaration of Independence, and opened on 1 May 1876. Its new, taller 'Great Tower' made the Colosseum the highest building in Philadelphia, and from it visitors were able to enjoy a sensational bird's-eye view of the centennial trade fair, and indeed of the entire city.

A note on the handbill states that 'Paris by Night' was 'not a panorama but a stationary picture'. With the revival of interest in such pictures in the 1870s the word 'cyclorama' was frequently applied to 360° paintings; the word 'panorama' (particularly in the U.S.) tended to be reserved for moving panoramas.

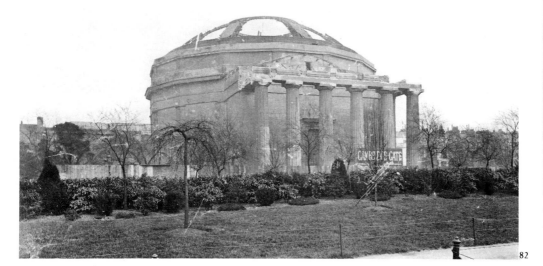

82

83

96

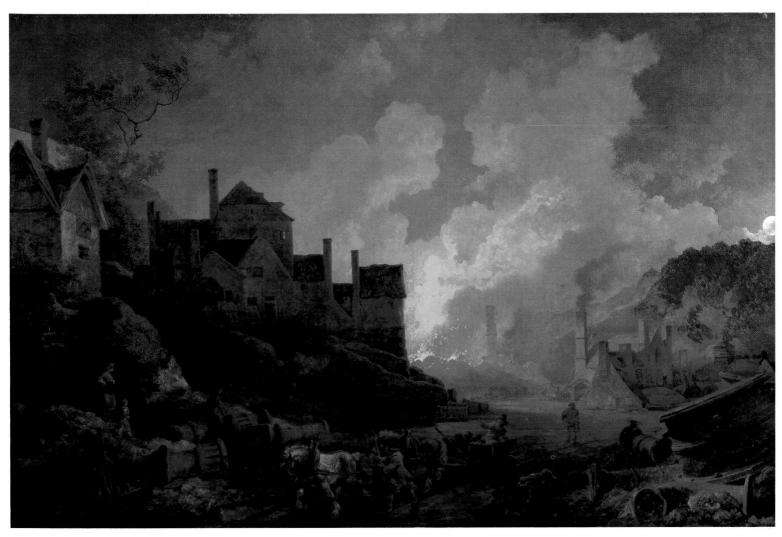

92 Coalbrookdale by Night 1801
PHILIPPE JACQUES DE LOUTHERBOURG

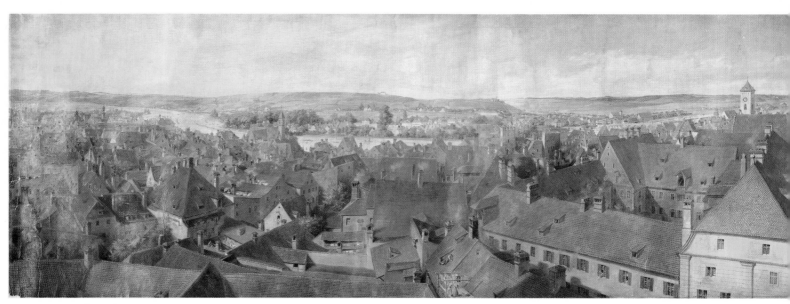

58 Panorama of Ratisbon 1846
GEORGE SCHARF SNR.

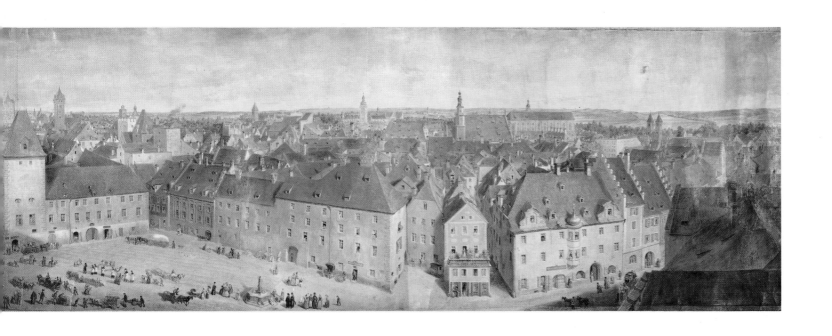

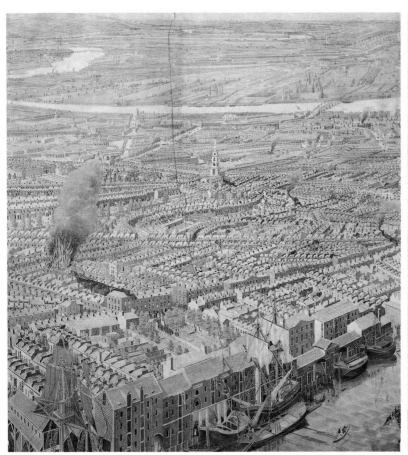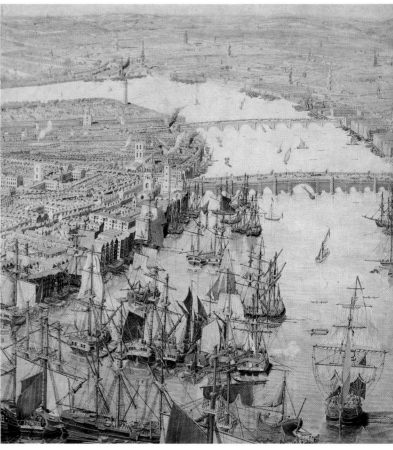

53 The 'Rhinebeck' panorama of London c.1810
ANON

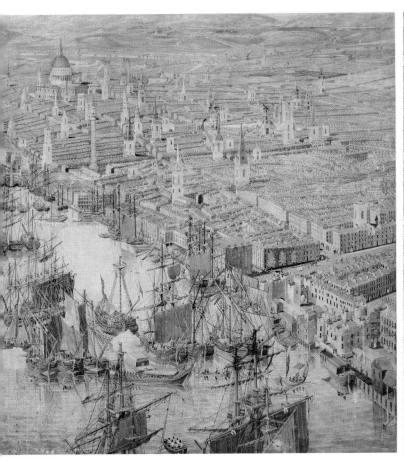 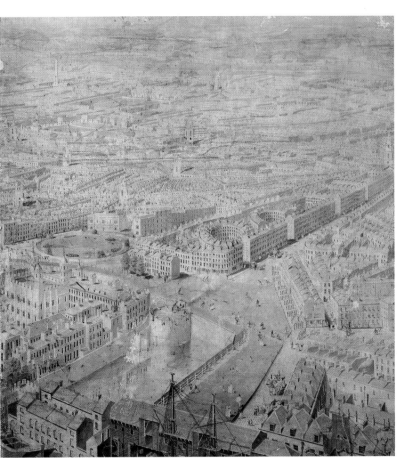

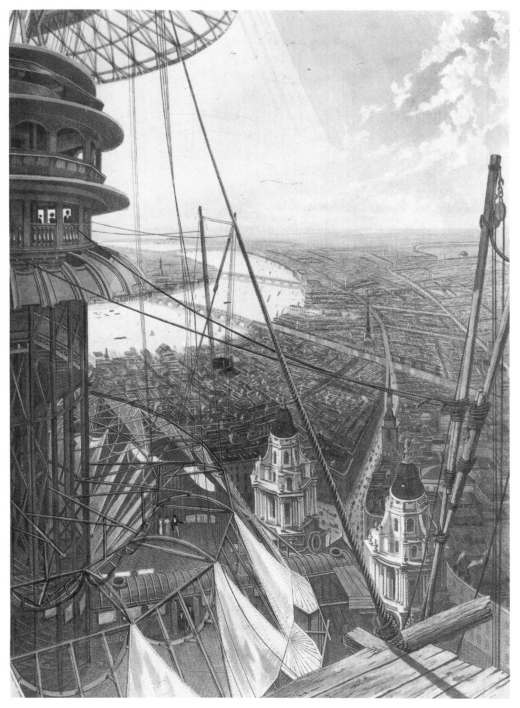

71 Birds-Eye View from the Staircase and Upper Part of the Pavilion in the Colosseum, Regent's Park 1829
ANON

79 A view of London and the Surrounding Country Taken from the Top of St Paul's Cathedral c.1845
ANON

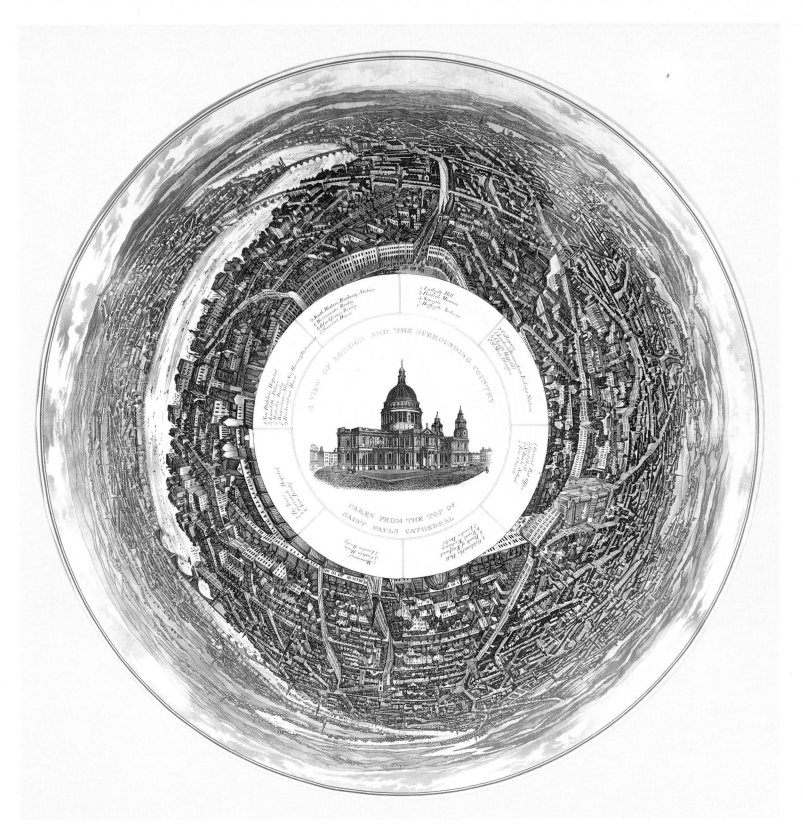

A VIEW OF LONDON AND THE SURROUNDING COUNTRY

TAKEN FROM THE TOP OF
SAINT PAULS CATHEDRAL

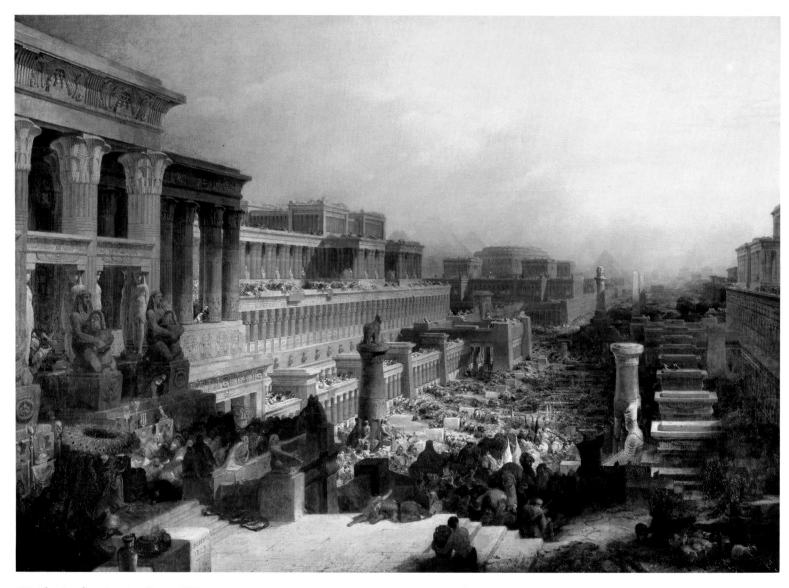

107 The Israelites Leaving Egypt 1829

DAVID ROBERTS

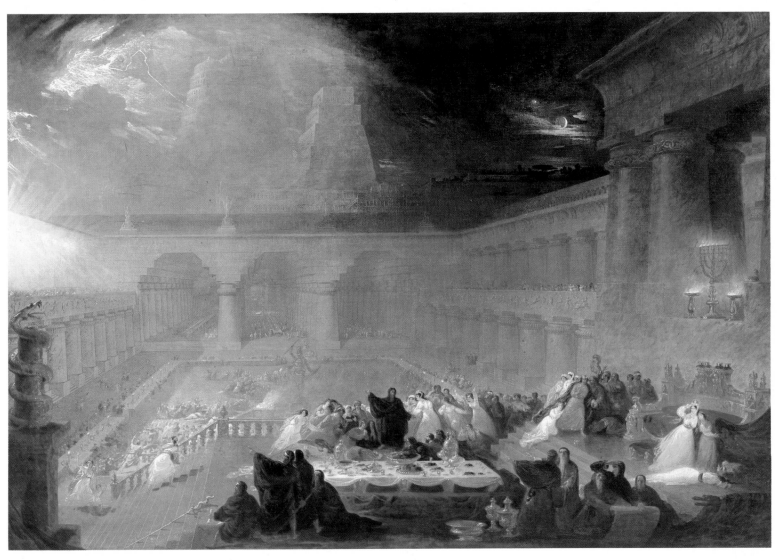

109 Belshazzar's Feast 1820
JOHN MARTIN

119 Storm in the North Sea
HUBERT SATTLER

121 The Escorial
HUBERT SATTLER

120 Eruption of Vesuvius
HUBERT SATTLER

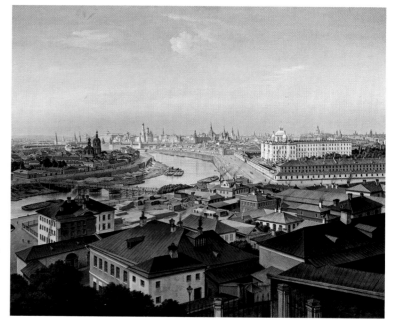

122 View of Moscow
HUBERT SATTLER

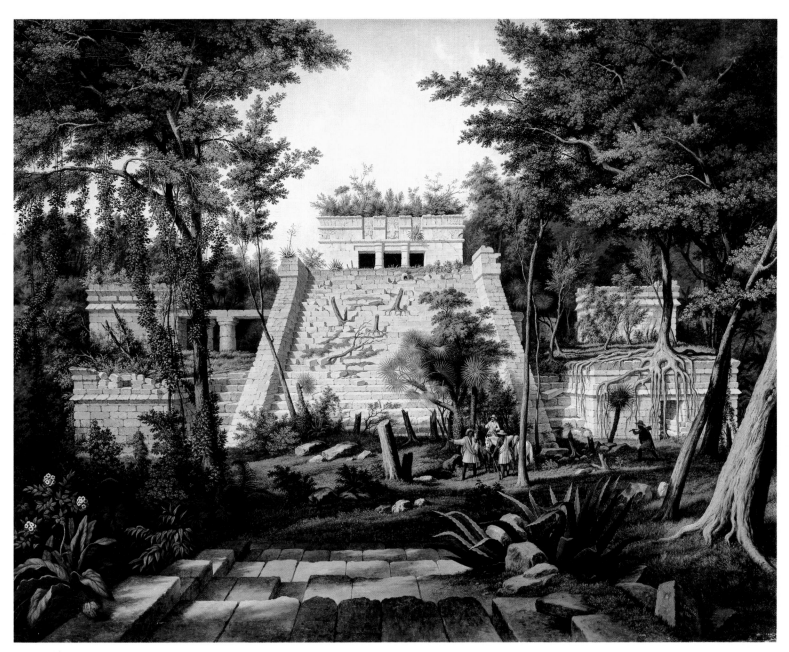

125 Orizaba, Mexico

HUBERT SATTLER

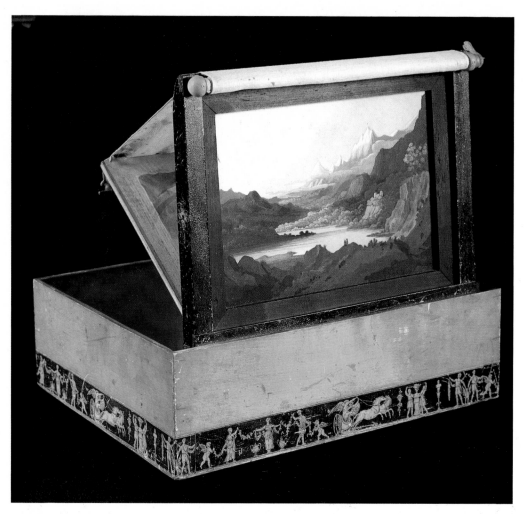

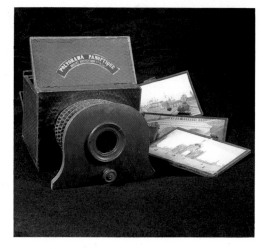

115 Polyorama Panoptique c.1851

113 The Portable Diorama 1826
JOHN CLARK

IV DIORAMAS

The objective of the panoramist is to create an illusion, to fool the spectator's eye so he feels he is actually there. The more sustained that sensation the happier the critics will be. With 360° panoramas two factors militate against their effectiveness: generally they are silent; and – even more important since this can so severely affect the illusion – they do not move. Thus in 'London from the Roof of the Albion Mills' trees stand motionless, road and river traffic is halted, and the man in Albion Place knocks on the door in vain. With panoramas of military battles or naval engagements the problem is very greatly magnified.

In the first decades of the nineteenth century strenuous efforts were made to overcome these inherent problems. Long moving panoramas (see Section VI) could develop a story and so presented one solution. Dioramas – large realistic paintings which seemed miraculously to change their appearance – presented another.

Although the diorama when it was introduced in the early 1820s seemed a great novelty, several of the elements of the new entertainment had been widely understood and commercially exploited for quite a while. Moving pictures operated by clockwork had been exhibited in Britain since Pepys' day. Transparencies – pictures lit from behind – in the eighteenth century had featured on public buildings at times of public rejoicing, in evening entertainments in Vauxhall Gardens, and on the stage at the Drury Lane Theatre. The control and manipulation of light was an area that had been well explored by Giovanni Girolami Servandoni at the Opera in Paris, and in London by Philippe Jacques de Loutherbourg.

De Loutherbourg had been well acquainted with Servandoni when living and working in Paris in the 1760s. He arrived in Britain in 1771 taking up an appointment in the scenic department of Drury Lane. There he introduced new forms of scenery with moving objects, and clever lighting that involved the use of screens, coloured slides, reflectors, and transparencies. In February 1781 he opened a small theatre in his house in Lisle Street, Leicester Square, with a stage ten feet wide, six feet high, and eight feet deep. This was the Eidophusikon. Five scenes were exhibited at each performance being introduced by 'Aurora; or the Effects of Dawn, with a View of London from Greenwich Park'. The other scenes consisted of Tangiers at noon, Naples with a sunset, moonlight over the Mediterranean, and finally a storm at sea complete with claps of thunder and forked lightning. Between scenes, Michael Arne, son of the composer, played musical selections on the harpsichord.

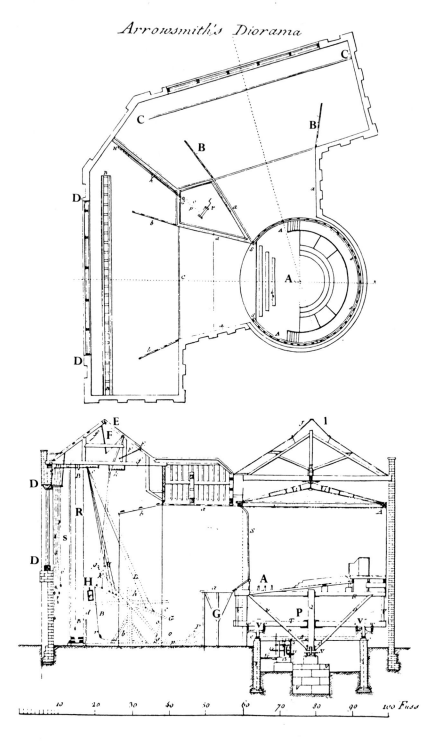

Arrowsmith's Diorama

Key to the Regent's Park Diorama

A Revolving auditorium

B-B and **C-C** in the plan and **R** in the section represent the dioramic picture

D-D are the rear windows providing light from behind the picture

E and **F** are skylights and shutters regulating the illumination from the front of the picture

G and **H** is the system of levers and weights to operate cords at **K,L** and **M**, to open and close shutters, and **P** a crank to control the system

1 Skylights

s coloured blinds behind picture

v v18in. wheels (two out of a set of eight) on which the auditorium revolved about its fulcrum '**o**'

110

94 Portrait of L J M Daguerre

Similar experiments were being made in Berlin by Karl Friedrich Schinkel, who would later make his name as an architect. In 1807, with the backing of Wilhelm and Carl Gropius, the young Schinkel created mechanical Christmas displays consisting of views of Constantinople and Jerusalem. In 1808 and 1809 he became more adventurous with 'optical perspectives' of subjects such as a 'Swiss Valley in the Morning Sunshine', 'Vesuvius in its Infernal Fire-Glow', and 'St Peter's in Rome, Illuminated for the Feast of Saints Peter and Paul'. Schinkel's Christmas display for 1809 was larger and more elaborate. The spectator stood approximately 30 feet away from the pictures – measuring 13 feet and 20 feet – and viewed each between deceptively long colonnades. The pictures were lit by artificial light from the front, but also, since they incorporated transparencies, from behind. To create the required mood for each picture a choir sang backstage. In Bruderstrasse in 1811 Schinkel exhibited the most dioramic of all his pre-dioramic pictures, an early version of his 'Gotischer Dom am Wasser'. This showed a town by the sea linked to a soaring Gothic cathedral by a bridge on very high arches. The scene was dramatically illuminated by the rising sun. Boats rowed past on the river and a swan swam by. A man in the foreground staggered past with a heavy load on his back, a military procession advanced across the bridge to cannon-shots (real sparks flared), whilst the organ in the cathedral thundered.

The inventor of the diorama was Louis Jacques Mandé Daguerre. Daguerre and his collaborator, Charles-Marie Bouton, had both been assistants of Pierre Prévost, France's principal panoramist. In 1822 he opened the first Diorama establishment in Paris. It stood at 4 Rue Sanson, one wing facing onto the Place du Château d'Eau. (The Place de la République now stands on the spot.) An instant success, he planned a second for London, despatching his brother-in-law, Charles Arrowsmith, to England to seek a site and an architect. Augustus Charles Pugin, the French émigré assistant working for John Nash, was appointed to design the building. Park Square East, at the south-east corner of Regent's Park was chosen as the site. Within four months the building was constructed at a cost of £9,000. It was designed to take an audience of 200. The Regent's Park Diorama opened on 29 September 1823.

Spectators entered the Diorama through double doors in the centre of the terrace. If you were late, or if the auditorium were being rotated, you were obliged to wait for a while in an antechamber. On entering the somewhat gloomy saloon you took your place either in one of the boxes at the back or on one of the benches in the front. The walls of the saloon were tastefully decorated. The ceiling, which was transparent, bore the portraits of celebrated artists. Dim light was diffused through the ceiling from a conical skylight above.

In front of the spectator was an opening, and between this and the painting, positioned 45 feet away, there were opaque screens forming a tunnel down which the spectator's attention was drawn. The screens served to hide the edges of the painting and made the painting appear a far greater distance away than in fact it was. Above the front of the canvas was a second skylight furnished with movable blinds of coloured silk and cotton. The picture itself consisted of transparent canvas. It was painted on both sides so as to provide two different effects, one from light directed onto it from the front, the other from light directed onto it from behind. The illuminat-

ion from behind came from a tall window of ground glass. Between the picture and this window was a series of coloured screens, again made of thin silk and cotton, suspended by cords. The dioramic effects were produced by the manipulation of the blinds and screens at each source of light using a system of cords and pulleys. Some of the screens were opaque and could shut off light where required, others were coloured and with these the light-level could be controlled and the colours modified.

The picture one saw could be very gradually transformed. In other words it did not represent one moment frozen for ever as did the static panorama, but an extended period of time. With 'The Interior of Trinity Chapel, Canterbury Cathedral', for example, the Cathedral was alternately bathed in sunlight or cast in gloom by passing clouds. With 'The Castle and Town of Heidelberg' there was a change of season, ice and snow melting and giving way to a summer landscape 'full of life and beauty'. Concentration was called for: with 'Ruins in a Fog' (cat. No. 99) the mist gradually dissipated revealing the mountains and surrounding country. 'The changes being naturally slow and gradual', warned the exhibition booklet, '[they] must be carefully fixed by the spectator, or the effects will be lost.'

After a quarter of an hour a bell would ring and spectators then had the sensation of the picture drifting past them. What in fact was happening was that the entire saloon – walls and ceiling included – was being rotated, conveying them to a second opening with its own 'invisible' dark tunnel and painting beyond. Though the ingenious machinery for this weighed 20 tons, even when the saloon was crowded it could be moved, so it was said, by a lad twelve years of age.

The diorama entertainment introduced by Daguerre in 1822 made far more commercial sense than any of its forerunners, providing a standard show for a sizeable fee-paying audience in a building designed to accommodate that audience and all the machinery necessary to transform the scenes. In Paris Daguerre's Diorama continued until 1839; the branch in London remained in business until 1851.

Daguerre's necessarily French Diorama in Regent's Park, however, soon found itself in competition with a British rival. In 1828 a prosperous retail goldsmith named Thomas Hamlet opened the Royal Bazaar at the rear of 73 Oxford Street, including in it, as an attraction and diversion for shoppers, a 'British Diorama'. Theatre scene painters, Clarkson Stanfield and David Roberts, were engaged to paint the pictures. Unlike the Regent's Park Diorama, the amphitheatre at the British Diorama was stationary, and the paintings were moved on and off by rollers. The picture changes were produced by an iris effect in which four screens closed simultaneously. Stanfield and Roberts' dioramas received enthusiastic reviews and attracted large audiences. The illusion at the Oxford Street establishment, however, was considered inferior to that at Regent's Park. The use of artificial light and the proximity of the audience to the paintings would not have helped. In May 1829 disaster struck when Stanfield's 'City of York with the Cathedral on Fire' actually caught fire. Virtually the entire Royal Bazaar was burnt to the ground. In 1830 it was replaced by a new building and a new British Diorama. There, in addition to the conventional dioramas, gargantuan pictures were exhibited that had been painted, as publicity put it, in the 'dioramic style': a

108 Handbill advertising
Departure of the Israelites

greatly enlarged version of Roberts' 'Departure of the Israelites' (cat. No. 107) an enlarged plagiarism of Martin's 'Belshazzar's Feast' (cat. No.109), and 'The Destruction of the Temple in the City of Jerusalem' by Lambert. The British Diorama closed in 1836.

Dioramas from both the Diorama establishments in London travelled. Within months 'Trinity Chapel, Canterbury Cathedral' was being exhibited in temporary rooms in Edinburgh (Wilcox, p.97). A permanent panorama building was opened in December 1827 in Lothian Road, Edinburgh, and a British Diorama was erected next door to the panorama rotunda on the Mound. In Liverpool in February 1825 'Trinity Chapel' was exhibited in a fairly imposing Diorama erected at the upper end of Bold Street. In June of the same year, to accommodate all classes of the community at a lower rate, back galleries were installed in the building. 'Brest Harbour', 'Holyrood Chapel', 'Roslin Chapel', and 'The City of Rouen' – all from Regent's Park – were subsequently exhibited there. Regent's Park dioramas were also exhibited in the Diorama in Cooper Street, Manchester, and in the Diorama, Gt Brunswick Street, Dublin.

Most fascinating was the Diorama in Bristol. Here in August 1825 'Holyrood Chapel' and the 'Interior of Canterbury Cathedral' were exhibited in a specially designed, though temporary, building erected in St James's Churchyard during the St James's Fair. Whilst the Dioramas in Edinburgh, Liverpool, Manchester, and Dublin were able to show only one picture at a time, the auditorium at the Bristol Diorama, as in Regent's Park, incorporated a turning saloon and was able to show two. In an advertisement in the *Bristol Mercury* (27 August 1825) the proprietor claimed the Diorama had been visited by 500,000 persons (surely a wild exaggeration.) A contributor to the paper expressed some surprise at finding it there amongst the side shows. On 19 September the paper reported the saloon crowded with fashionables. The paintings and revolving saloon, it predicted would 'secure the proprietors a golden harvest and amply reward them for the vast expense they must have incurred in erecting so large a building for so temporary a purpose'. It was assumed that the Diorama had been put in the St James's Fair by the Regent's Park establishment. On 7 November, however, an outraged *Bristol Mercury* reported:

The Foreign Artists who introduced the Diorama into this country...have had the presumption to apply for an injunction against the proprietors of the Diorama now exhibiting in Bristol; that they failed must be a source of congratulation to the admirers and patrons of British talent; but the proprietors of the Bristol Diorama have the greatest cause to triumph, as the very attempt was an unwilling homage to the very superior claims of their beautiful picture...'

It seems likely that this Diorama would have followed other fairs around the West of England. This has yet to be investigated.

No diorama seems to have been seen in North America before the 1830s, the earliest appearing in 1833 in Philadelphia. In 1835 the Columbian Circus in Philadelphia was converted into a Diorama. Two large dioramic paintings were exhibited there – 'The Departure of the Israelites' (presumably the painting that had been exhibited at the British Diorama in 1831), and 'The Crucifixion, with the City of Jerusalem' painted by Hippolyte Sebron. Meanwhile in New York in

1834 a dioramic version of Francis Danby's 'Opening of the Sixth Seal' was shown in Niblo's Gardens, Broadway. Regent's Park dioramas were exhibited in the city in 1840 and 1849.

Although Daguerre's dioramas did not tour Europe, several Diorama buildings were erected – in Breslau, Stockholm, Cologne, and Berlin. The proprietor of the Berlin Diorama was Carl Wilhelm Gropius, and the paintings predictably were by Karl Friedrich Schinkel. Schinkel had visited Paris in 1826 and had been entranced by Daguerre's Diorama. Gropius's Diorama, erected at the corner of Georgen and Universitätsstrasse on a site made available by King Friedrich Wilhelm III, was opened in October 1827. A refinement of Daguerre's arrangement, which Schinkel incorporated into his design, was long mirrors fitted outside the windows. The dioramas exhibited included a copy of Schinkel's 'Gotischcher Dom am Wasser'. (Some of the drawings for Schinkel's dioramas are held by the Altes Museum in East Berlin.) The actual diorama paintings were destroyed in a fire in August 1881.

Following the closure of the Diorama in Regent's Park in 1851 the building was converted into a Baptist chapel by the eminent Baptist railway engineer, Sir Samuel Morton Peto. (The mews at the back of the Diorama is named after him). Peto removed the tall windows of ground glass in Peto Place, replacing them with ecclesiastical ones, and inside the building removed the revolving machinery and the inner shell of the auditorium. In 1921 the building was sold again and acquired by the Middlesex Hospital, who installed a therapeutic pool and used the premises as a rheumatic clinic. Following the Second World War and up to 1977 the Diorama building served as an annexe to London University's Bedford College. Today it is occupied by 'Diorama Arts', a body that provides workshops and studios for artists and therapists. Plans are afoot to rebuild the interior once more but this time to incorporate into the stucture a museum devoted to the history of dioramas and related entertainments. As the only Diorama building in the world its fortunes are followed with keen interest.

Gropius's Diorama, Berlin
(By courtesy of Berlin Museum)

84. Perforated view: Prospect von den Leicester Platz der Stadt London . . . c.1755

B.E. LEIZEL AFTER THOMAS BOWLES

Coloured line engraving
27.3 x 40.2 cm
Bill Douglas & Peter Jewell Collection

The earliest transformation prints were perforated. When lit from the front they presented day scenes, but when lit from the back with strong light they were transformed into night scenes, the perforations become lamps, a larger hole the moon, and slits in the paper light from windows. The topographical prints produced by Thomas Bowles, next door to the Chapter House in St Paul's Churchyard at mid-century, lent themselves admirably for such adaptation. This print represents a German plagiarism, reversed as a *vue d'optique.*

85. Perforated view: A North West View of St. Paul's Cathedral, London, c.1755

Coloured line engraving
26.5 x 40.5 cm
Bill Douglas & Peter Jewell Collection

A perforated Italian plagiarism of a London original.

86. Exhibition of a Democratic Transparency

JAMES GILLRAY

Published by H. Humphrey, 15 April 1799
Coloured aquatint
34 x 42 cm.
David Robinson

Members of the Secret Committee of the House of Commons are sitting at a table looking at documents on the United Irishmen and other revolutionary organisations. Hanging from the ceiling, and lit by a lamp on the table, is a large transparency. It consists of four scenes, each representing a supposed revolutionary intention – 'Plundering the Bank', 'Assassinating the Parliament', 'Seizing the Crown', 'Establishing the French Government [at] St James's Palace'. The transparency is irradiated. Members of the Opposition flee the room.

By the late eighteenth century large transparencies were being hung up in public places in celebration of momentous events.

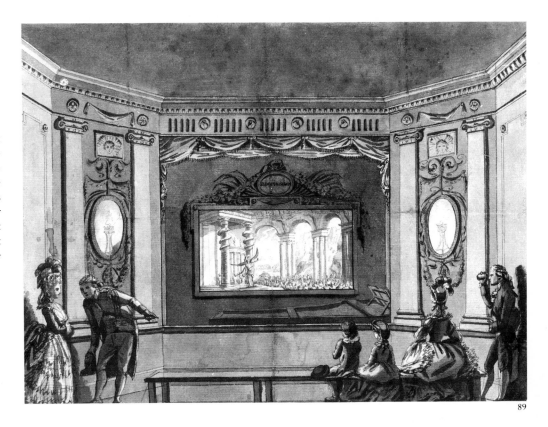

89

87. Essays on Transparent Prints, by Edward Orme, 1807

Book by Edward Orme
David Robinson

In this volume, Orme claims he invented by accident the process for producing paper transparencies 'some seven years earlier.'

88. View on the Rhine near Bingen

F.J. MANNSKIRSCH

Published by Rudolph Ackermann, 16 July 1798
Aquatint
15.5 x 21.5
Bill Douglas & Peter Jewell Collection

Despite Orme's claim, the earliest paper transparencies may have been issued by Rudolph Ackermann; this print would seem to have been published two years before Orme's first. It shows a ruined castle; the moon illuminates the clouds and the sea. Though published twenty-four years prior to the opening of the Diorama it is thoroughly Daguerrean.

89. The Eidophusikon, c.1782

EDWARD FRANCIS BURNEY

Watercolour
19.5 x 27.3
Trustees of the British Museum, Department of Prints & Drawings

De Loutherbourg's Eidophusikon in Lisle Street, Leicester Square held up to 130 people. The entrance fee was high – five shillings. The select and fashionable audiences sat on backless benches. The programme included vocal and instrumental music: a harpsichord is to be seen in the pit.

The scene on stage is 'Satan Arraying his Troops on the Banks of a Fiery Lake, with the Raising of the Palace

of Pandemonium'. This episode from Milton's *Paradise Lost* was added to the programme on 31 January 1782. The engraver, W.H. Pyne, visited the Eidophusikon in 1786 and included a vivid description of it in his *Wine and Walnuts* account. In the foreground of Pandemonium, he tells us, 'a chaotic mass rose in dark majesty, which gradually assumed forms until it stood, the interior of a vast temple of gorgeous architecture, bright as molten brass, seemingly composed of unconsuming and unquenchable fire'. Behind the proscenium de Loutherbourg had fixed Argand oil lamps. By manipulating slips of coloured glass that he had mounted in front of lamps, lights of various hues were thrown onto the picture, changing the scene from sulphurous blue, to red, to a pale, vivid light, and so on. The sounds that accompanied the picture were, to Pyne's astonished ear, 'preternatural'. A great roll of thunder, and a series of terrible groans 'struck the imagination as issuing from infernal spirits'. The Pandemonium scene in Burney's drawing includes a zig-zag of forked lightning, a favourite stage effect of de Loutherbourg's.

90. **Self portrait,** 1805-10

PHILIPPE JACQUES DE LOUTHERBOURG

Oil on canvas
127 x 101 cm
National Portrait Gallery

De Loutherbourg was born in Strasbourg in 1740, the son of a miniature painter. In 1755 he moved with his family to Paris where he very quickly made a name for himself. Before reaching the compulsory age of thirty he was elected to the Academie. He arrived in London 1n 1771 to take up stage designing at Drury Lane Theatre. Later he became acquainted with the theurgist and freemason, Count Cagliostro, and practised faith healing.

De Loutherbourg's Eidophusikon gave rise to a number of imitations. Charles Willson Peale, Philadelphian artist and creator of America's first popular museum of natural science and art, in 1785 built in his gallery a miniature theatre of light and sound with the cumbersome title, 'Perspective Views with Changeable Effects, or, Nature Delineated, and in Motion'. Following the invention of the diorama the German showman, W. Dalberg, introduced a revised Eidophusikion, repeating some of de Loutherbourg's most popular scenes – 'London from One Tree Hill, Greenwich', for

example – but introducing new ones such as 'a Diorama of the Ladyes Chapel, Southwark, with the Effects of Light and Shade'. As late as 1852 the Linwood Gallery in Leicester Square was advertising the 'Eidephusicon [sic], A beautiful Exhibition of Animated Scenes, Picturesque and Mechanical'.

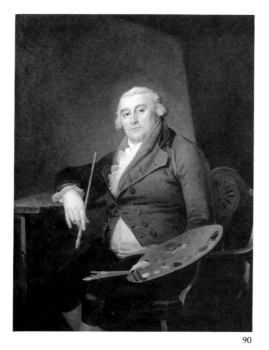

90

91. **Exhibition Rooms, over Exeter 'Change, Strand...The Eidophusikon, Invented and Painted by Mr. De Loutherbourg...,** 1786

Handbill
21 x 25.5 cm
Guildhall Library, City of London

This handbill announces the re-opening of the Eidophusikon at the Exeter 'Change for positively its last season in London. By this date de Loutherbourg's entertainment belonged to a Mr Chapman. In addition to the Eidophusikon's 'Mediterranean by Moonlight', with a total eclipse of the moon, he exhibited Jervais' stained glass, transparent paintings by de Loutherbourg, and

transparent drawings by Paul Sandby. The entrance fee was now reduced to a more reasonable one shilling.

In 1799 Chapman exhibited a 'New Eidophusikon' in a room in Panton Street off the Haymarket. Though on this occasion the Eidophusikon was not de Loutherbourg's, the programme included 'The Palace of Pandemonium, or Milton's Hell'. It also included conjuring tricks performed by a 'miraculous and dexterous swan'. The Panton Street building was burnt down and the 'New Eidophusikon' destroyed on 21 March 1800.

92. **Coalbrookdale by Night,** 1801

PHILIPPE JACQUES DE LOUTHERBOURG

Oil on canvas
68 x 106.7 cm
Science Museum

Dramatic scenes of new industry had a special fascination for de Loutherbourg. In 1800 he visited Coalbrookdale and Madeley where he made several pen and ink studies, in the following year exhibiting 'Coalbrookdale by Night' at the Royal Academy. The romantic presentation of sublime elements, the red smoke, and the yellow glare which illuminate this night scene, all make this pre-diorama painting dioramic in essence. Thomas Hornor would also be drawn to industrial sites – he recorded the ironworks of Merthyr Tydfil in 1817 – and Karl Friedrich Schinkel would visit Coalbrookdale during his visit to Britain in 1826.

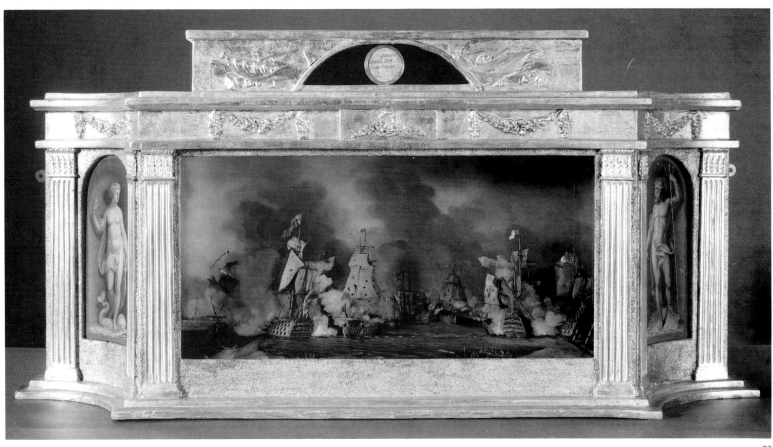

93

93. **Model of the Battle of the Saints,** c.1782.

UNKNOWN ENGLISH MAKER

Dimensions of internal unit; back, 29.5 x 69.2 cm; front, 26.9 x 52.5 cm; depth 13 cm.
Wood, glass, paper, thread and gesso modelling; painted.
Dimensions of case; 45.4 x 96.5 x 20 cm
Gilded wood and gesso with oil on metal lunettes.
National Maritime Museum

This model shows the end of the Battle of the Saints, 12 April 1782, the last major naval action of the American Revolutionary War, which took place in the West Indies and saw the defeat of the French fleet under the Comte de Grasse by the British under Admiral Sir George Rodney. Rodney's flagship Formidable is stern-to in the left group; de Grasse in the Ville de Paris surrenders to the Barfleur on the right.

The source is an oil painting by Richard Paton, which was published as an engraving in 1783. The model probably copies a badly coloured print which would account for mistakes in the colouring of significant flags. Its interest here however derives from its close overall resemblance, especially in terms of the decoration of the case, to de Loutherbourg's Eidophusikon as recorded by E.F. Burney's drawing (cat. No.89.)

The Eidophusikon was first exhibited in February 1781 and while its exact techniques are unknown they certainly involved perspective modelling and probably glass painting, as well as displaying several marine views. Allowing for the difference of scale, purpose, and the fact that the Eidophusikon showed a moving spectacle, this model appears to be derived from, or at least inspired by, the larger device. How it was orginally lit is unclear. The left end of the internal unit is however of glass and light may have been reflected in through it from the back. The background of painted glass may also have been conceived as a transparency, though if so it is no longer effective as such.

The model may have belonged to Rodney himself and certainly to his family from whom it was acquired in 1939.

(Pieter van der Merwe)

94. Portrait of Louis Jacques Mandé Daguerre

PIERRE LOUIS GREVEDON

Lithograph

36 x 27 cm

Gérard Lévy Collection

L.J.M. Daguerre, before becoming an assistant to the panorama painter, Pierre Prévost, served apprenticeships with an architect in Orleans and Deotti, chief designer at the Paris Opera. For a while he was employed as a designer with the theatre Ambigu-Comique and the Opera. With Charles-Marie Bouton he invented the diorama. He was also a pioneer in photography, experimenting in that field from c.1824; the invention of the daguerreotype was eventually announced in 1839. He retired in 1840 to Bry-sur-Marne. In the local church he painted a *trompe-l'oeil* behind the altar which may still be seen.

Pierre Louis (called Henri) Grevedon was an associate of Daguerre. His portrait of the dioramist – that exhibited is a proof before title – constitutes the prototype for the portraits of Daguerre that appeared in the 'Galerie de la Presse' and the 'Galerie du Voleur' by Julien, and also for the frontispiece in Daguerre's *Historique et Description des Procédés du Daguerreotype* (cat. No.95).

95. Historique et Desription des Procédés du Daguerreotype et du Diorama, 1839

Booklet

22 x 13.7 cm

David Robinson

This manual, Helmut and Alison Gernsheim tell us (*History of Photography, 1955*), was prepared by command of the French Government; during 1839 and 1840 it passed through at least thirty editions in eight languages.

96. Le Château d'Eau. Marché aux Fleurs

PHILIPPE BENOIST (THE FIGURES BY A. RAYOT)

Published by Gihaut Frères

Lithograph

25 x 35 cm

Gérard Lévy Collection

The Paris Diorama was built in the Place du Chateau d'Eau. It can be seen on the left in this image. In its roof is the skylight called for to direct light onto the front of the diorama canvases, and in the wall the tall windows which directed light onto the backs of them. The public entrance to the establishment was in the Rue Sanson at the side. The second wing, also with skylights, can be seen behind the Place du Chateau d'Eau wing.

The artist responsible for this lithograph was a pupil of Daguerre's, and exhibited at the Salon from 1836. The Diorama building was destroyed in a fire on 8 March 1839.

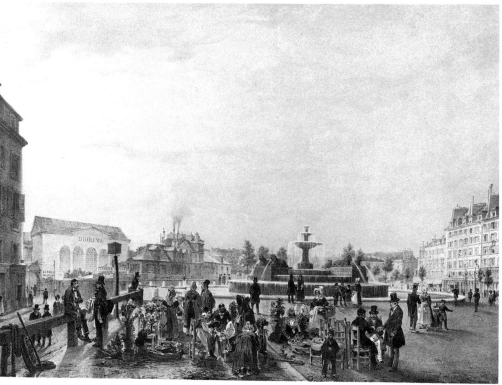

96

97. Tableau de Paris. Le Diorama... Port de Boulogne

MARLET

Lithograph

17 x 26.5cm

Bill Douglas & Peter Jewell Collection

Visitors to the Paris Diorama view a diorama of the port of Boulogne.

98. Diorama. Vue Interieure de la Chapelle en Ruines du Chateau d'Holyrood, à Edinbourg (effect de lune) Peinte par Daguerre, 1823

Handbill

26.5 x 20.5 cm

Bill Douglas & Peter Jewell Collection

One of the earliest dioramas was Daguerre's 'Interior of Holyroodhouse, Edinburgh, Effect of Moonlight'. It was exhibited in the Diorama in Paris from 20 October 1823 to 23 September 1824, and then in the Diorama, Regent's Park from mid-March 1825. The *Mirror of Literature*, 26 March 1825, described it as 'the greatest triumph ever achieved in pictorial art'. There is a large easel version of the subject by Daguerre in the Walker Art Gallery, Liverpool.

99. The Effect of Fog and Snow Seen through a Ruined Gothic Colonnade, 1826

LOUIS JACQUES MANDÉ DAGUERRE

Oil on canvas

102 x 154 cm

Gérard Lévy Collection

Soon after the opening of the Dioramas in Paris and London Daguerre provided three dioramas with Scottish subjects. The first of these, 'The Ruins of Holyrood Chapel, Edinburgh, by Moonlight' was followed by 'Roslyn Chapel near Edinburgh, Effect of Sun', shown in Paris 24 September 1824 to 14 August 1825 and in London from 20 Febuary 1826.

The painting here exhibited is based on Daguerre's third Scottish subject. The Romanesque building is imaginary but one of the two figures wears a kilt. The painting is thoroughly romantic and in spirit corresponds to the work of Caspar David Friedrich and Karl Friedrich Schinkel. It strongly manifests the literary influence of Sir Walter Scott.

The diorama version of this image was shown in Paris, 15 August 1825 – 4 May 1826, and in London from early June 1827. The diorama's transformation effect was described at length in the *Mirror of Literature*, 30 June 1827:

All is sombre, desolate, and mournful; the long drawn aisles, at first glance, are alone perceived, for a thick fog reigns without, and such is the illusion of the scene that you actually fancy yourself chilled by the cold and damp air. By degrees, however, the fog disperses, and through the vast arches are plainly discovered the forests of pine and larch-trees that cover the valley. The magic of this effect of light is indeed most extraordinary and the illusion is complete and enchanting . . .

Daguerre's related easel painting after the diorama shows us the scene when the fog has dispersed. That the painting was painted later than the diorama is evidenced by the date on it – 1826. The figure in the picture accompanying the kilted gentleman wears the red emblem of the Legion of Honour, a reference, it would seem, to the artist himself who had the Cross of the Legion bestowed on him by Charles X in January 1826.

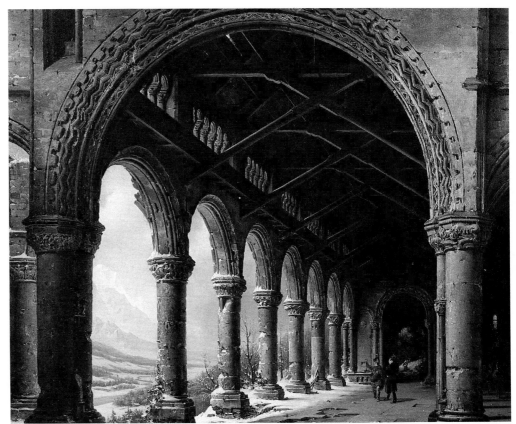

99 (detail)

100. The East Side of Park Square, and the Diorama, Regent's Park

W. WATKINS AFTER THOMAS HOSMER SHEPHERD

Published by Jones & Co., 6 June 1829
Steel engraving
8.7 x 14.2 cm
Guildhall Library, City of London

The Diorama in London occupied 17-19 Park Square East, a terrace linking the New Road (now Marylebone Road) to the Outer Circle of Regent's Park. John Nash was the architect responsible for its elevation, but the building was otherwise designed by Augustus Charles Pugin, assisted by a civil engineer named James Morgan. The word 'DIORAMA' was incised on the face of the building over the attic storey.

The steel engraving appeared in '*Metropolitan Improvements; or, London in the Nineteenth Century*', by T.H. Shepherd (London: Jones & Co. 1827-29). An attractive but exceedingly rare aquatint of the terrace was published by the Bloomsbury tailor, Benjamin Read.

101 Morgan's Improved Protean Scenery: Basilica of St Paul

Lithograph incorporating a transparency
26 x 35.7 cm (overall)
Guildhall Library, City of London

To view the dioramic slides for a polyorama panoptique (cat. No.115) and to examine the scenes in Samuel Leigh's Portable Diorama (cat. No.113) a viewing-box was called for. With protean views no box was needed – one simply held them up to a bright light. Two firms specialised in their production – William Morgan, and William Spooner.

Morgan's print of the basilica of St Paul's was directly related to a diorama of the destruction of St Paul's Outside the Walls in 1823 by Bouton, exhibited at Regent's Park in 1837. The Diorama programme for this show described the transformation as follows:

The Picture as first seen represents the Interior of the Church before its destruction. The roof supported by beams of cedar, the beautiful ornamented columns, the portraits of the Popes, the altar, and the pavement, will give the spectator an idea of its former richness.
In the second aspect of the Picture, the roof has disappeared, and is succeeded by a beautiful azure sky; the

columns are shattered, and their mutilated parts, with the calcinated remains of rafters, beams, &c. cover the pavement and are no longer visible.

A wood engraving in Edmond Texier's Tableau de Paris (1853) shows an audience viewing the 'Basilica of St Paul's' painting in the Paris Diorama.

102. Mount Vesuvius, as Represented at the Surrey Zoological Gardens

Published by W. Morgan
Lithograph incorporating a transparency
16.7 x 23 cm
Bill Douglas & Peter Jewell Collection

Morgan's view transforms to show Vesuvius in eruption. The image is of a gigantic panorama erected in the Surrey Zoological Gardens in S. London. Produced by Danson & Sons it was erected at the far side of the miniature lake in the gardens which for the duration served as the Bay of Naples. At night the painted Vesuvius erupted and the modelled scene became a backdrop for a pyrotechnic display. In other years 'The Eruption of Mount Hecla', a 'Colossal Model of Rome', and 'The Siege of Sebastopol' with a cast of one hundred veterans, served as subjects at the Surrey Zoological Gardens.

Just as 360° panoramas, dioramas, and moving panoramas went on tour, so too did pleasure garden panoramas. Besides being shown in the Surrey Gardens, 'The Siege of Sebastopol' in 1855 was performed in Belle Vue Gardens, Manchester.

From 1852 Danson & Sons presented in Manchester a new panorama each year. Ever-popular subjects such as 'The Battle of Trafalgar', 'The Storming of Seringapatam', and 'The Burning of Moscow' at Belle Vue Gardens were interspersed with panoramas of recent incidents such as 'The Afghan War', 'The Fall of Khartoum', and (later) 'The Battle of Omdurman'. In anticipation of a German invasion in 1910 the panorama consisted of an imaginary 'Battle of Manchester'. Panoramas continued to be displayed at the edge of the main boating lake in the gardens at least until 1955. The lake was drained in 1964.

Audiences attracted to such entertainments were mixed. A reviewer of a Belle Vue panorama described it as 'a gala place for thousands and thousands of working class men'(*The Critic*, 15 June 1872.) Another writer expected to feel ashamed of being there: 'When how-

ever we got there we found this feeling entirely groundless, and the audience composed of thoroughly respectable persons' (*The Shadow*, 9 June 1869.)

103. Bombardment of Algiers, as Represented at the Zoological Gardens, Liverpool, Painted by Mr George Danson

Published by William Spooner
Lithograph incorporating a transparency
16.3 x 76.5 cm
Bill Douglas & Peter Jewell Collection

This Spooner print transforms from a peaceful scene to Lord Exmouth's bombardment of the city of Algiers, 1816, when, as the descriptive booklet puts it, 'the Mediterranean was freed from a band of lawless Corsairs, and Christendom was delivered from a scourge and a disgrace'. Danson's modelled panorama of the subject was exhibited both at the Zoological Gardens in Liverpool and at Belle Vue Gardens, Manchester.

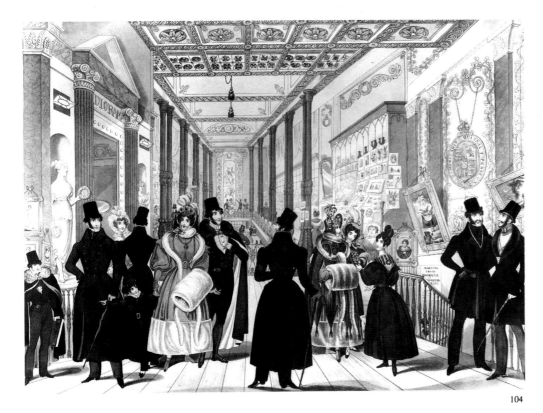

104

104. Queen's Bazaar, Oxford Street

ANON.

Published by Benjamin Read, 1833
Coloured aquatint
38.5 x 53.5 cm
Private collector

Interior of the second Queen's Bazaar depicted in a plate showing fashions for the coming winter season. The imposing entrance to the British Diorama is to be seen on the left. The dioramic version of John Martin's 'Belshazzar's Feast' is announced on a poster on the stairs on the right.

105. British Diorama, Royal Bazaar, c.1828

Designed and published by A.P. Harrison
Coloured lithograph
15.5 x 14.5 cm
Private collector

This *trompe l'oeil* consists of the title with representations of each of the eight dioramas by Clarkson Stanfield and David Roberts that were exhibited at the first British Diorama in 1828. Stanfield's 'York Minster on Fire' which caused the fire that virtually burnt the Bazaar to the ground, can be identified in the centre.

106. Destruction by Fire of the Royal Bazaar, Oxford Street, 1829

Handbill
28 x 25 cm
Guildhall Library, City of London

Of the dioramas by David Roberts and Clarkson Stanfield exhibited at the British Diorama in Oxford Street, the most ingenious was Stanfield's 'The City of York with the Cathedral on Fire'. This re-created an incident on 1 Febuary 1829 when John Martin's mad brother, Jonathan Martin, set light to the roof of York Minster. British Diorama audiences looked across the city to the Minister at dawn. A light appeared at the window then vanished. Then thick smoke appeared, fire illuminating the window by degrees until the flames burst out to unroof the building. The conflagration then raged with irresistable fury. Reviewers agreed the illusion was managed with masterly skill.

The show opened on 20 April 1829. On 27 May it was even more realistic. To give a crimson appearance to the flames the dioramist ignited a chemical preparation behind the painting the principal ingredient of which seems to have been turpentine. On this occasion the flare touched a loose screen, or possibly the painting itself, and before the flames could be dowsed they spread to other parts of the auditorium and then to the Bazaar itself. Virtually the whole building was burnt. Some of the lady stallholders lost their entire stocks. The four dioramas currently being exhibited were destroyed, and four more which had been exhibited earlier.

Dioramas were fire hazards. Charles Marshall's Kineorama in Pall Mall – a cross between a moving panorama and a diorama – was destroyed by fire in 1841: the light from 150 jets of gas was manipulated by large frames of coloured oiled silk which on this occasion came in contact with each other. Daguerre's Diorama in Paris was destroyed by fire in 1839 and his successor's in 1848.

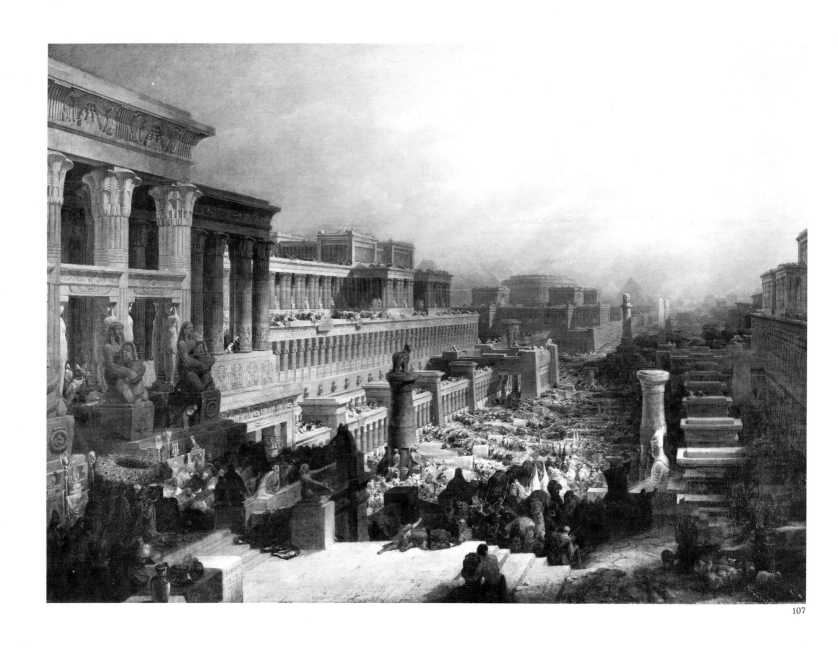

107. **The Israelites Leaving Egypt** 1829

DAVID ROBERTS

Oil on canvas
137.2 x 182.9 cm
Birmingham City Museums & Art Gallery

David Roberts' most Martinesque picture, 'The Israel-
ites Leaving Egypt', was painted for Lord Northwick.
(The Department of Prints and Drawings at the British
Museum have a pen, ink, and wash study for it made in
1827.) It was exhibited at the Society of British Artists

in 1829 and at the Scottish Academy in 1830. Moon, Boys & Co published a mezzotint after it. In January 1833 the reopened British Diorama exhibited an enlarged version of the image with dioramic effects which they entitled 'The Departure of the Israelites out of Egypt'. It was four times the size of the Bazaar's standard dioramas. *Townsend's Monthly*, January 1833, pronounced it 'the first illustration of Scriptural History ever painted on so grand a scale'. Admittance to it and to the 200 square foot long gallery of physioramas (i.e. cosmoramas) was one shilling. Whether Roberts had any part in painting the dioramic version of his painting seems most improbable: his manuscript notes on works painted makes no mention of such an undertaking. One assumes that as an artist employed by the Bazaar the proprietor obtained his permission.

108. Departure of the Israelites, 1833.

Handbill

9.7 x 17 cm

Westminster City Libraries, Marylebone Collection

This handbill in effect urges the public to see the British Diorama picture before it is too late. It promises to invite the royal family, members of both Houses of Parliament, and all (!) the nobility and gentry to a grand feast. Whether this most improbable event took place has not been established.

109. Belshazzar's Feast

JOHN MARTIN

Oil on canvas

95.3 x 120.6 cm

Yale Center for British Art

The enlarged dioramic version of Roberts' 'Departure of the Israelites' was replaced at the British Diorama in June 1833 by 'Mr Martin's Grand Picture of Belshazzar's Feast, Painted with Dioramic Effects'. This 2,000 square foot reversed enlargement was not in fact by John Martin at all. It had been copied from the 1820 original by Daguerre's former assistant and present collaborator, Hippolyte Sebron. *The Times* felt that the scale of the painting made Martin's image more imposing, but was not entirely happy with its colouring and questioned (surprising this) whether the subject chosen was the best for a dioramic representation. In-

furiated by the plagiarising of his work Martin took out a court order to close the show. He was unsuccessful.

As Feaver has demonstrated Martin set out to treat 'Belshazzar's Feast' as a panoramic spectacle, viewing it from above like a battlescape. Though it did not transform from one image to another, in its use of light and perspective it pointed forward to Daguerre's imminent invention. The painting was exhibited at the British Institution in 1820 where, like a panorama, it was hung low. It was so popular that it had to be railed off. The painting was purchased by Martin's former employer, William Collins, who later exhibited it in his shop at 343 Strand. As at a panorama rotunda visitors were able to purchase a descriptive booklet and key.

Feaver points out the similarity between the composition of Martin's 'Belshazzar's Feast' and that of 'The Temple of the Sun' by Karl Friedrich Schinkel, designed in 1815 as a set for 'The Magic Flute'.

Martin produced several versions of 'Belshazzar's Feast'

The exhibition painting is now in a private collection in England, there is a smaller version in the Wadsworth Athenaeum in Hartford, Connecticut, and there is another small version in the Yale Center for British Art – the one exhibited here. Martin also painted the image on glass, this serving as a display advertisement in Collins' shop window. The glass version at Syon Park (sadly cracked) may be this item.

Sebron's dioramic copy of 'Belshazzar's Feast' was transported to North America and exhibited at the Diorama, Niblo's Garden, Broadway. There it was on show from 9.00 am till dusk: due to the arrangement of the lights it could be viewed in dull weather. From this it would seem that daylight was crucial but that artificial light was available to supplement it. The descriptive booklet announces special rates for young ladies' schools.

110. A Description of the Belshazzar's Feast, Painted by Mr Martin, Lately Exhibited at the British Institution and now at 343 Strand...

Published by William Collins

Booklet

Yale Center for British Art

This descriptive booklet for John Martin's 'Belshazzar's Feast' was sold to those visiting the exhibition of the

painting at William Collins' shop. The arrows and numbers on the diagram indicate how the artist intended the visitor to 'read' his painting. One is led from the handwriting on the wall on the left, to the large column with the brazen serpent entwined round it below, to Daniel interpreting the handwriting in the centre, to Belshazzar on the right who on hearing his fate from the Prophet drops his cup, to the assassins, soothsayers, and concubines, to the foreground, and then along the banqueting hall past gardens and temples to the distant towers of Babel and Baal. The compiler of the descriptive booklet for Sebron's dioramic version exhibited in Niblo's Garden, New York seems to have made full use of Martin's booklet.

111

111. Mr. Martin's Grand Picture of Belshassar's Feast, Painted with Dioramic Effect...at the Queen's Bazaar, Oxford Street..., 1833

15 x 17 cm

Westminster Public Libraries, Marylebone Collection

Sebron's plagiarism of Martin's painting is stated to be five times as large as Benjamin West's 'Death on the Pale Horse', and four times the normal size of dioramic views.

112. Diorama, Bold Street, Liverpool. A View, 80 Feet by 50, of Trinity Chapel, in Canterbury Cathedral, 1825

Booklet
20.8 x 13 cm
Liverpool City Libraries

'The Chapel of the Trinity in Canterbury Cathedral' by Charles-Marie Bouton was the very first diorama to be exhibited in Paris (11 July 1822 to 18 February 1823), and then in London (29 September 1823 to August or September 1824), featuring with Daguerre's 'Valley of Sarnen, Switzerland'. It was later shown in temporary rooms in Edinburgh, at the Diorama in Liverpool, and then at the Diorama in Cooper Street, Manchester. The Diorama in Bold Street, according to *The Stranger in Liverpool* (1829), was erected at an expense 'which nothing but the splendid specimens of art which are intended to be therein submitted for public inspection could justify'.

113. The Portable Diorama, 1826

JOHN CLARK

Published by Samuel Leigh, 1826
Aquatints in box
20.2 x 33.4 x 26.6 cm
David Robinson

Leigh's 'Portable Panorama' was advertised in *The Times*, 25 January 1826, as 'An Elegant Present for the Families of the Nobility and Gentry'. Fitted up in an attractive box it was priced at three guineas. The toy came with romantic, grand, and picturesque scenery, and the necessary apparatus for producing the effects of sunrise, sunset, moonlight, the appearance and disappearance of clouds, and a rainbow, on the principle of the Diorama in Regent's Park.

Samuel Leigh specialised in panorama-related toys and prints. They included a 'Panorama of the Rhine', a 'Panorama of the Maine', a 'Panorama of the Thames from London to Richmond', and a 'Myriorama' of Italian scenes that was capable of 620,448,401,733,239,439,360,000 permutations. Most of Leigh's products were drawn by John Clark (also known as Waterloo Clark and John Heaviside Clark).

114. Hand fire-screen, incorporating a transparent moving panorama

38 x 21 cm
Barnes Museum of Cinematography

This scene was designed to be held by a person sitting near an open fire to shield the heat from the face. The stationary part of the view consists of the interior of a theatre with an audience in boxes, and an orchestra with a conductor in the pit. On the stage the scene consists of a miniature moving panorama which can be rolled along by turning the tiny cranks below. The flickering fire in the hearth brings the transparent picture to life. Another copy of the fire-screen seen in a private collection bears a label stating that it was sold in the Passage des Panoramas, Montmartre.

115. Polyorama Panoptique, c.1851

Accompanied by six coloured lithographic slides of London scenes
17.5 x 22 x 12 cm
Guildhall Library, City of London

The 'Polyorama Panoptique' peep-box was invented during the Second Empire by a Parisian optician named Lemaire. It consists of a box with expanding bellows, a lens at the back of the bellows, a shutter that lifts up and down over the box, and an aperture to take slides at the front. The slides are hand-coloured scenes on transparent paper tightly stretched onto wooden frames. When one lifts the shutter and looks through the lens the view on the slide is seen in daylight. As one closes the shutter it gradually dissolves into evening and night, or (as is the case for the Great exhibition slide) it is transformed into an entirely different image.

116. The Diorama, Regent's Park today

Four colour photographs
20 x 28 cm each
Private collector

Photographs taken for the Appeal by Greycoats Developments in 1984 against the London Borough of Camden's refusal to permit an office development on the site of the Diorama. They show: (i) the Park Square front; (ii) the internal area; (iii) the building's skylight (this originally illuminated the fronts of the canvases); (iv) the lecture theatre (on the site of the original auditorium).

V THE PEEPSHOW IMPROVED

In effect cosmoramas were glorifed peepshows. One entered a tastefully decorated but dimly lit room, and though a series of windows (each in fact a convex lens) peeped at sensational scenes beyond. The subjects, brightly lit by gas or daylight, were panoramic – bird's-eye views, monuments of antiquity, great waterfalls such as the Niagara, and storms at sea. Following the invention of the diorama some of them were also dioramic. Thanks to the lenses the pictures seemed to be full-scale. A Cosmorama Room was an ideal place to relax in when shopping, or to take your children on a wet afternoon. Cosmoramas, as their proprietors never ceased to proclaim, educated and entertained simultaneously.

The first Cosmorama was opened in Paris in 1808 by a *Société des Voyageurs et d'Artistes*. The company's optical idea and a selection of the minutely executed paintings were exported to New York in 1815. It was not until May 1821 that the Cosmorama Room was opened in London in adapted premises at 29 St James's Street. The organisers called themselves the Society for the Encouragement of English and Foreign Artists but in the early years most of the paintings seem to have been passed on from the Parisian establishment. On 7 May 1823 the Cosmorama Room moved to purpose-built premises, designed by Augustus Charles Pugin, at 209 Regent Street. Here a total of fourteen views were exhibited at any one time, six more than in St James's Street, and the views were illuminated by daylight rather than gaslight. The establishment consisted of two galleries for the cosmoramas, a refreshment room, and a number of rooms for subsidiary, temporary exhibitions. The entrance fee was one shilling. Occasionally cosmoramas of a dioramic nature were exhibited, 'Mount Vesuvius, Where is Seen the Fire, Smoke and Lava in Full Motion', for instance, and 'Edinburgh, with the Effect of a Conflagration'. Puckler-Muskau, who viewed 'Edinburgh' in 1827 wondered cynically if the proprietor's kitchen might be behind the picture, and whether the fire that 'heated the fancy of credulous spectators' like himself 'roasted a leg of mutton which our shillings paid for'.

Very soon cosmoramas became a standard attraction at bazaars – the department stores of the day. A Monsieur Dalberg exhibited cosmoramas by 'artists of eminence' at the Saville House Bazaar, and at the St James's Bazaar paintings by Messieurs Sechan, Feuchere, Desplecuin, and Dieterle were exhibited to the music of Mozart's Requiem. The Lowther Bazaar in the Strand exhibited its cosmoramas in a Magic Cave: Louis-Philippe between 1848 and 1850 paid it frequent visits and presumably approved of it; Albert Smith unkindly described it as 'a melancholy

little collection of mechanical contrivances'. The Queen's Bazaar in Oxford Street boasted a Physiorama – in reality a standard Cosmorama – which was supposed to have attracted 15,000 visitors in the first few weeks. (The Albion Bazaar at Manchester, which also had a Physiorama, may have been the recipient of superceded cosmoramas from Oxford Street.) So anxious was the short-lived Oriental Bazaar in High Holborn to attract shoppers it dispensed with the near-standard shilling entrance fee and burst into bad verse:

> The Riches here of East and West
> Your fancies will amuse,
> Besides to give a greater zest,
> We've cosmoramic views.

The main exponent of cosmoramic views in Europe and the United States was Hubert Sattler. Sattler was born in 1817, the son of a portrait painter, Johann Michael Sattler. In 1824 Sattler Senior was commissioned to paint a giant 360° panorama of Salzburg (cat. No.258) – Austria's first. This was completed in 1828 and exhibited in a temporary wooden rotunda in Hannibalplatz, today's Marktplatz. In 1829 J.M. Sattler was granted the Freedom of Salzburg and set off with his panorama on a tour of Europe that would last ten years. The family accompanied him, Hubert working with his father painting cosmoramas. They visited Munich, Linz, Vienna, Bohemia, Saxony, Hamburg, Copenhagen, and Oslo, as well as towns in Holland, Belgium, and France, covering 1,400 miles with a weight load of 30,000 kilos (15 tons).

Back in Salzburg twenty-six of Hubert Sattler's cosmoramas were displayed in Michael Sattler's rotunda. In 1843 Hubert married Maria de Toda, and in 1844 the couple had their first child, Hubert Junior. Hubert Senior chose this year, however, to set off on a sketching tour of Nubia, Arabia and Sinai. Two years later Sattler was on his travels again, visiting Italy, Greece, Turkey, Syria, Egypt and Libya. The cosmoramic paintings resulting from these tours were exhibited in an 'art hut' that was successively erected in Dresden, Leipzig, and Berlin. Hubert Sattler in 1845 was awarded the title of 'Professor' by Hanover. In 1850 he sailed to America.

Cosmoramas in the United States had a lamentable reputation. A writer in the *Literary World* recalled juvenile visits to the American Museum and a flattening of noses on glass at the Castle Garden when viewing a church, the city of Lisbon, or the Great Square of Mexico, 'an amplification of the style and spirit of the engravings in the spelling book'. (This and the quotes below are taken from *Opinions of Artists and the Press Respecting Professor Sattler's Cosmoramas*.) Sattler's cosmoramic views were in an entirely different class from the earlier examples, however. 'Reader, if you have not visited the Professor's magical galleries', begged the *Bulletin of the American Art Union*, 'let not the first bright morning pass without doing so. Gloomy-looking places you will find them to be; quite bare and unfurnished; nothing but dark avenues with partitions of baize along which at regular intervals are distributed small square openings. Look through one of these openings and you are straightway thousands of miles from home.' 'Go', the *Albion* recommended, 'and take your children: they will learn more this way in an hour than three month's poring over Atlases and Physical Geography Books can teach them.'

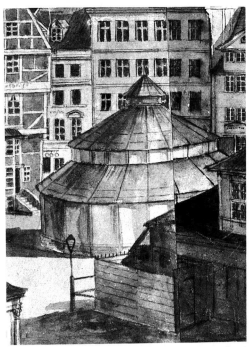

126 (detail)

In New York Sattler's cosmoramas went on exhibition in an iron hut on Broadway at 13th Street. Sattler himself was usually in attendance and must have been gratified by its popularity. The *Literary World*, reviewing a change-round of the paintings, urged the artist to add a series of American scenes to his collection. Sattler took up the challenge and set off on a fresh tour, visiting Boston, Philadelphia, Mexico and the West Indies.

In 1870 Sattler presented the city of Salzburg with his father's panorama and his own cosmoramas. To house them the city erected a permanent rotunda. This was opened in 1875 and a street – Hubert Sattler Gasse – was named after him. An engraved cross-section of the building indicates that the cosmoramas were displayed in a circular corridor below the panorama, and that, unlike the Cosmorama Rooms in Regent Street, visitors sat on chairs to view them.

Hubert Sattler died in Vienna on 3 April 1904 and was buried in the family grave in Salzburg Municipal Cemetry. His rotunda was demolished in 1937. Over a hundred Sattler cosmoramas are still preserved in the Salzburger Museum, and seven of these are exhibited in the present exhibition.

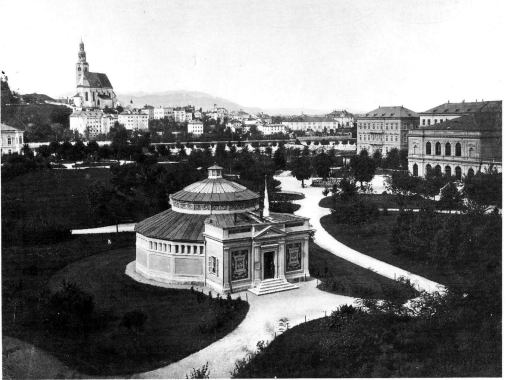

57

117. Explanation of the Cosmorama

La Belle Assemblee, 1 Dec. 1821
Aquatint
14 x 22 cm
Guildhall Library, City of London

This print represents the Cosmorama Room at the establishment's original London premises, 29 St James's Street. Fig 1 shows the room itself, six of the eight windows (marked 'A') being visible. Fig 2 at top right shows the optical arrangement from above: the cosmoramic painting at the top, the lens below, 'boundary screens' on left and right. Fig. 3 at bottom right shows the arrangement in section the painting on the left, the lens on the right.

118. A Schoolboy's Visit to London, c.1820

Published by Edward Wallis, c.1825
Bill Douglas and Peter Jewell Collection

Harry, up from the Country, is shown the sights of London by Tom (presumably his cousin.) They set off from Grosvenor Square and view the Tower, the Customs House, the Monument, St Paul's, the British Museum, and Vauxhall Gardens. The climax of their day out is a visit to the Cosmorama Rooms in Regent Street:

> Now to the Cosmorama come,
> Behold the view of mighty Rome,
> Egypt, or Paris, or Madras,
> To see them all, peep through the glass
> The flowers too bloom, so rare and gay:-
> Now home; enough we've seen today.

Visitors to the Cosmorama Rooms were able to purchase catalogues describing each scene. The galleries were so dimly lit, however, that one could only read them from the light seeping through the little windows. A note printed in some of the catalogues informed the public that for a charge cosmoramic views could be set up in country houses.

As an extra entertainment a 360° panorama of Rome was exhibited at the Cosmorama Rooms in 1824. According to publicity it received the 'approbation of upwards of 10,000 travellers, including the major part of our nobility and gentry.'

The cosmoramic views, and the windows, lenses, looking glasses, show cases, and other fitments were disposed of cheaply when the establishment's proprietor retired in November 1861. The fate of the paintings has not been established.

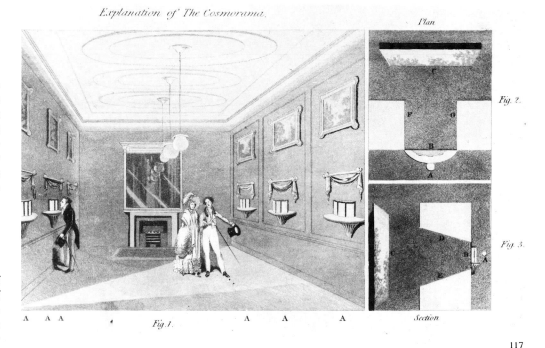

117

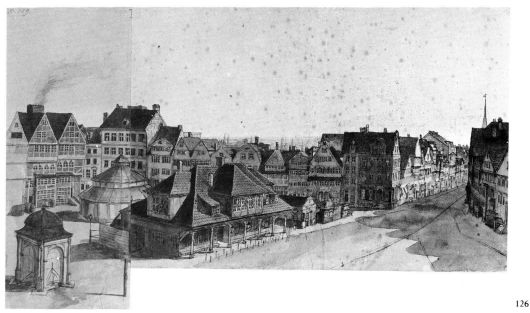

126

119. Storm in the North Sea

HUBERT SATTLER

Oil on canvas
105 x 134 cm
Salzburger Museum Carolina Augusteum

This storm, identified in New York's *Churchman* as one occuring during a passage from Norway to Holland, was immensely popular with American visitors to Sattler's Cosmorama. The *Herald* considered it so perfect and true to nature it almost made one shudder; whilst the *Home Journal* described it as 'sublime beyond description.' Sattler's descriptive booklet describes it as follows:

On all sides the turbulent waves tower up like mountains and seem to be swallowing up the ship. A wreck floats in the foregound, part of a mast or mast-head of a ship that has perished on some shore.

120. Eruption of Vesuvius

HUBERT SATTLER

Oil on canvas
105 x 131.5 cm
Salzburger Museum Carolina Augusteum

This painting shows the crater of Mount Vesuvius as it appeared in the spring of 1845. Two intrepid travellers are shown, accompanied by guides. The lady would seem to have been conveyed to this point in the portable chair.

121. The Escorial

HUBERT SATTLER

Oil on canvas
99 x 121.5 cm
Salzburger Museum Carolina Augusteum

122. View of Moscow

HUBERT SATTLER

Oil on canvas
99 x 124 cm
Salzburger Museum Carolina Augusteum

123. Memnon, Egypt

HUBERT SATTLER

Oil on canvas
104.5 x 132.5 cm
Salzburger Museum Carolina Augusteum

124. View of New York City

HUBERT SATTLER

Oil on canvas
99 x 124 cm
Salzburger Museum Carolina Augusteum

125. Orizaba, Mexico

HUBERT SATTLER

Oil on canvas
99 x 126 cm
Salzburger Museum Carolina Augusteum

126. Neue Markt, Hamburg, with Sattler's rotunda

HUBERT SATTLER

Watercolour
Salzburger Museum Carolina Augusteum

J.M. Sattler's rotunda, for exhibiting his panorama of Salzburg (cat. No.57) and his son's cosmoramas, was set up in the market place of many towns in Germany, Austria, Holland, France, Sweden and Norway.

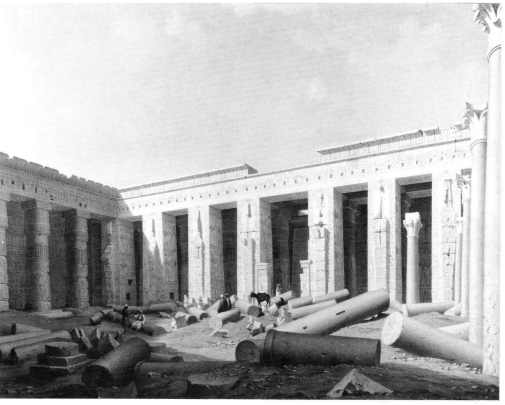

123

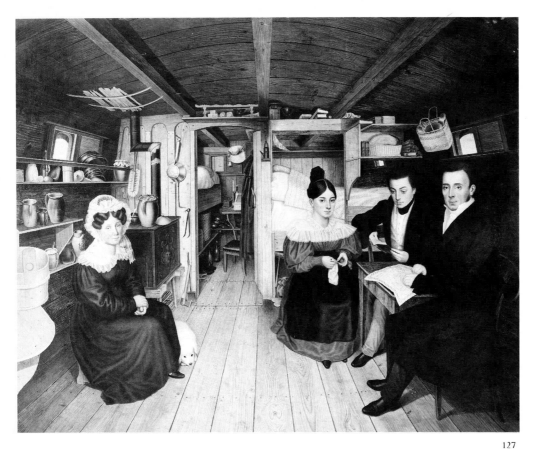

129. A Cosmoramic View of London

JOHN HENRY BANKS

Published by Edward Wallis and John Henry Banks, 1843
Steel engraved aquatint
38.7 x 90 cm
Private collector

An advertisement for Banks' 'Cosmoramic View' claimed it showed every public building in London, 'with the Docks, Railroads, Parks, Bridges, Squares, Palaces, and every object worthy of notice; equally useful and interesting to the resident, stranger, or foreigner'. It had been 'especially adapted for Coffee Rooms, Hotels, Libraries, and Public Buildings'. The print sold for five shillings plain, fifteen shillings coloured.

Whether this view was based on one exhibited at an actual cosmorama has not been established. When reissued in 1845 its title had been changed to 'A Panoramic View of London.'

130. Kaiserpanorama, Berlin

Colour photograph
By courtesy of the Berlin Museum

The Kaiserpanorama allowed up to 24 visitors to see an extensive series of images in succession. It is now in the Berlin Museum and is still in operation.

131. Stereorama, c.1860

47.5 x 49 cm (diam.)
Barnes Museum of Cinematography.

With this German stereograph a series of stereo-transparencies may be viewed simultaneously by four spectators. The stereographs are fed into the viewer through a slot in the top. When the handle is turned the stereographs are carried round within the drum to each spectator in succession before being dropped out of the bottom through a second slot. The chimney at the top of the drum serves as a flu for the paraffin lamp inside, which illuminates the stereographs.

127. The Sattler family in their boat

Oil on canvas
Private collector

Much of the Sattlers' travelling between 1829 and 1839 was accomplished in their boat. In this painting Joseph Michael is portayed on the right, with his son Hubert next to him. The lady seated next to Hubert is most probably his sister. On the opposite side of the boat sits Joseph Michael's forebearing wife.

VI MOVING PANORAMAS

Though the word 'panorama' was intended for giant, stationary 360° paintings such as Robert Barker's at the Panorama, Leicester Square, it was almost immediately applied to virtually any large picture displaying a broad scene. This was especially the case if the painting were by a scene-painter and exhibited at a theatre. At the turn of the century a new entertainment and application of the word was introduced – the 'moving panorama'. Moving panoramas, which in Britain and America became even more ubiquitous and popular than the 360° variety, consisted of canvases of often enormous length wound round a concealed spool which were unwound horizontally across prosceniums onto a second concealed spool. The earliest seems to have been an entertainment consisting of a series of views 'of the most magnificent buildings in London' which was displayed at Drury Lane's Christmas pantomime – *Harlequin Amulet* – in 1800.

Despite this early start it was not until the 1820s that moving panoramas became a regular feature in London pantomimes. In 1820 scene 14 in the Theatre Royal, Covent Garden's production, *Harlequin and Friar Bacon*, consisted of a rolling canvas that depicted a steam packet's voyage from Holyhead to Dublin. The artist responsible for this and many subsequent panoramas was Thomas Grieve. Moving panoramas lent themselves perfectly to river trips. A substantial portion of Grieve's panorama commemorating George IV's 'Northern Excursion' to Scotland in 1822, consisted of the river procession from Greenwich to the Nore; *Harlequin and the Dragon of Wantly* in 1824 featured a Thames sailing match, the heroes competing for the Cumberland Cup against a moving panorama displaying Lt Col Trench's proposed Thames Embankment. By rolling the canvas vertically it was possible to present aeronautical excursions. In *Harlequin and Poor Robin* Grimaldi in 1824 undertook a panorama balloon trip from London to Paris. In Covent Garden panorama's topicality was an important element. Responding to public curiosity the management in 1829 had David Roberts paint a panorama of Cpt Ross's recent quest for the North-West Passage. Queen Victoria's triumphal visit to the City in 1837 occurred on 9 November – Lord Mayor's Day. This left insufficient time to paint before Christmas a panorama that did justice to the occasion. Grieve therefore painted for Drury Lane's *Harlequin Jack-a-Lantern* a 'Grand Moving Panorama Exhibiting Queen Elizabeth's Royal Visit to the City.'

One must appreciate that moving panoramas were not restricted to the theatre. In the exhibition world they were liable to appear in just about any premises that could be quickly adapted, being toured from one town to the next by specialists such as J.B. Laidlaw, M. Barker (unrelated

to H.A. Barker), Daguire & Co., and above all Messrs Marshall. Important elements in their shows were musical accompaniment and additional, subsidiary entertainments. The Marshalls, when displaying their 'peristrephic' panorama of the 'Frozen Regions' in Glasgow in 1822, as an added attraction put on show a 'Collection of Natural and Artificial Curiosities from those almost unknown Regions'. The same firm in 1825 invited Waterloo veterans on Waterloo Day to don their medals and march with a military band 'to the field of battle' – to the painted field, that is, as shown on Marshall's 'Peristrephic Panorama of the Battles of Ligny, Les Quatre Bras, and Waterloo'. These showmen sought to attract the widest possible audience. Children – not babes in arms though – were encouraged to come, and concessions were offered for school parties. Laidlow put ladies and gentlemen in the boxes, 'all other classes' in the gallery; working class visitors at the American Exhibition in High Holborn were admitted at half-price. At fairgrounds the panorama showman had to compete with helter-skelters, freaks, and menageries.

Since no examples of exhibition moving panoramas of the early period survive, assessing their artistic merit is difficult. Marshall and Laidlaw often mentioned their sources in their advertisements and handbills. These were much the same as Burford's – drawings obtained from naval and military officers who had been present at the depicted engagement, Cpt Ross (Lt Beechey too) for Polar expeditions, and Frederick Catherwood for a panorama of Jerusalem. Laidlaw, who claimed to have received the 'united approbation of the most eminent Artists in London', invited the artists and lovers of fine art in Liverpool to inspect his 'Battle of Algiers', thoroughly confident it would exceed their most sanguine expectations.

No examples of pantomime panoramas survive either. From preparatory sketches, from the reputation of the artists – David Roberts, Clarkson Stanfield, and the Grieve family – and from contemporary theatre reviews, it is abundantly clear that they were of a very high order. Their absence from the corpus of nineteenth century British art is tragic.

A few moving panoramas continued to be exhibited in the 1840s, both in the theatre and on the road, but interest in them had certainly waned. The revival of interest at the end of the decade was triggered off, ironically, by the arrival in London of two rather indifferently painted panoramas from the United States. Both were of the Mississippi.

The first of these Mississippi panoramas was by a self-styled poor, untaught artist named John Banvard. Banvard began his drawing in 1840. He travelled thousands of miles in an open skiff, crossing and recrossing the rapid stream, in some places over two miles in breadth, to select appropriate points from which to make his sketches. When painted the panorama was, according to Banvard, the largest picture ever executed by man, showing 1,200 miles of river from the Missouri to New Orleans. In early publicity it was said to be three miles long. Banvard showed his panorama at Armoury Hall in Boston, Mass. where in nine months it attracted 251,702 visitors. Excursion trains were laid on by the railway companies to bring people from neighbouring towns. It was then exhibited at Panorama Hall on Broadway, New York, adjoining Niblo's Gardens. Here in seven months it was seen by 175,890. Banvard arrived with his panorama in England in the autumn of 1848. It opened at the Egyptian Hall, Piccadilly in December.

It was not only the length of Banvard's panorama that was a novelty; the lecture he gave was too. Though descriptive and statistical it was laced with jokes and poetry, all delivered with an attractive Yankee twang. From Banvard onwards no panorama show was complete without a lecturer – later called the cicerone – and a painting's success or failure would depend at least as much on this man's wit and luxuriant vocabulary as on the panorama's qualities as a work of art.

Three months after Banvard opened his panorama the second appeared on the scene, that of 'Professor' Risley and John R. Smith. Banvard promptly denounced it as a spurious copy. Risley and Smith responded by publishing the opinion of the photographer of Red Indians, George Catkin, that Banvard's panorama was 'the work of some one's imagination'. In any case their panorama was *four* miles long.

Between 1850 and 1852 Banvard toured his 'Mississippi' throughout England, Scotland, Wales and Ireland, exhibiting it in assembly rooms, mechanics institutes, corn exchanges, athenaeums, and concert rooms in over forty towns. In London it had been seen by 604,524 people in twenty months, an average of 1,259 per day. In Edinburgh it was exhibited for nine weeks at the Waterloo Rooms where it was seen by 48,352 people. Banvard calculated that in a thousand days the panorama was attended by over a million visitors (Banvard Scrapbook, p.39).

Perhaps in response to the American challenge Britain's theatre panoramists now broke free from pantomimes and addressed themselves to the wider world. Thomas Grieve, William Telbin, John Absolon, and David Roberts produced a very superior and artistic 'Overland Mail to India', painted with assistance and encouragement from the P. & O. Company. It was exhibited at the Gallery of Illustration in Regent Street before touring. Charles Marshall, a regular scene-painter at Drury Lane, meanwhile, launched a moving panorama of a 'Tour Through Europe.' Periodically revised and updated this panorama continued to be popular in other showmen's hands until the 1890s.

Where lecturers were concerned, however, there was no-one to challenge Albert Smith. Smith gave 2,000 performances of his panorama lecture. Mostly it was presented at the Egyptian Hall, but between September and November 1851 Smith toured the provinces. So popular was his show that it fostered a veritable flood of Mont Blanc-iana – Mont Blanc fans, roses, board-games, sheet music, and even nougat.

From mid-century moving panoramas became ever more sophisticated, and it was in the provinces rather than in London that the panoramists did most of their business. In 1850 E. Wigglesworth conveyed two tons of panoramic machinery to Bridgnorth. The storm at sea in Wigglesworth's panorama included agitation of the waves, clouds that obscured the sky, rain falling in torrents, thunder claps, and lightning flashes – and 'Capt Manby's humane invention for saving ship-wrecked seamen' thrown in for good measure.

In the north of England and in Scotland the principal panoramists were the Hamilton family; in the south it was the Poole family. The two firms worked closely. Eventually the Pooles had six shows on the road, each with a staff of thirty-five including members of the band, machinists, the cicerone, and variety artists. (Joseph Poole's staff totalled 280.) The Pooles had spare panoramas

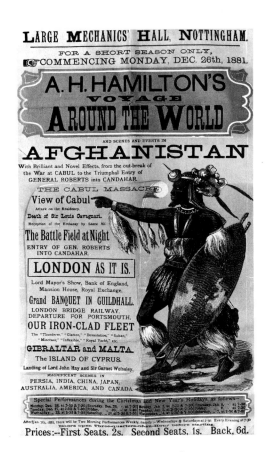

171 Poster advertising A H Hamilton's Voyage around the world

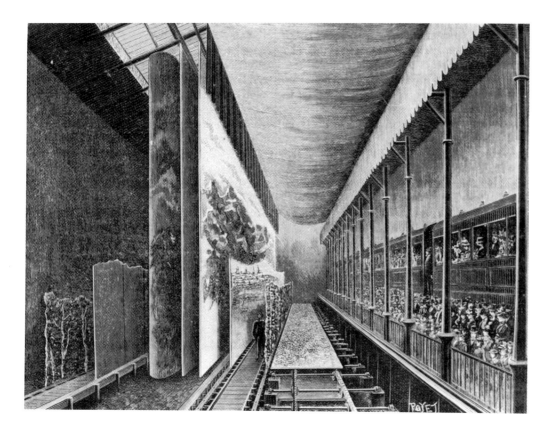

Trans-Siberian Railway Panorama, 1900

*Raffaelle Viledub, painting the first section, six miles in length... of his monster panorama of ALL CREATION. This section*says the Daily Snub, *which for strength & tone of color, is unequalled by the most powerful of the old masters, embraces that portion of time when DARKNESS WAS UPON THE FACE OF THE DEEP, & truly may it be said the artist has left nothing to be desired. Some a mile or two more of canvas.*

Caricature of Raffaelle Viledub painting 'Creation'

stored in London, a small studio in Bristol, and an extensive studio in Malmesbury, Wilts., where panoramas were painted, repaired, or updated. They employed ex-Barnum staff and were masters of publicity. Before arriving in Manchester up to fifty sandwich men, window billers, handbillers, and ticketers would be sent into the streets. During the season these agents would paste up about 11,000 posters and distribute up to a million half-price tickets from door to door.

In North America moving panoramas have been considered a uniquely American entertainment; Britons may be forgiven for considering them something of a British phenomenon too. The truth is, however, that they were far more widespread. They were known on the Continent of Europe, and popular in Australia.

Like circus showmen panorama proprietors travelled from one country to the next ignoring national boundaries. Readers of the *Exeter Flying Post* on 13 October 1828 were informed by M. Barker & Co. that a panorama of 'The Latest Days of Napoleon' was arriving in Exeter on its way from London to France. John Banvard in 1850 took his 'Mississippi' panorama to Paris, exhibiting it in the Bazar Bonne-Nouvelle. And in the 1880s Joseph Hamilton took his 'Overland Route from Charing Cross to Calcutta' to Italy, Switzerland, and France, spending ten months in Paris.

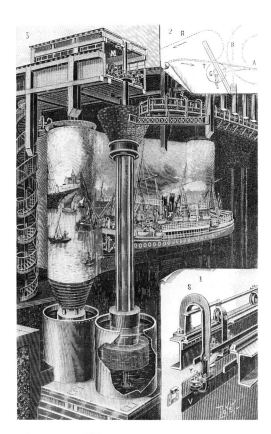

Mareorama, 1900

Panoramas were also brought from the Continent to Britain. Monsieur St Clair took a new grand moving dioramic panorama of the 'Victory over the Turks by the Greeks', painted on 20,000 square feet of canvas, around Britain, and Monsieur P. Daguire & Co. at about the same time toured a panorama of the Paris uprising of July 1830.

The moving panoramas which were most appreciated in Europe were those which gave spectators the sensation that they were moving. In Berlin in 1832 Gropius converted his Diorama into a Pleorama. Audiences sat in a ship whilst moving panoramas rolled past providing an hour-long excursion down the Rhine. The most elaborate of this species of panorama were those shown at the Exposition Universelle in Paris in 1900. They included a trip from Moscow to Pekin on the Trans-Siberian Railway, in which spectators sat in railway carriages whilst painted canvas sped past their windows; and the Mareorama which provided a Mediterranean cruise from Villefranche to Constantinople (stormy at one point) for 700 spectators standing on the deck of a steamer. At the Mareorama spectators were sandwiched between two simultaneously rolling moving panoramas.

In Britain in 1907 the Pooles took over 'Hamilton's Excursions' effectively eliminating all serious competition. Their programmes now included singing humorists, ventriloquists, jugglers, tight-rope artistes, and the acrobatic Leo-Tardi brothers. The public continued to enjoy Poole's 'Bombardment of Alexandria'. At Darlington a spark back-fired into a magazine box from one of that panorama's canon 'shoots', causing an explosion that blew out the windows and illuminated the hall with red fire. (The audience, according to the Poole business-house history, loved it.) Also popular was their 'Loss of the Titanic', the cicerone describing the disaster with such feeling that audiences wept.

From 1895 the Pooles had included film in their programmes. After 1910 the quantity of film steadily increased. Convenient spools of film replaced cumbersome rolling canvases. Cicerones were no longer needed, nor troupes of entertainers. The pianist, so necessary in the past with minor moving panoramas, once more came into his own. By the 1920s the Pooles had become proprietors of a chain of cinemas. The last performance of a Poole myriorama took place in Edinburgh in the Christmas season of 1928.

132. The Moving Panorama, or, Spring Gardens Rout

C. WILLIAMS

Published by S.W. Fores, June 1823
Coloured etching
25.8 x 36.2 cm
The Trustees of the British Museum, Department of Prints & Drawings

In the 1820s the principal proprietors of moving panoramas in the show world (as distinct from the theatre world) were Messrs Marshall. Their firm originated in Edinburgh where Peter Marshall, who had exhibited a moving panorama of the Clyde in Prince's Street as early as 1809, received permission to erect a wooden building on the N.E. corner of the Mound on 10 December 1818. In Glasgow the Marshalls erected a rotunda in George Square in 1822, moving to Buchanan Street in the following year; and in Liverpool they set up a rotunda in Gt. Charlotte Street in 1825. Popular 'peristrephic' panoramas (as the Marshalls

called theirs) of 'The Battle of Algiers', 'The Shipwreck of the Medusa', 'The Polar Regions' and 'The Coronation of George IV', were not only performed in such purpose-built structures, but also in adapted premises in a host of other towns – Bristol, Exeter, Dublin, Norwich, Hull and Manchester for instance. The regular venue for Marshall panoramas in London was Wigley's Great Room (sometimes the Lower Great Room also) in Spring Gardens.

H.A. Barker's Coronation panorama in Leicester Square netted £10,000. Barker retired on the proceeds. 'Messrs Marshalls' Grand Peristrephic Panorama of the Coronation of His Majesty George IV', which reached London in 1823, was similarly successful, and Williams' caricature conveys the excitement it aroused: 'I am told the King looks very majestic and elegant', says one person, fighting to get in. 'He is positively moving like life, and as large too', responds another. 'Give me your hand, Ma'am', says a letcher, 'I like to assist a lady to a good thing.' 'I really thought myself in the Abbey', says another coming out.

According to the publicity Marshall's Coronation consisted of 10,000 square feet of canvas, displaying on it 10,000 figures, 500 of the principal foreground figures being life-size. It had been painted under the direction of Sir George Nayler, Clarencieux King at Arms, from drawings taken on the spot. (Nayler also produced a sumptuous volume on the subject, *Ceremonial of the Coronation of ... King George the Fourth* (1823). During the evolutions a military band played Coronation music, in part to cover the noise of the machinery, one assumes.

133. 'Description of Messrs Marshall's Grand Historical Peristrephic Panorama of the Coronation of His Majesty George IV, now Exhibiting in the Exchange Room, Manchester', 1821

Booklet
20 x 12 cm
Manchester City Libraries

Before reaching London Marshall's Coronation panorama was exhibited in Edinburgh in the Pavilion, Princes Street, opposite Hanover Street; and then in the Exchange Room, Manchester. In May 1826 it was shown in the Rotunda in Buchanan Street, Glasgow.

134. Panorama of a Durbar procession of Akbar II, c.1815

ANONYMOUS DELHI ARTIST

Watercolour
15.7 x 238.8
British Library Board, India Office

The scroll records a procession of Akbar II, Emperor of Delhi, ·1806 to 1837. The Emperor's remarkable weekly procession from the Red Fort to the Mosque was commented upon by Western visitors. The event depicted most probably was on the occasion of the Id or after Ramadan. The Emperor is followed by his sons and by the British Resident (presumably Charles Metcalfe, Resident at Delhi, 1811 to 1819). The rest of the procession is made up of other high Indian and British officials, the ladies in closed bullock carriages, with elephants, camels, horses, and even a leopard. There are two gun carriages. The royal insignia – suns, umbrellas, fishes, etc. – are borne aloft.

Scrolls such as this were popular in India in the early

years of the nineteenth century. Robert Havell, the principle producer of long aquatinted panoramas of river excursions in the 1820s, had a relative who was resident in Madras. It is conceivable that he and his rivals were influenced by Indian scrolls as well as by Marshall's moving panoramas.

135. 'Theatre Royal, Covent Garden ... December 26, 1822 ... Harlequin and the Ogress, or the Sleeping Beauty of the Wood

Theatre bill
33 x 19 cm
Guildhall Library, City of London

Scenes 16 to 18 of 'Harlequin and the Ogress' consisted of a moving panorama of George IV's triumphal visit to Scotland in 1822. It was the first visit to Scotland by a reigning English sovereign since Charles II's in l650 and caused great public excitement. The panorama opened with a view of the embarkation at Greenwich, the royal vessel surrounded by the Lord Mayor's barge, City Company barges, and pleasure boats. The Royal Squadron then made its way down river, Woolwich being represented in the evening, Gravesend at night. (The Gravesend houses were illuminated, no doubt, on the same principle as perforated prints.) At the dis-embarkation at Leith kilted Scots sang lyrics written for Covent Garden by Sir Walter Scott. The panorama concluded with the grand procession down Calton Hill, Edinburgh. Mayer describes this panorama as one of the most popular scenic pieces of the decade. It served as the standard against which all later theatre panoramas were measured.

136. Costa Scena, or A Cruise Across the Southern Coast of Kent

ROBERT HAVELL JNR.

Coloured aquatint
8.3 x 554 cm in lacquered case
Private collector

Moving panoramas lent themselves naturally to the portrayal of river trips. One of the Marshall's earliest was of a 'Fashionable Tour for One Hundred Miles along the Banks of the Clyde', and in mid-century Warren, Fahey, and Bonomi's 'Grand Moving Panorama of the Nile' competed with rival, imported panoramas of the Mississippi.

137

In 1822 Robert Havell Jnr, an artist with an especial interest in the Thames (later he transferred his interest to the Hudson) published an aquatinted 'Panorama of London' from Vauxhall Bridge to Wapping which pulled out of a lacquered case. (Such boxes were sometimes referred to by Havell as 'Tunbridge cases' and on other occasions as 'Brighton-ware cases.') Armed with this attractive aid the steamboat ex-cursionist could establish which point he had reached on the river. 'Costa Scena' takes the excursionist on from Greenwich to France. In the Greenwich section George IV embarks for Edinburgh – the celebrated 'Northern Excursion', recorded by Turner. Those in the steamboat, however, proceed down river past Woolwich, Greenhithe, Margate, and Ramsgate, nego-tiating with ease a storm in the Channel to reach Calais. Like Havell's long London panorama, 'Costa Scena' pulls out of a lacquered case.

137. Lindenrolle, 1820

ANONYMOUS GERMAN ARTIST
Coloured lithographs
9.5 x 394.5cm (N. side); 9.5 x 382.7cm (S. side)
Hildegard Fritz-Denneville Fine Arts Ltd

A pair of panorama prints showing all the buildings in Berlin's Lindenstrasse as they appeared 1817-18. They were advertised in the *Haude & Spenerschen* newspaper on 18 November 1820. The panorama representing the N. side of the street unrolls to the right, revealing the buildings from the Royal Castle to the Brandenburg Gate; its companion representing the S. side, unrolls to the left to show the buildings between the Branden-burg Gate and the Catholic Cathedral.

In 1849 a second panorama of the Lindenstrasse was published in Berlin. Similar views were produced of Nevsky Prospect in St Petersburg by V. Sadovnikov; of the Champs-Elysées in Paris by Martinez (see cat. No.138); and of Regent Street in London by G.C. Leighton after R. Sanderson.

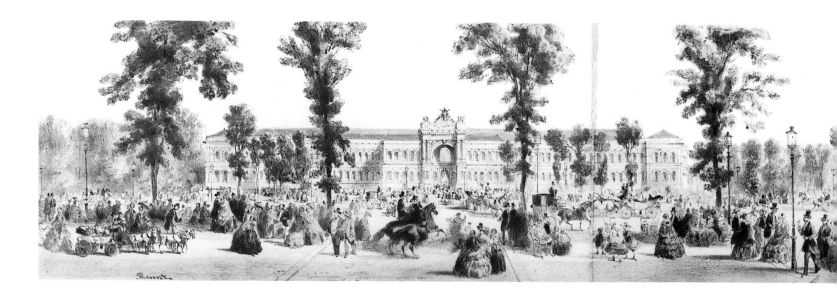

138. **Avenue de la Rue de Rivoli, des Tuileries, et des Champs Elysée,** c.1855

A. PROVOST

Published by Martinet
Coloured lithograph
11 x 200.5 cm
Private collector

This street panorama extends W. from the Place de la Bastille to the Arc de Triomphe, and shows the N. side of the Champs-Elysée. Like all examples of the genre it displays a wide variety of street type – itinerant traders, porters, roadsweeps, children with hoops, etc. – and also an interesting selection of vehicles.

Provost produced at least two companions to this panorama. From the style of the ladies' dresses they would seem to be earlier. The first, the 'Panorama des Champs-Elysée', begins at the Arc de Triomphe and extends E. to the Chateau des Tuileries and thus shows the S. side of the street. The other, the 'Panorama Interieur de Paris', extends from the Madeleine along many of the most fashionable boulevards to the Place de la Bastille.

139. **H. Alken's Panorama of a Fox-Hunt. Showing a large scope of the Leicestershire, Rutlandshire, and Lincolnshire Counties: with all sorts of Riders, Good, Bad, and Indifferent.**

HENRY ALKEN

Published by R. Ackermann Jnr, 1 Jan. 1828
Lithograph in lacquered case
9.6 x 321.3 cm
Private collector

The sporting printsellers, S. & J. Fuller of 34 Rathbone Place, and Rudolph Ackermann Jnr. of the Eclipse Gallery in Regent Street, issued a number of sporting panoramas. Several of them were drawn by Henry Alken – 'Going to Epsom Races', 1819; 'A Panorama of the Progress of Human Life', 1820; 'Epsom Races – The Derby Day', n.d. Of immense length they were marketed in lacquered Tunbridge cases such as this example, or folded into covers. Alken's 'Panorama of a Fox Hunt' was re-issued in covers in 1840.

140. **The Race and the Road, Epsom,** 1851

ACKERMANN & CO.

Etching, concertinaed into covers
12 x 224 cm
Private collector

A motley assortment of vehicles including stage coaches, omnibuses, hackney coaches, and traps make their way in great haste and with much commotion from the Elephant & Castle, via Kennington Gate, to Epsom, stirring up great clouds of dust. The drivers suffer numerous accidents. At

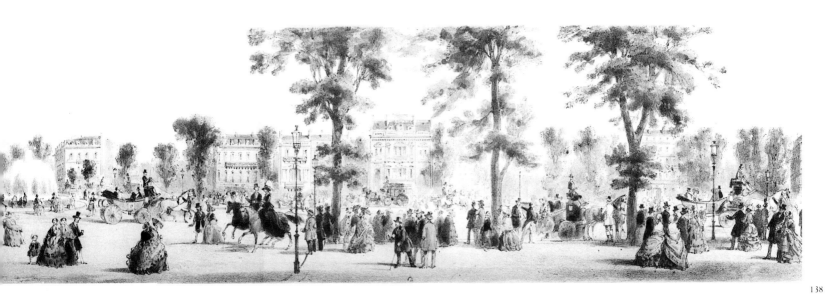

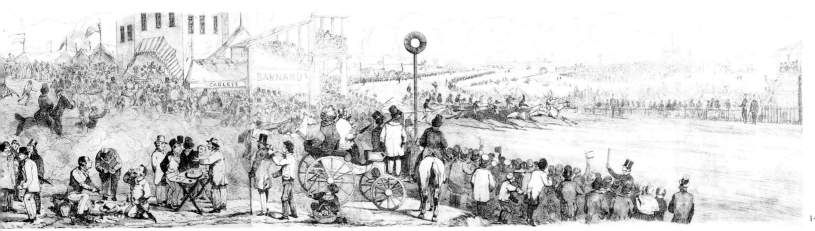

Epsom the punters lay bets, picnic, and view the races.

In the same year Ackermann & Co. published a parallel racing panorama – 'Epsom National Derby Day: Open to All Nations.' Signed by H. Alken, it was a skit on 'The Race and the Road.' The race this time was between camels, ostriches, lions, tigers and elephants, each ridden by a monkey. The punters were all foreigners, in London, presumably, for the Great Exhibition. They were shown making the return journey from Epsom to the Elephant & Castle.

141. A home-created moving panorama, c.1840

MARIANNE SMITH

Watercolour
15.5 x 1630 cm
Lady Elton

This panorama consists of a sequence of scenes presented as a continuous image. The lender has kindly supplied the following notes: 'One scene suggests Queen Square [Bristol] with the Rysbrack equestrian statue. The drawing-room where the party is taking place is

probably a Georgian house in Clifton, or maybe Kingsdown Parade, Clifton. Fanning out from Bristol [the artist] could easily have travelled the few miles to Tintern Abbey. The Cheddar Gorge seems easily identifiable. The only substantial forest near here is the forest of Dean, and other scenery suggests the Wye Valley. The village on the Bristol Channel might, with a stretch of the imagination, be seen from Clevedon.'

Marianne Smith (1785-c.1873), daughter of a wealthy merchant who lived in Queen Square, Bristol,

was a talented amateur artist who had connections with the Fraternity of Sketchers, a group who met regularly at Leigh Woods above the Avon Gorge. She devoted her life to her sister (Sara), her brother-in-law (Sir Abraham Elton of Cleveland Court), and their eleven children. It seems likely that she produced the panorama to amuse the children or their off-spring.

Most probably the watercolour would have been set up in a cabinet with two spools, and cranks to wind the panorama on from one spool to the other. Reversed lettering in one section suggests that the cabinet was furnished with a mirror to produce a three-dimensional effect.

142. Betts's Pictorial Noah's Ark

PHILLIP, SON & NEPHEW

Aquatint
24.5 x 33
Barnes Museum of Cinematography

This instructional toy was designed to teach small children the names of a wide range of animals. By rolling the panorama the animals disappear two-by-two into the Ark.

143. View of the North Bank of the Thames from Westminster Bridge, to London Bridge. Shewing that Part of the Improvements Suggested by Lt.-Col Trench, which is Intended to Carry into Execution.

T. M. BAYNES

Published by Rudolph Ackermann, Jan. 1825
Lithograph
19.5 x 544 cm
Guildhall Library, City of London

In 1824 Lt. Col. Frederick William Trench MP proposed the construction of an eight-foot wide ornamental quay extending from Scotland Yard to Blackfriars. Its purpose was to improve the appearance of the river and relieve traffic congestion in the Strand. Trench's embankment would incorporate a terrace of grand houses, wide stairs from St Paul's descending to the river, and a large equestrian statue of George IV. Although the scheme received the backing of a proportion of London's high society, it was attacked by the wharfingers, the benchers of the Temple, tradesmen in the Strand, and aristocrats with houses bordering the river. To inform his fellow Members of Parliament and to win public support Trench commissioned Baynes to draw a ten-sheet perspective of the scheme and Ackermann to publish it. A few presentation copies were printed on silk. Trench's Bill was presented in the House of Commons in March 1825. It was not enacted.

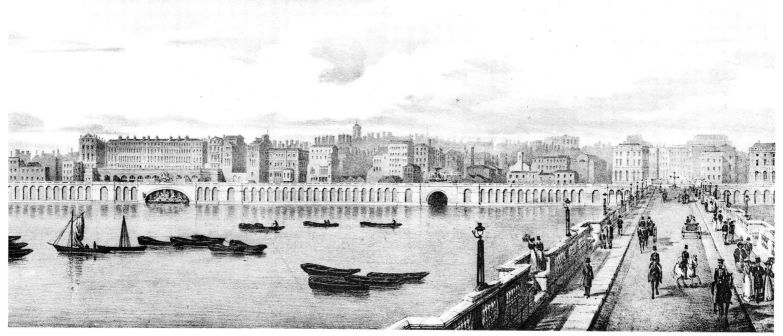

143 (detail)

144. 'Theatre Royal, Covent Garden...Harlequin and the Dragon of Wantly; or, More of More Hall . . . ', 1824

Theatre bill
Guildhall Library of London

Colonel Trench's proposed Thames Quay was ideal for a pantomime panorama: of necessity it had to consist of a long river view; the subject was currently the talk of the town; and the view informed curious London audiences of the threatened improvement to their city. That the Colonel and his scheme were not taken too seriously in some quarters provided a light-hearted touch. The panorama was first shown on 27 December. 1824 and it continued to be performed well into 1825. Since the Baynes lithographs (cat. No.143) were not marketed until 5 March 1825, the scene-painters (Grieve) would seem to have had direct access to Trench's plans. In the performance four boats raced from Blackfriars Bridge to Cumberland Gardens for the Cumberland Cup, the movement of the London topography on the panorama giving the impression that the boats were in motion.

Other town improvements that featured in theatre panoramas included Dance's double London Bridge (cat. No.36), and 'Mr Thorne's intended port of Norwich' (*Norfolk Annals*, p.291).

145. A Trip to Antwerp in the Steam Frigate Rhadamanthus...Grand Moving Panorama Painted by the Messrs Grieve in the Pantomime 'Puss in Boots', Theatre Royal Covent Garden, 26 December 1832

GRIEVE FAMILY

Watercolour and body colour on cut card, inscribed with the names of places shown:
13.4 x 213.5cm between lines
University of London Library, Grieve Collection

This model is one of the few designs known to survive for a theatrical moving panorama and it is certainly the most elaborate. The principle element is a moving panorama cloth, cut at one point for a 'dioramic' transparency of moonlight over the fleet. The cloth may not have been a continuous length and the three 'pop up' set pieces incorporated in the design would have been mounted further upstage from it as tableaux. The rising curtain would thus have revealed the fleet at anchor off Deal with the cloth showing them under sail drawn on to conceal this. The view of Ostend would then have been set up to replace Deal and be revealed in its turn before being covered by the next stretch of painted cloth. The Citadel of Antwerp on fire was set up as the finale in the same way. Gauzes were almost certainly used both for effect and to give the cloth structural integrity at points irregularly cut. An engraved key published in the 'book of songs' of the pantomime (cat. No.146) shows the sequence and also indicates that two small sections may now be missing from the design.

The scale of the model is 1/4 in: 1ft, showing that, as staged, the panorama and related set pieces would have been 20 to 21 feet high by about 400 feet long. About 30 feet would have been visible at any time, movement being from left to right with the usual musical and sound effects accompaniment.

The subject derives from the major European news story of late 1832 when, as a result of Dutch resistance to territorial and tariff implications in the formation of what is now the kingdom of Belgium, a British squadron was sent to blockade the Scheldt while a French army besieged and captured the citadel of Antwerp after a stiff Dutch defence. The Grieves had clearly read news reports of the devastation caused in the citadel well before its final surrender on 23 December, as well as being aware that the Paddle Sloop

Rhadamanthus, then the latest thing in naval technology, had been part of the British squadron. This was probably represented by a painted cut-out, with paddles turning, set in front of the cloth.

The Grieve family of scene-painters – John and his sons Thomas and William – virtually ruled the Covent Garden scene-room for thirty years and their work is often difficult to tell apart; comparison however now suggests this design is by Thomas, 1799-1882.
[Pieter van der Merwe]

146. Book of songs for 'Puss in Boots'

Pamphlet
Dr David Mayer

A books of songs, serving the same purpose as the theatre programme, was often issued for pantomime audiences. It provided the *dramatis personae*, songs from the production, and descriptions of the scenery, including the panorama if there was one. A key to the panorama would be appended. The key to the 'Trip to Antwerp' panorama provides us with numerous clues on how it was exhibited.

147. Reconstruction: The New and Splendid Diorama designed and painted by Mr Stanfield From Sketches taken on the spot during his last continental tour. The Various Views will display Venice and its Adjacent Islands

DESIGNED AND PAINTED BY CHRISTOPHER BAUGH, AFTER CLARKSON STANFIELD

No. 1. The Grand Canal; No. 2. The Church of the Santa Maria della Salute; No. 3. The Dogano; No. 4. St. Georgio Maggiore; No. 5. The Lido; No. 6. The Lagunes at Night; No. 7. The Bridge of Sighs, by Moonlight; No. 8. The Piazza de San Marco; No. 9. The Ducal Palace
Construction by Michael Lewis and Peter Spurrier
Electronics by Adrian Wood
Research by Pieter van der Merwe

Tyne and Wear Museums Service, (Sunderland Museum)

Clarkson Stanfield RA, 1793-1867, was the most celebrated theatrical scene-painter of the early nineteenth century as well as being one of its leading marine and landscape artists. He worked at the Theatre Royal, Drury Lane from 1822 to 1834 and was particularly famous for the vast moving panoramas which he crea-

ted for the Christmas pantomimes of 1823-34 and 1828-33. 'Only those who have seen these really stupendous works', wrote Henry Ottley, 'can form an inventive talent and artistic skill ...developed in them. They opened the eyes of the mixed audience of a theatre to the beauties of landscape painting...and...led to a permanent advance and improvement in the scenic decoration of our theatres'.

While no designs of Stanfield's dioramas appear to survive, the general principles on which they operated can be reconstructed from designs by others, 'keys' published in pantomime 'books of songs' (including two Stanfield examples), and other sources.

In general such theatrical panoramas consisted of a panorama cloth around 400 feet long and 20 feet high unrolled across the stage with complex effects of gaslight and mechanics. The cloth may not have been in a continuous length and in some cases seems to have drawn off to reveal 'pop-up' scenic tableaux behind while other areas were given depth by set-pieces in front, either moving or stationary. Transparent areas in the cloth allowed dioramic effects of light, and the whole spectacle – which would take about 15 to 20 minutes – was accompanied by music and sound effects both to enhance the impact and cover the inevitable mechanical creakings, signals, (and sometimes audible swearing) which the technology and the co-ordination of a large stage crew involved.

The model shown here is a hypothetical reconstruction at approximately 1:12 scale of Stanfield's Venetian panorama for *Harlequin and Little Thumb*, which opened in Drury Lane on 26 December 1831. The published key for this clearly shows the principle views and how closely these spectacles could resemble an 'unrolled' Barker-type stationary panorama. The spectator here is, in theory, viewing the scenes from a boat on the Giudecca, and the 'book of songs' gives the lyrics of a gondoliers' chorus which formed part of the musical accompaniment, as well as indicating the night effects employed. Theatrical panoramas were usually mounted well up-stage and framed by a formal setting – in this case apparently formed by the previous scene which showed the interior of the Haymarket Theatre. The magic was thus enhanced both by distance and a double effect, that of seeing the panorama in a theatre-within-a-theatre.

This model was built in 1979 for the Clarkson Stanf-

ield exhibition, organised in Bonn and Sunderland, by the Tyne and Wear Museums Service. As with many original panoramas in the theatre, it has proved surprisingly robust and has well outlived its designed lifetime. The original music is unknown and the accompaniment is taken from Rossini's *William Tell* and *Otello*. (Pieter van der Merwe)

148. **Machinery for Banvard's moving panorama**

From *Scientific American* 16 December 1848
Photograph of line engraving

149. **Risley & Smith's Mississippi panorama**

Handbill
Westminster City Libraries, Westminster Collection

Banvard's 'Mississippi' soon found itself in competition with a rival work of precisely the same subject, painted by John Rowson Smith, in partnership with a showman acrobat, 'Professor' Risley. An alarmed Banvard alerted the public, warning against this 'spurious copy.' Smith and Risley responded, denouncing Banvard's work as 'an utter imagination', full of 'glaring omissions and incongruities.'

150. **S. C. Brees, C.E., Late of Wellington, New Zealand**

G.B. BLACK

Tinted lithograph
35.5 x 28 cm
Westminster City Libraries (Westminster Collection)

Brees's panorama, exhibited at 5-6 Leicester Square (i.e. the Linwood Gallery), was more sternly educational than most, and its purpose in part was to encourage emigration. It opened in December 1849, the exhibition room being agreeably heated and lit so that the panorama could be viewed to as much advantage during the frosty, dark winter weather as it could be in the middle of the summer.

Brees, the principal surveyor and engineer of the New Zealand Company, was a populariser of matters technical. His *Glossary of Civil Engineering* claimed to be the first elementary book on that subject. The New Zealand panorama was based on his own drawings but the painting was undertaken by W.A. Brunning, J.

Zeitter, H.S. Melville, W. Wilson, E. Hassell and various assistants. An enthusiastic reviewer reported the details that he had enjoyed most: fern beds, bush life, roaring night fires, and, above all, 'hair-breadth escapes from the Natives who gave an account of themselves and their customs, on hearing which we found they were not as bad as they appeared.' *The Times* reviewer was also impressed: 'Mr Brees's Panorama', he declared, 'will do more to promote emigration than one thousand speeches and resolutions.'

150

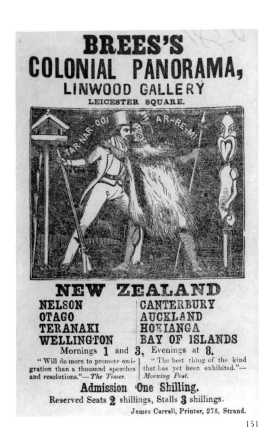

152

151. 'Brees's Colonial Panorama, Linwood Gallery, Leicester Square'

Handbill
20 x 13 cm
Westminster City Libraries, Westminster Collection

In the wood engraving on his handbill Brees rubs noses and exchanges friendly noises ('Tar-nar-qoi ar-re-mi') with a Maori warrior.

152. Route of the Overland Mail to India

Book. Published by Atchley & Co. [c.1851]
The P. & O. Group

The Gallery of Illustration's 'Route of the Overland Mail to India', April 1850 – Febuary 1852, was far superior to the general run of moving panoramas and elevated panoramas 'from a mere source of instruction to a work of art', as *The Times* put it (quoted by Wilcox p. .) Like the American Mississippi panoramas then in London it had a lecturer – J.H. Stocqueler, who was a journalist and an expert on India – and very great length, for it consisted of forty or so tableaux. Where it differed was in the quality of its execution. Three of the ablest scene painters of the day collaborated – Thomas Grieve, William Telbin, and John Absolon (who drew the figures). David Roberts contributed drawings for the Egyptian scenes. As at Burford's Panorama, Leicester Square, use was made of sketches made by officers serving in remoter places. The P. & O. Company supplied the costumes. The panorama was performed at the Gallery (formerly John Nash's Regent Street residence) behind a flattened oval-shaped frame. The music consisted of national airs of countries passed through.

The voyage depicted on the panorama began at Southampton Docks where embarkation on a steamer took place. The route was via Osborne, the Needles, Cintra, Gibraltar, Algiers, Malta, and Alexandria. Crossing the desert in vans resembling omnibuses, the travellers were able to observe artificial egg-hatching, nomadic encampments, Bedouin tribesmen, Joseph's Well, and a dead camel. At Suez they took ship for Jeddah, Mocha, and Aden. A voyage across the Indian Ocean brought them to Point de Galle, Ceylon, where the steamer re-fueled before proceeding to Madras and Calcutta.

A *Punch* reviewer (18 (1850), p.208) thought the panorama 'a most lovely work of art...radiant with beauty, and sparkling with most costly Indian gems'. The desert sand, it noticed, was alive with Arabs and omnibuses: 'Camels too are dying – which is a great proof of the picture's accuracy, for we never recollect a view of the desert yet but that there was sure to be a camel dying in it...Finally', the notice concluded, 'we have reached Calcutta, and by the noise and shuffling are reminded that we have never left London. It is most curious on coming out into Regent Street to find the porters and cabmen are not black, and that persons are riding around on horses instead of camels.'

This volume contains 32 scenes from the 'Overland Mail', engraved after watercolours by Henry Fitzcook.

143

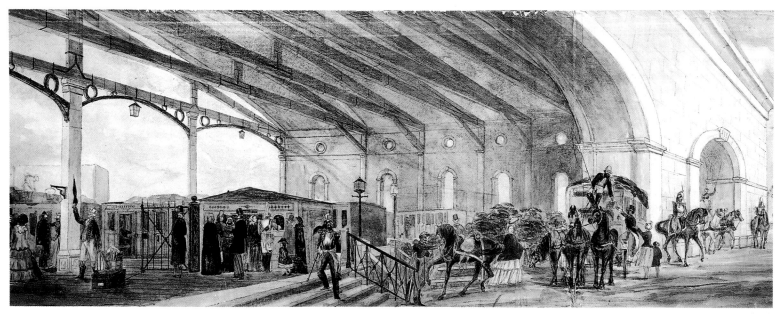

153. **London to Hong Kong in Two Hours,** c.1860

JOHN LAMB PRIMUS AND JOHN LAMB SECUNDUS

Watercolour

37.5 x 5,338.5 cm

David Brill, deposited at the Museum of London

This moving panorama of a trip to Hong Kong was produced for a Christmas entertainment in a Victorian family. Compared with most professsional panoramas its scale was modest. A volume survives giving two versions of the lecture to be read with it, notes on sources for the images, and a diagram to show how the proscenium should be erected. The area of the panorama visible to the family audience at any one moment would not have been larger than a 24″ T.V. screen.

The panorama conducted its audience to the Orient using the Overland Route – i.e. crossing the Sahara Desert rather than sailing round the Cape. Allusions are made to the Indian Mutiny (1851-58) and the Second Opium War (1856-60). The artists, two John Lambs, father and son, were commission and general shipping agents in Moscovy Court near the Tower. Some parts of the panorama are crude, others far more ably executed. Comparison with the P. & O. Group's Fitzcook drawings suggest that the Lambs were influenced by the Gallery of Illustration's 'Overland Mail'.

The journey begins at London Bridge Wharf. We are taken down river past Billingsgate, the Tower, London Docks, Blackwall, Tilbury, and the Nore, crossing the Channel to Ostend. From there we travel to Marseilles by rail. From Marseilles we embark for Jaffa, sailing past Malta, and then Mount Carmel. Briefly we visit Jerusalem before setting off for Suez. In the desert we pass a Bedouin encampment, travel through a rocky pass infested with lawless robbers, have the experience of a mirage, and inspect the pyramids. We sail from Suez down the Red Sea and across the Indian Ocean. In Ceylon we marvel at a banyan tree, watch a tiger hunt, and, at Pointe de Galle, spot some of the Poonah Light Horse who had remained loyal to Britain in the Mutiny. Again we set sail but in the Strait of Malacca encounter a storm. On arriving in Hong Kong we see a body of troops in Victoria Harbour preparing to return to India after an engagement in the China War, in which they 'licked' the 'Tartars.' In the city we pass the shop of 'Esing', a Chinese baker who had attempted to kill the English by poisoning all the bread. From the grounds of a Chinese friend we view the harbour. Finally we admire an illuminated fountain.

The panorama incorporates dioramic effects for the moon-lit nights, the mirage, and a rainbow that appears after the storm.

153 (detail)

153 (detail)

154. A Sectional View of Mr Wyld's Great Globe

From the *Illustrated London News*, June 1851
Photograph of wood engraving.
Guildhall Library, City of London

James Wyld II, mapseller in the Strand and 'Geographer to the Queen', in 1851 obtained a ten-year lease on Leicester Square. In its centre he quickly erected a vast globe. To inspect it one had to penetrate the globe, climb a series of cast-iron staircases, and view it from within, for it was on the inside that the world's surface was represented. The snow-line of the mountains were delineated by a white incrustation that sparkled in the gaslight, and all the volcanoes were shown in a state of eruption. From hour to hour descriptive lectures were delivered. To encourage people to return Wyld held exhibitions of an educative nature, and also moving panoramas.

155. View of the exterior of James Wyld's Globe, 1857

Stereoscopic photograph

Barnes Museum of Cinematography

Before becoming a mapmaker James Wyld had trained for the army at the Royal Military Academy, Woolwich. At his Monster Globe he reminded all of his continuing interest in matters military, exhibiting models and maps of Crimean seats of war. His moving panoramas (at the theatre he called them 'dioramas') included 'A Dioramic Tour from Blackwall to Balaclava', 'The Diorama of the Campaign in India', a 'New Diorama of the War in China', and a more pacific 'Diorama of Russia' painted by the theatre scenepainter, Charles Marshall. The Russia panorama is advertised on the building in this stereoscopic photograph.

156. Great Globe, Leicester Square...Diorama of Russia, 1857

Handbill
25 x 12.5 cm
Barnes Museum of Cinematography

The moving panorama of Russia exhibited at Mr Wyld's Monster Globe was made up of forty-four tableaux. Places made familiar by the recent Crimean War were inevitably included. The panorama's climax was the Coronation of the Czar in the Cathedral of the Assumption, Moscow. Performances of the Russia panorama were alternated with performances of a panorama of Upper India, now topical thanks to the Indian Mutiny.

157. Portrait of a Gent [ie Albert Smith]
D. DRYPOINT

Published by D. Bogue
Etching
34 x 24.5 cm
Barnes Museum of Cinematography

Britain's answer to America's John Banvard was Albert Smith whose panorama and lecture on an ascent of Mont Blanc was performed 2000 times in six seasons at the Egytian Hall. In fact Albert Smith had been showing panoramas for some years, his interest in Mont Blanc having been sparked off by *The Peasants of Chamounix*, given to him on his tenth birthday. He created his first panorama of the subject at the age of eleven. As a young man when invited to give a lecture at Chertsey Literary & Scientific Institute he presented an improved version of the Mont Blanc lecture. So popular was it that he was soon in demand in local towns. 'I recollect', he wrote, 'how my brother [Arthur] and I used to drive our four-wheeled chaise across the country with Mont Blanc on the back, and how we were received usually with the mistrust attached to wandering professors by the man who swept out the Town Hall, or the Athenaeum, or wherever the institution might be located...I recollect too how the heat of my lamps would unsolder those above them, producing twilight and oil avalanches at the wrong times; and how my brother held a piece of wax candle-end behind the moon on the Grand Mulets, which always got applause.'

Smith moved to London in 1841 and embarked on a career of writing, turning out novels, articles, parodies,

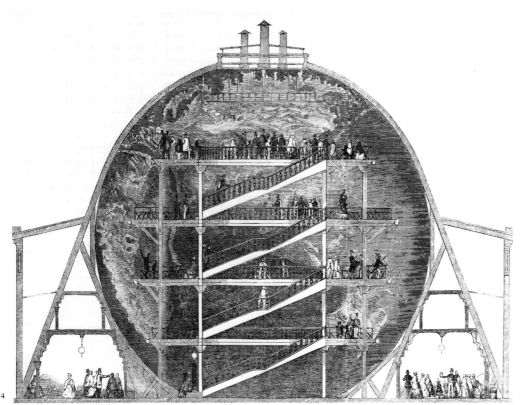

154

plays, and pantomimes. He contributed frequently to the *Illustrated London News*, and it was in this journal on 5 August 1850 that he coined the word 'panoramania', using it to describe the craze sparked off by Banvard's 'Mississippi.' In the following year he produced his own panorama, 'Albert Smith's Overland Mail', which he exhibited in Willis's Rooms in London, and then, between 1 September and 28 November 1851, in no fewer than 42 provincial towns. In August 1851 he visited Mont Blanc, accompanied by the scene-painter William Beverley. The celebrated 'Ascent' was the outcome.

In 'Drypoint's' portrait Albert Smith is shown with many of his fictional characters.

158. Albert Smith presenting his 'Ascent of Mont Blanc' panorama at the Egyptian Hall, Piccadilly

From *Illustrated London News*, 25 December 1852
Photograph of a wood engraving

Smith opened his Mont Blanc entertainment in a suitably adapted Egyptian Hall on 15 March 1852. At the front of the room a Swiss chalet had been erected, and in front of this was placed a pool, stocked with fish and surrounded by Alpine plants. On the walls were the banners of the various Swiss cantons. Smith gave his lecture in full evening dress. This consisted of anecdotes, literary description, character impersonation, and patter songs; it was regulary rewritten to introduce allusions to current news items. For the journey to Chamounix Beverley's scenes moved across the stage horizontally. After the intermission for the actual ascent they moved vertically. Not all visitors approved of the show. Gideon Mantell (*Journal*, p.290) pronounced himself heartily tired and altogether chagrined that such a sublime subject could be so frivolously treated, and that Smith's lecture should be received with such unbounded delight: 'Had it been a trip to Margate, or the ascent of the hill in Greenwich Park on Easter Monday, it would have been very well: the scenery, the subject, the man, the manner, and the audience would have been in excellent keeping! As it was, I felt the sanctity of the Lake Leman and the sublime monarch of mountains was desecrated. The moveable transparent scenes were very beautiful.'

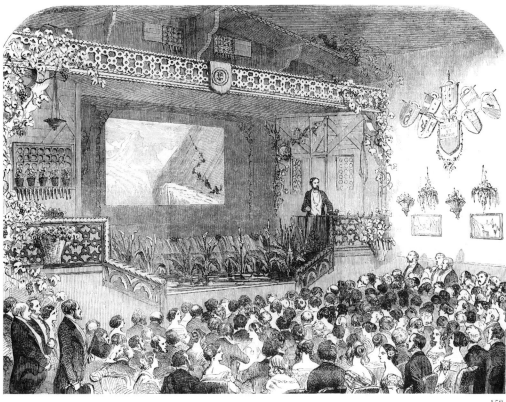

158

159. Albert Smith scrapbook

Mike Simkin Phantasmagoria Museum

This scrapbook of items relating to Albert Smith and his career as a panorama showman was compiled by Albert's brother, Arthur. Arthur served as Albert's manager, and 'knew all the tricks of the trade as well as Barnum' (Hollingshead, pp.142-43.) He put off opening the doors of the Egyptian Hall every night for five minutes and caused a traffic jam in Piccadilly. When complaints were made he offered to pay a £50 fine for another five minutes 'obstruction'. His scrapbook contains newspaper cuttings, programmes, tickets, some drawings, paper roses, and manuscript letters. It is opened to display sheet music entitled, 'The Mont Blanc Qudarille'.

160. Model of the Egyptian Hall, Piccadilly, exhibiting Albert Smith's 'Ascent of Mont Blanc' panorama

David Francis

161. Lantern slide projector, with slides of 'The Ascent of Mont Blanc'

Mike Simkin Phantasmagoria Museum

These four glass panoramic lantern slides were hand painted after William Beverley's scenes for 'The Ascent of Mont Blanc'. They were manufactured in 1885 by Isaac Knott of Liverpool, instrument and slide maker to the Royal Polytechnic Institution, London. The horizontal dissolving view magic lantern, with limelight illumination, was also made by Knott, and in the same year.

162. The New Game of the Ascent of Mont Blanc

A.N. Myers & Co. Second edition, 1861
Coloured lithograph
53.5 x 43 cm
Mike Simkin Phantasmagoria Museum

This board game version of Albert Smith's panorama consists of 53 scenes including the William Beverley images. Each player receives three dozen counters. To advance from the Egyptian Hall, Piccadilly players spin a tee-to-tum. Those not feeling sick when crossing the Channel are awarded six counters; those landing on St Bernard's Convent must surrender six to pay the monks for their hospitality. Whilst climbing the mountain charges are made for guides, ropes, and walking poles. The player reaching the summit of Mont Blanc first wins. Descending to Chamounix the players open a bottle of champagne and cry, 'God Save the Queen!'

163. Paper rose, displaying scenes from Albert Smith's 'Ascent of Mont Blanc'

23 cm in diameter
Mike Simkins Museum of Phantasmagoria

This paper rose unfolds from a wedge shaped single petal to reveal an array of tiny steel engraved vignettes. They include minute versions of William Beverley's paintings for the 'Ascent of Mont Blanc.'

Paper roses such as this one were a speciality of Rock Brothers, illustrated letterpaper printer in Walbrook in the City of London.

163

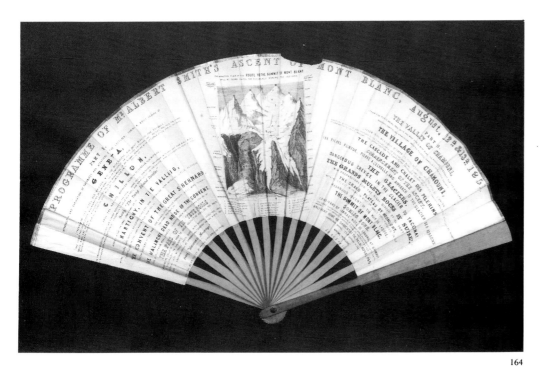

164

166. Artemus Ward presenting his Mormon panorama

From the *Illustrated London News*
Photograph of wood engraving.

Ward's show at the Egyptian Hall in Piccadilly, which opened on 13 November 1866, was a drole send-up of other panoramists' performances, particularly those of Albert Smith who had earlier lectured with such success in the same premises. Ward's moving panorama of an overland trip to Salt Lake City periodically stuck, he had great trouble with his Moon, and his pianist drowned out his punch lines. On his programme he proudly asserted, 'The Panorama used to Illustrate Mr. Ward's Narrative is rather worse than Panoramas usually are.' His staff, so he claimed, included a crankist, an assistant crankist, a moppist, a broomist, a doortendist, a gas man (Artemus Ward, of course), and a Dutchman played by a Polish refugee called McFinnigan.' Tall and slender, with a beak of a nose and a large moustache, Ward presented his lecture in a most solemn manner, never ever smiling however much his audience laughed. Now and then he would stop and gaze earnestly at the awful panorama with affected admiration. The show closed on 23 January 1867. Ward, who had been in very bad health throughout the season, died six weeks later.

164. Fan with title: 'Mr Albert Smith's Ascent of Mont Blanc, Augst. 12th & 13th 1851.'

Lithograph
12 cm (high) x 44 cm (across when open)
David Robinson

This item, printed in Paris, on the front reproduces three of Beverley's views – The 'Mur de la Côte', the 'Grand Mulets', and 'The Coming Down.' On the reverse there are full details of Smith's programme at the Egyptian Hall.

167. Programme for 'Artemus Ward Among the Mormons.'

Halesowen Institute Furnishing Fund, 1880
Programme
21 x 13 cm
David Francis

Following Ward's early death a Mr W. Hinton in the 1880s continued to present the 'Artemus Ward Among the Mormons' lecture in provincial clubs and infant school rooms. Posters proclaimed it a 'Farcical, Extravaganzical, Mechanical, Epidemical, Whimsical, Vocal, Side-Splittical, Panoramical, and Bioglyphical Entertainment'. Evidently blessed with the same whimsical humour as Ward, Hinton said he had 'delivered lectures before ALL THE CROWNED HEADS OF EUROPE ever thought of delivering lectures'.

165. Earthenware plate commemorating Albert Smith's 'Trip to China' panorama

25.5 cm diameter
David Robinson

The Mont Blanc show finally closed on 6 July 1858. Smith had resolved to replace it with an overland trip to China and almost immediately set off for the Far East, his trip admirably managed by the P. & O. Company. The new panorama lecture, 'Mont Blanc to

165

China', opened on 22 December. On the opening night willow-patterned china plates bearing Albert Smith's portrait were on sale in the foyer, priced at one shilling. At the two-hundredth night the plates were presented to those who attended.

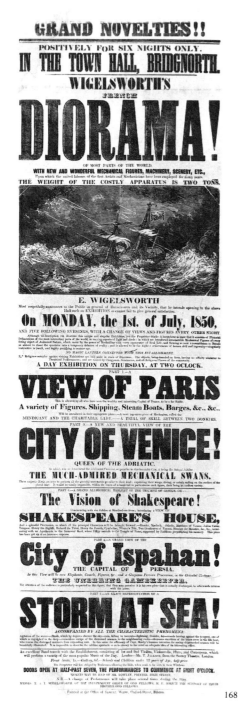

168. 'Wigglesworth's French Diorama of Most Parts of the World', at the Town Hall, Bridgnorth, 1850

Poster with wood engraving

73.5 x 24 cm

Bill Douglas & Peter Jewell Collection

Wigglesworth's panorama heralded the more sophisticated shows that would become common in the 1860s through to the 1900s. The show included not only the storm with its ingenious effects described in the essay above, but also mechanical swans that expanded their wings and dived in the lagoons of the painted Venice. Wigglesworth called upon brother Odd Fellows in particular to support him. 'Religious scruples against visiting Exhibitions are laid aside in the cases of Dioramas', he assured Evangelicals, 'the objects being founded on facts, having no affinity whatever to Theatrical Performances; and are visited by Clergymen, Seminaries, and all Religious Classes of the Community.'

169. Dyson's 'diorama' and gipsy choir, c.1893

Pamphlet with lithographic illustrations

28 x 22 cm

Mike Simkin Museum of Phantasmagoria

Joshua Dyson's lively and energetic entertainment toured the provinces from 1885. It boasted a repertory of 3,000 'real works of art', and some 200 pieces of music played and sung by a gipsey band and choir. Images seem to have been projected onto a screen with a Steward Triple Lantern. In this pamphlet Dyson claims his show had attracted over 3 million visitors in the past five years.

170. Hamilton's Delightful Excursion to the Continent and Back within Two Hours!

Poster with wood engraving

49.5 x 24 cm

Bill Douglas & Peter Jewell Collection

The Hamilton dynasty launched their first panorama in 1848. Though particularly active in Scotland and the North of England, they occasionally exhibited in the South and in London. The firm produced its own panoramas and acquired those of rivals. These included Philip Phillips' fine 'Grand Moving Panorama of Hindoostan', originally exhibited at the Asiatic Gallery in the Baker Street Bazaar.

In the descriptive booklet for 'Hamilton's Excursion to the Continent' it is claimed that the panorama had been drawn by Alfred Hamilton, assisted by other eminent artists. The panorama seems originally to have been Charles Marshall's, however. Alternatively it may have incorpoated parts of Marshall's panorama. Marshall, a scene painter at Drury Lane, had been the proprietor of the Kineorama, Pall Mall and an artificial ice-rink in Grafton Street. His 'Grand Tour of Europe' was exhibited in 1851 at her Majesty's Concert Rooms in the Haymarket, and at the Linwood Gallery in Leicester Square. By September. 1862 it was being performed at the Assembly Rooms, Princes Street, Bristol. The *Illustrated London News* on 22 February 1851 reproduced the first scene of that panorama – a paddle steamer at the Tower of London. The image corresponded precisely with that on Hamilton's poster.

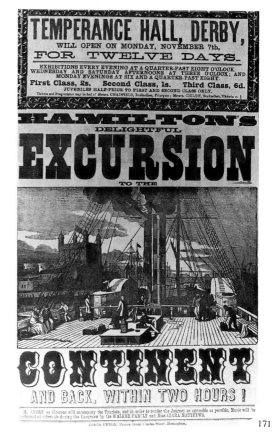

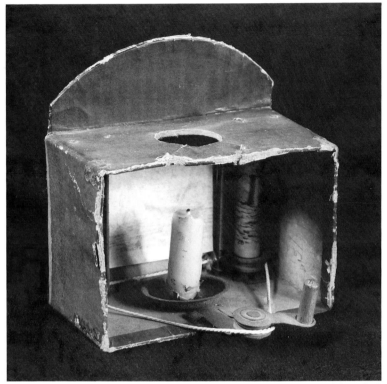

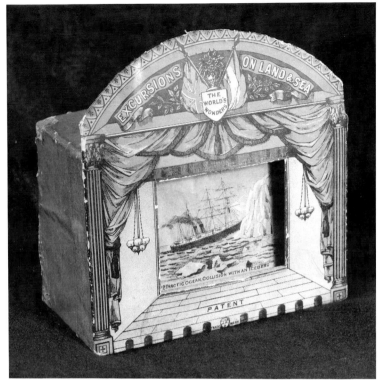

172 (rear view) 172 (front view)

171. A.H. Hamilton's Voyage Around the World at Large Mechanics' Hall, Nottingham, 1881

Poster
51 x 30 cm
Bill Douglas & Peter Jewell Collection

Towards the end of the nineteenth century Hamilton's panoramas, like the Pooles', became ever more concerned with events in Britain's growing empire, and fervently patriotic. Imperialistic adventures in Africa and Asia predominate in Hamilton programmes and posters. On this poster a Zulu warrior draws attention to the Cabul Massacre of the Afghanistan War, and the triumphal entry of General Roberts into Candahar.

172. Excursions on Land and Sea: The World's Wonders

Toy panorama
18 x 17 x 14 cm
David Robinson

The panorama scroll itself, printed on transparent paper, is wound from one spool onto the other using the single crank at the back. To allow illumination there is a holder for a candle within the box. The chromolithographic printing on the front of the proscenium resembles that used on many of Hamilton's programmes and posters. This and the use of the word 'Excursion' in the title indicates a definite link with Hamilton's panorama 'Excursions.'

173. Shrewsbury Music Hall...Panorama of the War between France and Prussia 1874

Theatre bill
56.5 x 25 cm
Bill Douglas & Peter Jewell Collection

A bill printed on silk advertising Poole & Young's panorama of the Franco-Prussian War. The panorama was exhibited under the patronage of Lt. Col. Corbett MP and the officers of the Shropshire Militia.

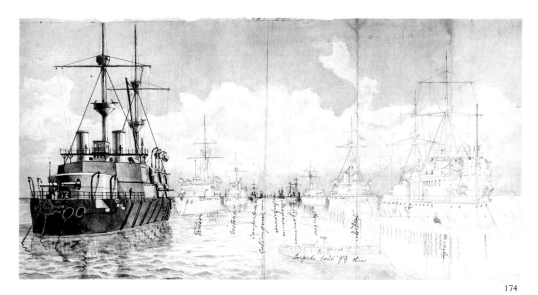

174

174. Drawings for a Poole 'myriorama' of a naval review

ARTHUR C. ROGERS

Watercolour
25 x 52 cm
G.A.S. Ramsden

Ships could be moved across moving panoramas on separate spools. According to the Pooles' business history *S.S. Egypt,* when being pulled across on one occasion, caught in some unexplained manner, tore right across the top, and fell in a heap on the stage.

175. Poole's multicycle

Photograph
21.5 x 29.5 cm
G.A.S. Ramsden

The Poole family were masters of publicity. The multicycle constituted a mobile advertisement for their myrioramas and was guaranteed to turn heads.

176. A Poole band

Photograph
21.5 x 29.5cm
G.A.S. Ramsden

Music played a vital part in any moving panorama, being used to manipulate the audience's emotions. Though many showmen made do with a hard-working pianist, the largest firms – Marshall in the 1820's and the Pooles from the 1880s – used brass bands. Each of Poole's 'orchestras' (as they grandly called them) normally consisted of ten musicians.

177. A Poole vehicle for transporting panoramas

Photograph
14.3 x 27cm
G.A.S. Ramsden

Poole's panoramas were transported in special pantechnicons and trains. As with circus and fairground vehicles the conveyances simultaneously served as moving advertisements. The firm boasted that in the event of a mishap a replacement panorama could almost instantly be supplied. Thus when Joseph Poole's myriorama was destroyed in a fire in Newcastle in January 1900 a Boer War panorama was rushed there and was on show within four days.

175

176

177

178. **Selection of tickets for moving panorama exhibitions**

Private collector; Westminster City Libraries (Westminster Collection)

When a moving panorama came to town the full-price at first would be charged for admission. Later large numbers of 'half-price tickets' would be distributed on the principle that packed houses at half price were better than a third-full house at full price. So plentiful were the 'half price tickets' that schoolboys collected them. A *Times* correspondent (17 August 1933), recalling boyhood visits to panoramas, wondered if anyone *ever* paid the full price for a Hamilton ticket.

Benefit nights were not unusual. Marshall gave a benefit in York for a young girl who had been injured at his panorama in the previous week; Banvard gave one in Dublin 'for distress in Ireland, with which we are unhappily too familiar.'

179. **Cycloramique View of Weymouth Bay** c.1837

Published by E. Groves
Aquatint
16.5 x 551.5 cm (concertinaed into covers)
Private collector

Despite its title this is not a 360° view. The panorama extends from the Bill of Portland on the left to Lulworth Cove on the right. The town of Weymouth is in the centre. The label on the front cover illustrates an optical contraption, presumably to take a rolled version of this publication.

Panoramas of the seaside towns associated with members of the royal family – Weymouth (George III), Brighton (George IV) – featured both as large show entertainments and as paper versions. Barker's painted panorama of Weymouth was exhibited in the Upper Circle at the Panorama, Leicester Square in 1807-08. E. Groves, a local stationer, later published three paper panoramas of Weymouth.

180. The Funeral of Arthur, Duke of Wellingto
1852

HENRY ALKEN AND GEORGE AUGUSTUS SALA

Published by Rudolph Ackermann Jnr
Coloured aquatint
13 x 2042 cm
Private collector

On Wellington's death (14 September 1852) Messrs Ackermann commissioned George Augustus Sala and Henry Alken to draw and engrave a panorama of the funeral procession. Alken, as a sporting artist, was assigned the task of drawing the hundreds of horses and had already produced a 'No Popery' panorama in 1850 and a comic panorama of the Great Exhibition in 1851 – 'The Exhibition Wot Is!'

Prior to the funeral – one of the greatest spectacles in the nineteenth century – the authorities at the Horse Guards were persuaded to supply the artists with information on the uniforms to be worn. The Corporation of London and the Dean of St Paul's were also helpful and provided certain facilities. From the Chief Commissioner of Police Sala managed to obtain a document that gave him the freedom to 'pass between the lines' of the procession. The funeral took place on 18 November 1852. In his autobiography, *Life and Adventures of George Augustus Sala* (1896), Sala describes how he worked, walking between the serried ranks of military and police, sketching from the first floor window of a stationer's in Fleet Street, and finally making drawings in St Paul's Cathedral during the four-hour long service. The aquatinting of the steel plates took until Christmas, the fumes from the acid used for 'biting-in' severely affecting Sala's eye-sight. The experience caused the artist to permanently abandon the etching process. The print when finished was over 66 feet in length making it, so it was claimed, the longest print ever published.

In effect the Alken/Sala panorama constituted a pocket-sized moving panorama, but Wellington's funeral also featured in full-scale exhibition panoramas. Scenes from the funeral were added to the 'Life of Wellington', already on show at the Gallery of Illustration, Regent Street. A panorama devoted specifically to Wellington's funeral procession was exhibited at the Royal Assembly Rooms, Newington Causeway in Febuary 1854. It had several thousand 'moving figures': the entrance fee was phenomenally low – one penny.

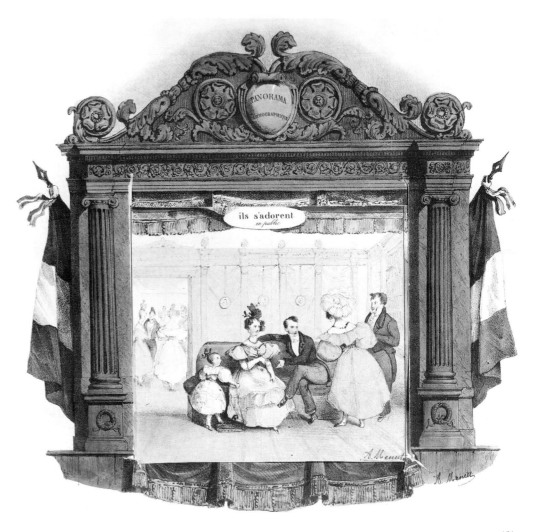

181

An especially fine copy of the print, in an elaborate viewing-box with winders, was sold at Christie's, South Kensington in May 1985.

181. Panorama Lithographique

Coloured lithograph
20.8 x 22 cm
Private collector

This paper proscenium, published in France, was designed to take a selection of double, pull-out views, each presenting an amusing or moral subject. The first scene on the pull-out exhibited shows a family on its best behaviour in public, at war with itself in private.

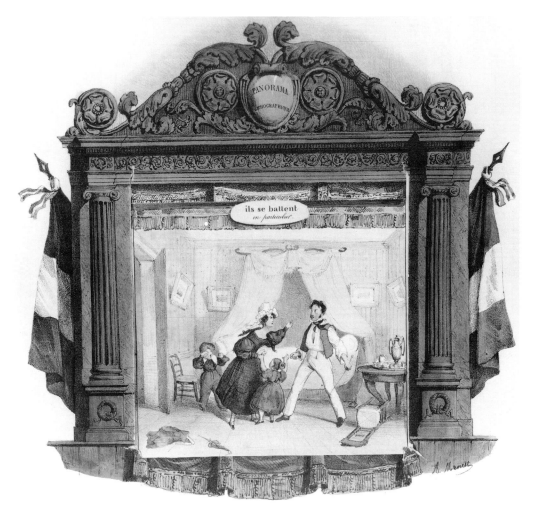

182. Toy panorama: 'The Monarch', containing a panorama entitled 'War in South Africa'

7 x 6.5 x 4 cm

Bill Douglas & Peter Jewell Collection

A patriotic pocket panorama on minute spools fixed in a tin theatre stage celebrating Britain's part the Boer War. The journey takes one rapidly from England to South Africa where one is presented with such scenes as lancers charging an armoured train, a bridge being blown up, war balloons, and finally a caricature of Kruger on crutches having a tantrum.

Throughout the conflict Poole's panoramas regularly included views from the seat of war. A correspondent in *The Times*, 17 August 1933, recalled a panorama cicerone during this period advancing to the footlights before a scene showing a white troopship in Table Bay. There he gave a lively recitation of Kipling's 'Absent-Minded Beggar' as a prelude to taking a collection to provide comforts for our boys in South Africa.

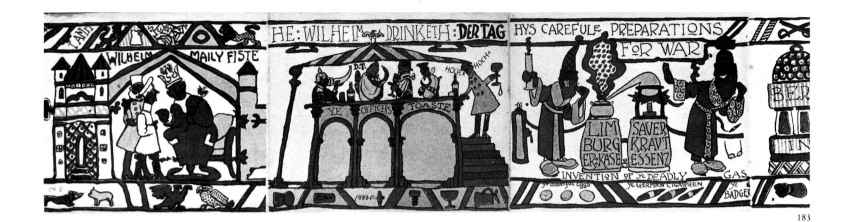

183. Ye Berlin Tapestrie: Wilhelm's Invasion of Flanders 1916

JOHN HASSALL

14.5 x 496 cm

Bill Douglas & Peter Jewell Collection

This amusing panorama has as its subject the early stages of the First World War, presenting the story in the manner of William the Conqueror's invasion of England on the Bayeux Tapestry. The opening scenes are captioned: 'His careful Preparations for War', 'Invention of ye Deadly Gas', and 'Wilhelm Teareth up ye Treatie & then with Artillery and with Cavalrie and with Infantrie with Women & Children in Front...he passeth through Luxenburg into Belgium & Nth France'. However, 'Quite unforeseenly', Wilhelm 'encountereth ye bulldog & ye Frenchmen so diggeth himself in behind ye Barbed Wire & so do the Allies...'

John Hassall was renowned as a poster designer and illustrator. His two-dimensional style, with flat colours and heavy outlines, was ideal for this particular topic.

184. Victoria Moving Panorama of Nursery Tales

R.J. MASTER & CO.

18.3 x 25.5 x cm

Bill Douglas & Peter Jewell Collection

On opening the two halves of the front of the box a moving panorama is revealed within. The two knobs on the top are turned to move the panorama along.

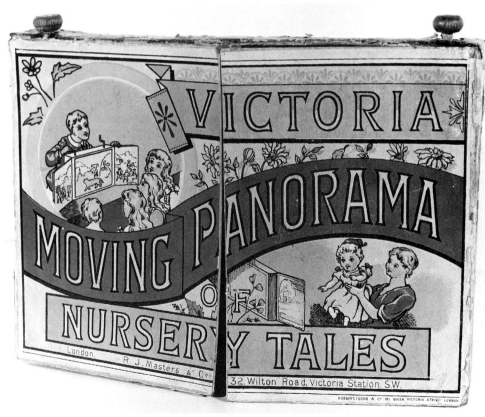

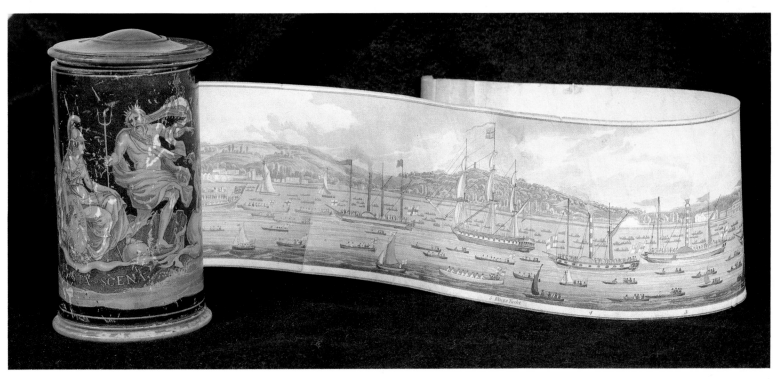

136 Costa Scena 1823
ROBERT HAVELL JNR

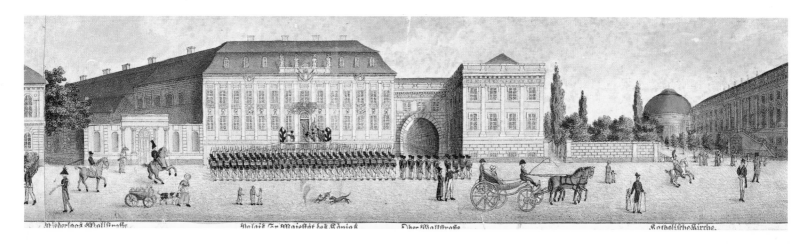

Niederlaes Wallstraße. Palais Sr. Majestät des König. Ober Wallstraße. Katholische Kirche.

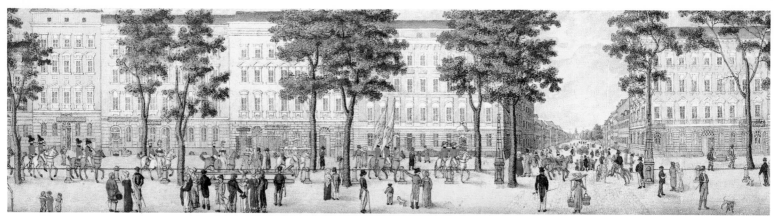

137 Lindenrolle 1820
ANON

158

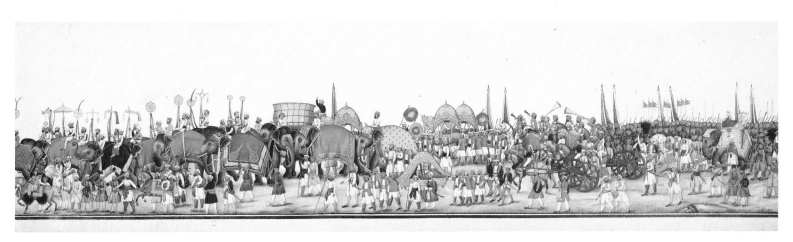

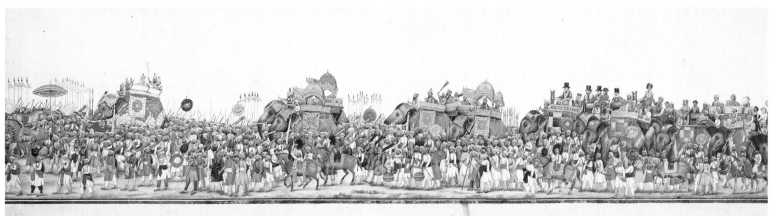

134 Panorama of a Durbar procession of Akbar II c.1815
ANON

159

153 Details from
London to Hong Kong in Two Hours c.1860
JOHN LAMB PRIMUS AND JOHN LAMB SECUNDUS

160

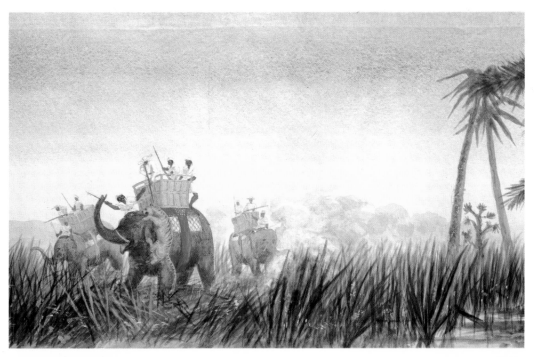

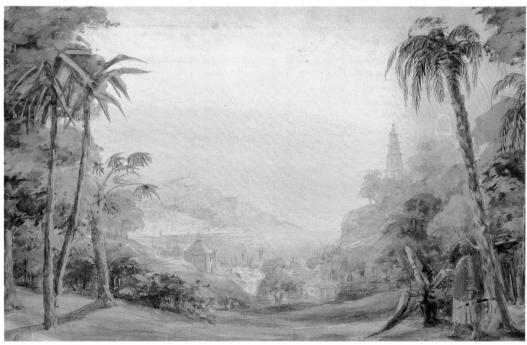

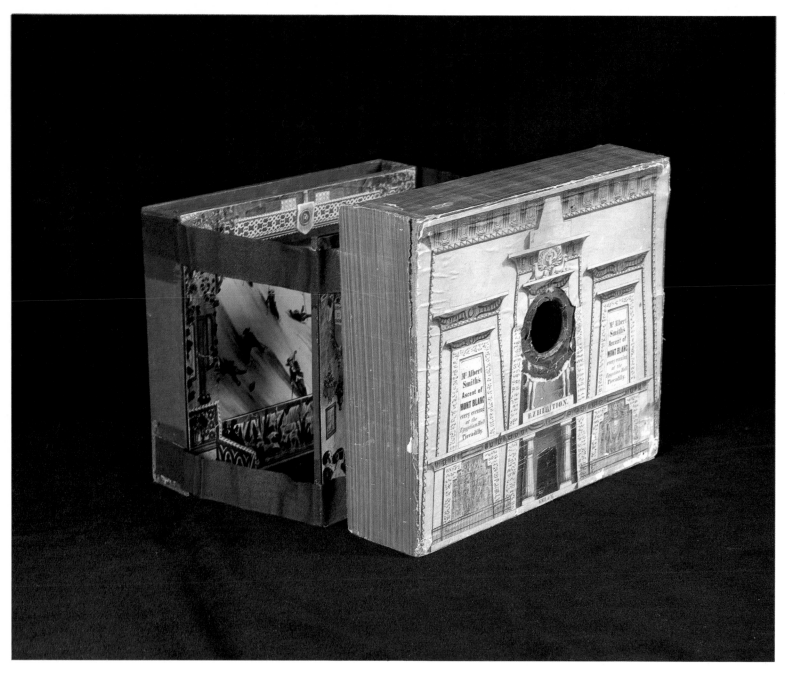

160 Model of the Egyptian Hall, Piccadilly exhibiting Albert Smith's 'Ascent of Mont Blanc' panorama

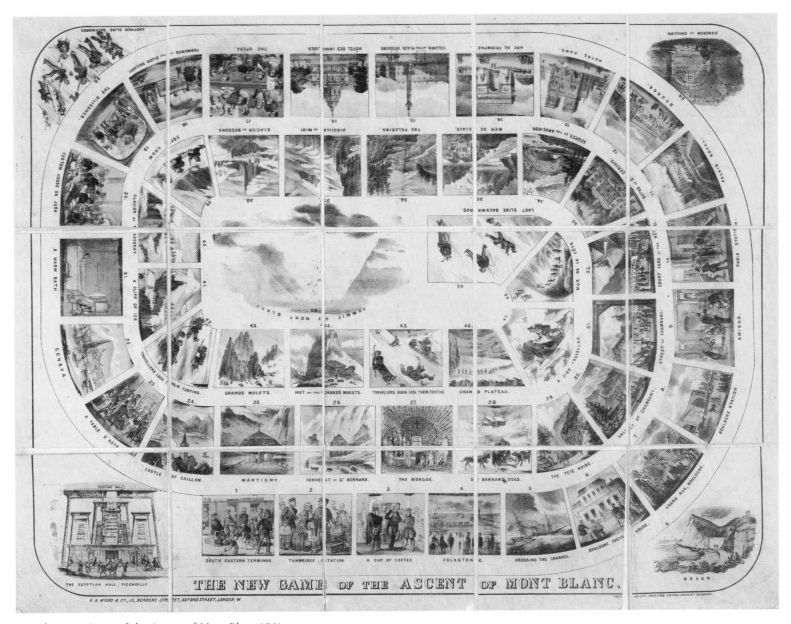

162 The New Game of the Ascent of Mont Blanc 1861

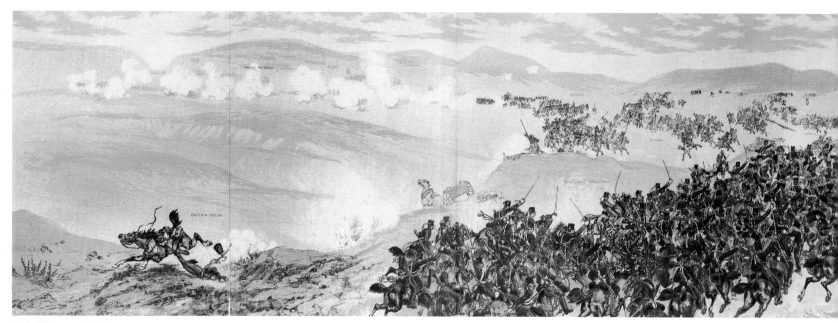

187 Charge at Balaclava 1881
THEOPHILE POILPOT AND STEPHAN JACOB

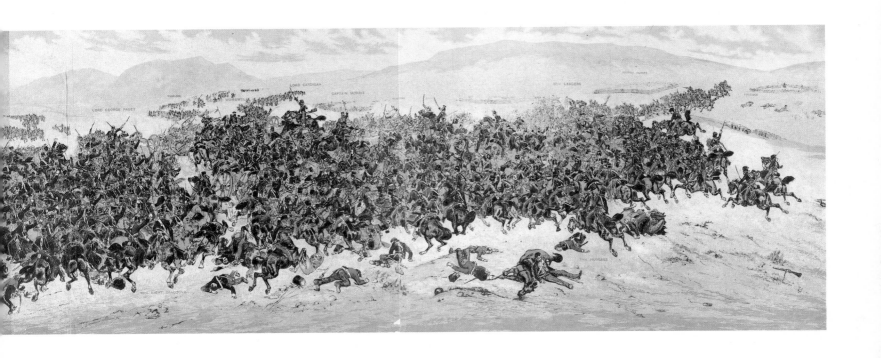

198 The Chariot Race c.1898
ALEXANDER WAGNER

99. The Effect of Fog and Snow Seen Through a
Ruined Gothic Colonnade 1826
LOUIS JACQUES MANDE DAGUERRE

VII THE PANORAMA REVIVAL

In Europe the 360 degree panorama was essentially a Georgian entertainment, its period of greatest popularity being 1800 to 1830. It survived into the Victorian era only in one or two major cities. By the 1850s few remained, and by the mid-1860s only Charles Langlois' rotunda in the Champs-Elysées still operated. That it did so was due to the assistance it received from the State and the municipality: its primary purpose was not to make profits but to serve Louis Napoleon as a State controlled propaganda instrument. Langlois died after a prolonged illness on 24 March 1870, four months before the outbreak of the Franco-Prussian War.

Langlois' successor was Henri Félix Emmanuel Philippoteaux. A renowned painter of military subjects he was commissioned after the Prussian victory to record the heroism of the Parisian resistance in a new panorama for the Champs-Elysées rotunda. It opened in November 1872. This panorama, 'The Siege of Paris', provided a populace, stunned and embittered by the acceptance of Prussia's humiliating peace terms, with a source of solace for their injured pride. The painting was packed with action but highly emotional featuring horror and pathos in abundance. This was not just another panorama with a patriotic theme by a theatre scene-painter; it was a real work of art by a *Salon* painter of high repute. It set standards for all future panoramas.

The 'Siege of Paris' was immensely popular and a huge box-office success. For the first time financiers became seriously interested in investing in panoramas and a large number of companies (*sociétés anonymes*) were set up to build rotundas and furnish them with startling battle scenes. Most of these companies were Belgian though their titles tended to disguise the fact. The production and exhibiting of panoramas now became a highly systematic and competitive business. The methods of painting them were refined and standardised. The panoramas – multiple copies of the most lucrative ones – were despatched to a dozen countries or more. The *faux terrains* became as important as the paintings themselves. And because electric lighting had now arrived panoramas could be effectively illuminated after dusk. Many of the panoramas were associated with international trade fairs. Substantial iron-framed buildings were often erected and then dismantled just a few months later. In the English speaking world the new panoramas were frequently refered to as 'cycloramas.'

The men responsible for directing the production of these new-style panoramas were all of them capable artists; many were well-known as *Salon* exhibitors. (Several of them worked together in partnership). The most prolific were Paul Dominique Philippoteaux (Félix's son),

Théophile Poilpot and Stephan Jacob, Charles Castellani (a Belgian who had assisted Félix Philippoteaux painting 'The Siege of Paris'), Édouard Detaille and Alphonse Deneuville, Olivier Pichat, Joseph Bertrand and Lucien Sergent.

'The Siege of Paris' itself was immediately in demand elsewhere. An American on a pleasure tour in Europe, a descriptive booklet tells us, visited the rotunda in the Champs-Elysées in 1874. So vivid an impression did the panorama make on him that he resolved to exhibit it two years later during the celebrations of the one hundreth anniversary of the Declaration of Independence. The *Compagnie Général des Panoramas*, however, refused his request for it. The artist (more probably the artist's son, Paul, who had served as a soldier during the Siege) was persuaded to produce a second version, this time showing the scene from the heights of Chatillon. The French government gave encouragement and support, supplying the artist with military data and remitting half the freight and export charges. Philippoteaux accompanied the work to America, supervising the installation in a new rotunda in Elm (now Parkside) Avenue and 40th Street, Philadelphia, close by the Centennial Exposition buildings. Philadelphians and Exposition visitors therefore had the unique opportunity to compare an old-fashioned panorama from the Regent's Park Colosseum, 'Paris by Night', with a new-style panorama from Paris.

By 1880 the revival was truly under way. New rotundas were erected in London, Paris, Brussels, Rotterdam, the Hague, Berlin, and St Petersburg. In London Cubitt put up a Royal London Panorama on the site of the Linwood Gallery, just yards from the rotunda that had housed Barker and Burford's paintings. The painting shown was 'The Charge at Balaclava' (i.e. the Charge of the Light Brigade). It was the property of a Paris *société* and had been painted by Poilpot and Jacob. A second rotunda was opened in June 1881 near the rosery in the grounds of the Crystal Palace at Sydenham, showing a rather less gory version of 'The Siege of Paris' by Félix and Paul Philippoteaux than that exhibited in the French capital. Alma Tadema made a speech at the opening. The company was Belgian – the *Société Anonyme du Panorama du Palais de Cristal, Sydenham*. Panoramas continued to be exhibited at the Crystal Palace rotunda for many years: 'The Battle of Rezonville' by Detaille and Deneuville, 'The Battle of Tel-el-Kebir' by Paul Philippoteaux, and 'The Defence of Rome by the Garibaldians'. The 'Siege of Paris' was brought back twice. In 1910 the rotunda was converted into a boxing arena. Before being demolished in the late 1950s or early '60s it was occupied by the Baird T.V. company.

Three days after the opening of the rotunda at Sydenham a third was opened in York Street (today's Petty France) behind Victoria Street in Central London. Originally called the Westminster Panorama its first work was 'The Battle of Waterloo' by Castellani. Painted in Brussels it had been viewed by the King of the Belgians before shipment. The rotunda was erected by Belgian workmen. On 15 September a fourth rotunda was opened in North London in the grounds of Alexandra Palace. The panorama exhibited there was Langlois' 'Battle of Sebastopol', brought over from Brussels where it had been featuring in the Exposition du Cinquantaire.

Brussels was the main centre of the panorama industry but Munich also became important, panoramas being painted in wooden rotundas in Munchen-Schwabing. Like the Belgians the

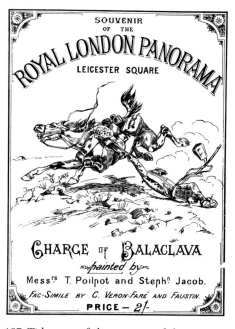

187 Title page of the souvenir of the panorama, Charge of Balaclava

Bavarians supplied customers with battle panoramas but religious subjects were their speciality.

In order to paint a convincing and truthful 'Jerusalem on the Day of the Crucifixion' Bruno Piglhein, with his assistant Karl Frosch, set off for the Holy Land, armed with references from the Papal Nuncio and the Archbishop of Munich. There they took photographs and made a large number of sketches. The resulting panorama was exhibited in 1886 in Goethestrasse in Munich. Shortly afterwards Frosch went to the United States joining William Wehner at his panorama studio in Milwaukee. The canvases he produced there included plagiarisms of Piglhein's image. One of these was shipped to London using a 'straw company' in Buffalo, N.Y. It was installed in the Niagara Hall (earlier called the Westminster Panorama). On hearing of it Piglhein took advantage of new copyright powers given by the Berne Convention and sued the proprietors. Several other Bavarian panoramas were successfully shown in London, however: Edmund Berniger's 'Egypt in its Grandeur' at the Niagara Hall, Philipp Fleischers 'Battle of Waterloo' at the National Panorama in Ashley Place, and 'Ancient Rome and the Triumph of Constantine' by J. Buhlmann and Alexander Wagner at the Victorian Era Exhibition, Earl's Court. In Scotland a hotelier, Albert M. Theim, purchased Fleischer's panoramas of 'The Battle of Trafalgar', 'The Battle of Bannockburn', and 'The Battle of Omdurman', exhibiting them at his rotundas in Glasgow, Edinburgh, and Manchester. Large segments of the original panoramas of 'Bannockburn' and 'Omdurman' are today pasted to walls in the Hotel Hydro at Peebles.

In Europe most panoramas exhibited were either of triumphs or humiliations in the Franco-Prussian War, or of decisive battles of long ago. In contrast, but inevitably, in the United States the most popular panoramas were of battles of the American Civil War. Paul Philippoteaux painted four 'Battle of Gettysburgs', latterly using a studio in Harlem, New York. Poilpot also set up a studio in the United States, with French assistants, painting 'The Battle of Monassas' and 'The Great Naval Battle between Merrimac and Monitor'. Bertrand and Sergent's 'Battle of Vicksburg', on the other hand, was painted at Messieurs Marlier Frères' panorama studio in Paris; Bracht, Roechling, and Koch's 'Battle of Missionary Ridge' had to be transported from Berlin, where it was painted, to Kansas City via New York.

Between 1883 and 1889 Milwaukee was the principal centre of panorama production in the United States. Sometimes referred to as 'Little Munich', Milwaukee has also been dubbed the Hollywood of the panorama industry. Most of the Milwaukee panoramas were produced by the American Panorama Company which had been established by the Chicago businessman, William Wehner. Besides luring Karl Frosch from Piglhein's studio, Wehner also recruited about twenty other German artists in Dresden, Weimar, Frankfurt, Berlin, and, in particular, Munich. They included August Lohr, William Heine, Karl Frosch, Franz Rohrbeck, and George Peter. In his letters to them Wehner stressed that in Milwaukee they would be able to enjoy a German theatre, a German beer garden, and even German newspapers. The panoramas these artists painted in Wehner's studio rotunda at 628 West Wells Street, included two versions of 'The Battle of Missionary Ridge', two of 'The Battle of Atlanta', two of 'Jerusalem on the Day of the Crucifixion', and one of 'Christ's Triumphal Entry into Jerusalem'. At a second, rival Milwaukee panorama

studio on West Kilbourn Avenue at North Sixth Street, Louis Kidt and Thomas Gardner, scene-painters from the German theatre, painted a 'Battle of Shiloh' and a 'Battle of Gettysburg'. Of all the Milwaukee panoramas the only one to survive is Heine and Lohr's 'Battle of Atlanta' which today can be seen in Grant Park, Atlanta.

By the 1890s panoramas even reached Australia and Japan. In Australia a 'Battle of Gettysburg', a 'Siege of Paris', a Crimea War panorama, 'Jerusalem on the Day of the Crucifixion' (Piglhein's, made under licence by Philippoteaux in his Chicago studio), and Bertrand and Sergent's 'Battle of Waterloo' were exhibited in Adelaide, Sydney, and Melbourne. In Japan at least seven rotundas were erected. The first panorama to be shown there was 'The Battle of Vicksburg', exhibited in Asakusa Park, Tokyo. Subsequent panoramas were of Japanese battles.

By the mid-90s the Panorama Revival was running out of steam. The limitation of 360° panorama painting – that the scenes did not move – would soon be overcome by cinematography. Competition from cinemas when they arrived in the early years of the twentieth century virtually killed the panorama industry. Throughout the world since its invention something in the region of 300 giant panoramas seem to have been painted. Some had been destroyed in fires, others overpainted, and many worn out by transportation and constant exhibiting. Those left were rolled up and put into store. There they rotted or became bad debts. Bishop & Sons, warehousemen in Belgrave Road in London, after forty years used a 'Siege of Paris' and a panorama of Palestine ('Jerusalem on the Day of the Crucifixion' presumably) as coverings for their pantechnicons. Detaille and Deneuville's 'Battle of Champigny' and 'Battle of Rezonville', on the other hand, were cut up, the fragments being disposed of at auction (cat. No.186). Rather than lose panoramas completely one might wish this had happened to some others.

Paul Philippoteaux, in later life an advisor to the Egyptian government on matters relating to art in education, died in Paris on 2 July 1923. By then only about a dozen of the great panoramas were still on display, and of these only one – the 'Crucifixion' at Ste Anne de Beaupré – claimed any connection with Philippoteaux. The Chicago version of Philippoteaux's 'Gettysburg' – till recently the largest painting ever painted – remains today in store, its private owner seeking a purchaser.

186a

185. The Siege of Paris, 1881

Descriptive booklet

Bodleian Library

It was Félix Philippoteaux's 'Siege of Paris' panorama in the Champs-Elysées that had triggered off the Panorama Revival. In 1881 a panorama by the same artist, in collaboration with his son Paul, and showing the Siege but from a different point (the roof of a house in Montretout), went on show at a new rotunda at the Crystal Palace, Sydenham. The *Daily News* reporter described his visit on the first day. Before descending to the grounds he paused on the terrace of the Crystal Palace and enjoyed the panorama of nature: 'The eye ranges over a vast area of country forming a glorious harmony of hills, vale, wood, pasture, and human habitation.' Arriving at the rose garden he entered the new rotunda, walked through the dark passage, and climbed the winding stairs which brought him out onto the viewing-platform. It seemed to him as if the far-stretching landscape which moments before he had been enjoying outside was still there, only altered in character, 'transformed from the smile of peace to the frown of war. The spectator is momentarily bewildered at the illusion caused by a union of high pictorial art with mechanical effect. For a considerable time he will be unable to realise that the objects around are not real but what seems to be a natural horizon, say ten miles distant, is in reality a circle of canvas only 120 feet in diameter...

186. Panorama of the Battle of Rezonville, 1883

JEAN BAPTISTE EDOUARD DETAILLE AND ALPHONSE MARIE DENEUVILLE

Oil on canvas (fragments):
a) General d'Auvergne, Chef d'Etat Major du General Bourbaki et son Aide-de-Camp, Commandant Laperche
 260 x 212 cm
b) A Moment's Rest
 213 x 121.3 cm
c) At Rezonville
 144 x 172 cm
The Forbes Magazine Collection, New York

Detaille and Deneuville's 'Battle of Rezonville' depicted a scene during the Franco-Prussian War when, on 16 August 1870, General Bourbaki and his troops attacked the Prussians besieging Paris. The French soldiers were shown resting after the battle – the skir-

186b

mishers of the Imperial Guard, the Cavalry, and the Grenadiers of the Guard. Near the cross in the village General Bourbaki with his staff could be identified meeting Marshal Anrobert, shown saluting him. On 18 August Bourbaki's troops were defeated.

The 'Battle of Rezonville' was the second panorama by Detaille and Deneuville, their first being another Siege of Paris subject, 'The Battle of Champigny', painted in 1882. Contemporaries considered 'Champigny', and even more so 'Rezonville', as the ultimate in panorama painting. The sketch for 'Rezonville' was exhibited at the *Salon* in 1884; the panorama itself was awarded the Grand Prix d'Honneur at the Exposition Universelle in Paris, the first panorama to receive the distinction.

On its completion in 1883 the Rezonville panorama was sent to Vienna. It returned to Paris in time for the Exposition Universelle in 1889 being exhibited in the Panorama National in the Rue de Berri and replacing 'The Battle of Champigny'. By May 1890 the panorama was in London, being displayed at the rotunda in the gardens of Crystal Palace. In *The Times* it was advertised as 'the finest [panorama] ever exhibited in England'. Three years later it was exhibited in Berlin.

In 1892 sixty-five tableaux were cut out of the 'Battle of Champigny' canvas. They were auctioned on 13 May. According to the *Illustrated London News* report (11 June 1892) the total sum realised amounted to 149,000F, only 1,000F less than the artists had been paid for painting the work initially. Later 115 tableaux were cut out of the 'Battle of Rezonville' panorama, and these were auctioned on 16 June 1896. The *Forbes*

Magazine possesses several fragments of both works. (For an account of the massacre, as Detaille called it, and a catalogue raisonée of studies and fragments see Robichon, 1979).

Detaille served as a soldier during the Franco-Prussian War, fighting at Bandy, Chatillon, and Villejuif. At Champigny he was ordered to sketch enemy positions. Deneuville also saw action at Champigny. Detaille and Deneuville's methods of painting panoramas are described in some detail in Germain Bapst's *Essai* where 'Rezonville' is referred to as 'le plus parfait qui ait encore produit'. They were the first panoramists to illuminate their panorama indirectly, installing a white cloth in the form of a cylinder above the light shield which served as a reflector.

186c

187. **Souvenir of the Royal London Panorama, Leicester Square, Charge of Balaclava, Painted by Messrs. T. Poilpot and Stephan. Jacob. Facsimile by C. Veron-Faré and Faustin**

Chromolithograph
Bodleian Library

In 1880 Poilpot went to Russia and made sketches of the Crimean landscape where the Light Brigade had made its fatal charge. By October the *Builder* was able to report that the rotunda for the panorama, designed by Monsieur L. Demoulin of Paris, was under construction. Poilpot and Jacob arrived in London about the same time to begin the painting. Their canvas was smaller than most of this period, 15,000 square feet compared with the almost standard 20,000 square feet. *The Times* was much taken by the detail of Cpt. Nolan – the bearer of the message that led to the unnecessary expedition – being dragged along by his horse, his foot caught in the stirrup.

The *Punch* reviewer, having groped from the Leicester Square entrance down the obligatory dark, subterranean passages, found himself confronted by a heavy oriental curtain. Fearing he had somehow wandered from the Panorama and into a Turkish bath he lifted the curtain gingerly and then was much relieved to a hear from above a shrill voice calling, 'Book of the panorama, sixpence!' He ascended the stairs to the viewing-platform where he was confronted by a crush of visitors: 'Go straight before you', he advised his readers, 'Elbow everyone out. Here you will be wedged in by several other people with elbows as energetic and powerful as your own, and here you will have to remain until you fight your way to another position'. Before leaving he foolishly dropped his guide book into the field of battle: it reappeared in the hand of a dummy dead Russian.

188. **'Royal London Panorama, Leicester Square...The Charge of the Light Brigade at Balaclava', 1881**

Handbill
25.5 x 16.5 cm
Westminster City Libraries, Westminster Collection

The panorama was lit by electricity using the 'Jamins

system' – thirty electric lights providing illumination, it was said, equivalent to 2,700 candles. (In June one of the lamps shot its live carbon into the straw in an ambulance waggon standing in the *faux terrain:* the blaze was quickly brought under control). A survivor of the Charge, Sergeant Henry, late of the Eleventh Hussars, was employed to answer visitors' questions on the engagement and relate his personal experiences. In June the Royal London Panorama installed a new attraction – the *Salon à Londres.* This display enabled Londoners to view approximately one hundred paintings previously exhibited in the Paris *Salon.*

189. **At the 'Panorama'**

Punch, 11 June 1881
Photograph of etching
Guildhall Library, City of London

The 'Charge at Balaclava' in Leicester Square was the first panorama to be shown in Britain that had a *faux terrain* – earthworks, modelling, and real objects placed between the viewing-platform and the canvas. The merging of this three-dimensional foreground with the two-dimensional painting considerably heightened the illusion of reality. This (for Londoners) novel feature was much remarked upon by reviewers, and both *Punch* and its rival *Judy* carried *faux terrain* cartoons. In *Punch's* cartoon Pa has dropped his hat into the foreground and has clambered over the barrier to retrieve it. Spectators mistake him for W.H. Russell, the celebrated Crimean correspondent of *The Times.*

AT THE ' PANORAMA."

Spectators (delighted). " BEAUTIFULLY PAINTED, ISN'T IT ! LOOK THERE ! WHO IS IT ! WHY, IT 'S THE—OF COURSE—WHAT 'S-HI NAME—THE *TIMES* CORRESPONDENT ! ! " [*Pa's new Hat had fallen down, and he would go and get it*

189

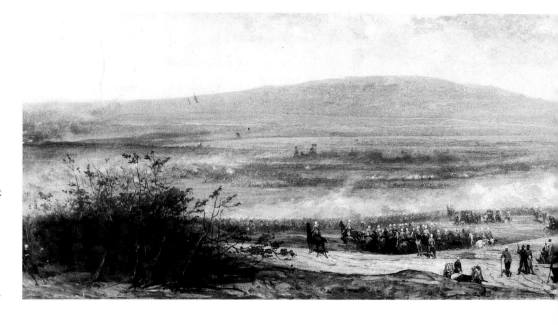

190. Westminster Panorama, Waterloo' 1881

Descriptive booklet

22 x 15.5 cm

James Poole

The Westminster Panorama, a 16-sided polygon, 130 feet in diameter (5 feet larger than the Colosseum had been) stood in York Street (today's Petty France) on a site almost opposite where the Passport Office now is. Though not a traditional area for entertainment the proximity of the Wellington Barracks caused the proprietors, no doubt, to consider it an appropriate venue for a Waterloo panorama. Designed by R.W. Edis FSA the building had few architectural pretensions. From the vestibule one entered a corridor painted in a dark chocolate colour, lit by a few lamps with blue glass shades. This prepared the vision of the visitor for the full realisation of the scene that was about to be presented. A spiral staircase ascended to the circular platform, 30 feet in diameter. The distance between platform and canvas was 50 feet. Before designing the building Edis had made a European tour of existing rotundas.

Castellani's 'Battle of Waterloo' had been seen by half a million visitors to the Brussels Exhibition before arriving in London. The proprietors promised it would be followed by 'The Battle of Ulundi', still in Brussels;

'The Battle of Tetnam' which was currently in Madrid; 'The Last Days of the Commune,' which was in Vienna', and 'The Last Days of Pompeii' which was in Naples. (A 'Battle of Trafalgar' was being painted by Castellani for Liverpool.) In the event the rotunda was renamed the National Panorama in 1882 and Olivier Pichat's 'Battle of Tel-el-Kebir' was the next panorama to be exhibited.

191. The Battle of Ulundi, c.1880

ADOLPHE YVON

Oil on canvas

138.3 x 347 cm

National Army Museum

The Battle of Ulundi, between 5,000 British troops under Lord Chelmsford armed with rifles and 20,000 Zulus, took place on 4 July 1879. On this occasion the Zulus were routed with a loss of over 1,500; the British losses amounted to 15 killed and 78 wounded. The panorama views the battle from the centre of the British position at an advanced stage; the Zulus are shown in the middle distance in flight towards the hills in the background.

A panorama of the subject was exhibited in Brussels

in 1881. It was promised for the Westminster Panorama in London but in the event seems not to have arrived. Yvon's representation of the subject was painted for the Empress of Austria and belonged to Emperor Franz Joseph, presumably as a gift from the Empress. The Emperor was Colonel-in-Chief of the King's Dragoon Guards who feature in the painting.

To be seen as the artist must surely have intended, the Battle of Ulundi needs to be exhibited curved to about 180 degrees. The smoke throughout the picture will then ascend in a uniform direction, and the image will acquire great depth. Yvon's 'Battle of Ulundi', one feels, would benefit from a *faux terrain*.

Yvon, a portraitist and painter of historical and battle scenes, enjoyed great popularity during the Second Empire for his paintings of French victories in the Crimean War. He was patronised by Napoleon III whose portrait he painted.

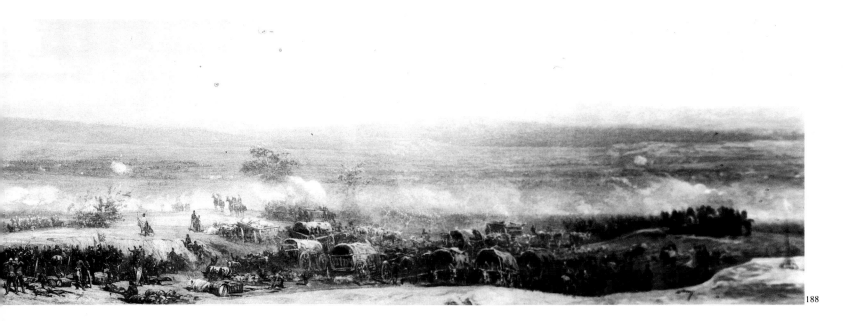

188

192. 'Have you seen Niagara Falls? If not, go now to Niagara Hall, where the finest panorama ever painted is on view,' 1888

Handbill
24 x 17 cm
Bodleian Library

From c.1883 the National Panorama in York Street stood empty. In 1888, however, an American syndicate resolved to show the 'Niagara Falls' panorama by Paul Philippoteaux and Adrien Schulz in the British capital. John Hollingshead, theatre impressario, was prevailed upon to locate an appropriate building; in the absence of anything better he recommended the National Panorama. ('Rather a fall for the Falls to come down to the slightly dull locality known as York Street', *Punch* thought.) The building, renamed the Niagara Hall, was provided with a new facade, and the panorama was shipped over from Philippoteaux's Harlem studio. Londoner's loved it. If the management's claims are to be believed it attracted over a million visitors. Besides the panoramas there were wigwams with working Indians; sweetmeats could be purchased at an American sweatmeat store. A duplicate of the panorama was sent to Paris for exhibition in the Avenue du Bois de Boulogne rotunda whilst the Exposition Universelle of 1889 was in progress. According to Hollingshead's account, it was not a success there.

'Niagara in London', as the show was called, was taken next to Chicago. It was replaced by Karl Frosch's plagiarism of 'Jerusalem on the Day of the Crucifixion.' 'Jerusalem' was removed by court order, and 'Egypt in its Grandeur', which had been painted by Edmund Berninger, took its place. Berniger's panorama was purest Cecil B. de Milne: it showed the Great Sphinx as it appeared newly painted 3,000 years ago, villas, vast temples, a procession of the gods, the Pharaoh's palace, and the Egyptian queen borne by Nubians and surrounded by musicians. 'Egypt' in due course gave way to a new 'Niagara Falls', painted this time by an Englishman, Edward J. Austen, who had emigrated to the States. (Austen assisted Piglhein paint the 'Jerusalem' panorama now at St Ann de Beaupré, Canada.) When the Niagara Hall was converted into a skating rink 'Niagara' was left on the walls, providing an appropriate backdrop until the establishment's closure in 1904.

Have you seen Niagara Falls?
If not, go now to
NIAGARA HALL
Where the finest Panorama ever painted is on view.

ST. JAMES' PARK STATION
YORK STREET, WESTMINSTER
(Two minutes' walk from Westminster Abbey)

ST. JAMES' PARK STATION
YORK STREET, WESTMINSTER
(Two minutes' walk from Westminster Abbey).

If you have, then revive your memories of the sublime picture of Nature by visiting Niagara Hall, and see them clothed in their beautiful Winter garments.

DAILY, 10 to 10. ADMISSION, ONE SHILLING.

192

193. 'A Waterloo Veteran's Pedestrianism', 1890

Handbill
Bodleian Library

The fifth rotunda to be erected in London during the Panorama Revival was the National Panorama, Ashley Place, behind Victoria Street. This building, designed by Robert Erneric Tyler FRIBA – he had also designed the recently completed rotunda in the Avenue du Bois de Boulogne, Paris – stood on the edge of a site that had been cleared for the building of Westminster Cathedral. It opened on Boxing Day 1889. Philipp Fleischer's 'Battle of Waterloo' was exhibited there. As at the Colosseum in former times the National Panorama placed great emphasis on extra attractions. These included James Davey, a 94 year old Waterloo veteran who walked twenty miles a day and would answer visitors' questions; Hereat, the American illusionist, performing the 'Mystery of She', whatever that was; and Edison's latest phonograph. During the Christmas season 1891 the management set up the tallest Christmas tree in London, and gave children 'valuable' presents.

194. Guide to the Great Scottish National Panorama – 'Battle of Bannockburn', by Philipp Fleischer of Munich

Descriptive notes by Emil Clauss
21.8 x 14 cm
Bodleian Library

The works which Belgian and Bavarian panorama studios manufactured and supplied to foreign countries were almost invariably of great landmarks or turning points in those nations' history. For Scotland Philipp Fleischer painted the most obvious subject – the Battle of Bannockburn. Measuring 30 feet in height and 300 feet in circumference this panorama weighed 15 hundred weight (including 2 hundred weight of paint and varnish). A rotunda for it – the Great National Panorama – was erected in 1888 on the North side of Sauchiehall Street in Glasgow. The Managing Director of the Scottish Panorama Company which owned the establishment was Albert Theim, the (Bavarian?) proprietor of hotels in Edinburgh and Peebles. (Meals in the rotunda's restaurant were accompanied by Bavarian and Viennese lager beer).

According to a contemporary advertisement the panorama 'breaths such a spirit of reality that [the spectator] finds it hard to believe that he is not gazing on living and ferocious men, and he feels the breeze from the hillside on his cheek'. After Glasgow the work was exhibited in 1892 at the Scottish Panorama in Deansgate, Manchester. (A notice in a Manchester paper claimed it had been seen in Glasgow by two million people).

In June 1898 'Bannockburn' was hung again in the Great National Panorama, Glasgow. It was followed in 1901, during the Glasgow International Exhibition, by the 'Battle of Omdurman' of 1885, painted by Philipp Fleischer.

195. The Great National Panorama, the Battle of Trafalgar & Museum of Nelson Relics

Descriptive booklet
27 x 17 cm
Mitchell Library

Fleischer's 'Battle of Trafalgar' complemented his 'Battle of Waterloo' (cat. No.190). It was exhibited in Edinburgh during the Edinburgh International Exhibition, 1890; in Manchester at the Scottish Panorama, Deansgate, also in 1890; and in London at the Royal Naval Exhibition, 1891. The rotunda for it in London was designed by R.E. Tyler, the architect responsible for the National Panorama, Ashley Place, and the Panorama de l'Avenue du Bois de Boulogne, Paris. The painting showed the battle as it was at 1.15 pm on 21 October 1805, i.e. at the moment when Nelson exclaimed, 'They have done for me at last, Hardy; my backbone is shot through'. When researching the subject Fleischer received much help from the Admiralty. He studied the logs of the different ships which participated to establish their exact positions, and sketched those vessels that were still in existence. For uniforms, arms, etc. he visited museums.

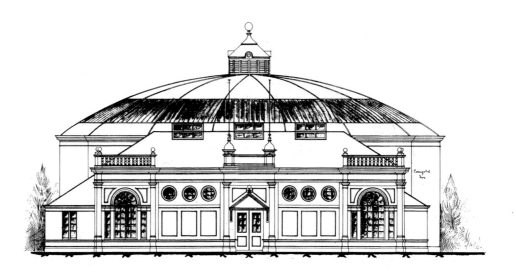

— ELEVATION TO ELMBANK STREET —

196a

196. Contractors' drawings for building the Bath Street Cyclorama, Glasgow

MESSRS FISHBURN

Pen and ink
a) Front elevation
b) Cross-section
c) Plan
Strathclyde Regional Archives, Mitchell Library

Not far from the Great National Panorama in Sauchiehall Street, at the corner of Bath Street and Elmbank Street where the King's Theatre now stands, W.A. Fishburn of North Shields erected a second rotunda – the Bath Street Cyclorama. Designed by the Glasgow architect, Charles H. Robinson, it opened in August 1890 with 'Jerusalem on the Day of the Crucifixion' by Bruno Piglhein. Lectures on the panorama were delivered every half hour, and a grand organ played in the intervals. As extras the establishment had a lounge and reading room where visitors could consult prints, maps, and books relating to the Holy Land. After Glasgow the 'Jerusalem' panorama was exhibited in 1892 at the Scottish Panorama in Deansgate, Manchester. A reader in the Glasgow *Evening Citizen*, 1936 recalled viewing a panorama of the Niagara Falls (Philippoteaux's?) exhibited at the Bath Street Cyclorama, very realistic except for the absence of noise. 'Niagara' was also exhibited in the Manchester rotunda.

197. **'Das Alte Rom mit dens Triumphzuge Kaiser Canstantin in Jahre 312 N.Chr...von...J.Buhlmann and Alexander Wagner'**

Key
Published by Franz Hanfstaengl Kunsverlag A-G
Munchen 1890
Process
15.8 x 170 cm
John Ronayne

This key gives some idea of the magnificence of Buhlmann and Wagner's panorama, 'Rome in the Year 312 AD.' The original painting was 50 feet high and had a circumference of 394 feet. Commissioned by the Munich Panorama Company, it was exhibited in Munich in 1890 and also in Berlin. In 1897 it was displayed at the Victorian Era Exhibition at Earl's Court. The Victorian Era catalogue describes it as follows:

Rome standing on its seven hills, and revelling in a splendour long since departed, is seen in the very zenith of its splendour on the day when the Emperor Constantine made his triumphant entry through its gates. Every phase of the important day is shown. While the victorious legions of the first Christian Emperor are entering the city, the old religion, still existing in another portion, is depicted in pagan sacrifices which are yet continued. But no words can adequately describe the remarkable painting built up, foot by foot, from the ruins of the Eternal City by the patient research and technical skill of these great artists. From the crowds which line the streets to the glorious atmosphere the spirit of true art reveals itself, and the spectator will be at a loss which to admire most, the stirring action of the life-like figures in the city, or the dreamy restfulness of the Italian sky. No-one who enters the Victorian Era Exhibition gates this year should miss seeing this masterpiece of perspective art.

After being displayed in London, 'Rome in the Year 312 AD' was transported to America.

198. **The Chariot Race**

ALEXANDER WAGNER

Oil on canvas
138.3 x 34 7 cm
Manchester City Art Gallery

Though not a panorama this painting is utterly panoramic in conception. Painted by one of the panoramists responsible for 'Rome in the Year 312 AD' (cat. No.197) it provides another grand vision of antiquity. Typical of panoramas of the Panorama Revival it is packed with spectacle, drama, action, and emotion. The image is almost three-dimensional: the chariots seem to charge through the canvas and over one's head. Wagner's 'Chariot Race' is the forerunner of Ben Hur and the wide-screen films of the 1950s.

Alexander Wagner (1838-1919), Hungarian by birth, received his training in Vienna and Munich. As Professor of Art at the Munich Academy he painted historical Hungarian scenes, Turkish and German battles, and visions of ancient Greece and Rome.

A copy of Wagner's 'Chariot Race' was painted by the fun-fair artist, Edwin Hall, as decoration on a Ben Hur Speedway.

199. **Panorama Berezyna, par Julian Falat et A. de Kassak**

E. MARTENS & CO., 1896

8 plates in portfolio, each 29 x 34 cm
Bill Douglas & Peter Jewell Collection

Falat and Kassak's panorama of Napoleon's retreat from Moscow was exhibited at the Nationalpanorama in Herwarthstrasse, Berlin between 1896 and 1898.

200. **Panorama de la Bataille de l'Yser**

8 half-tone postcard reproductions in folder
29 x 34 cm
Bill Douglas & Peter Jewell Collection

Alfred Bastien painted his panorama of the 1914 battle in 1920, and exhibited it firstly in an existing rotunda in the Rue Maurice Lemonier in Brussels, and then in a new rotunda erected for it in Ostend. During the Second World War this rotunda was damaged by R.A.F. bombing. The panorama, in an exceedingly delapidated state, hangs now along one wall of an aircraft gallery at the Musée Royal de l'Armée et de l'Histoire Militaire, Brussels.

VIII PHOTOGRAPHIC PANORAMAS

When the *Illustrated London News*, Britain's first pictorial newspaper was launched on 14 May 1842 regular subscribers were promised a large wood-engraved panorama of London. Initially the plan was to copy the Hornor/Parris panorama at the Colosseum; in the event the proprietors resolved to provide readers with the view from the Duke of York's Column instead. The print would be a town prospect in the tradition of those produced in the previous three centuries. The *Illustrated London News*, however, were anxious to associate it in the public mind with modern show panoramas and kept the word Colosseum in its title. They also wanted to demonstrate to the world that they were utilising the latest technology and called upon the services of London's leading daguerreotypist, Antoine Claudet.

In fact Claudet was the sole licencee in Britain for practising the daguerreotype process. On hearing of the invention he had travelled to Paris in 1839 and learnt the art of daguerreotyping from Daguerre himself. No-one was more qualified than he, therefore, to undertake the *Illusrated London News'* commission. In order to photograph the capital he erected his equipment at the summit of the Column. Two views were needed, one looking north, the other looking south. Claudet set about making a large number of silver plates, arranging them to make up the required images. An artist was employed to copy the topographical detail recorded on the silver plates, and another artist transferred the image onto box-wood. The views were then engraved by a team of engravers, and printed off. When this huge double-panorama appeared on 7 January 1843 it caused considerable excitement. It proved to be the first of many.

With the 'Colosseum View' photography was able to demonstrate it could contribute something to one stage in the production of a panorama. Before the year was over it would also demonstrate that it was quite capable of producing the end product. In Vienna an optician named Wenzel Pokesch built the very first panorama camera to the designs of a Retz pharmacist, Herr Puchberger. Puchberger proceeded to photograph public squares, masses of troops, and the elevation of St Stephen's Cathedral. Rather better known is the camera made in 1844 by the German, Friedrich von Martens. This had a lens that swivelled round a fixed axis. As the lens was turned the picture was recorded through a vertical slit. The image was formed on a curved plate. Martens' panoramic daguerreotypes of Paris, five inches by

seventeen-and-a-half inches, are commendably sharp, but like all daguerreotypes present a mirror image. The camera was produced commercially by N.P. Lerebours, but no other photographer seems to have been able to cope with the problem of maintaining uniform exposure.

In the following decade more reliable cameras began to appear on the market. For those who could afford it, and had the strength to carry it, there was Johnson's Pantoscope. Invented in 1862 by John Robert Johnson, a Yorkshire industrial chemist, this camera introduced several new features. In operation the whole camera rotated round its optical axis, and its flat-plate travelled in a straight line. It was motor-driven. Photographers of more modest means followed Fox Talbot's example. Instead of using a panorama camera, a normal plate camera could be used. A sequence of shots would be taken, the camera being turned after each shot. The objective was to produce a series of overlapping images. It was vital that the camera should be mounted on a tripod that was really firm, and also that the camera should be precisely level. Evenness of exposure and development were of course vital. Despite the availability of purpose-made cameras, Fox Talbot's was the method most commonly used by professionals as well as by amateurs in the nineteenth century.

Though best known as a photographer of movement and a pioneer of cinematography, the most able panorama photographer in the Victorian era was probably Eadweard Muybridge. Muybridge, born in Kingston-upon-Thames in England, showed an interest in panorama photography from early in his career. His work included a panorama taken during the Modoc War, and an eleven-segment panorama of Guatemala City. Between 1877 and 1878 he made three panoramas of San Francisco from the roof of a house on Nobb Hill. The first, consisting of eleven segments and measuring eight feet in length, was sold with a key bearing 220 references. The second was taken with a mammoth 18 x 12 field camera. It consisted of thirteen segments, and measured over seventeen feet in length. Following a fire at his publishers which destroyed the negatives for the first two San Francisco views, Muybridge made the third panorama. This was also in thirteen segments and over seventeen feet in length. Technically it was the most successful of the three having no noticeable breaks in its vertical register. Hales (1984) describes it as 'the finest example of the genre ever made'.

Very often the subjects chosen by panorama photographers were the same as those regularly selected by show panoramists. Especially popular were sublime and exotic scenes taken in distant lands that served to thrill and act as a spur to, or as a substitute for, foreign travel: the Niagara Falls, for example, Peking, the Pyramids, Inca ruins in the Andes, or Sydney Harbour. Just like show panoramists, panorama photographers were keen to capture anything especially newsworthy. Roger Fenton in the Crimea in 1855-56 recorded encampments and battle-fields in multi-segment panoramas. With at least one of these a key was published: its style resembled those in Burford's descriptive booklets. Fenton was succeeded in the Crimea by James Robertson and Felice Beato who also produced multi-segment panoramas of the battle-fields. Beato would later record places associated with the Indian

Mutiny and the Second Opium War.

Not all panoramas were of sensational or popular subjects. Many owed their existence to the Victorian compulsion to explore and record. Panorama photographs provided the breadth to capture entire scenes whilst simultaneously – and indiscriminately – recording every minute detail. For explorers and geographers they provided an ideal means of reporting back on the world they were opening up. Many such panoramas are to be found in the collections of the Royal Geographical Society and the Royal Commonwealth Society in London.

From time to time panorama photographers were affected by the show panoramist's weakness for size. Francis Frith in 1858 exhibited at the Photographic Society's London exhibition a seven-segment panorama of Cairo. This was as nothing compared to a photograph of the Krupp steelworks produced in 1867 which consisted of fifteen segments and measured thirty-five feet. In 1903 the *Neue Photographische Gesellschaft* of Berlin produced an even larger multi-segment panorama of the Gulf of Naples: this was five feet wide and thirty-nine feet long yet printed on a single sheet. There being no dark room large enough for it, the photograph was processed in the open air on a moonless night (see cat No. 222).

For a while it seemed that photography might come to the aid of the ailing show-panorama industry. Charles A. Close in 1893 suggested that cycloramic paintings be given a coat of white paint and photographic images projected upon them. He himself devised a way of doing this, exhibiting at the Chicago World's Fair in 1893 an Electric Cyclorama. The apparatus he used for projecting his 360° images consisted of a battery of projectors, kinetoscopes, and kinemotographs, accommodated (with their operator) in a giant lantern hung from the ceiling like a vast chandelier. Even more ambitious was the Electrorama patented in the U.S. by Thomas W. Barber. In 1898 Londoners had the opportunity of judging the effectiveness of the Electrorama for themselves when it was set up at the former panorama rotunda in York Street – the Niagara Hall. There Barber projected the image from a central tower onto a 360° screen, forty feet high and four hundred feet in circumference. A similar entertainment was tried in Paris. In 1901 the Lumière brothers, August and Louis, established at 18 rue de Clichy their Photorama, at which photographs of French scenery were projected onto a 360° screen.

Though panoramic photography failed to revive or replace cycloramic painting, it flourished during the Edwardian period as never before. The introduction of roll-film at the close of the nineteenth century encouraged inventiveness in camera design. Two portable panorama cameras were launched, both of them aimed at the popular market, the Al-Vista in 1896 and the Kodak Panoram in 1900. The Panoram was especially successful: light and compact, it could be loaded and unloaded in daylight, and, according to the handbook, could be 'mastered by anyone in a few minutes'. The Russian Imperial family were keen amateur photographers: the dowager Empress's worthy attempts with a Kodak Panoram are displayed in this exhibition (cat. No. 216). In England life at the seaside was recorded by George

Davison in East Anglia (see cat. No. 213), and by A.H. Robinson in Yorkshire. The one-armed Josef Sudek used a modified Panoram for his atmospheric scenes of Prague right up to his death in 1976 (see cat. No. 235).

The ultimate in panorama camera design, however, was the Cirkut camera, patented in 1902. Several models were produced, but it was the No. 10 – large, heavy, and splendidly robust – that found favour with professionals and for which the general public feels most affection. Besides being used for landscape photography – its original purpose – it has been used widely for group photographs. The film is wound and the camera slowly rotated by a spring motor. Members of a group being photographed are obliged to position themselves in an arc so that all are equidistant from the camera. As the camera rotates – it can take up to thirty seconds to pan a large group – a person who is photographed on the left can sprint round the back and be photographed again on the right.

In the nineteenth century, as we have seen, panoramas were used for recording wars; in the twentieth century they have been used for fighting them. Photographic panoramas of the enemy's trenches taken with field cameras were used for range-finding by the artillery of both sides during the Great War. The gunner carried his panorama with him in a small buckram case in his pocket. A warning stamped on the panorama reminded him that the panorama should be used solely for military purposes, never be given to the press, and promptly handed over to whoever relieved him. Several thousand multi-segment field panoramas survive. The British examples are utilitarian, the German ones far more attractive.

After the First World War panoramic photography was confined largely to professionals, the best of them tending to use the Cirkut No. 10. The most celebrated of these photographers was Eugene O. Goldbeck who died in 1987. Goldbeck modified his camera so that it could be pointed downwards from a high tower and still make 360° pans of the horizon. Tall towers of scaffolding became a Goldbeck trademark: he had one that could be erected rapidly over his car. His topographical subjects included the Grand Canyon, the Pyramids, and the Summer Palace of Peter the Great, Leningrad, but group photographs were his speciality. In 1947 he erected a 212-foot tower and photographed 21,765 servicemen lined up in the shape of the Lockland Air Force Base insignia. The shot took him seven weeks to prepare and cost him £5,000. He sold over 10,000 copies of the photograph.

Panoramic photography in recent years has become popular once again, particularly with artists. In 1987-88 the Hudson River Museum, N.Y., organised an exhibition of panoramic photography, *The World is Round,* at which recent work by twenty-four artists and photographers, including David Hockney's, was shown. The challenge for the photographer is the distorted perspective. Invariably the centre of the panoramic image bulges forward whilst the edges recede. This produces a feeling of great space, indeed of haunting emptiness, that can pervade the whole photograph. When panoramas are taken from a moving aircraft the distortions become even more acute – the image in fact becomes 'S'-shaped. Some photographers of the past such as Sudek were adept at disguising the distortion by careful composition. Nowadays there are photographers

182

who emphasize this element, deliberately creating an art-form out of the panorama's warping shapes.

Of the modern experimenters special mention must be made of Dick A Termes. Termes produces what he calls 'total photos' – photographs which in their final form are actually three-dimensional and resemble twelve sided puzzles. His principal tools are a tripod-supported dodecahedron and a camera with a superwide lens. The camera is mounted on each of the dodecahadron surfaces, a photograph being taken from each viewing angle. The artist Bob Chaplin, who uses a Russian Horizont camera, combines photographic techniques with etching and screen printing. He presents strips of landscape in pairs, expressing the layers of time – hourly, seasonal, and historical – which he perceives in his subjects (see cat. No. 245).

Landscape panoramas of a more traditional nature continue to be produced however. In France Joachim Bonnemaison photographs landscapes and seascapes with a Panoptic camera which he has invented. Michael Westmoreland, Britain's foremost panorama photographer, records the world with his Cirkut cameras. He has photographed Paris from the Notre Dame, Hong Kong from the land and from the sea (cat. No. 241), and London from the top of Shell Centre. One of Westmoreland's most disturbing panoramas is of the tortured topography beneath Spaghetti Junction, Birmingham. In the United States Jerry Dantzic, who also uses a Cirkut camera, is engaged on a project he calls 'America at Length', for this recording the most spectacular scenes in every state in the Union. He anticipates that the collection will consist of over 400 panoramas when completed.

201. The Illustrated London News Colosseum View of London, 1843

Coloured wood engraving.
29.3 x 223 cm, wound on a roller
David Robinson

The 'Colosseum View' was the first engraved panorama to be given away by an illustrated newspaper. The *Illusrated London News* continued to issue such views for its readers until the 1890s, a practice imitated by its rivals, the *Pictorial Times* and the *Graphic*. For its first London view Antoine Claudet's daguerreotypes were copied by Henry Anelay, the image then being redrawn on wood by G.F. Sargent. To engrave it eighteen engravers worked under the supervision of Thomas Bewick's pupil, Ebenezer Landells.

When issued by the *Illustrated London News* as a giveaway the print consisted of two views printed on a single sheet, one over the other. The panorama was subsequently reissued for non-subscribers, coloured and wound onto a roller with a key within a buckram wrap-around cover.

202. Talbot's printing establishment, Reading, c.1845

WILLIAM HENRY FOX TALBOT

Photograph
25.8 x 150 cm
Science Museum

Reading was selected for Talbot's establishment, it being mid-way between London and his home at Lacock Abbey, Wilts. From 1843 Talbot produced numerous multi-segment panoramas, marking on them the points at which they should overlap. This panorama consists of two segments. Many of Talbot's multi-segment panoramas were subsequently separated and appear as individual prints in different collections.

203. View of Paris taken from the vicinity of the Pont Neuf, c.1844

CHARLES CHEVALIER

Daguerreotype
11.5 x 35.5cm
Science Museum

The Parisian opticians, Vincent and Charles Chevalier, were pioneers of photography, in contact with both Joseph Nicéphore Niepce and Louis Daguerre. They built a camera for the former. The daguerreotype of Paris is one of two presented by Charles to Fox Talbot's assistant in the Reading Printing Establishment, Nicholas Henneman. As regards detail and technique it is considered an especially fine example.

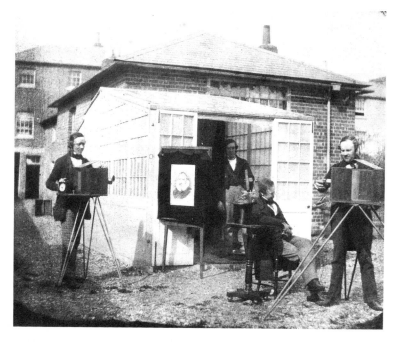

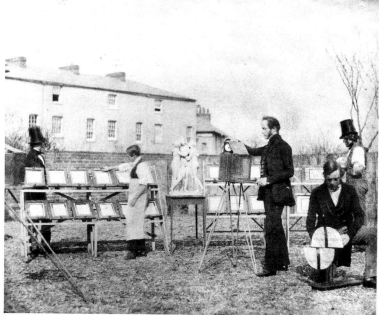

202

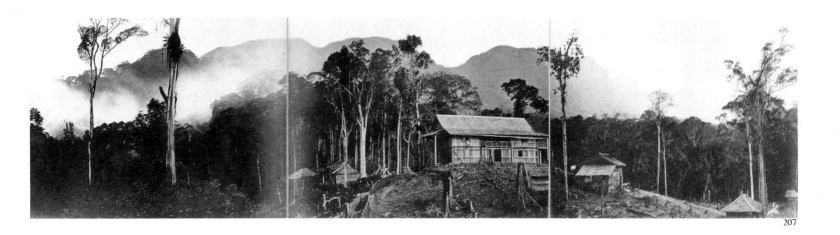

204. **Constantinople**

JAMES ROBERTSON AND FELICE BEATO

Photograph
25 x 150 cm
John Hillelson

Robertson and Beato worked together from 1852 to 1865. Initially they took photographs of sites in Egypt, Athens, and Constantinople. In 1855 they arrived in the Crimea and recorded its battlefields, succeeding Roger Fenton who had returned to England. The Robertson/Beato Crimea photographs include a panorama of the harbour of Sebastopol as it appeared after the Siege.

The Constantinople panorama, in five segments, would have been taken in the early 1850s. This copy is taken from General Gordon's album.

205. **Lucknow from the Kaiserbagh,** 1858

FELICE A. BEATO

24.8 x 200.6 cm
Trustees of the Victoria & Albert Museum

Beato and Robertson travelled to India in 1857 and photographed scenes connected with the Indian Mutiny. Beato is given the credit for the photographs that were taken after the Siege of Lucknow. By 1860 the partnership had disintegrated and Beato travelled alone to China to record the Second Opium War. He produced a six-segment panorama of a deserted Peking, and also a panorama of Hong Kong showing the encampment of Elgin's Chinese Expeditionary Force.

206. **Nagasaki**

ATTRIBUTED TO FELICE A. BEATO

Photograph
19.6 x 132 cm
John Hillelson

In 1863 Beato joined Charles Wirgman, a 'special artist' to the *Illustrated London News*, in Yokohama, Japan. Together they established a photography business carefully recording the manners and customs of the Japanese and also the nation's topography. Their work excited curiosity. In some quarters photography was regarded with suspicion, the camera being considered a 'murder box' that would absorb the soul of those photographed.

Beato took many of his Nagasaki photographs in 1873. Since this six-segment panorama was bound into General Gordon's album in the 1860s it must obviously be earlier. Christianity, brought to the city by St Francis Xavier in 1548, survived the Tokugawa shogunate. A Christian church is to be seen in the centre of the image.

207. **Album of Sarawak scenes,** c.1865

PHOTOGRAPHER UNIDENTIFIED

33.5 x 100 cm
Private collector

In addition to jungle and mountain scenes, this album contains a number of photographs of mining activities. This perhaps indicates that they were commissioned by a British mining engineer resident in Sarawak. The most spectacular of the multi-segment panoramas in the volume shows a long-house on a mist-shrouded hill-side. The album's binding carries the label of the London Stereoscopic Company.

208. **Harleyford,** c.1870

VICTOR ALBERT PROUT

110 x 280 cm
Royal Photographic Society

Victor A. Prout designed his own camera for photographing panoramas. It resembled Johnson's Pantoscope, but instead of scanning a continuous image took a sequence of exposures in plate perspective on a wide flat-plate. Prout's camera was made for him by Ross & Co., opticians at 7 Wigmore Street.

Prout's speciality was narrative photography arising from *tableau vivant* staged in country houses. His stereoscopic views were published by James Elliott.

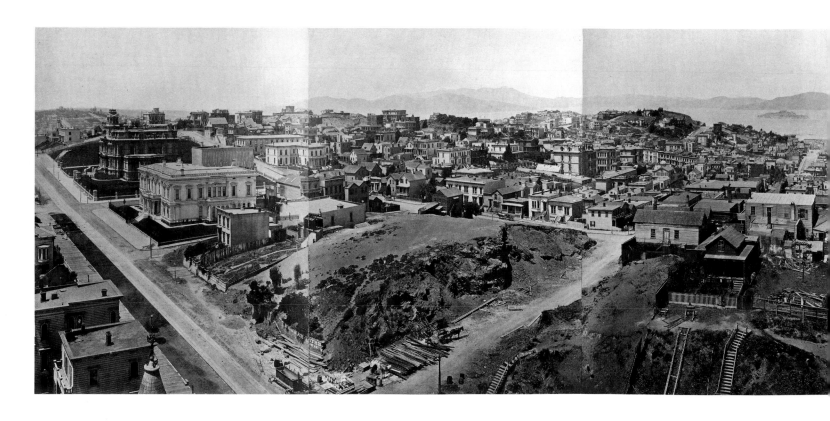

209. Friedrich Krupp steelworks, Essen c.1880

PHOTOGRAPHER UNIDENTIFIED

4.7 x 27.5 cm
Private collector

In 1867 a 35-foot photographic panorama of Krupp's steelworks, made up of 15 segments, was exhibited in London. The comparatively tiny view of c.1880 seems to have been made for advertising purposes, and is in the tradition of lithographic bird's-eye views of factories commissioned by proud factory owners. Krupp's steelworks, the largest in Europe at this date, contributed greatly to the German victory in the Franco-Prussian War.

210. San Francisco from California Street Hill, 1878

EADWEARD MUYBRIDGE
Copy photograph after original prints with Kingston Heritage
56.2 x 539.5 cm

This thirteen-segment panorama of pre-earthquake San Francisco was taken by Muybridge from a belvedere on the roof of the house of Mark Hopkins, one of Stanford's railway kings. In retirement Muybridge returned to his home town, Kingston-upon-Thames. He died there in 1904 bequeathing this panorama and other items to Kingston.

211. The Burning City, San Francisco, 10.00am, 18 April 1906

R.J. WATERS

41 x 172 cm
John Hillelson

San Francisco is shown after the 1906 earthquake. It was a panorama of this subject that inspired Eugene O. Goldbeck to take up a career as a panorama photographer.

San Francisco in fact had long been a favourite subject of panorama photographers. In the early 1850s several daguerreotype panoramas were made of the city: one of these, a seven-segment image, is in the collection of the California Historical Society. For Muybridge's panorama see cat. No. 210.

212. The Desolate City, 1906

R.J. WATERS

41 x 178 cm
John Hillelson
San Francisco after the earthquake.

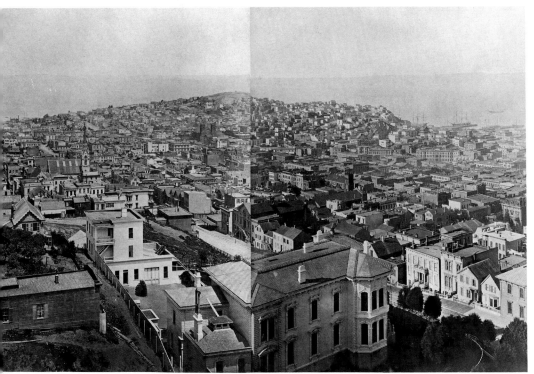

210

213. **Views of Lowestoft and Great Yarmouth**

GEORGE DAVISON

Six photographs 8 x 29 cm each
Kodak Collection, National Museum of Photography,
Film & Television

George Davison, born in Lowestoft in 1857, was one of the first members of the London Camera Club, and a member of the Linked Ring Brotherhood which broke away from the Photographic Society in 1892. Between 1900 and 1908 he was Managing Director of Kodak. Though dismissed by George Eastman he continued to serve on the company's board of directors. He took to anarchism and whilst still a member of the board paraded down Kingsway with a banner reading, 'Down with Capitalism'. Eastman wrote to him: 'I am not too intolerant to view with great interest the tendency of a man of your stamp towards anarchy, and would not have a word to say against it if I did not think it was inconsistent with your holding the position of director of our companies'. Davison excelled in landscape photography. Much of his work was carried out in East Anglia.

213

214. Kodak panorama album, c.1905

ALBERT PAINE BUTLER

Kodak Collection, National Museum of Photography, Film & Television

Butler's album of photographs, taken with a Kodak Panoram, is displayed open to show panoramas of Marble Arch and Piccadilly Circus. The photographer, an employee of Hastings Ltd., a furnishing company of Clapham Junction, had worked for Kodak previous to his marriage in 1902.

215. Kodak panorama album, c.1901

PHOTOGRAPHER UNKNOWN

9 x 30.5 cm each
Kodak Collection, National Museum of Photography, Film & Television

The album is opened to display two photographs of the Glasgow Exhibition of 1901 taken with a Kodak Panoram.

216. Russian Imperial Album, c.1906

9 x 43.2 cm
Private collector

This album consists of snap-shots taken by the Dowager Empress of Russia with a Kodak Panoram. The most interesting of them show the Imperial family relaxing and at play on their country estates. Kodak had a franchise in St Petersburg from c.1900.

217. The Surviving members of the Russian Imperial family on board H.M.S. Marlborough, Yalta, 1919

Two photographs, approx. 9 x 31 cm each
Private collector

Photographs taken by the Dowager Empress with a Kodak Panoram.

218. Two 'total view' postcards of Vladivostock, c.1910

Published by Granbergs Art Industri Co, Stockhom
Process
14 x 80 cm (overall)
Royal Geographical Society

Panorama postcards were to become common, particularly in the 1950s and '60s, but were uncommon at this date. The view of Vladivostock, made up of two colour postcards that form one image when butted together, shows ships of the Russian Imperial Navy at anchor.

216

220 (detail)

219. **Eight photographs taken in Antarctica**

HERBERT G. PONTING

Copy photographs
12.5 x 32 cm each
Polar Research Institute

Herbert Ponting (1870-1935) was the official photographer to the British Antarctic Expedition, 1910-13. By the time of his appointment he had already established a world-wide reputation, his photographs of India, China, and Japan having appeared in leading U.S. and British Journals. He arrived in Antarctica on the *Terra Nova* on 4 January 1911 with an extensive range of cameras. 'Ponting is the most delightful of men', wrote Scott in his journal. 'He declares this is the most beautiful spot he has ever seen, and spends all day and most of the night in what he calls "gathering it all in" with camera and cinematograph'.

Ponting took a panoramic telephotograph of the Western Mountains, and claimed that the resulting negatives formed one of the longest distance panoramic telephotographs ever made. On 31 October when Scott and his team set off for the Pole Ponting accompanied them for just the first few miles.

220. **Delhi Durbar**, 1911

PHOTOGRAPHER UNIDENTIFIED

18.3 x 106.2 cm
National Army Museum

George V, as King-Emperor, held a durbar at Delhi on 12 December 1911, during his Far East visit, announcing in his speech the partition of Bengal. The large assembly of troops represented most of the regiments then in India. There is no sign of George V in the photograph and it has been suggested the photograph depicts a rehearsal.

factured in 1912. Before the pigeon was released the moment of exposure was set by adjusting the pneumatic delayed action shutter. The lens swivelled and the film carrier was curved. There are examples of the tiny panoramas produced – the extreme ends blurred by flapping wings – in the Deutsches Museum.

222. **Grand photograph of the Bay of Naples,** 1903

Copy photograph
Barnes Museum of Cinematography

To develop the *Neue Photographische Gesellschaft's* vast multi-segment photograph giant tanks were specially constructed. The exposed paper was wound round a wooden wheel, forty-one feet in circumference. The tanks, on railway lines, were pushed beneath it and the wheel lowered and turned. At final rinsing the paper was carefully unrolled into the outsized water tank.

221

221. **Dr Julius Neubronner's panoramic camera strapped to a pigeon**

PHOTOGRAPHER UNIDENTIFIED

Copy photograph
Original camera and stuffed pigeon in Deutsches Museum, Munich

The Doppel-Sport camera, a miniature panoramic camera designed to be attached to a pigeon's chest, was invented by Dr. Neubronner in 1908 and was manu-

222

223. First Army Panorama, No. P124, 1917

PHOTOGRAPHER UNIDENTIFIED

16.5 x 397.5 cm
Imperial War Museum

This British multi-segment field-panorama of the German trenches, marked with gunnery data, was taken from a sequence of points on 26 June 1917. The camera and tripod for it would have been set up some way behind the front lines, out of range of snipers' bullets.

224. Rundbild v.d. Kurpromenade

PHOTOGRAPHER UNIDENTIFIED

Imperial War Museum

An example of a German field-panorama of Allied trenches.

225. Hun Prisoners and Wounded Captured by Canadians; Paschendale – Now a Field of Mud; The French Lines at Sedd-el-Bahr; Camps and Stores at Sedd-el-Bahr

PHOTOGRAPHER UNIDENTIFIED

Four photographs
Imperial War Museum

Examples of panoramas being used for war reportage. The photographs were most probably taken with a Kodak Panoram.

226. Survey panorama of mountainous terrain in Macedonia, 1917

OC SURVEY COMPANY, ROYAL ENGINEERS

32.2 x 315.2 cm, in 6 sections
Royal Geographical Society

In 1917 the British forces in Macedonia were fighting in rugged country which had never been properly mapped. Consequently the Royal Engineers provided a large number of panorama photographs to assist in making accurate surveys of the region. This panorama is described as 'From Signal Grec Avance [i.e. Greek Front Signal] on February 5 1917'.

227. Artillery Manual, 1944

Printed text
18 x 12 cm
Royal Artillery Institution

This restricted manual, issued by the War Office during World War II, lists the uses of military panoramas and describes how to make them.

228. Panoramic Sydney

WARD AND FARRAN

Book published by N.S.W. Bookstall Co. Ltd., Sydney
Half-tone reproductions
22.5 x 57.8 cm
Royal Geographical Society

Panoramic Sydney consists of a collection of full-page and double-page panoramas. The title-page describes it as 'unique', and 'undeniably the best series of photographs ever published in Australia'. Those wishing to acquire originals of the individual photographs were advised to contact the studio of Messrs Ward and Farran.

225

231

229. **The Most Up-to-Date Sydney Panoramic Views**

Book published by H. Phillips, Katooba, N.S.W.
Half-tone reproductions
24 x 53 cm
Royal Geographical Society

230. **Railway Clerks Association: 23rd Annual Delegate Conference, Scarborough,** 1920

PHOTOGRAPHER UNIDENTIFIED

21 x 113 cm
Kodak Collection, National Museum of Photography, Film & Television

Group photography has provided the stable income for most panorama photographers in this century. The more sitters the greater is the potential return. In Britain until recently there were two principal firms specialising in this branch of photography, visiting schools and recording conferences. These were Panora and Buchanan's. Panora have now gone out of business, and Buchanan's have discontinued panoramic photography.

230

231. Seventh International Congress on Photography, London, 1920

Eagle Photo Co.
17.5 x 69.8 cm
Kodak Collection, National Museum of Photography, Film & Television

232. The Chaplin Essanay Co. – During the Making of 'The Bank', 1915

PHOTOGRAPHER UNIDENTIFIED

22 x 116 cm
David Robinson

Chaplin is to be seen second from the left, and next to him is Edna Purviance. Charlie played the spurned janitor in *The Bank*, and Edna, the bank's beautiful secretary. Standing both at the extreme left and the extreme right of the group is Jesse Robbins, Essanay's producer and director. (The company's name was formed from the initial letters of the founders, Spoor and Anderson – 'S' and 'A').

233. Tennis match; Bull fight, c.1925

PHOTOGRAPHER UNIDENTIFIED

Two photographs, 9 x 30 cm each
Kodak Collection, National Museum of Photography, Film & Television

These sporting photogaphs were taken with a Kodak Panoram. Kodak's may have had them made for advertising purposes, in order to demonstrate what their camera could do.

234. Vertical panorama of a woodland scene under snow.

PHOTOGRAPHER UNIDENTIFIED

10 x 33 cm
Private collector

A photograph taken with a Kodak Panoram No.4. In their handbook Kodak encouraged Panoram owners to try vertical shots, suggesting as subjects high waterfalls, mountain peaks, and narrow ravines: 'A little practice and experiment will lead to the most charming results'. Despite this advice very few vertical panoramas exist.

235. View Across the River Vltva, 1954

JOSEF SUDEK

10 x 29.2 cm
Kodak Collection, National Museum of Photography, Film & Television

Sudek was born in Bohemia in 1896. Originally he was a bookbinder. During the First World War he lost his right arm, yet afterwards took up photography as a career. He regarded himself as primarily an artist, and his photography was much influenced by romantic landscape painters. He died in 1976. A volume of his Prague panoramas was published in 1959.

236. Prague in the winter, 1955

JOSEF SUDEK

9.5 x 29 cm
Kodak Collection, National Museum of Photography, Film & Television

236

237. The Barbican after the Blitz

ARTHUR CROSS

19.6 x 130 cm
Guildhall Library, City of London

Police Constable Arthur Cross was the City of London
Police Force's photographer between 1939 and 1945.
As such his principal responsibility was to take 'mug
shots' for police identity cards. Once the blitz began,
however, he was assigned the additional task, with his
colleague Frederick Tibbs, of photographing war dam-
aged buildings in the City. He continued this work
throughout the war years, producing approximately
400 photographs.

Cross's five-segment panorama of the Barbican area
would seem to have been taken from a building in Little
Moorfilds. It shows the scene from Coleman Street on
the left to Chiswell Street on the right. Barrage bal-
loons are to be seen on the ground and in the air.

238. Colour photograph of the Golden Gate, San Francisco

UNKNOWN PHOTOGRAPHER

6.5 x 80.3 cm
Kodak Collection, National Museum of Photography,
Film & Television

239. Red Square, the Kremlin, Moscow, 1969

EUGENE OMAR GOLDBECK

22.3 x 186.8 cm
Private collector

Goldbeck visited the Soviet Union in 1950, 1969, and
1977. Though it was primarily from group photo-
graphy that he made his living he also photographed
what might be called postcard subjects.

240. Hebden Bridge under Snow, 1971

MICHAEL WESTMORELAND

23.5 x 181.6cm
Michael Westmoreland

Hebden Bridge, Westmoreland's favourite beauty spot,
is highly sympathetic to the turning camera. For this
cibachrome photograph he used his Cirkut No.10.

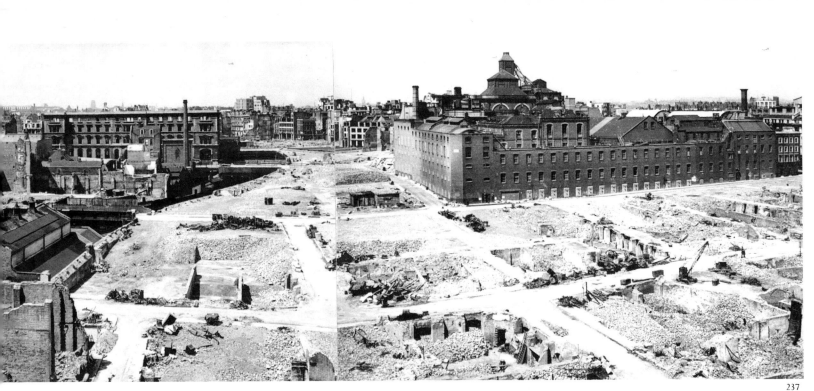

237

239

242

241. **Hong Kong Harbour Front,** 1980

MICHAEL WESTMORELAND

12 x 261.6 cm
Michael Westmoreland

Hong Kong Harbour being crescent-shaped, presents an ideal subject for a turning camera. This 270-degree cibachrome shows the entire sweep of the harbour from the sea. It reminds one of the long aquatinted panoramas of the nineteenth century which pulled out of lacquered cases. On his visit to Hong Kong in August 1980 Westmoreland took a second panorama of the city from the top of the Hong Kong Hilton. For both he used a six-inch Cirkut camera.

242. **London from the NatWest Tower,** 1979

LEN DANCE

Panorama Ltd
39.5 x 39 cm
Guildhall Library, City of London

To take this photograph the photographer stood in the bucket attached to the cable of a crane on the top of the NatWest Tower. The NatWest building – the tallest in London – at this date was still under construction.

243. **View down a skyscaper, New York City** 1983

NORMAN WEISBERG

137 x 38 cm
Norman Weisberg

Weisberg used a GlobuScope camera to take this photograph from the top of Block 30 of the Rockefeller Plaza.

244. **Panoramic View of Manhattan,** 1983

NORMAN WEISBERG

20 x 162 cm
Norman Weisberg

Like Cat. No. 243 this photogaph was taken from the top Block 30 of the Rockefeller Plaza with a Glob-uScope.

196

243

245. Lofoten, Norway series: Angel Lakes Steigen; Islands and Skerries, Lofoten Crossing Point, Two Ferries, Lofoten, 1985

BOB CHAPLIN

Three works, each 89.5 x 59.5 (overall)
Bob Chaplin

Bob Chaplin is one of several contemporary artists who uses a panoramic camera. – a Russian Horizont. He describes it as the camera is an extension of his mind's-eye. Chaplin stations himself on one spot and takes photographic strips out of the landscape, selecting, emphasising, and encompassing. Often he will return to that spot, re-recording the scene. In this way he builds up the idea of time-lapse, adding an extra dimension to his images, and conveying more completely the spirit of the place. The photograph is modified by etching, serigraphy, or paint. A number of Chaplin's panoramas have the fjords and mountains of Norway as their subject.

246. Apollo 17 panorama of the Moon's surface, 1966

NATIONAL AIR & SPACE AGENCY, WASHINGTON D.C.

A view of the Earth as seen from 232,000 miles above the surface of the Moon. This panorama was transmitted by Orbiter I to the NASA tracking station at Robledo de Chevela, Spain.

247. Viking I panorama of Mars, 1976

NATIONAL AIR & SPACE AGENCY, WASHINGTON D.C.

To send 300° panoramic images of Mars the Viking probe in July-Aug. 1976 used a £27.4 million system. The camera that had been developed admitted a beam of light which fell on twelve photoelectric cells. As the camera turned, the cells read the landscape as a series of vertical lines, each line divided into hundreds of elements. These produced signals which were encoded in the camera and then radioed to Earth. At the Jet Propulsion Laboratory, Pasadena, computers translated the scenes into detailed photographs.

248. Johnson's Pantoscope camera, c.1865

Science Museum

Johnson and Harrison's camera had a clockwise revolving mechanism in a baseplate that was attached. It produced 110-degree views on 7 1/2 x 12-inch plates.

249. Kodak Panoram, No.1

Brian Polden

Following the launch of its successful Panoram No.4, Kodak in 1901 introduced the No.1. This was smaller and even more successful. It used a 120 film (which means it can still be used today with a small amount of adaptation), and gave a 120-degree angle of view. The photographs it produced measured 2 1/4 x 17 inches. Kodak recommended their Panorams for landscapes, seascapes, and broad open thoroughfares at the intersection of streets.

250. Instructions for Using No. 4 Panoram Kodak, 1924

Booklet
14.5 x 9.5 cm
Kodak Collection, National Museum of Photography, Film & Television

The No.4, Kodak's first Panoram, was introduced towards the end of 1899, and continued to be manufactured until 1923. It had a negative size of 3 1/2 x 12 inches.

251. Instructions for Using No. 3A Panoram Kodak, 1926

Booklet
14.5 x 9.5
Kodak Collection, National Museum of Photography, Film & Television

The Panoram No.3A appeared in 1926, replacing the No.1. Its negative size was larger – 3 1/2 x 10 3/8 inches. It was not a commercial success.

252. Cirkut No.10 camera

Brian Polden

The Cirkut No.10 has been called the Rolls Royce of panorama cameras. It was introduced in 1904, continued to be manufactured until 1941, and is still being used by professional photographers today. It produces 10 x 144-inch negatives.

253. **Michael Westmoreland**

COSTA RATACOUZINOS

Michael Westmoreland

Westmoreland with his Cirkut No.10 camera. His 14-foot wooden tripod has a metal turntable on the top which allows the whole camera to rotate the full 360 degrees. It is believed to have been made for photographing the 1937 Coronation.

254. **Cirkut No.5**

Brian Polden

The Cirkut No. 5 was the smallest of the range of Cirkuts manufactured, producing a 5 x 42-inch negative. It was made between 1915 and 1923.

255. **Horizont camera**

Brian Polden

The Russian Horizont, a 120-degree format camera, was introduced in 1966 replacing the Spaceview which had come onto the market eleven years earlier. It was relatively cheap – about £60. It continued to be manufactured until 1975.

256. **GlobuScope camera**

National Museum of Photography Film & Television

The GlobuScope 1000, a more recent hand-holdable 35mm camera, was manufactured in New York by the brothers Ron, Rick, and Steve Globus. Its body is made of stainless steel, and it weighs only 3 1/2 lbs. It has no gears, electricity, or batteries, but instead has a spring motor which discharges into a fluid clutch. Its head rotates in increments of 180 degrees or more. With no viewfinder and no film counter it is not an easy camera to use.

253

IX THE PANORAMA TODAY

In the opening years of the twentieth century the effect of the cinema on the panorama was even more calamitous than the effect in the 1960s of television on the cinema. In the face of cinema competition virtually every rotunda in the world shut up shop. Of the very few that survived several were located at pilgrimage centres – Lourdes in the Pyrenees, Einsiedeln in Switzerland, Altötting in Germany, and Ste Anne de Beaupré in Quebec.

Though panoramas had been shown in Russia in the nineteenth century they had been imported from Western Europe. Now, very late in the day, they began to be painted by Russians. Franz Roubaud completed a panorama of the Siege of Sebastopol in 1905, and then another of the Battle of Borodino in 1912. Following the Russian Revolution several panoramas were painted on the theme of the Civil War, 1918-22.

In Belgium the panorama industry just about survived. Louis Dumoulin produced a 'Battle of Waterloo' which still exists in a rotunda erected on the site of the battle, and Alfred Bastien painted panoramas of First World War engagements. By far the most ambitious new war panorama was one entitled the 'Panthéon de la Guerre'. Forty-five feet high and 402 feet long this panorama celebrated the victory of the Allies and paid homage to those who died. It included over six thousand life-sized portraits of heads of state, political leaders, military and naval leaders, and war-time heroes, standing against a background consisting of the battlefield from Calais to Belfort. Well over a hundred artists were engaged to paint this French panorama, under the direction of Pierre Carrier-Belleuse and Auguste François Gorguet. After being exhibited in Paris it was sent to the United States where, for a while, it formed an attraction in Madison Square Garden.

Just occasionally a panorama would be painted for an international trade fair. There was a panorama of North Africa, for instance, at the Exposition des Arts Décoratif in Paris in 1925. For the Bicentennial Exposition in the United States in 1933 the 'Panthéon de la Guerre' was transferred to Washington D.C. Afterwards it was moved to Chicago for the Century of Progress Exposition, 1933-34. In the main, however, the panorama as a form of entertainment was forgotten.

Surprisingly, after the Second World War there was renewed interest in panoramas and an inclination to cherish the few examples that had miraculously survived. Panoramas damaged by war, or by atrocious storage conditions, have been extracted from stores, unrolled, and conserved at horrendous cost, and then hung in new, modern rotundas. Russia led the way in 1949-50,

restoring Franz Roubaud's 'Battle of Borodino'. Like the French panoramas after the Franco-Prussian War 'Borodino' celebrates a defeat, not a victory. The patriotic heroism of the defenders of Mother Russia against an invader from the West is held up as an example: the need for vigilance and the necessity for being adequately armed are the lessons it seeks to teach the present generation. Four years later a copy of the same artist's 'Siege of Sebastopol' went on display – another panorama that celebrated a defeat.

Poland's only panorama, on the other hand, is an expression of that nation's fierce determination to exist. It commemorates the Battle of Raclawice which took place on 4 April 1794 between a Polish peasant army armed with scythes fixed upright on staves and the greatly superior forces of the Czar. The Poles won. The panorama of this short-lived triumph was painted by a crew of Polish and German artists under Jan Styka and Wojciech Kossak, and exhibited for the first time at the National Exhibition at Lwow on the centenary of the Battle in 1894. In 1980 its fourteen sections were taken out of store and completely conserved. The panorama went on exhibition again in a new rotunda designed by Ewa and Marek Dziekonski in 1986.

Few panoramas that compare with those of Russia or Poland survive in Western Europe. Even if they had been kept it is difficult to imagine that the Battle of Sedan, the Siege of Paris, the Battle of Champigny, or the Battle of Rezonville would have enough meaning to draw the crowds. Such panoramas speak of Europe's past disunity: mercifully disharmony between France and Germany is a thing of the past. Those that have been rescued are of more benign subjects. In 1961 the 'Panorama of Thun' by Marquand Wocher – the earliest of the surviving panoramas – was restored and hung in a new rotunda in the town's Schadaupark. In Austria Michael Sattler's 'Panorama of Salzburg,' which had been in store since 1937, was restored and rehung in 1977 in a new panorama room attached to the Café Winkler Casino. The Victoria & Albert Museum in London has resurrected a very pretty panorama of Rome, painted by Ludovico Caracciolo in the 1820s, and has put it on display in a gallery devoted to the history of the panorama. A new panorama of the city of Bath, painted single-handed by Roger Hallett, is now on exhibition at the Thames Barrier, Charlton.

To Americans the Civil War – the last war to be fought on their soil – has a perpetual fascination. The Boston version of Philippoteaux's 'Battle of Gettysburg' was restored in 1959-61, and can now be seen in the Cyclorama Center on Cemetery Ridge in the National Military Park in Gettysburg. At Atlanta in Grant Park is F.W. Heine and August Lohr's 'Battle of Atlanta.' This battle celebrates a Federal victory in a Confederate state but it was restored by Gustav Berger in 1980-82 at the behest of the local black administration. Gustav Berger was also responsible in 1983 for the restoration of John Vanderlyn's 'Palace and Gardens of Versailles', on show at The Metropolitan Museum of Art in New York City.

What is most exciting is the appearance of entirely new panoramas. If the period 1789 to the early 1860s represents the first generation of panoramas, and 1872 to 1900 the second, then it would seem we are now witnessing a third.

In 1982 the M.V. Grekov Studio of War Art in the USSR completed a panorama entitled 'The

Defeat of the German-Fascist Forces at Stalingrad.' This panorama, which depicts the moment in 'Operation Ring' when the Soviet Union's 21st and 62nd Armies finally met, splitting the invader's forces in two, is exhibited in a most awesome rotunda that stands in a complex of museums devoted to the Battle in Volgograd.

Curiously, but interestingly, some of the panoramas of the new generation are being exhibited in countries with no panorama tradition. In Al-Mada'in, Iraq, 44 kilometers south-east of Baghdad, there is a rotunda displaying 'The Battle of Al-Qadissiyah, A.D. 637'. There, having ascended by stairs or lift to the viewing-platform, one finds oneself in the midst of a battle in which Arabs on horseback, under the leadership of Sa'id bin Abi Waqqas, defeat the Persian army, mounted on elephants. The panorama serve to inspire today's Iraqi (Arab) youth in their country's eight-year war against the Iranian (Persian) forces of Ayatollah Khomeini.

Given the rivalry between East and West it is not surprising that in Germany two panoramas are being painted. The one in the German Democratic Republic is the work of Professor Werner Tübke of Leipzig University. It spectacularly depicts a tragic episode in the Peasants' War when the straggling army of Thomas Muentzer of Allstedt, a one-time follower of Luther, was slaughtered by the armies of the rulers of Hesse and Saxony. The panorama is now scheduled to open to the public in 1989. The Federal Republic of Germany's answer to Bad Frankenhausen is a painting 99 feet in circumference dealing with the ill-fated Frankfurt Parliament. This elected assembly in 1848 attempted to provide Germany with a democratic constitution. It was crushed by conservative forces one year later. The painting is being carried out by a Berlin artist, Johannes Gruelzke, and it is to be hung in the Paulskirsche where the Frankfurt Parliament assembled.

In the Far East in Pyongyang, North Korea, a panorama has recently been painted of the Battle of Tetschou, an historic landmark in Korea's protracted struggle against Japanese occupation. In Peking a panorama was completed this year for the Memorial Museum of Anti-Japanese War by Mao-Wen Biao and He-Kong De. It shows 'Battle of lu Gou (i.e. Marco Polo) Bridge, 7 July, 1937'. The Egyptian Army, meanwhile, has commissioned a huge panorama of the Arab-Israeli war. Measuring 55 feet by 435 feet its dimensions exceed those of what was previously the largest panorama in the world – the Chicago version of Philippoteaux's 'Battle of Gettysburg.' At the time of writing, the work is being completed by eighteen North Korean artists.

257. Panorama of Thun

Fold-out reproduction

This is the earliest of the surviving panoramas having been painted in 1814 by a Swabian artist, Marquand Wocher (1760-1830). His later work included a transparency of the Nativity.

After Wocher's death the panorama of Thun was sold at auction. It was presented to the town in 1899, restored in 1958-59, and then purchased by the Federal Gottfried Keller Foundation in 1960. It can now be seen in a rotunda in Schadau Park.

A panorama of Thun from the N. was exhibited at the Colosseum in London in 1851, replacing 'Paris by Night.'

258. Panorama of Salzburg

Fold-out reproduction

Since 1977 Joseph Michael Sattler's panorama of Salzburg has been on exhibition in the Cafe Winkler Casino, Salzburg.

Sattler drew his panorama of Salzburg in 1825 from the roofs and towers of Hohensalzburg Castle. When painting the large, final version he received assistance from Friederich Loos, who contributed the more distant landscape and Johann Josef Schindler, who contributed the staffage. The work was completed in 1829.

A retrospective exhibition of J.M. Sattler's work was held in the Salzburger Museum Carolino Augusteum in 1977.

259. The Bourbaki panorama

Book: 'Les Bourbaki' by André and Heinz Horat (1983); Journal: Special panorama issue of the *Swissair Gazette'*, 9 (1986)

The Bourbaki Panorama in Lucerne is unique: instead of presenting a heroic scene of soldiers in battle, it shows the remnants of an army in retreat. During the Franco-Prussian War the French Eastern Army under General Bourbaki attempted to relieve the Siege of Belfort. It was defeated. Bourbaki was replaced by General Clinchant who lead the army to Switzerland. Edouard Castre's panorama shows endless columns of exhausted soldiers and horses arriving in the frontier town of Verrières, surrendering their weapons to their neutral hosts. The *faux terrain* includes a real railway waggon; it is on actual railway lines which merge into painted railway lines on the canvas. The panorama was shown for several years in Geneva; since 1889 it has been exhibited in Lucerne.

260. Panorama of Gettysburg

Fold-out reproduction

The 'Battle of Gettysburg' can be seen in the Gettysburg National Military Park. Painted by Paul Dominique Philippoteaux, it was exhibited in Boston from 1884 till 1892. For a while it lay rolled in a crate which was left in the open behind the Boston Exhibition Hall. Rescued in 1904 it was exhibited in several East Coast towns before reaching Gettysburg in 1913.

The original rotunda for this panorama, in Norman castle style, today serves as the nucleus of the Boston Center for the Arts.

261. Jerusalem on the Day of the Crucifixion

Reproduction from booklet

Gustav Berger informs the author that this Crucifixion panorama at Ste Anne de Beaupré was made under licence from Bruno Piglhein of Munich, and painted in the early 1890s in the Chicago studio of Paul Philippoteaux. A duplicate of the panorama, made in the same studio, was sent to Australia.

An early descriptive booklet for the panorama records that Piglhein produced the original image, and that Dr Ernest Pierpont obtained 'the necessary data' from Munich. Strangely, a later edition of the booklet with an otherwise identical text substitutes Philippot-

eaux's name for both Piglhein's and Pierpont's. The artists who actually painted the panorama were O.D. Grover and C.A. Corwin (both natives of Chicago); E.J. Austen (an Englishman); and E. Gros and S. Mege of Paris (who had assisted with the painting of several earlier Philippoteaux panoramas). The panorama arrived at Ste Anne de Beaupré in 1895.

262. Panorama of the Crucifixion

Booklet with key and postcard strip

This Crucifixion panorama, like the Jerusalem panorama in Canada, is situated at a place of pilgrimage – the cathedral of Einsiedeln in Switzerland. The panorama that was originally exhibited was by Karl Frosch, assisted by J. Krieger and W. R. Leigh. It was not one of Frosch's plagiarisms however. It was completed in 1892.

On 17 March 1960, whilst the panorama was being restored, it was destroyed in a fire. The present panorama is a replica of Frosch's, painted under the direction of Professor Max Huggler by two Viennese artists, Hans Walz and Josef Fastl. The colouring is not to everyone's taste.

263. The Panorama Mesdag, Scheveningen

Leaflet

This panorama shows the fishing village of Scheveningen near The Hague, painted by the noted Dutch marine artist Hendrik Willem Mesdag. It is probably the best known panorama in Western Europe, and certainly the most painterly. Commissioned by a Belgian company, the 'Société Anonyme du Panorama de La Haye' in 1880, it was opened on 1 August 1881. 'The only fault of this painting', Van Gogh said on his first visit, 'resides in its being faultless'. In 1886 Mesdag acquired the rotunda and the panorama for himself and thenceforth it was operated at his expense. For a short time he exhibited it in Munich and then in Amsterdam. The panorama returned to the Hague in 1891, and it has remained there until the present day. Though currently being conserved it remains on view to the public and attracts large numbers of visitors.

264. Panorama of the Battle of Isel

Booklet: 'Das Innsbrucker Riesenrundgemalde', by F. Caramelle

The Panorama of the Battle of Isel, 13 August 1809, belongs to the Raiffeisen Zentralkasse fur Tirol. It depicts a decisive battle in the Tirol's struggle for freedom. Painted by Michael Zeno Diemer (1869 – 1939) in his Munich-Schwabing studio, it was initially exhibited at the 1896 International Sports Exhibition in Innsbruck. In 1906 it was transported to London for the Anglo-Austrian Exhibition in Earl's Court. After several years of neglect it was acquired by an Innsbruck innkeeper, Josef Hackl, who put it on exhibition again in 1924. About 20,000 people now visit it each year.

265. Panorama of the Battle of Lipany

Photographs

The panorama of the Battle of Lipany, 30 May 1434, stands in the Julius Fucik Park of Culture and Recreation in Prague. It was commissioned for an exhibition of the work of Czech artists and engineers which took place in 1898. Ludêk Marold (1865-1898) painted the figures, and Václav Jansa (1859-1913) the landscape. The *faux terrain* was the work of Karel Stapfer. In the winter of 1929 the rotunda collapsed under the weight of snow and the painting was damaged. The new, iron-framed building which replaced it was opened on 30 May 1934, the 500th anniversary of the battle.

266. Panorama of the Battle of Waterloo

Fold-out reproduction

Of the many Battle of Waterloo panoramas that were painted just one survives, that exhibited in a rotunda at the foot of the Lion's Mound on the battlefield, S. E. of Brussels. It was painted in 1912 by the French painter, Louis Dumoulin. Today it is severely water-stained and in great need of conservation.

267. Panorama of the Battle of Borodino

Book: '1812: The Borodino Panorama' by I.A. Nikolaeba, N.A. Kolosov and P.M. Volodin (1982);
Postcards

The Battle of Borodino panorama in Moscow was commissioned in 1910 for the celebrations of the centennial of the battle in 1912. The artist was Franz Alekseyevich Rouboud, born in Odessa of French parentage in 1918, after the Revolution the building was closed; the panorama was rolled up and left outside in a water repellent fabric. Later it was moved to a monastery. In 1949 the panorama was restored, but it was not until the 150th anniversary of the Battle of Borodino in 1962 that a new rotunda was built for it in the centre of Kutuzov Square and the panorama, with a new sky, put on show again. The panorama is lit by artificial light.

268. Panorama of the Siege of Sebastopol

Booklet: 'Museum of Sevastopol's Heroic Defence and Liberation' (1984);
Fold-out reproduction;
Postcard

In 1854-55 Britain, France, Turkey and Sardinia laid siege to the city of Sebastopol. The Siege, which continued for 349 days, provided panoramists with an ideal subject: Burford's 'Sebastopol' went on show promptly in May 1855, Colonel Langlois' in 1860, and Franz Roubaud's on the fiftieth anniversary of the event in 1905. The ornate rotunda built for Roubaud's, and shown in this exhibit, was erected on the site of the Siege.

During World War II the rotunda and the panorama were severely damaged when the city was again under siege. Both were restored in 1955 to commemorate the original Siege. A diorama – 'The Storming of the Sapun Hills, 7 May 1944' – was painted to commemorate the second siege.

Roubaud's panorama depicts the scene from within the Malakhov Mound as on 6 June 1855. The city lies in ruins yet the mood remains defiant.

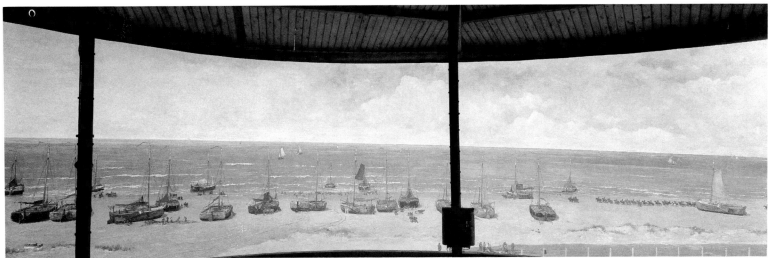

263

269. Panorama of the Battle of Atlanta

Photograph of conservation;
Booklet: 'The Atlanta Cyclorama', by W.G. Kurtz

In 1976 when the roof of the Atlanta Cyclorama was severely damaged in a storm, water soaked the canvas causing streaking, clouding, and a vast tear to appear. The city resolved that the work should be comprehensively restored. A £7.8 million appeal was launched and Gustav Berger engaged to undertake the conservation.

Rather than remove the giant canvas from the rotunda Berger constructed a work-tower at the rear. An 18-ft section of wall was opened up to permit access to the back of the canvas. The canvas was then put on rails, pulled round, and attended to in vertical strips. A cradle was then hung from a second rail within the rotunda allowing conservators to move up and down the face of the painting – in much the same manner as Hornor and Parris's artists in the 1820s.

270. Panorama of the Battle of Raclawice

Leaflet

The panorama of the Battle of Raclawice, was recently restored, and in 1986 once again placed on exhibition in a modern rotunda in Wroclaw, to inspire Polish patriotism. The panorama depicts a battle during the 1794 Rebellion when Polish troops under Kosciusko fought and defeated the Russian army. The collapse of the Rebellion six months later lead to the Third Partition of Poland. The Raclawice Panorama now constitutes a branch of the National Museum of Wroclaw. The painting featured on a recent Polish postage stamp.

271. Panorama Guth, Alice Springs

Fold-out reproduction

Henk Guth's panorama of Central Australian scenery was completed in 1975. Guth, who was born in Arnhem in the Netherlands in 1910, emigrated to Australia in 1960 and set up a studio in Melbourne. In 1966 he moved to Alice Springs where he opened the Art Studio Guth. Guth made friends with the Aboriginal people and built up a museum of Aboriginal culture. Inspired by the Panorama Mesdag he began a panorama of the local landscape, being assisted for a while by a compatriot, Frits Pieters. The painting was finished in six months.

The Panorama Guth's rotunda is virtually the same size as Hallett's Panorama of Bath. The space below the viewing-platform serves as a gallery for a permanent collection of Guth's paintings.

272. Panorama of the Battle of Al-Qadissiya

Descriptive booklet

This panorama, which uniquely features dying elephants, is on exhibition in a rotunda in Al-Mada'in, Iraq. It was inaugurated in July 1968. The battle depicted on it was fought in 637 AD between the Arabs, who were commanded by Sa'ad ben Abi Waqqas, and the Persians commanded by Rustum. When the Arabs put out the eyes of one of their opponents' elephants the Persians' other elephants panicked. As at the Battle of Atlanta Panorama the Batttle of Al-Qadissiya is provided with sound effects.

273

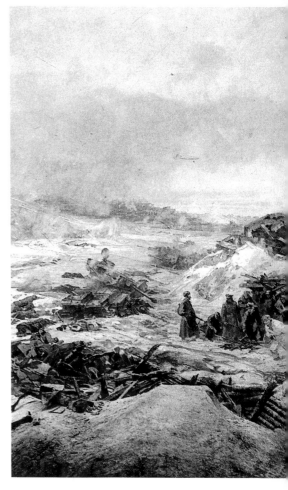

273. Panorama of the Battle of Stalingrad

Postcards
Fold-out reproduction

Ninety percent of Stalingrad was destroyed in World War II. In 1944 the Soviet Union's Committee for Architectural Affairs held a competition for designs for rebuilding the city. Although the conditions of the competition did not stipulate that a panorama should be included, many of the entries did include one. Following the War several travelling panoramas of the Battle of Stalingrad were painted.

On 2 February 1968 the complex of museums and the panorama devoted to the Battle of Stalingrad was opened. The panorama depicts the battle from the summit of the Mamaev tumulus.

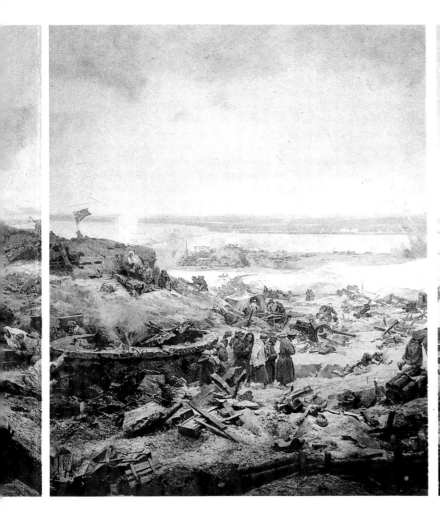
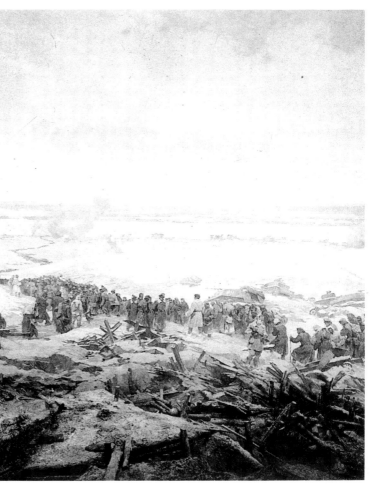

273

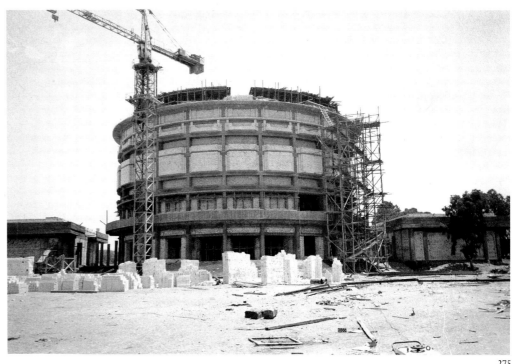

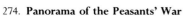

274. **Panorama of the Peasants' War**

Reproduction; leaflet

Werne Tübke's panorama of the Battle under the Rainbow, a gruesome episode during the Peasants' War, 1524-25, has now been completed and is due to open to the public early in 1989. It is accommodated in a rotunda erected on a hill outside Bad Frankenhausen, Thuringia (now in the G.D.R.). On this spot in 1525 rac Protestant reformer, Thomas Muentzer of Allstedt and his followers fought the combined forces of the Lutheran Prince of Hesse and the Catholic Duke of Saxony. When a rainbow appeared in the sky Muentzer interpreted it as a sign of certain victory. In the event he and his followers were decimated: between 6,000 and 7,000 peasants were slaughtered on the battlefield, and Muentzer was captured and beheaded.

Tübke's painting, though overwhelming, is not a conventional, illusionistic panorama but rather a 360° mural. It incorporates elements of the work of Hieronymus Bosch, Pieter Breugel, Albrecht Dürer, and other 16th-century German artists.

275. **Panorama of the Arab-Israeli War,**

Photographs of the rotunda

At the time of writing the Egyptian Army's panorama of the Arab-Israeli War is due to be completed on 6 October 1988. The photographs, taken by Douglas Pike in 1987, show the massive rotunda for this, the largest panorama in the world, under construction in Heliopolis on the outskirts of Cairo.

276. Hallett's Panorama of Bath

Two mosaics of photographs taken for the Bath panorama, Twerton to Royal Crescent; study of roof-tops, including Marks & Spencers; study showing Bath Technical College; model of the artist's studio; model of the rotunda for Hallett's Panorama of Bath

Hallett's Panorama of Bath opened at its present site alongside the Thames Barrier in May 1988. In the previous year it had been exhibited on London's South Bank. Like Henk Guth (see cat. No.271) Roger Hallett was inspired by the Panorama Mesdag. His painting represents Bath as seen from a hot air balloon 50 feet above Alexandra Park on 14 October 1983. The preliminary photographs were taken from such a balloon; more photographs and drawings were made from a crane successively positioned at a number of points on the perimeter of the Park. The panorama was painted in a disused fuller's earth works on the outskirts of Bath. There being insufficient space to hang the entire 360 degrees of the canvas, the artist was obliged to paint the panorama one segment at a time, progressively moving the completed parts of the canvas along the rail into an area which he called the 'wardrobe'. The work took four years to complete.

277. Panorama of Lhasa, 1986

PAUL OSBORNE

Pencil and watercolour
40.6 x 243.6 cm
Paul Osborne

Osborne's drawing, unconsciously in the style of artists such as Catherwood who supplied Robert Burford with images, was made between 3.00 pm and 5.00 pm on Christmas Day 1986. Lhasa is shown from the golden roof of the Jokhang Temple. The Potala is to be seen in the distance in the centre. The artist selected this particular viewpoint as no Chinese buildings could be seen from it; the panorama is thus restricted to Lhasa's traditional topography. Osborne has also made panoramas of London from the roof of the Royal College of Art, London from Southwark Cathedral (a parallel to Hollar's long view of 1647), Florence, Constantinople, and Ladakh.

278. Paul Osborne's sketchbook

Pencil and watercolour sketches
30 x 41 cm
Paul Osborne

This volume contains preparatory sketches for a number of Osborne's images. It is opened to display the Monastery of Dochiariou, Mouth Athos.

279. Map-View of the City of London, 1986-88

NORBERT CEULEMANS

Photographic enlargement
244 x 488 cm
Norbert Ceulemans

Norbert Ceulemans' map-view of London has just been completed, and is being exhibited in the *Panoramia!* exhibition for the first time. (The complete map-view covers the West End too.) To create the City portion Ceulemans commissioned 1,200 photographs to be taken with a Hasselblatt camera from a Brengine helicopter. Peter Meyvis, his photographer, clad in polar clothing, was strapped beneath the craft. A further 2,000 photographs were taken at ground level. The data assembled was painstakingly transferred by draughtsmen from the photographs to the emerging map-view.

To date Ceulemans has produced map-views of Amsterdam, Brussels, Ghent, Antwerp, Mechelen. Lier, Leuven, Kortryk, Roslare, and Ieper. Paris is in hand and Vatican City and Lourdes are projected. The published map-views are normally purchased for wall decoration; folded sheets with place-names are envisaged for the future. The new London map-view magnificently demonstrates that the sixteenth-century tradition of all-embracing bird's-eye perspectives, illustrated in Section I by Barbari's 'Venice' (cat. No. 1), still lives.

276

CHRONOLOGY

1739		Birth of Robert Barker
1774		Birth of H.A. Barker
1781	26 February	P.J. de Loutherbourg's Eidophusikon opens in Lisle Street, Leicester Square
c.1785		Robert Barker invents the panorama
1787	19 June	Robert Barker granted patent for his invention
	18 November	Birth of L. M. M. Daguerre
1788		Barker's 'Edinburgh' panorama exhibited in Edinburgh and Glasgow
1789	14 March	Barker's 'Edinburgh' exhibited at 28 Haymarket
1790-91		H. A. Barker makes sketches of London from the Albion Mills
1791		The word 'panorama' invented
	June	'London from the Albion Mills' exhibited at 28 Castle Street
1793	25 May	First purpose-built rotunda – the Panorama – opened in Cranbourne Street, Leicester Square
c.1793		Jacob More paints panorama of Rome for Buckingham House
1795		Copy of 'London from Albion Mills' exhibited in New York
1796		Panoramas begin to be exhibited in the Great Room, Spring Gardens, the first being 'Campus Nautica' by Robert Dodd
1799	April	Robert Fulton and Joel Barlow in Paris granted *brevet* to exploit Barker's invention
	September	Fulton opens first panorama in Paris in the Jardin du Couvent des Capucines
	8 December	Fulton sells *brevet* to James Thayer
1800	17 April	Panoramas begin to be exhibited in the Great Room, Lyceum, the first being 'The Storming of Seringapatam' by Robert Ker Porter
		J. A. Breysig's rotunda opens in Berlin
		Fulton assigns rights to James Thayer
1801-02		Twin panorama rotundas opened on Boulevard Montmartre
1802	August	Thomas Girtin's 'Eidometropolis' exhibited at Spring Gardens
	November	Girtin dies
1803	11 November	T. E. Barker's and R. R. Reinagle's Panorama, Strand opens
1806	8 April	Robert Barker dies. H. A. Barker takes over his father's business
1807	1 January	T. E. Barker dissolves partnership with Reinagle
1808		K. F. Schinkel exhibits Palermo panorama in Berlin
		First cosmorama exhibition opens in Paris
1814		Wocher's 'Panorama of Thun' completed
1817		H. A. Barker and John Burford buy out Panorama, Strand
1819		Vanderlyn completes 'Palace and Gardens of Versailles'
1821	May	Cosmorama opens in St James's Street
1822		H. A. Barker retires leaving Panorama, Leicester Square, and Panorama, Strand in hands of John and Robert Burford
	11 July	Daguerre opens Diorama at 4 Rue Sanson, Paris
1823	7 May	Cosmorama reopens at 209 Regent Street

	29 September	Diorama, Regent's Park opens
1824	10 February	John Arrowsmith granted patent for diorama invention
		Caracciolo's 'Panorama of Rome' painted
1826		John Burford retires. Robert Burford becomes sole proprietor of Leicester Square Panorama
1827	September	Neorama of the 'Basilica of St. Peter's, Rome' exhibited in Rue St-Fiacre, Paris
	October	C. W. Gropius opens Diorama in Berlin
1828		British Diorama opens at Royal Bazaar, Oxford Street
c.1828		Francis Danby plans painting and exhibiting panorama of mountain scenery
		J. M. Sattler exhibits panorama of Salzburg in Hannibalplatz, Salzburg
1829	10 January	Colosseum opens
	27 April	British Diorama destroyed by fire
1830	20 March	New British Diorama building opens
		Bouton takes over management of Diorama, Regent's Park
	18 May	Neorama of the interior of Westminster Abbey opens
		'Panorama of Madras' by William Daniell and F. T. Parris exhibited in temporary rotunda, Coromandel Place
1831		Charles Langlois's rotunda in Rue des Marais opens
		Panorama, Strand closes
1832	February	Coromandel Place rotunda closes
1836		Closure of British Diorama, Oxford Street
1839		Longlois moves to new rotunda in Champs-Elysées, designed by J. I. Hittorff
	8 March	Paris Diorama destroyed by fire; replaced by new building in Boulevard Bonne-Nouvelle
1841		Third circle added to Panorama, Leicester Square
1845	7 May	Colosseum reopens
1848		Destruction by fire of second Paris Diorama building
		Cyclorama at Colosseum opens
		'Paris by Night' opens at Colosseum
	September	Diorama, Regent's Park sold
	December	John Banvard's Mississippi panorama opens at Egyptian Hall, Piccadilly
1849	26 March	Risley and Smith's Mississippi panorama arrives in London
1850	April	'Route of the Overland Mail to India' opens at Gallery of Illustration, Regent's Street
1851	April	Diorama, Regent's Park closes
	10 July	Death of Daguerre
		Wyld's Monster Globe opens in Leicester Square
1852	15 March	Albert Smith opens 'Ascent of Mont Blanc' at Egyptian Hall
1853		Diorama, Regent's Park purchased by Sir Samuel Peto
1855	2 May	Diorama reopens as Baptist Chapel
1860		New rotunda for Langlois designed by J.G.A. Davioud opens in Champs-Elysee
1863	12 December	Panorama, Leicester Square closes
1864		Colosseum closes
1866	13 November	'Artemus Ward Among the Mormons' opens at Egyptian Hall
1868	11 June	Panorama, Leicester Square reopens as French church
1870	24 March	Langlois dies
1872	November	'Siege of Paris' by F. and P. Philippoteaux exhibited in Paris
1874		Colosseum, New York opens
1875		Colosseum, Philadelphia opens
		Philippoteaux's 'Siege of Paris' exhibited in Philadelphia
1881	28 March	Royal London Panorama opens in Leicester Square, exhibiting Poilpot and Jacob's 'Charge at Balaclava'
	3 June	Panorama rotunda opens at Crystal Palace exhibiting Philippoteaux's 'Siege of Paris'
	6 June	Westminster Panorama, York Street opens with Castellani's 'Battle of Waterloo'

	15 June	Panorama rotunda opens at Alexandra Palace exhibiting Langlois's 'Siege of Sebastopol'
		Mesdag's 'Panorama of Scheveningen completed
1882		'Battle of Champigny' by E. Detaille and A. Deneuville exhibited in Paris
1883	August	'Battle of Rezonville' by Detaille and Deneuville exhibited in Vienna
	22 October	Cyclorama to house Philippoteaux's first 'Battle of Gettysburg' opens in Chicago
1884	22 December	Cyclorama to house Philoppoteaux's second 'Battle of Gettysburg' opens in Boston, Mass.
1886	January	Philippoteaux's third 'Battle of Gettysburg' opens in Philadelphia
		Heine and Lohr's 'Battle of Atlanta' completed
	15 October	Philippoteaux's fourth 'Battle of Gettysburg' opens in Brooklyn, N.Y.
1887	26 February	F. W. Heine and August Lohr's 'Battle of Atlanta' opens in Detroit
1888	12 March	Westminster Panorama, improved and renamed Niagara Hall, displays Philoppoteaux's 'Niagara in London'
1889	26 December	Great National Panorama, Apsley Place, opens with P. Fleischer's 'Battle of Waterloo'
		Gervex and Stephens' 'L'Histoire du Siècle' opens in Jardin des Tuileries
1892		Jan Styka's 'Battle of Raclawice' completed
1894	August	Charles A. Chase exhibits Electric Cyclorama in Chicago
1896		M. Z. Diemen's 'Battle of Isel' opens in Innsbruck
1897		Buhlmann and Wagner's 'Ancient Rome' exhibited at Earl's Court
1898		L. Marold's 'Battle of Lipany' opens in Prague
		T. W. Barber exhibits Electrorama at Niagara Hall
1900		Lumière brothers invent Photorama
1902		Niagara Hall closes
1905		F. Roubaud's 'Battle of Sebastopol' completed
1910		Panorama rotunda at Crystal Palace ceases to be used for panoramas
1912		L. Dumoulin's 'Battle of Waterloo' opens
		Roubaud's 'Battle of Borodino' completed
1913		Philioppoteaux's second 'Battle of Gettysburg' displayed in new rotunda at Gettysburg
1918		Carrier-Belleuse completes 'Panthéon de la Guerre'
1922		Diorama, Regent's Park converted into clinic for rheumatic diseases
1923	2 July	Paul Philippoteaux dies
1929		W. L. and A. Wyllie paint 'Battle of Trafalgar'
1933		'Panthéon do la Guerre' exhibited at Bicentennial Exposition, Washington D.C.
1933/4		'Panthéon de la Guerre' exhibited at Century of Progress Exposition, Chicago
1948		Diorama building converted to become London University annex (Bedford College)
1962		M. B. Gekov's 'Battle of Stalingrad' completed
		Wulz & Fastl's 'Panorama of the Crucifixion of Christ', Einsiedeln, completed
		Philioppoteaux's second 'Battle of Gettysburg', now restored, goes on display in Visitor Center, Gettysburg
1968		'Battle of Al-Qadissiyah' painted in Baghdad
1972		First proposals for redevelopment of Diorama, Regent's Park
1975		'Panorāma Guth,' Alice Springs opens
1977		N. W. Owetsjkin's 'Liberation of Pleven' opens at Pleven
1984	December	Graycoat Developments' appeal against Borough of Camden's refusal to allow an office development on the Diorama site rejected by D.o.E. inspector
1986		Styka's 'Battle of Raclawice' re-opens in Wroclaw
1987		Hallett's 'Panorama of Bath' opens on S. Bank
1988	17 June	Hallett's Panorama reopens at Thames Barrier
1988	6 October	Panorama of Arab-Israeli War due to open in Cairo
1989		W. Tübke's 'Panorama of the Peasant War' due to open in Bad Frankenhausen

BIBLIOGRAPHY

This bibliography does not include descriptive booklets and keys sold to visitors at panorama shows. To have included them would almost have doubled its length. Locations for booklets issued by Barker and Burford, in connection with panoramas exhibited at the Panorama, Leicester Square and the Panorama in the Strand, are supplied by Wilcox, pp.254-65

General

Altick, Richard, *The Shows of London* (Cambridge, Mass.: Harvard U.P. 1978).

Avery, Kevin J., '"The Heart of the Andes" Exhibited: Frederic E. Church's Window on the Equatorial World', *The American Art Journal*, 18 (1986), pp.52-72.

Bapst, Germain, *Essai sur l'Histoire des Panoramas et des Dioramas* (Paris: Imprimerie Nationale, 1891). Extract from the Reports of the Jury to the Universal Exhibition, 1889; illustrations by Edouard Detaille.

Barnes, John, *Catalogue of the Collection: Pt. I: Precursors to the Cinema* (St Ives: Barnes Museum of Cinematography, 1967).

Berger, Gustav A., 'Conservation of Large Canvas Paintings: The Role of Constant Tension Mounting systems', *Technology & Conservation*, (Spring 1980).

Berger, Gustav A., 'The role of Tension in the Preservation of Canvas paintings: A Study of Panoramas', *Preprints of Contributions to the Sixth Triennial Meeting of ICOM, Ottowa*, (1981).

Bordini, Silvia, *Storia del Panorama: La Vissione Totale nella Pittura del XIX* (Rome: Officina Edizioni 1984).

Born, Wolfgang, 'The Panoramic Landscape as an American Art Form', *Art in America*, 36 (1948), pp.3-19.

Bosshard, Emil., 'Gemalte Grosspanoramen und ihre Erhaltung'. *Revue Suisse d'Art & Archéologie*, 42 (1985), pp.297-302.

Bosshard, Emil, and Marty, Christian, 'Riesenpanoramen und ihre Erhaltung – eine Bestandsaufnahme', *Maltechnik Restauro*, 3 (1985), pp 9-32.

Britton, John and Pugin, Charles Augustus, *Illustrations of the Public Buildings of London* (London: John Weale 1838) Chapters on the Diorama, the Colosseum, and the Roman Catholic Chapel, Moorfields.

Ruddemeier, H., *Panorama, Diorama, Photographie: Entstehung und Wirkung neuer Medien im 19 Jahundert* (Munich: Wilhelm Fink, 1970).

Fawcett, Trevor, *The Rise of English Provincial Art* (Oxford: Clarendon Press, 1974). Panoramas and dioramas – pp.153-58.

Fruitema, Evelyn, and Zoetmulder, Paul A., *The Panorama Phenomenon* (The Hague: Mesdag Panorama, 1981).

Hollingshead, John, *My Lifetime* (London: Sampson Low, Marston & Co., 1895).

Hyde, Ralph, *Gilded Scenes and Shining Prospects: Panoramic Views of British Towns, 1575-1900* (New Haven: Yale Center for British Art, 1985). Exhibition catalogue.

International Panorama and Diorama Society Newsletter, 1985 onwards.

Jackson, Joseph, *Cyclopaedia of Philadelphia* (Harrisburg: National Historical Association, 1931-33). Entry for 'Panorama in Philadelphia' on pp.960-64.

Lee, Elizabeth Harvey-, 'Printed Panoramas', *Journal of the Antique Collectors' Club*, Feb. 1985, pp.23-26.

Levie, Pierre, 'Optical Views', *New Magic Lantern Journal. Oct. 1985*.

Marsh, Janet, 'When Art Widened its Appeal to the People', *Financial Times*, 26 June 1985.

Marty, Christian, and Baumgartner, Marcel, 'Bibliographie zum "Panorama"' *Revue Suisse d'Art et d'Archéologie*, 42 (1985), pp.339-48.

Marty, Christian, 'Panoramas: Realisation et Restauration', *Swissair Gazette*, 9 (1986), pp.20-21.

Meyer, Andre, 'Das Panoramagebaude: Zweckbau und Monument', *Revue Suisse d'Art et d'Archéologie*, 42 (1985), pp.274-80.

Meyer, André, 'Zweckbau oder Monument? Die architektonische Form und Konzeption des Panoramagebaudes', *Swissair Gazette*, 9 (1986), pp.22-23.

Norris, Hilary, 'A Directory of Victorian Scene Painters' *Theatrefile*, 1 (1984), pp.36-53.

Oettermann, Stephan, *Das Panorama* (Frankfurt am Main: Buchergilde Gutenberg 1981).

Oettermann, Stephan, 'The Panorama – an Early Mass Medium', *Swissair Gazette*, 9 (1986), pp.15-19.

Oetterman, Stephan, 'The Rise and Fall of the Panorama: the Art Form of an Epoch', *Swissair Gazette*, 9 (1986), pp.24-30.

Old Humphrey (pseud.) *Walks in London* (London: Religious Tract Society [1843?]). Describes visits to the Panorama, Leicester Square; the Cosmorama, Regent Street; and the Colosseum, Regent's Park. The author was George Mogridge.

'On Cosmoramas, Dioramas, and Panoramas', *Penny Magazine,* (1842), pp.363-64.

'Panoramas', *Chambers's Journal of Popular Literature*, (1868) pp.33-35.

The Panoramic Image (Southampton: John Hansard Gallery 1981). Exhibition catalogue.

Pückler-Muskau, Prince, *Tour in Germany, Holland, and England*, vol.3 (London: Effingham Wilson 1832). Describes panorama and cosmorama exhibitions in London and Dublin during the author's travels.

Rendle, T. McDonald, *Swings and Roundabouts: A Yokel in London* (London: Chapman & Hall 1919). Has a chapter on the 'Passing of the Panorama'.

Robichon, Francois, 'Le Panorama, Spectacle de l'Histoire', *Le Mouvement Social*, No. 131 (1985), pp.65-68

Sillevis, John, 'The Hague: Panorama Mesdag. 1881-1981', *Burlington Magazine*, 123 (1981), p.766

Solar, Gustave, *Das Panorama, und seine Vorentwicklung bis zu Hans Conrad Escher von der Linth* (Zurich: Orell Fussli Verlag, 1979).

Timbs, J., *Curiosities of London* (London: Virtue & Co. [1877?]).

Vogt, Adolf Max, 'Rotunde und Panorama: Steigerung der Symmetrie—Anspruche seit Palladio', *Neue Zurcher Zeitung*, 25/26 Oct. (1986), p.69.

Weber, Bruno, 'Formen und Funktion alterer Panoramen', *Revue Suisse d'Art et Archéologie*, 42 (1985), pp.257-68.

Wellbeloved, Horace, *London Lions* (London: William Charlton Wright 1826).
Includes information on the Panorama, Leicester Square; Marshall's Peristrephic Panorama; the Diorama; the Eidouranion, etc.

Wernick, Robert, 'History from a Grandstand Seat', *Smithsonian*, 16 (1985), pp.68-84

Wickman, Richard Carl, 'An Evaluation of the Employment of Panoramic Scenery in the Nineteenth Century Theatre'. PhD dissertation, Ohio State University, (1961).

Yates, Edmund, 'Bygone Shows', *Fortnightly Review*, 39 (1886), pp. 633-47.
Includes recollections of Albert Smith's 'Ascent of Mont Blanc', W. S. Woodin's 'Olio of Oddities', etc.

Yates, Edmund, *Edmund Yates: His Recollections and Experiences* (London: Richard Bentley, 1884).
Includes anecdotal recollections of the Colosseum, the Diorama, the Gallery of Illustration, etc.

Precursors

Battersby, Martin, *Trompe l'Oeil: The Eye Deceived* (London: Academy Books, 1974).

Murray, Edward Croft-, *Decorative Painting in England, 1537-1837*, (Feltham: 'Country Life' [1970]) vol.2 – 'The Eighteenth and Nineteenth Centuries.'

Roethlisberger, Marcel, 'Raume mit durchgehenden Landschaftsdarstellung', *Revue Suisse d'Art et Archéologie*, 42 (1985), pp.243-50.

Schulz, Juergen, 'Jacopo de' Barbari's View of Venice: Map Making, City Views and Moralized Geography Before the Year 1500', *Art Bulletin*, 60 (1978), pp.425-74.

Scouloudi, Irene, *Panoramic Views of London, 1600-1666* (London: Guildhall Library, 1953).

Early years

Andrew, Patricia, 'Jacob More's Panorama of Rome, 1793, *International Panorama and Diorama Society Newsletter*, 3 (1987), pp.16-17.

Bollaert, Herman, 'Optical Toys and the Development of the Projected Image', *New Magic Lantern Journal*, 4 (1986), pp.36-38.

Brockerhoff, Kurt, 'Eduard Gaertner's Panoramen von Berlin', *Berlinische Blatter*, 25 Oct. (1933), pp.13-18.

Brodbeck, Yvonne Boerlin-, 'Fruhe 'Basler' Panoramen: Marquard Wocher (1760-1830) und Samuel Birmann (1793-1847)', *Revue Suisse d'Art et d'Archéologie*, 42 (1985), pp.307-14.

Cameron, A.D., *The Man who Loved to Draw Horses: James Howe, 1780-1836* (Aberdeen U.P. 1987).
Howe's panoramas of Waterloo and Quatre Bras were exhibited in Edinburgh and Glasgow, 1816.

Corner, G.R., *The Panorama: with Memoirs of its Inventor, Robert Barker, and His Son, the late Henry Aston Barker* (London: J. & W. Robins 1857).
Reproduced from article in *Art Journal*, N.S. 3 (1857), pp.46-47.

Crick, Clare, 'Wallpapers by Dufour et Cie', *Connoisseur*, 193 (1976), pp.310-16.

Dickinson, H.W., *Robert Fulton, Engineer and Artist: His Life and Works* (London: John Lane, The Bodley Head 1913).

Eduard Gaertner, Architekturmaler in Berlin (Berlin Bauwochen 1968), Exhibition catalogue

Eitner, Lorenz E.A., *Gericault: His Life and Work* (London: Orbis 1982).
Describes the exhibiting of 'The Raft of the Medusa' in England, pp.209-12.

Feaver, William, *The Art of John Martin* (Oxford: Clarendon Press, 1975).

Gardner, Albert Ten Eyck, *The Panoramic View of the Palace and Gardens of Versailles. Painted by John Vanderlyn* (New York: Metropolitan Museum of Art, 1956).

Girtin, Thomas, and Loshack, D., *The Art of Thomas Girtin* (London: A. & C. Black, 1954).
Discusses the Eidometropolis.

Hendricks, Gordon, *Albert Bierstadt: Painter of the American West* (New York: Harry N. Abrams Inc. in association with the Amon Carter Museum of Western Art, [1975]).

Hittorff: Un Architecte du XIXeme (Paris: Musée Carnavalet, 1986).
Pages 163-69 are devoted to the architect's panorama rotunda in the Champs-Elysées.

Hittorff, J.J., *Description de la Rotonde des Panoramas Elevée dans les Champs-Elysées* (Paris: Revue Generale de l'Architecture, 1842).

Huntington, David C., *The Landscapes of Frederic Edwin Church* (New York: George Braziller, 1966).
Church's 'Niagara Falls' and 'The Heart of the Andes' were exhibited in New York and London in much the same way as panoramas.

Hyde, Ralph, 'Agostino Aglio, and London's Romish Panorama', *Country Life* (at press).

Johnson, Lee, 'The "Raft of the Medusa" in Great Britain', *Burlington Magazine*, 96 (1954), pp.249-54.

Karl Friedrich Schinkel, Architektur Malerei Kunstgewerbe 1981).
Catalogue of exhibition held in Charlottenberg 13 Mar.-13 Sept. 1981.

McClure, Ian, 'John Knox, Landscape Painter', *Scottish Art Review*, 14 (1974), pp.20-24.

McKinsey, Elizabeth, *Niagara Falls: Icon of the American Sublime* (Cambridge U.P. 1985).
Panoramas of the Niagara discussed on pp. 65-74, 150-52; Frederic Edwin Church's painting of the Niagara Falls pp.243-45.

Mondello, S., 'John Vanderlyn', in *New York Historical Society Quarterly*, 52 (1848), pp.161-83.

Pragnell, Hubert J. *The London Panoramas of Robert Barker and Thomas Girtin circa 1800* (London Topographical Society, 1968).

Pundt, Hermann G., *Schinkel's Berlin: A Study in Environmental Planning* (Boston: Harvard U.P. 1972).

Rubin, Rehav, 'The Search for Stephan Illes: An Elusive Mapmaker and His Extraordinary Model of Jerusalem', *Eretz*, Autumn 1985, pp.45-48.

Von Hagen, Victor Wolfgang, *Frederick Catherwood Archt.* (New York: OUP, 1950).

Whitley, William T., 'Girtin's Panorama', *Connoisseur*, 69 (1924), pp.13-20.

Colosseum

Britton, John, *A Brief Account of the Colosseum in the Regent's Park:* (London: The Proprietors, 1829).

'The Colosseum', *Penny Magazine*, 2 (1833), pp.121-23.

A Description of the Colosseum as Re-opened in M.DCCC.XIV...with Numerous Illustrations, and Eight Coloured Sections of the Panorama of London... (London: Printed by J. Wertheimer & Co., [1845]).

Hyde, Ralph, *The Regent's Park Colosseum* (London: Arthur Ackermann, 1982).

Hyde, Ralph, 'London as Seen Through a Fish's Eye', *Map Collector*, No. 39 (1987), pp.34-39.

Reilly, Joan, 'Lady Waldegrave's Stage Connection: Episodes in the Life of Her Father, John Braham', *Strawberry Fare*, Autumn 1987, pp.82-88.
An account of the Colosseum when owned by Braham.

Dioramas

Adams, Eric, *Francis Danby: Varieties of Poetic Landscape* (New Haven: Yale U.P., 1973).
Discusses influence of diorama on Danby's work.

Allen, Ralph G. 'The Eidophusikon', *Theatre Design & Technology*, 7 (1966), pp.12-16.

Clark, John, *The Amateur Assistant...to Accompany the Subject which Form the Portable Diorama* (London: S. Leigh, 1826).

Daguerre, Louis Jacques Mandé, *Historique et Description des Procedes des Daguerrotype et du Diorama* (Paris: Alphonse Giroux & Cie. 1839)

'The Diorama', *Mechanics' Magazine,* (1826), pp.289-91.

'Dioramic Painting', *Imperial Journal of Art, Science, Mechanics & Engineering*, 1 (1840), pp.244-45

Gage, John, 'Loutherbourg: Mystagogue of the Sublime', *History Today*, 13 (1963), pp.332-39

Gernsheim, Helmut, and Gernsheim, Alison, *L.J.M. Daguerre: The History of the Diorama and the Daguerrotype* (London: Secker & Warburg, 1956).

Gill, Arthur T., 'The London Diorama', *History of Photography*, 1 Jan. 1977, pp.31-36

Hyde, Ralph, and Van der Merwe, Pieter, 'The Queen's Bazaar', *Theatrephile*, 2 (1987), pp.10-15
An account of the British Diorama.

Paley, Morton D., *The Apocalyptic Sublime* (New Haven: Yale U.P., 1986).
Appendix 3 describes the various versions of John Martin's 'Belshazzar's Feast'.

Remise, J., Remise, Pascale, and Van der Walle, Regis, *Magie Lumineuse du Théâtre d'Ombres à la Lanterne Magique* (Paris: Balland, 1979).
Pages 214-25 for polyorama panoptiques.

Richardson, Edgar P., *Charles Willson Peale and His World* (New York: Harry N. Abrams, 1982).
Describes Peale's version of the Eidophusikon – 'Perspective views with changeable effects, or nature delineated and in motion'.

Robinson, David, 'Daguerre's Pleasure Dome', *Times Saturday Review*, 5 Feb. 1977.

Rosenfeld, Sybil, 'The Eidophusikon Illustrated', *Theatre Notebook*, 18 (1963/4), pp.52-54

Sellers, Charles Coleman, *Mr Peale's Museum* (New York: W. W. Norton, 1980).

Whatman, Gordon, 'The Dioramas of R. T. Roussel', *Studio*, Mar. 1959, pp.78-81.
Deals with museum display-case 'dioramas'.

Williams, W., *Transparency Painting on Linen*. 6th edn. (London: Winsor & Newton [n.d.]).

Cosmoramas

Adburgham, Alison, *Shops and Shopping* (London: Allen & Unwin, 1964).

Galinou, Mireille, 'Adam Lee's Drawings of St Stephen's Chapel Westminster: Antiquarianism and Showmanship in Early 19th-century London', *London & Middlesex Archaeological Society Transactions*, 34 (1983), pp.231-44.

Sattler & Sattler: Olgemalde Graphik (Salzburg: Salzburger Museum 1977). Exhibition Catalogue, 24 Apr.-26 June 1977.

Stopfer, Beate, 'Hubert Sattler (1817-1904): Materialen zur Monographie eines Reismalers', 22 (1976), pp.103-48.

Moving Panoramas

Arrington, Joseph Earl, 'Leon D. Pannarede's Original Panorama of the Mississippi River', *Mississippi Historical Society Bulletin, 9 (1953), pp.261-73*

De Vries, Leonard, *Victorian Inventions* (London: John Murray 1971).
Contains descriptions of the Trans-Siberian Railway panorama, the Mareorama, and a Cineorama Air Balloon panorama.

Dickens, Charles, 'The American Panorama [i.e. Banvard's Mississippi] in *Dickens' Works*, vol.35 (London: Chapman & Hall, 1908).

Dickens, Charles, 'Moving (Dioramic) Experiences', *All the Year Round*, (1867), pp.304-7.

Fitzsimons, Raymond, *The Baron of Piccadilly: the Travels and Entertainments of Albert Smith* (London: Geoffrey Bles, 1967)

Hall, Elton W., 'Panoramic Views of Whaling by Benjamin Russell', in *Art & Commerce: American Prints of the Nineteenth Century* (Charlottesville, Va: U.P. of Virginia [1978], pp. 25-49.

100 Years of Showmanship: Poole's, 1837-1937 (Edinburgh: Pillons & Wilson, 1937).

Hyde, Ralph, 'Mr. Wyld's Monster Globe', *History Today*, 29 (1970), pp.118-23.

Lanman, Jonathan T., 'An Unusual Double Panoramic Viewbox', *Map Collector*, No. (1986), pp.40-41

Lewis, Henry, *Making a Motion Picture in 1848,* with an introduction and notes by Bertha L. Heilbron (St. Paul: Minnesota Arch. Soc., 1936).
Journal of a Mississippi panoramist.

McDermott, John Francis, *The Lost Panoramas of the Mississippi* (Chicago: University of Chicago Press, 1958)

'Pictures Before the Crimea: A Travelling Panorama', *The Times*, 17 Aug. 1933.

Mayer, David, *Harlequin in His Element: The English Pantomime, 1806-1836* (Camb., Mass: Harvard UP, 1969)
Includes information on pantomime panoramas.

'A Panorama Party: And How to Make it a Success', *New Penny Magazine* (1901), pp.290-92.

Reynolds, Ernest, *Early Victorian Drama (1830-1870),* (Cambridge: Heffer & Sons, 1936).
Describes the use of panoramas in London theatres.

Rose, A., *The Boy Showman and Entertainer* (London: Routledge, 1920).
Contains chapters on making a peepshow, and making a moving panorma.

Rosenfeld, Sybil, *Georgian Scene Painters and Scene Painting Cambridge U.P. 1981)*
Pages 155-61 are devoted to panoramas and dioramas.

Schmitz, Marie L., 'Henry Lewis, Panorama Maker', *Quarterly Journal of the Missouri Historical Society*, 3 (1982-83), pp.37-48.

Simkin, Mike, 'Albert Smith: A Nineteenth Century Showman', *New Magic Lantern Journal*, 4 (1986), pp.68-71.

Southern, H., 'The Centenary of the Panorama', *Theatre Notebook*, 5, (1951), pp.67-69.
Article devoted to the Poole and Hamilton panoramas.

Thorington, J. Monroe, *Mont Blanc Sideshow: The Life and Times of Albert Smith* (Philadelphia: John C. Winston Co., 1934).

Waldron, Bob, 'Hand-Painted History', *Columbus Dispatch Sunday Magazine*, 19 July 1970, pp.7-11.
Describes a surviving moving panorama – 'The Campaigns of Garibaldi'.

Ward, Artemus, *Artemus Ward's Lecture, as Delivered at the Egyptian Hall, London* (London: John Camden Hotten, 1869).

Whittier, John G., *The Panorama, and Other Poems* (Boston: Ticknor & Fields, 1856)
Expresses thoughts aroused by a performance of a moving panorama.

The Panorama Revival

Bartmann, Dominik, *Anton von Werner: Zur Kunst und Kunstpolitik im Deutschen Kaiserreich* (Berlin: Deutscher Verlag fur Kunstwissenschaft [1985])

Bruschweiler, Jura, 'La Participation de Ferdinand Hodler au "Panorama" d'Edouard Castres et l'Avenement du Parallelism Hodlerien'. *Revue Suisse d'Art et d'Archéologie*, 42 (1985), pp.292-96.

Catton, Bruce, 'The Famous Cyclorama of the Battle of Atlanta', *American Heritage*, 7 (1956), pp.32-45.

Davis, Theodore R., 'How a Great Battle Panorama is Made', *St Nicholas Magazine*, Dec. 1886, pp.99-112

Georg, Kathleen R., 'The Tipton Panorama Photos. of Gettysburg', *Military Images*, Sept.-Oct. 1984, pp.15-25

Hopkins, Albert A., *Magic, Stage Illusions, and Scientific Diversions* (New York: Benjamin Blom, 1967).
Chapter 7 is devoted to 'cycloramas'.

Jamison, Alma Hill, 'The Cyclorama of the Battle of Atlanta', *Atlanta Historical Bulletin*, July 1937, pp.58-75.

Kelly, Margaret, 'Call to Arms!' Edouard Detaille and His Contemporaries (The Tampa Museum 1981).
Exhibition catalogue. Items selected from the Forbes Magazine Collection.

Kampfen-Klapproth, Brigit , 'Das Bourbaki – Panorama als Werk von Edouard Castres', *Revue Suisse d'Art et d'Archéologie*, 42 (1985), pp.288-91.

Meyer, André, and Horat, Heinz, *Les Bourbakis* (Lucerne: Editions 24 Heures, 1983).

'The Panorama of the Battle of Trafalgar', *Royal Naval Exhibition Pall Mall Gazette Extra* (1891), pp.30-33.
Describes Philipp Fleischer's 'Battle of Trafalgar' panorama, previously exhibited in Edinburgh and Manchest-er.

The Panorama Painters and Their Work (Milwaukee County Historical Society, 1969).
Exhibition catalogue. It contains an essay, 'The Panorama Painters' Day of Glory', by Frances Stover, which tells the story of panorama painting by German artists in Milwaukee.

Robichon, François, 'Emotion et Sentiment dans les Panoramas Militaires après 1870', *Revue Suisse d'Art et d'Archéologie*, 42 (1985), pp.281-87.

Robichon, François, 'Les Panoramas de Champigny et Rezonville par Edouard Detaille et Alphonse Deneuville', *Bulletin de la Société de l'Histoire de l'Art Français*, 10 Nov. 1979, pp.259-80.
Includes a *catalogue raisonné* of fragments of, and studies for, these two panoramas.

Stanton, Théodore, Stevens, Alfred, and Gervex, Henri, 'The Paris Panorama of the Late Nineteenth Century', *Nineteenth Century*, 39 (1889-90), pp.256-69.

Telbin, William, 'The Painting of Panoramas', *Magazine of Art*, (1900), pp.555-58.

Photographic panoramas

Alfieri, Bernard, 'Panoramic Views, and How They are Taken', in *The Modern Encyclopaedia of Photography*, vol. 2 (London: Amalgamated Press n.d.).

Burleson, Clyde W., and Hickman, E. Jessica, *The Panoramic Photography of Eugene O. Goldbeck* (Austin, Texas: Univ. of Texas Press, 1986)

Eadweard Muybridge: The Stanford Years, 1872-1882 (Stanford University Museum of Art, 1972). Exhibition catalogue.

Fabre, Charles, *Traité Encyclopédique de Photographie* (Paris: Gauthier-Villars, 1889-1906).
Entries for 'chambres panoramique' and 'photographie en ballon'.

Haas, Robert Bartlett, *Muybridge: Man in Motion* (Berkeley: University of California Press, [1975]).

Hales, Peter B., *Silver Cities: The Photography of American Urbanization, 1839-1915* (Philadelphia: Temple U.P., [1984])

Miller, R. Steven Hyde, 'A Portrait of New York City in 1874'. *Bulletin of the City of New York*, Sept.-Oct. 1982. William W. Silver's photographic panorama of New York.

Morrison, John, 'A Panoramic View', *Camera*, Jan. 1985, pp.43-46
Review of the work of Michael Westmoreland.

Panoramic Eye, 1981 onwards. An irregular periodical.

Panoramic Photography (New York University, Faculty of Arts and Science, 1977). Exhibition catalogue.

'A Photographic Robot on Mars', *Photographic Year, 1977-1978,* (Time Life International, 1977).

Polden, Brian, *Panoramic Camera* (In preparation).

Sexton, Sean, 'Thomas Sutton's Panoramic Camera and Outfit', 2 (1981), pp.6-13.

Westerbeck, Colin L., 'Taking the Long View', *AA Forum*, Jan. 1978.

Watney, John, 'Harding's All-Round Vision', *British Journal of Photography*, 8 Feb. 1985.

The World is Round: Contemporary Panoramas (Hudson River Museum, 1987). Exhibition catalogue.

Cinematic Panoramas

Ceram, C.W., *Archaeology of the Cinema* (London: Thames & Hudson, 1965).

Fieldings, Raymond, 'Hale's Tours: Ultrarealism in the Pre-1910 Motion Picture', *Smithsonian Journal of History*. 3 (1968-89), pp.101-21.

Toulet, Emmanuelle, 'Le Caméra à l'Exposition Universelle de 1900', *Révue d'Histoire Modern et Contemporaine*, 33 (1986), pp.179-209.

The Panorama Today

Barker, Felix, 'Bath in Oils', *Telegraph Sunday Magazine*, 25 May 1986, pp.13-14.

Bates, Lincoln, 'As Big as Life', *M.D. Magazine*, Feb. 1985, pp.155-62.

Berger, Gustav A., 'New Approaches for Special problems: The Conservation of the Atlanta Cyclorama', *Preprints of Papers Presented at the Ninth Annual Meeting of the American Institute for Conservation of Historic and Artistic Works*, Philadelphia, 1981.

Coutts, Herbert, 'The Living City: A Television Panorama of the City of Edinburgh', *Museum Journal*, Sept. 1985, pp.81-83.

Hodgkiss, A.G., 'The Bildkarten of Herman Bollman', *Canadian Cartographer*, 10 (1973), pp.133-45.

H.W. Mesdag, S. Mesdag-van Houten: Their Lives and Works (The Hague: Panorama Mesdag, 1981).

Kampfen-Klapproth, Brigid , 'Les Grands Panoramas Suisses', *Swissair Gazette*, 9 (1986), pp.31-42.

Masten, Susannah, 'The New Cyclorama', *Atlanta Impressions*, Spring 1982, pp.48-55.
Describes the restoration of 'The Battle of Atlanta' and the renovation of its rotunda.

Nitkiewicz, Walter J., 'Treatment of the Gettysburg Panorama', *Studies in Conservation*, 10 (1965), pp.91-118.

Ochrono Zabytkow, No. 4 (1984), pp.232-303.
This issue of this quarterly journal is devoted to the history and conservation of the Raclawice Panorama.

O'Reilly, Emma-Louise, 'A Room with a View', *Country Life*, 22 Aug. 1985, pp.518-19.

Powell, Jim, 'Fantasy in the Round', *Americana*, 11 (1983), pp.59-64.
Describes the restoration by Gustav Berger of 'The Battle of Atlanta' and the 'Palace and Gardens of Versailles'.

A Salute to Raclawice (New York: The Kosciuszko Foundation, 1978).

Tübke, Werner, 'Zur Arbeit am Panoramabild in Bad Frankenhausen (DDR)', *Revue Suisse d'Art et d'Archéologie*, 42 (1985), pp.303-6.

Wyllie, W.L., 'A Panorama of the Battle of Trafalgar', *Society for Nautical Research: Annual Report for 1929*.

Zoetmulder, Paul A., *Catalogue of the Collection of Paintings and of the Panoramic Roundview, on Permanent Exhibition in the Mesdag Panorama Museum*. (The Hague: Panorama Mesdag, 1986).

INDEX

Photographic Acknowledgements

We would like to thank all the lenders of works from private and public collections for kindly supplying photographs of their loans, and for allowing us to reproduce them here. We would also like to thank the following for supplying photographic material for the exhibition: Conway Library, Courtauld Institute (cat. no. 242); Professor Kerry Downs (cat. N. 23); David Trace (cat. nos. 210 & 219) National Air & Space Agency, Washington DC (cat. nos. 246 & 247).

Thanks must also be extended to Jonathan Morris-Ebbs for undertaking particularly difficult photographic work for this exhibition. We are also grateful to the following photographers: Godfrey New, Val Rylands, Studio I.